The Other End
of the Needle

Inequality at Work:
Perspectives on Race, Gender, Class, and Labor

Series Editors: Enobong Hannah Branch and Adia Harvey Wingfield

Inequality at Work: Perspectives on Race, Gender, Class, and Labor provides a platform for cultivating and disseminating scholarship that deepens our knowledge of the social understandings and implications of work, particularly scholarship that joins empirical investigations with social analysis, cultural critique and historical perspectives. We are especially interested in books that center on the experiences of marginalized workers; that explore the mechanisms (e.g., state or organizational policy) that cause occupational inequality to grow and become entrenched over time; that show us how workers make sense of and articulate their constraints as well as resist them; and have particular timeliness and/or social significance. Prospective topics might include books about migrant labor, rising economic insecurity, enduring gender inequality, public and private sector divisions, glass ceilings (gender limitations at work) and concrete walls (racial limitations at work), or racial/gender identity at work in the Black Lives Matter era.

Julie C. Keller, *Milking in the Shadows: Migrants and Mobility in America's Dairyland*

David C. Lane, *The Other End of the Needle: Continuity and Change among Tattoo Workers*

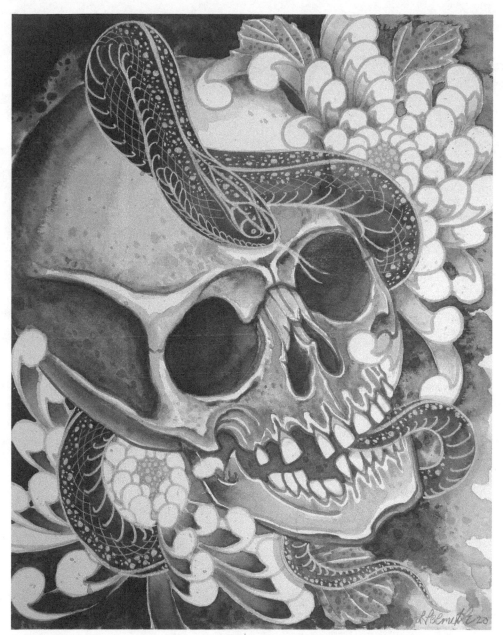

Frontispiece of tattoo artwork from Dana Helmuth's *Ghost Snake* series, 11 × 14, sumi ink on paper.

The Other End of the Needle

Continuity and Change among Tattoo Workers

DAVID C. LANE

Rutgers University Press

New Brunswick, Camden, and Newark, New Jersey, and London

Library of Congress Cataloging-in-Publication Data

Names: Lane, David C., author.
Title: The other end of the needle : continuity and change among tattoo workers / David C. Lane.
Description: New Brunswick : Rutgers University Press, [2020] | Series: Inequality at work: perspectives on race, gender, class, and labor | Includes bibliographical references and index.
Identifiers: LCCN 2020007179 | ISBN 9781978807471 (paperback) | ISBN 9781978807488 (cloth) | ISBN 9781978807495 (epub) | ISBN 9781978807501 (mobi) | ISBN 9781978807518 (pdf)
Subjects: LCSH: Tattoo artists. | Tattooing—Sociological aspects.
Classification: LCC GT5960.T36 L36 2020 | DDC 391.6/5—dc23
LC record available at https://lccn.loc.gov/2020007179

A British Cataloging-in-Publication record for this book is available from the British Library.

∞ The paper used in this publication meets the requirements of the American National Standard for Information Sciences—Permanence of Paper for Printed Library Materials, ANSI Z39.48-1992.

www.rutgersuniversitypress.org

Manufactured in the United States of America

To all those who make tattooing happen each day

Contents

Introduction: Tattooing for Beginners 1

1 The Social World of Tattooing 12

2 Organizing Space 39

3 Careers of Tattooists 66

4 Legal Consciousness among Workers 98

5 Ties to Conventional Institutions and Ideas 121

6 Sources of Contention 140

7 External Threats and the Maintenance of Boundaries 158

Conclusion: Continuity and Change 183

Appendix A: Methodology 189
Appendix B: Breakdown of Participants 195
Acknowledgments 199
Notes 201
References 215
Index 225

**The Other End
of the Needle**

Introduction

Tattooing for Beginners

Madison, a first-year college student, sits in the front room of a tattoo shop; she's decided to get a tattoo today. As machines buzz in the back of the shop, she looks nervous while waiting for the tattooist, Kevin, to finish drawing a design for her. She is successful in school and has excellent relationships with her family, friends, and coworkers. Like some of her peers, she has decided to get a small tattoo on the top of her foot. The design she has chosen is a small lily, and for her, it is not just a tattoo but a symbolic mark in remembrance of her late grandmother. Once finished, she will join the more than 40 percent of those aged 18–25 in the United States who have at least one tattoo.[1]

While Madison is waiting for her drawing, Kevin is making a series of decisions that will affect the outcome of the tattoo. He considers the location—the foot, which has relatively thin skin—and ponders how to design the flower in a way that will fit the foot. He worries that Madison will not like the design and request another drawing, requiring more of his time. He decides it best to keep the flower within the conventional expectations of what most customers request. He assumes that Madison is like many other college students and just wants a small tattoo to show that she dabbled in deviance while in college and that too much variation might deter her. Finished with his drawing, he moves to the front of the tattoo shop to show Madison. She finds it beautiful, and Kevin invites her beyond the dummy rail and back to his tattoo booth.[2]

With the smell of green soap lingering in the air, Kevin applies a thermal fax outline to Madison's foot and tries to ensure that it fits. He is worried about the angle of the flower, how it flows, and if it looks right on her body. The first attempt to apply the outline looks good, but Kevin is unsatisfied. He

rotates it slightly, almost unnoticeable to the untrained eye, and reapplies it in a position that seems to fit Madison's foot a little better. She approves, and he begins to assemble the materials needed to apply the tattoo. He pulls out the first needle he will use, a 5RL (short for "5 round liner"), and he places it, still in its presterilized blister package, on the table. He chooses to outline using one of the coil machines his late mentor left him. Later, when he shades and colors the tattoo, he will use the rotary machine he has been bragging about for the past couple of months. Then Kevin puts a heaping dollop of petroleum jelly on the table. He spreads a tiny amount of it across his workspace. In the spread petroleum jelly, he places several small plastic cups, 12 millimeters in diameter and about a half inch tall. Then Kevin takes three different bottles of ink—pigmented black, green, and purple—and squeezes several drops from each into the separate cups.

For a moment, he pauses, then says, "You wanted the flower part blue, right?" Madison confirms this. Kevin's eyes begin to dart between several different bottles containing hues of blue ink. He wonders whether the blue ink he just purchased a couple of months ago from an older tattooist at a tattoo convention would work for this, or if he should stick with the blue he has been using for the past year. It would be the time to test out that new blue, as foot tattoos are not always visible to others. However, he starts to think she is probably not coming back for another tattoo. If she does not come back, he will not be able to evaluate how the ink looks in several months or years. He selects the older blue that he is confident about using.

After taking the needle out of its package, and putting it in the machine, Kevin presses his foot down on the switch that provides power. *BZZZZZZZZZ*—the machine whirs for a split second. Kevin turns a knob up on his power supply, hits the foot switch, and the machine buzzes for a few brief seconds. Unsatisfied, Kevin turns the knob again. He holds the machine close to his ear and pushes down on the foot switch. Blankly staring at the floor, he concentrates on the sound of the machine and how it feels in his hand. He adjusts the knob again, this time only moving it slightly. The machine's vibrations barely change, but Kevin notices a major difference.

The entire time Kevin was assembling these materials, he was talking to Madison. He was doing this to gain her trust. A comfortable client is ideal. The more rapport they develop, the easier the tattoo will be to produce. "Are you ready?" he finally asks, before starting the tattoo. Madison nervously nods, not knowing what to expect or how painful it may be. Kevin senses this tension and tries to increase rapport by cracking a foot fetish joke. Previously he told me that the foot is one of the most socially awkward and uncomfortable places to be touching someone's body—especially someone you do not know. Kevin is relieved when she laughs; if she had not, this quick and small tattoo was going to seem a lot longer and more demanding to complete. Throughout

the application of the tattoo, Kevin continues to talk to Madison, asking questions and telling entertaining stories. This tattoo seems to pass by more quickly than the others that day. Soon enough, Kevin is asking for one final picture—documenting what he produced—before he bandages this fresh tattoo and Madison walks out the door with some care instructions.

Each day, clients walk into one of the over 10,000 tattoo shops that currently exist in the United States. Like Madison, some are getting their first tattoos, while others may be working on larger ones, such as a sleeve or bodysuit. In seeking out an expert to apply the tattoo, someone like Madison must enter the social world of tattooing—Kevin's world. It is a world that exists in the margins of formal institutions. It has its own cultural code, with members who carry out practices, hold sets of beliefs, and sustain values. Every day, tattooists like Kevin must not only apply tattoos to people but also navigate the complex cultural matrix that is the social world of tattooing.

For example, for Kevin to create Madison's tattoo, he had to acquire the necessary materials. This seems relatively simple. However, the materials for this kind of activity are not readily available. Kevin needs pigment and a tool—or machine—that will push that pigment into the skin. Most stores do not carry these kinds of items on their shelves. Tattooists rely on contacts within their world for these supplies. Tattooists cultivate these contacts as they earn the right to become full-fledged members of the occupation.

In producing this single tattoo, Kevin was concerned with the kinds of feedback he would receive. Many others can see a single tattoo, and their reactions can have complex effects on Kevin's career. On the one hand, he was concerned with Madison's reaction and the reactions of her immediate friends and family members. To attain her business, he needed her to be pleased with a drawing of the tentative tattoo. Typically, word-of-mouth refers tattooists to potential clients, so Kevin was also considering Madison's friends and family. Their reactions could hurt or help Kevin's reputation among potential and current clients.

On the other hand, Kevin was also worried about how his colleagues would interpret the tattoo. Tattooists, like those responsible for producing other types of cultural goods, need evaluation and feedback to perfect their craft. Recall Kevin's decision to use the old blue instead of the one he recently purchased. He felt that Madison would not be a repeat customer. Without seeing the new blue several months later, Kevin could not evaluate its effectiveness. The only evaluation of the tattoo he could receive would be from the photograph, which he would show some colleagues. This feedback confirms Kevin's own identity within this world, his status among colleagues, and helps him develop his craft.

Kevin, like other tattooists, needs a space where he can produce tattoos. This space facilitates Kevin and Madison encountering one another. Tattooists

tend to band together into small work groups to operate studios. In the studio where Kevin and Madison met, there were two other tattooists working. This small work group formed through personal contacts and experience. Often tattooists with similar degrees of experience, beliefs, and values work together.

Researchers have given this world little attention. To date, most research examines tattooed people or their assumed deviancy. These studies emphasize the meaning of tattoos or the outcome of a social process. By focusing on the outcome, research has largely ignored the world of the tattooist. This research is about understanding, as closely as possible, the world tattooists live within. It moves beyond tattoos and their meanings to understand the other end of the needle.

Tattooing has several interesting features to study. First, tattooists and tattoo workers create and sustain their social world. To the casual observer or outsider, tattooing might appear disorganized, run by deviants, criminals, or other social outcasts. However, to the insider, it has a flexible, decentralized, craft-like form of organization with a code of ethics based on tradition. This code defines the division of labor, reward systems, methods of socialization, and rules of the game. It also helps tattooists manage tensions of continuity and change. Remarkably, with no centralized bodies of socialization or unionization, or formal organizations or institutions, members of the tattoo occupation tend to coalesce around a set of core practices, ideas, and values.

Second, tattooing is currently a popular and growing occupation. To put the size of this occupation into perspective there were 9,434 tattoo shops in the United States in 2010. That same year, there were approximately 12,700 McDonald's restaurants and 12,800 Starbucks. By 2014, there were 10,873 tattoos shops in the United States, an increase of 15.25 percent in just a four-year period or an average of 359 more tattoo shops opening each year. None of these are chain businesses.[3] Even though the size and scope of the occupation have recently changed, tattooists have maintained their independence and small-scale form of social organization.

Third, tattooing contributes to our understanding of work and occupations. Studies have focused on complex organizations, the cultures that develop in them, and how professions sustain their positions of prestige.[4] Studies that examine labor in other spheres are often ethnographies about workers in positions of disadvantage who lack power.[5] Tattooing represents the middle ground between these two orientations. Data show that 99 percent of tattoo shops have less than 11 employees, and 90 percent have 5 or fewer employees. Tattooing has not evolved like other for-profit industries that have become bureaucratized. Instead, tattooists rely on their decentralized form of organization, which values local, authentic craft production.

What We Know about Tattooing

Except for a few works, most research focuses on the tattoo or the tattooed person. It examines the types of people tattooed, their motivations, or meanings associated with tattoos. Early research rooted tattoos in pathology, herd behavior, or the fascination with uncivilized other.[6] Recent scholarship has been more pro-tattoo, attempting to remove tattooing from its deviant past, but it still focuses on the meanings people assign to tattoos.[7] Collectively, research has overemphasized the outcome of a social process: the tattoo.[8]

By focusing on tattoos' meanings, studies have missed the mark. They overemphasize how people make sense of tattoos or consume them. However, tattoos, just like any other form of culture, are an active social process.[9] They are not something that people just consume. Instead, people produce, then distribute, and finally, consume tattoos. This book flips the lens to the other end of the needle, examining the processes preceding the consumption of tattoos.

Existing literature on tattooing fits under one of four general categories: tattooed individuals and their social psychology; group behavior; capitalism and commodification; and tattooing as a medium of art. Most research consists of ethnographic and anthropological fieldwork, although there are some recent statistical studies in psychology and business marketing.[10] These studies provide detailed accounts of people's tattoos and their meanings, including the identities of tattooed people. Remarkably, there are relatively few studies focused on the activity of tattooing.

Tattooed Individuals and Social Psychology

The majority of research on tattooing examines the social psychology of the tattoo wearer. Early psychological research tended to focus on tattooing as a sign of pathology. Later efforts reinforced the association between the presence of tattoos and someone's mental illness, deviance, or criminality.[11] Some recent works attempt to uncover the motives for why people get tattooed, concluding that tattoos are a form of self-expression written on the body.[12] Overall, psychological research consistently overemphasizes the connections between tattooed people and other types of problematic or deviant behavior.

Sociological research has focused more on the meanings people assign to tattoos.[13] Studies often emphasize how tattoos have symbolic meaning, tell a story about the wearer's identity, or allow people to create identities.[14] This includes the use of tattoos as a marker of a deviant identity.[15] Both early and contemporary efforts have explained how wearers learn to manage the tattooed self across social settings, including managing a stigmatized identity.[16] Importantly, sociologists have found that those who become tattooed engage in prosocial interaction in the process of attaining a tattoo and then learn to navigate the identity of being tattooed.[17] Concerning this process, scholars

examine the decision-making process of tattoo wearers, vividly depicting how they understand the size, placement, and visibility of tattoos.[18] Studies also look at how, for others, tattoos help them create resistant identities.[19] From this perspective, the body is a contested site of politics, and becoming tattooed is a way to reclaim ownership over it.

Group Behavior

A second set of research focuses on how tattooing and tattoos reinforce group boundaries and social positions. Historically, dominant groups used tattoos to mark outsiders, such as criminals, the socially undesirable (slaves), and various others (religious figures, ethnic groups, and so on) perceived to be threats.[20] They marked group boundaries by creating stigmatized bodies and identities. Yet there is evidence that some outsiders adopted their stigmatizing marks as symbols of their own resistance.[21] For example, the intention of tattooing prisoners was to stigmatize the wearer. However, some prisoners attained elaborate designs by covering the initial mark(s).[22]

A second way people used tattoos historically was to demonstrate loyalty, devotion, or allegiance to an in-group. Tattoos continue to be used to denote membership in families, subcultures, gangs, the military, countries, and religions.[23] There is a long history of familial, military, and subcultural tattooing.[24] These tattoos are symbolic representations of a person's membership in a group rather than a way of casting them as outsiders.[25] This strand of research emphasizes how members of groups use tattoos to denote the social boundaries of their in-groups.

Finally, research has demonstrated that members of some status groups adopted tattooing to reinforce their own social positions. In particular, this involves the middle-class appropriation of tattoo wearing from its working-class roots throughout the 1990s and early 2000s.[26] In this perspective, members of the middle classes legitimate their tattoos by tying them to the conventional motives, beliefs, and values of the middle classes.[27] This is a type of status politics, reinforcing the boundary between the middle classes and the lower and working classes through the consumption of tattoos.[28]

Consumption and Commodification: A Peculiar Good

A small set of research examines tattoos as a consumer commodity.[29] Sociologist Mary Kosut claims tattoo consumption is an ironic fad, since the current enthusiasm for them seems to resemble the classic fads curve.[30] However, tattoos are not easily discarded once the enthusiasm wears off like other fads, such as hula hoops or streaking.[31] Some even argue that tattoos cannot be a fad because of their permanence, a quality not associated with fads.[32]

Additionally, tattoos are distinct from other products of consumption in capitalism.[33] Each tattoo produced is one of a kind, no matter how many times

a tattooist re-creates the same image. It is also impossible to consume a tattoo without being present during its production. Finally, tattoos technically have no market value in capitalist systems. This is because once they exist, there is no market in which to exchange tattoos for other commodities. Tattoos are not like many other goods people consume in modern systems.[34]

The Medium of Tattoo

The final way scholars have examined tattooing is as an art form. They depict how boundaries between the institutional art world and tattooing have dissipated.[35] During the latter half of the 20th century, tattooing transitioned from folkcraft to a credentialed, artistic, occupation, in the United States. Specifically, trained artists moved into tattooing, creating new aesthetics that appealed to consumers with backgrounds in art or formal education.[36] This shift is what researchers and tattoo historians call the Tattoo Renaissance.[37]

The Tattoo Renaissance refers to changes that occurred to the occupation beginning in the late 1950s through the 1970s. These changes included an increased concern for health and safety, the incorporation of aesthetics from the institutional art world, and more custom tattoo designs. Additionally, more middle- and upper-class consumers became attracted to the practice. Some tattooists even incorporated intellectual and philosophical questions into their work.

Scholars attempted to explain how the Tattoo Renaissance was responsible for reducing or removing the stigma once associated with the practice.[38] Others emphasized how tattooing had become increasingly accepted as a legitimate art form.[39] In particular, research depicted how tattooing has increasingly become accepted by conventional institutions of art.[40] In sum, this strand of research described how tattooing ascended from a lowbrow form of folk art to a kind accepted by legitimate art worlds. Again, these studies focused on how people attach meaning to, or understand, tattoos as cultural forms.

Tattoo Work and the (Lack of) Research

This summary reveals a fundamental problem. Scholars have focused on the study of the tattoo, but not the processes of how the tattoo comes into existence. This is something scholars of art and culture have been critical of for many years.[41] Few studies have attempted to examine the work and organization of tattooists. Largely ignored in existing research are the identities of tattooists, their experiences, and the social forces and processes that affect their lives. Moreover, tattooists are situated in a specific social world where legal, economic, market, and cultural forces shape their work. By shifting attention to the process, the other end of the needle, this study examines those responsible for making tattoos—the tattooists.

Tattooists and Their World

Sociologists have long been concerned with the role of work in a person's life.[42] Making a living as a tattooist has similarities to other forms of work. Tattooists share an occupational culture, members are socialized into this work, their identity as tattooists is a significant part of their lives, and they have systems of hierarchy with established pathways of mobility, labor within legal constraints, and adapt to changes that affect their work.

Like other occupations, tattooists occupy a *social world*. The social worlds approach illustrates how people attach meaning to their work, the actions that create social organization, and how workers manage continuity and change.[43] This book is about understanding the social world of tattooists in Baltimore, Maryland.

Social Worlds and the Tattooist

The social worlds perspective depicts culture as a collective process. It emphasizes the active social process of creating and sustaining culture.[44] For example, tattooists have sets of meanings to explain their world. When tattooists find meanings useful, they also create a justification or reason for them. Useful meanings and justifications become embedded in their cultural code, which functions to reinforce their world and socialize new members.

Tattooists, like members of other occupations, have distinct understandings of their work. When a tattooist decides to produce a tattoo, they make this decision with reference to their skill level, method of socialization, status among peers, and position in networks—all of which tattooists learn through participation in this world. This explains why tattooists use certain needles or colors or commit to building machines. This world is a collectively agreed-upon construction that is larger than any one tattooist. It is not a static reality but one that is fluid, where people negotiate meanings that explain or manage the problems of their labor. Those meanings found useful in confronting the practical problems of their work become part of their cultural code, whereas people discard less useful meanings.

Tattooing is "a specific type of social world," an art world. Art worlds "consist of all the people whose activities are necessary for the production of the characteristic works which that world, and perhaps others as well, define as art. Members of art worlds coordinate the activities by which work is produced by referring to a body of conventional understandings embodied in common practice and frequently used artifacts."[45] Within tattooing, people engage in competitive and cooperative relationships. They negotiate rules and collaborate to procure, fabricate, or supply tools, equipment, aesthetics, and knowledge. The art worlds perspective emphasizes the networks of people necessary to produce, distribute, and consume tattoos. This process

is not something done in isolation, since it requires the collective activity of many people.

All art worlds have a division of labor, which defines all the tasks needed to produce works of art and who conducts those tasks.[46] Within the world of tattooing, some specialize in fabricating machines, which they sell to other tattooists. Apprentices often carry out grunt work or routine tasks, such as sterilization, sweeping and mopping, taking out the trash, drawing stencils, and scheduling client appointments. Tattooists rely on this division of labor to work efficiently.

Art worlds also have rules designating what is art and who is an artist.[47] A similar system operates to define who receives the honorific title of "tattooist" and what kinds of work constitutes legitimate tattooing. Central to these rules are reward systems that bestow honor, status, or reputation.[48] Some tattooists win awards for best tattoos or have their work featured in magazines, websites, videos, or blogs, while others never receive this kind of public attention. Additionally, tattoo collectors and tattooists alike designate and debate genres or styles of tattooing, noting which tattooist's work quintessentially represents these categories.

Networks of interdependence are necessary to carry out their work. Similar to other art worlds, tattooists "[work] in the center of a network of cooperating people, all of whose work is essential to the final outcome."[49] Somewhere, someone is a specialist mixing pigments, another person fabricates machines, and another provides a space to work. The specialist who builds machines is not present when a tattooist uses one. However, the specialist is necessary to produce the tools needed to make a tattoo. The individual tattooist is reliant on this cooperative network for gathering materials, accessing jobs, becoming socialized, earning rewards, and receiving feedback on their work.

When producing tattoos, the decisions made affect the outcome. To navigate these decisions, tattooists have rules of the game. These are "all the decisions that must be made with respect to works produced."[50] More generally, rules of the game dictate the bounds of an art world and the limitations of an art form. They are important for ensuring there are sets of cooperative relationships.[51] For tattooists, these rules help them by reducing conflict and determining who needs to do what, how much of it they ought to do, and who they need to do it with. It provides them with an established, but negotiable, way of doing things.

Key Contributions

This research contributes to the production of culture literature in three ways. First, it discusses how tattooists have been able to achieve some degree of independence from other spheres of society. Traditionally, studies tend to focus on those forms of culture produced and distributed by formal organizations, with

an emphasis on the ways organizational constraints limit the production and distribution of cultural forms.[52] Occasionally overlooked in the production of culture literature is the concept of autonomy, which occurs when cultural producers retain control over their associations and spaces of work and mechanisms of distribution.[53] In other words, tattooists rely on a cultural code that protects their autonomy.

Second, it extends our understanding of how law affects the production of culture. Previous scholarship on the production of culture focuses on law as a constraining force for creative activities.[54] It presumes that legal restraints limit agency to produce some cultural forms while simultaneously providing incentives or opportunities to produce other cultural forms. These constraints shape the decisions of cultural producers, distributors, and consumers. Chapter 4 merges that perspective with the concept of legal consciousness, adding to existing literature on the production of culture.[55] Merging these perspectives enables us to examine the imprint of law on cultural producers. As evidenced, law is not simply a constraining force structuring the work of tattooists but also a game played by them and a resource deployed to protect interests. This provides a distinct contribution to the literature about how cultural producers and members of creative industries enact their legal consciousness to achieve goals.

Third, this research extends our understanding of tattooing by using the framework of the social world.[56] I examine the cultural production of tattooing as an active social process, which enables me to show how the culture of tattooing is more complex than the high-low dualisms established in previous research.[57] These dualisms favored social class as the explanation for divisions within the world of tattooing. They also overemphasized the meanings people create around their tattoos or the consumption and interpretation of tattoos. By doing so, they ignored that social class may only be a determinant of how consumers or cultural receivers assign meanings to tattoos. Examining the social processes preceding the existence of a tattoo reveals the complex world of tattoo labor.

Summary

This introduction began with the example of Kevin creating a tattoo for Madison. He was making decisions that would affect the outcome of his labor—the tattoo on Madison's foot. Kevin made these decisions with reference to his social world, the world of tattooing. His orientation toward work, where he works, and his training, status, and identity within the world of tattooing were all contributing factors. This book is about that world Kevin belongs to, a world that scholarship has been hesitant to acknowledge.

Tattooing shares many similarities with other occupations and forms of cultural production. It has a hierarchy and system of stratification, methods of socialization, careers, and an occupational code. While tattooing shares these similarities with other forms of labor, tattooists operate outside of formal institutions and without a formal or centralized body of authority. They rely on the code of tattoo work, which is deeply rooted in tradition, to sustain their world. Tattooists favor experience, accomplishment, and honor over credentialism and formal education. Their traditions operate as an alternative to the mechanisms of organization seen in many other occupations. Tattoo work is a type of resistance to the principles of capitalism and formal rationality. This book explains how tattooists sustain their world.

1

The Social World
of Tattooing

There are no such ultimate maxims
when discussing culture. Culture is as
vast as people; you can never give only
one answer.
—Horiyoshi III

Horiyoshi III is arguably one of the most revered tattooists in the world. He
has mastered the creation of materials and the technical skill needed to tat-
too. In his mid-20s, he finished an apprenticeship under the tutelage of Shodai
Horiyoshi.[1] Horiyoshi III specializes in producing exquisite full-body suits
that are sought after and admired by tattoo collectors around the globe. He
holds a special position atop the world of tattooing, a position few tattooists
ever occupy. Tattooists, tattoo collectors, and the public view him as a master
or living legend.

Horiyoshi III did not simply happen to land atop this world as a genius or
maestro of tattooing. Instead, he had to navigate the complex social world of
tattooing. Someone like him has worked within specific conditions that have
provided him opportunities to earn these honors. It is easy to imagine that any
tattooist, even Horiyoshi III, works in isolation—in a dark, dingy cavernous
space—managing their career. However, he is merely standing on the shoul-
ders of giants, who provided him with expert training, an understanding of art
and literature, a body of knowledge, and different opportunities. Navigating

this world requires interaction with many other people, and Horiyoshi III was able to do so in a way that was different from other tattooists.

Horiyoshi III's tattoos are evidence of his reliance upon others. For him to produce a tattoo, he needs pigments, paper, pens, visual sources, needles, gloves, machines, ink cups, a clean space to work, and so on. He had to learn from others how to effectively use these materials to produce the desired effects. To facilitate this work, Horiyoshi III has several apprentices who ensure all the necessary materials and tools are available for him. A client funds the endeavor and provides their skin for a duration of time.[2] Horiyoshi III also needs an audience to define his tattoos as masterful works. Publishers (magazines and books—and increasingly, the internet) and the public judge and evaluate the outcome of his labor. While Horiyoshi III may tattoo by himself, he is situated in a network that facilitates the production and distribution of his work.

It is possible to learn much from examining masters like Horiyoshi III. However, they are outliers, as most tattooists never occupy this position. To understand the social organization of tattooing, it is more useful to incorporate a wider range of experiences. These would illustrate the cultural code, rules of the game, and stratified division of labor to reveal the complexity of tattoo work's social organization. This chapter begins by explaining the historical transformation b how tattooing became a full-time occupation in the United States. It emphasizes the cultural elements that shape the contemporary organization of the craft. The chapter then shifts to the contemporary system of stratification among tattooists and how they orient themselves toward their work.

From Folkcraft to Occupation

Most likely, the first professional tattooist in the United States was Martin Hildebrandt, who began tattooing in 1846. He opened a shop in 1875 in New York City.[3] Hildebrandt was probably not the first person to profit from selling this service. However, he was the first to settle into a shop, "what he called an atelier in [sic] Oak Street, between Oliver and James Streets, New York," estimated to be 77 James Street in Lower Manhattan today.[4] Prior to opening this shop, Hildebrandt tattooed as he traveled. He began his tattoo career in 1846 while working as a sailor and continued as a soldier with the Army of the Potomac during the Civil War. Both Northern and Southern troops welcomed him, as they coveted his tattoos.[5]

The significance of Hildebrandt's story is on account of his hoboing around before opening a shop,[6] which reveals the (lack of) organization among those producing tattoos in the late mid- to late 19th century in the United States.[7] Like Hildebrandt, other producers of tattoos were sailors or laborers who tended to move from place to place to secure work. Sailors specifically had

access to many materials and tools used to produce tattoos while aboard a ship.[8] So tattooing had a folkcraft form of organization, in which there is no sense of commitment other than as a hobby. Little training was involved as many transferred the skills of other folkcrafts to tattooing.

Given the amount of downtime, condensed space, and lack of leisure activities aboard ships, it should be no surprise that sailors got creative by engaging in various folkcrafts. To illustrate, U.S. sailors produced embroidered blouses, engraved scrimshaw designs, and developed intricate drawings while aboard. These kinds of folk art tended to contain nautical imagery, sentimental messages for loved ones, depictions of professional ranks or affiliations, and patriotic symbols.[9] In perhaps the best depiction of the continuity between these folkcrafts and tattooing, Matt Lodder claims, "The tools used to scratch tobacco tins, engrave love tokens and mend trousers—a needle and a piece of black cinder, charcoal, soot or even gunpowder for marking—are precisely the same set of implements needed to produce basic tattoo marks."[10] Sailors had access to sewing needles from their own sewing kits or the ship sailmaker, could process pigments from materials aboard the ship, encountered imagery to inspire their works, and most importantly, had access to people with skin and time. As a folkcraft, there is little evidence to indicate that a formal market, division of labor, or elaborate form of social organization occurred around tattooing aboard these ships. Instead, it was one of many maritime crafts.

Once Hildebrandt settled into a shop, it was not long before other tattooists began to follow suit. By 1876, Samuel O'Reilly opened in Chatham Square in New York City, just a few blocks north of Hildebrandt's shop.[11] By the 1880s, New York became the first city in the United States to have over one million residents, making it a splurging metropolis with many potential clients. Places like Chatham Square, and later the Bowery, had an influx of tattooists settling into shops in what were urban fun zones.[12] More tattooists—Lewis "Lew-the-Jew" Alberts, Charlie Wagner, "Electric" Elmer Getchell, and Louis Morgan—settled into shops in the early 1900s.[13] Between 1875 and 1925, shops opened in Philadelphia, Los Angeles, Seattle, San Francisco, Minneapolis, San Antonio, St. Louis, Boston, and New Orleans. Notice, most were port cities. Lenora Platt and August "Cap" Coleman settled in the city rumored among East Coast tattooists to be the greatest bounty of them all—Norfolk, Virginia, where there were plenty of sailors, including the U.S. Navy's new Great White Fleet of battleships.[14] By opening shops, tattooists changed their organization. For the first time, tattooing became a for-profit occupation.

As more tattooists opened shops they began to compete for customers.[15] Working in close proximity to one another, they defended their business interests to keep clientele. For example, Lenora Platt and Cap Coleman, known as the king and queen of Norfolk, competed with "E. J. Miller, Andy Sturtz, Bill Grimshaw, and Elmer Getchell [who] were all scattered along Main Street."[16]

Growing competition was such an issue that some even taught their wives how to tattoo as "a way to boost business without fear of losing them [as laborers] to competing shops."[17] In response to increased competition, they began to define who was, and who was not, a member of the occupation. The code of tattoo work began to emphasize who has earned the right to tattoo, and it valued a do-it-yourself (DIY) ethic.

There were two innovations associated with this shift in organization. The first was the electric tattoo machine, patented by Samuel O'Reilly in 1891.[18] Machines made tattoos more affordable, less painful, and quicker to produce; increasing their rate of diffusion and facilitating a more artistic style of tattooing in the United States and Europe.[19] The second innovation was flash. *Flash* were predrawn designs that hung on the walls of tattoo shops or outside carnival tents. These designs enticed customers by showing what tattooists were (supposedly) capable of producing. It made the reproduction of specific images easier for tattooists, and it increased their control over clients.[20] Tied to both innovations, skill hierarchies began to emerge among tattooists—a change in social organization.[21]

Prior to the electric tattoo machine, tattooists were largely responsible for producing their own tools and materials. They made hand tools by binding several needle points onto a short stick. To produce ink, tattooists mixed dried pigments with alcohol and water.[22] Due to variation in materials and methods, it was difficult to compare the skill of tattooists to one another. Once people adopted them, machines became a piece of technology that tattooists could use to compare their skills and talents.[23] A hierarchy and system of prestige enabled tattooists to rank themselves in relation to one another and claim expertise.[24] Those who were considered to have the greatest ability to manipulate machines or who honorifically earned their place in the prestige hierarchy landed atop this world.

The tattoo machine also became a physical representation of the tattooists' code. Tattooists operated independently and needed to be self-sufficient with a DIY ethic, but they were also interdependent, relying on one another for the exchange of knowledge and materials. Being a commercial art, tattooists often held onto their tricks of the trade to give them a competitive advantage in the market. For example, discussing tattoo machines, Pops, currently the owner and curator of a tattoo museum, claims, "Tattooists had to make their own repairs back then and really know the tricks of the trade just to keep up with the demand for tattoos. Some of those tricks are still used to this day."[25] These tricks of the trade are hard-fought and easily lost, something only to be passed on to trusted associates. This reflects the value for defining who honorifically earns the right to be in the know.

Machines represent a bundle of knowledge only shared with others who earn the right to possess it.[26] Jake, a skilled machine producer and mentor of

Kevin, a 34-year-old tattooist, decided it was time to teach Kevin about tattoo machines once he had grasped how to tattoo. Over several weeks, Jake began to teach Kevin the basics of machines and their mechanics. This occurred in a residential garage workshop. It included learning about the physics and geometry of machines and how those affect the way they run. The significance of this process is that Kevin honorifically earned the right to this knowledge, and it reveals the DIY social organization among tattooists.

While it is unknown when flash initially appeared, or when people first used the term, it certainly appeared sometime in the early 1900s. Its predecessors were sketchbooks and other handicrafts used by ship tattooists to advertise their skills.[27] The sketchbooks carried by early tattooists and advertised in supply catalogs through the 1910s were easy to store and transport, and they are evidence that many were still working and traveling extensively.[28] In contrast, flash were larger sheets of paper (usually 20″ × 15″ or 18″ × 24″), framed, and intended to be hung on the walls of tattoo shops.[29] Like sketchbooks, these enticed customers into choosing designs. Being larger, they were more problematic for travel.

As more tattooists settled into shops, flash replaced sketchbooks. Flash designs provided consumers with available imagery to select for tattoos.[30] Tattooists transferred the outlines of images on flash to the skin of clients via acetate etching, stencil, or tissue paper, providing an outline of the design.[31] Over time, people exchanged or reproduced flash designs with minor variations.[32] Occasionally, tattooists outright copied them off the bodies of tattoo wearers.[33]

Just like tattoo machines, people evaluated producers of flash based on a skill hierarchy. Louis Morgan, a San Francisco–based tattooist, describes differences between types of flash in the early 20th century: "Outlines of good designs can be had very cheaply by getting impressions of a good selection from a tattoo supplier. These outlines can easily be copied by making transfers for them or cutting stencils of them. Then the impression can be made on the drawing paper and the designs painted to suit the purchaser."[34] Morgan is suggesting there is a value for flash produced by more skilled tattooists. Those who were skilled were more likely to have their imagery distributed, reproduced, and copied by others. Flash created a degree of continuity in tattoo imagery.[35] This is how the traditional American style of tattooing developed its genre boundaries.

Flash were also a collective solution to the problem of commercial uncertainty.[36] It structured client choices by shaping the form and content of imagery. Folklore among tattooists exemplifies this problem of uncertainty and control. Kevin explained, "I remember one of the stories he [Jake] was telling me, there was days that he [Phil—Jake's mentor], there'd be a roomful of people waiting for tattoos, like sailors, and today he would be like, 'Today, I'm doing eagles, and if you're not getting an eagle, get the fuck out.' And he would

just do eagles all day. And you would see people get up and leave 'cause they weren't getting [did not want] an eagle that day." There are many versions of this lore, but the general narrative is about limiting uncertainty to maximize profits. Once they possessed them, tattooists could replicate designs from flash, enabling them to operate with less input from clientele and merely make minor modifications to efficiently produce tattoos.

Additionally, a subset of tattooists largely controlled the production and distribution of flash. Morgan notes, "The best designs to have are those produced by professional tattooers, as they will make so much better showing and will soon pay for their cost by selling so much more often than the ones made by the beginner."[37] In Morgan's depiction is evidence of skill hierarchy forming around the production of flash (not necessarily tattooing itself). Tattooists located known insiders to purchase from, with flash from the most reputable becoming the most sought after.[38] The innovation of flash provided tattooists with a mechanism to regulate the market for their services and construct a skill hierarchy to evaluate different producers. In contemporary tattooing, there is now a prestige hierarchy among tattooists who collect flash from historical legends and masters. However, many contemporary tattooists—especially the artists—have moved away from the efficiency of flash in favor of one-of-a-kind designs.

While these material innovations facilitated the production of tattoos, they also demonstrate the occupation's growing division of labor. They show the increasing sophistication and specialization among tattooists. The production and distribution of these innovations also reveals a growing cultural code among workers. This code emphasized a DIY ethic, a system of stratification, and the role of insiders or established tattooists who had access to specialized knowledge.

The Supply Company: Controlling the Means of Production

Even though tattooists value the DIY ethic, most do not have enough time to produce all the materials necessary to tattoo. Some tattooists and ex-tattooists specialize in producing and/or distributing these needed materials. For example, some fabricate tattoo machines, while others focus on mixing pigments to create inks. Those who distribute catalogs of these items are known as suppliers or supply companies. Remarkably, tattooists were historically successful at retaining a large degree of control over their means of production through supply companies. The transformation of tattooing into a full-time occupation involved coordinating with these support personnel.

It is clear, especially when speaking with contemporary tattooists, that machines are a vital tool. Some people specialize in creating them. Tattooists rank and debate over who makes the best machines for which tasks. Even historically, they recognized the importance of machines that function well. In an

interview with Don "Ed" Hardy, Paul Rogers once explained why Cap Coleman's tattoos were so good:

> I learned the mechanic work from Coleman, 'cause he was our best mechanic that we ever had. And he knew machines, so that's what I went by. And I got to fixin' machines for other people while I was there with Coleman . . . Most people that I knew wasn't artists in the old days and they were very poor mechanics as there was no way for them to know anything about it. If one guy had something good going he never revealed what his secret was. A lot of them thought Coleman had something he put in his ink since it went into the skin so good. And it wasn't nothin' but the machines was runnin'.[39]

Rogers worked with Coleman from 1945 to 1950. His talent, and having learned from Cap Coleman, led Rogers to eventually team up with "Huck" Spaulding in 1955, forming Spaulding and Rogers Supply Company. Throughout the 1960s and '70s, Spaulding and Rogers were known to produce some of the most exquisite tattoo machines in the United States.

Rogers's story is significant for several reasons. He indicates that knowledge about how to build and tune tattoo machines is only passed on to trusted associates. This eliminated competition and kept unwanted people out of the occupation. It is also part of that DIY ethic of earning the right to specialized knowledge. Additionally, a skill hierarchy emerged among those who were able to fabricate and tune tattoo machines. As Rogers claims, Coleman was a good tattooist not because of a secret ink but because of an understanding of how to alter the machine to produce desired effects. Finally, this narrative demonstrates how some people specialized in support work, such as building tattoo machines or forming supply companies. This transition led to a more complex division of labor. Tattooists and ex-tattooists initially dominated the arena of supply companies, controlling who had access to the tools of the occupation.

For example, Percy Waters's primary contributions to tattooing were as a machinist and salesmen of tattoo machines. By 1925, he had altered the original electromagnetic coil machine created by his mentor, Charlie Wagner. He moved the placement of the electromagnetic coils in the frame and added an on-off finger switch. He then began marketing these machines and tattoo equipment to tattooists.[40] His pamphlet read,

FOR YOUR PROTECTION—
DON'T BE BUNKED

By fly-by-nighters who pose the largest manufacturers of tattoo supplies in the world. Such jip artists can sell only to the inexperienced buyer. This type of mail order men do not last long, as they depend on

catching their customers once. They copy word for word literature put out by others. They retrace and offer for sale copies from crude photographed tracings among which you will find left hand clasp, rock of ages, woman clinging to the left side of the cross, Statue of Liberty with left hand up, flags on a steamboat waving north, the smoke going south; machines made over from door buzzers, radio parts, tubes made from metallic pencil or umbrella stem. Such crap could not be classed with tattooing machines and designs made by a skillful mechanic and artist of long reputation.[41]

Throughout the 1920s and 1930s, Waters's supply company was the largest in the United States.[42] As a trusted insider, he was able to claim legitimacy and authority over the production of tattoo equipment. His company would become one of the first reputable tattoo supply companies.[43] Despite the warning above, evidence indicates that Waters was selling more machines to other suppliers than to tattooists, even stating that "such supply dealers are not Manufacturers" on the back of his business card—another claim to legitimacy accepted by insiders.[44] These claims are part of the cultural code, which values known insiders for having the theoretical body of knowledge and skills to manufacture tattoo equipment and a tattooist-controlled system of production and distribution. By controlling supply companies, these people limited access to the materials needed to produce tattoos. They policed boundaries of tattoo work by acting as gatekeepers who limited access to the means of production. The growth of supply companies shows an increasing degree of interdependence between tattooists, enabling them to create supply companies that resonated with other tattoo insiders.

The Cultural Organization of Contemporary Tattoo Work

In the social worlds perspective, the emphasis is on all the efforts needed in the process of creating a cultural product. These efforts include the systems stratification and the socialization process among contemporary tattooists. The systems both facilitate and constrain work. For example, the tattooist who cleans their own shop, or mixes their own pigments, must dedicate a portion of their day to these activities, which limits the amount of available time for other activities. However, if an apprentice is responsible for cleaning the shop, the tattooist can focus their efforts on other forms of labor. Despite variations among individual tattooists, there is generally an agreed-upon way to divide these tasks between members of this world. A hierarchy ensures specific people carry out all those tasks. This is part of the cultural code. It is the basis for understanding a tattooist's occupational identities, orientation toward work, and position in relation to others.

Ideal types can be used to describe the system of stratification in tattooing. *Ideal types* are categories that represent the essential features or characteristics of social phenomena.[45] No one case exactly fits the criteria of a single ideal type, but there are general patterns where cases fit more within one type than another. In this case, ideal types are categories that depict the different kinds of tattooists and the ways they each understand their work, identities, and position in relation to others.

Traditionally, scholarship divides the tattoo world into two ideal types: the street shop and the high-art studio.[46] Rubin used these categories to explain changes to the occupation during the Tattoo Renaissance.[47] These categories divided the occupation of tattooing into a high-low art binary. However, this oversimplifies the social world of tattooing. Most obvious, it reduces tattooists to a binary division by presuming social class is the basis for cultural divisions within this world. Additionally, it excludes all those support personnel who make tattooing possible. Moreover, it does not measure the significance of the public in defining tattooists. Finally, and most important, a class-based model does not account for systems of prestige or the orientations toward work that exist among tattooists. A class-based model falls short in explaining how tattooists create and sustain cultural divisions within their world.

Figure 1.1 is a typology of the social world of tattooing. This model accounts for not only a hierarchical system of prestige among tattooists but also the orientation different types of tattooists have toward their work. It consists of categories people reference as identities in this world. At the top of this world are the legends and masters who have established themselves within the collective memory of the occupation. Legends and masters are those like Horiyoshi III, Cliff Raven, or Cap Coleman. These are people who have mastered both the craft and the art of tattooing. They take on a special kind of status, one that honorifically places them in a category above all other tattooists. Not only is their work exceptional, but they also have a following of people who consider them to be the epitome of a tattooist.

Craftsmen and artists are each hierarchically organized, with some overlap between the two types. There are fewer people at the top of each of these types than the bottom. Those who are at the top of these hierarchies benefit from greater privileges and rewards, such as widespread recognition, the ability to charge more money for their services, status among other tattooists, and increased control over their work.

Craftsmen orient their work around the time-bound traditions of tattooing. They have a reward system that values the traditional, established way of doing things. This way of doing things involves passing on traditions from mentor to mentee. Contemporary tattooists work within established channels to uphold these traditions as an honorific component of the occupation.

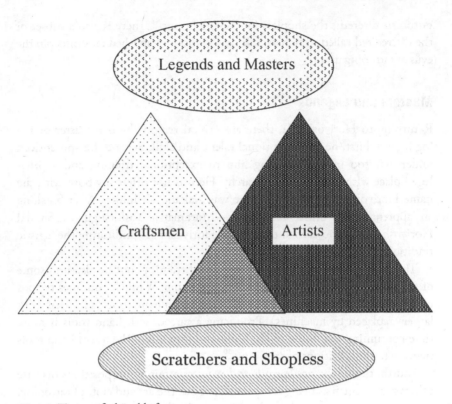

FIG. 1.1 The stratified world of tattooing

Artists, on the other hand, have their own hierarchy. Their reward system values artistic freedom. They seek to grow as artists and view tattooing as another medium through which to explore their artistic talents. Those who are artists value their creative freedom and are often at the forefront of promoting new aesthetics that may become legitimated genres of tattoos. Just like craftsmen, those at the top of this hierarchy have more freedom and control over their work than those at the bottom.

The overlap in figure 1.1 occurs because tattoo work requires cooperation between craftsmen and artists. Artists rely on the craftsmen to produce tools and materials. Craftsmen rely on artists to create new aesthetics and push the boundaries of the craft. Those in the craft hierarchy spend more of their time working on the tools and technical aspects of tattooing. Those in the art hierarchy are more interested in the art of tattooing.

At the bottom of this world are the shopless and scratcher tattooists. The shopless encompass all those cast as outsiders by the established tattoo world. These tattooists, usually untrained or self-taught, have entered the occupation without following the accepted cultural code. In other words, established

tattooists discredit the shopless for lacking honor.[48] There is also a subset of the discredited called scratchers, folk devils whom established tattooists pin the evils of tattooing upon.

Masters and Legends

Returning to Horiyoshi III, there are several reasons he is a master or living legend. First, he has exceptional talent and skill. Second, he apprenticed under a tattoo master, entitling him to exceptional training and a privileged place within the tattoo hierarchy. He was not originally born with the name Horiyoshi III. His birth name was Nakano Yoshihito. After finishing an apprenticeship under his master—Muramatsu Yoshitsugu, or Shodai Horiyoshi—Nakano earned the title of Horiyoshi III, indicating the artistic tradition of his master.[49]

Third, not only did he receive exceptional training, but he also uses some of the traditional methods and tools of tattooing. While he outlines tattoos using a machine, he colors and shades tattoos with hand tools (a form of work largely replaced by machines). Producing a tattoo with hand tools is more time-consuming, traumatic to the body, and expensive. The use of hand tools ties him to the traditions of tattooing.[50]

Fourth, those who are legends and masters attain these positions because others regard them as being exceptional at both the art and craft of tattooing. For example, it is easy to claim that Norman "Sailor Jerry" Collins was an artist who infused new aesthetics into American tattooing. However, he was also a legendary craftsman, known as one of the first people in the United States to unlock the secret of making purple ink that would last in the skin—a secret he guarded closely.[51] Similarly, Horiyoshi III is also an exceptional craftsman who followed the traditional apprenticeship model used by Japanese artisan and tattoo families. Under the direction of his mentor, he spent years producing the materials needed to tattoo, such as grinding pigments. He learned to master the tasks to produce the materials needed for tattoo work through support work while under the tutelage of his master.[52]

Those who end up being legends and masters have followings. On the one hand, these are people that other tattooists and consumers also define as being exceptional. Some enthusiasts and tattooists even collect their machines and flash. Their followings are large because they create works that resonate with audiences. These people are not simply good at tattooing but are honored for occupying a special position within the world of tattooing by audiences.

Craftsmen

Craftsmen are the second type of tattooist. For them, there is a traditional, established, way of doing things. They differ from others in this social world because their reward system values these traditions. It is a subcultural reward system specific to those who orient their work around the craftsman identity.[53] Since many tattooists apprentice under craftsmen, including artists, the craftsmen's values and beliefs percolate into the larger world of tattooing.

For craftsmen, people earn the honorific title of tattooist after completing an apprenticeship. This is personalized training, and it involves a mentor symbolically handing down the tools of the craft. Completing an apprenticeship is a reward, accompanied by a change in status (they can collect money for their services and gain a greater degree of autonomy), which is highly valued among established tattooists.

Apprentices typically perform mundane activities around the shop for no income. Dante, a 21-year-old apprentice, explained, "Everybody that first starts tattooing and they get into a shop—that's like paying their dues would be, like you start doing little petty things for them, so I can learn it. It's for—it's obviously for me to learn it, but it's also for the repetitiveness, but also to like help them out, and so it's like I do it to show my appreciation for them helping me [learn]." For him, paying his dues involves honoring established tattooists by showing devotion and gratitude for the opportunity to learn. The notion of paying your dues is a common sentiment that reflects honoring the traditions of tattoo work.

Craftsmen also value technical proficiency when producing tattoos. Technical proficiency means executing a tattoo with the utmost precision. For them, tattoo work should be executed in a manner that is consistent within the traditions of a genre. Thirty-four-year-old Samuel's description of a good tattoo depicts this value:

> I mean, of course to look good, it's gotta be solid, it's gotta be straight lined. You can't have some lines all squiggly and some lines all straight, [but] you want to be consistent throughout. You want your colors to go in really nice and solid and smooth. A good tattoo is, in my opinion, clean, solid, and straight. You want that always, but everybody has their own expectations of a good tattoo . . . We run into a lot of people—I've run into a lot of people over the years that will tell you how good their tattoo looks, and when you look at it you're like, "Ehhh not so much." And a lot of people don't have that understanding of what a really good tattoo should look like.
>
> DAVE: How do you know that it doesn't look so good?

SAMUEL: Whether or not it's solid. If it was done where the person really dug in too deep. Like, there's blowouts, there's scarring, there's splotchy color, where it's not solid throughout. The consistency isn't good. The lines aren't as consistent and straight throughout. There's a lot of times, if you look at line work, you'll see like some thick and thins, a little bit that's really in there and some that's not.

As a tattooist, he is talking about the level of skill a person has with using their tools and materials. The concern for Samuel is not the art of a tattoo, but that good tattoos have solid craftsmanship. When he speaks of depth, or "thick and thins," his concern is over the technical proficiency of the tattooist who manipulated the needle and machine when applying the tattoo to the skin. A preoccupation of craftsmen is executing each line and movement with technical proficiency.

Craftsmen focus on producing tattoos within the traditions of established genres. While they may innovate within the genre, the expectations of what that genre is supposed to look like limits their innovations. For example, in describing the traditional American genre, 36-year-old Joseph stated, "Something about the simplistic bold lines, bright colors, and there's no hidden meaning behind the tattoo. It's a rose, it looks like a rose, so it reads like a rose. It is a rose. Or you know what I mean, it's a panther head, or an eagle—there's no kind of hidden meaning behind them or anything like that . . . And again, it's simple looking, and I think just those kind of tattoos hold up the best over time." For him, a traditional American tattoo is an image with bold outlines and bright colors, which follows the time-tested rules established through tradition. Craftsmen limit aesthetic innovation by focusing on mastering the technical aspects of established tattoo genres.

The established rules reinforce each genre's boundaries. These rules are handed down through word of mouth by older tattooists and evidenced in the existing tattoos or flash of that genre. For example, one of the rules of traditional American tattooing is the one-third, one-third, one-third rule. Dorsey, a 36-year-old shop owner, claimed, "I finally get now that there's a value, the values of traditional tattooing. Like, one-third black, one-third color, one-third skin are really important. At least the black foundation and the contrast, I learned in art classes that if you could take something that's color and make it a black-and-white version, you could see how much the contrast is the balance of dark and light." This rule is a foundation for those who do traditional tattoo work. As someone who is more of an artist than a craftsman, Dorsey explained that these rules are still fundamental for tattoos that look right.

Craftsmen tend to value hard work and having a position in this world that reflects their commitment to labor. They view having an ego, and even

discussions of money, as disrespectful to the traditions of the craft. Instead, they depict their work as a passion or calling. Samuel demonstrated this when he was discussing his goals:

> The only goal I really have as a tattooer is to just keep getting better at it and just keep learning new things about it. The only thing that I want to do is just to consistently put a good tattoo on somebody. I don't really have a financial goal I'm trying to reach. I'm never going to retire at this age. I don't have a goal to retire. I don't have a goal of money to feel comfortable. I don't, I'm not going to be like one of these guys—I'm not going to be on *Inked* or *Next Tat Star*; I don't have any goals like that . . . It's not about money for me.

Samuel summarizes the rewards and values of craftsmen. For him, there is pride in being creative and learning how to improve his skill set. He claims he does not want to be famous and that it is not about the money. Taken together, these claims invoke that tattooing should not be associated with things like money or fame, values that craftsmen tend to avoid.

Crafting an Ethic of Support Work

Part of the craftsmen ethic values support work. Many view the production of tools or materials as a source of pride. This does not mean craftsmen abandon tattooing (although some eventually do). Instead, they have an additional interest in fabricating things tattooists need, such as machines and their parts or inks.

For those who build machines, called "machine builders" in this world, interest usually began early in their career. Since many tattooists prefer handmade machines, their support work is highly valued. Currently, Joseph's interest in machines is beginning to grow. He spends his spare time cutting springs and fabricating parts for himself and the other tattooists in his shop. At this stage, he is not yet building his own machines. However, he is learning how to make replacement parts to repair machines:

> I can tinker around with machines. I wouldn't say that I am a builder or anything like that, but I can put a machine together. I can tune it, and I can get it working again for you, but it is gonna be kind of the way that I would want it set up for me. Where a machine builder is going to build it to the way that you tattoo. Basically, if Henry breaks a spring and needs something fixed real quick, I can put a new spring on there for him and get it back to where was.

Similar to others who produce tattoo machines, Joseph's foray into support work initially started with an interest in how machines work. He is currently tinkering, but he does not consider himself a machine builder yet. To become

a machine builder, he will need to locate a more experienced person to learn the tricks of the trade. Becoming a builder would be a form of upward mobility within the craftsmen hierarchy.

Those who are involved in machine building fulfill the role of support personnel for other tattooists. Kevin traveled with his heavy metal band across the country each year. During these trips, he also worked as a traveling salesman of tattoo machines: "Well, my boss that passed away, he made machines. So I used to carry brochures with me, and I would carry [a] couple of machines with me, and be like, 'This is what they are. If you wanna tattoo somebody, go ahead. Here's how you get a hold of us if you need 'em. I'll get 'em for you for this price. I know the brochure says this, and if you want them, just contact me.' I used to sell machines. Some cities weren't so acceptable to outsiders coming in trying to sell the machines, but it worked." This support work is essential to distribute the materials needed to produce tattoos. Even though Kevin was on tour, he was visiting tattoo shops and pitching his former boss's machines to prospective buyers. Someone must build the machines, and someone must distribute them in this world. Tattooists are reliant upon the work of machine builders for one of their most important pieces of equipment.

A few craftsmen who are also machine builders attain a status that resonates widely among tattooists. Some of those I interviewed had purchased machines from Aaron Cain, a well-known tattooist from Baltimore who tattooists consider a legend or master. He now specializes in building machines. As 47-year-old John Lee stated, "There's another guy, Aaron Cain, who has ridden the top of tattooing for so long that now, mostly he makes machines. Because he's not making machines [doesn't mean] he's not that good of a tattooer. He's just got to the level of, the point where it's like, 'I need to do something else.'" Regardless of Aaron's motives, he has oriented his work around building machines. While he was an innovator in the biomechanical art genre of tattoos, he has since focused labor on the craft of support work, becoming recognized for mastering the production of machines. Being a master of both art and craft, he has a higher status than other tattooists who are solely craftsmen that build machines.

Other craftsmen learn to specialize in the production of pigments and inks used for tattooing. Just like Aaron Cain, they occupy a distinct position, as others consider them a special type of craftsmen. Their reputation is not just as tattooists but as specialists who produce high-quality materials or tools. Edgar, a 48-year-old shop owner, explained this to me:

I make that [*he points to his shelf full of containers, each with a different colored ink in them*]; I make 33 colors of that. I make one color of this [*he shows me a bottle of black ink*], and right now I make 21 colors of these [*he shows me a bunch of bottles of paint in a drawer*]: liquid acrylic paints to make paintings ... but I only focus on colors, like I don't have any interest in making anything else, because I know

colors. I've made it a point to make that my specialty, and so there's nobody around here that knows colors the way I know colors. That's—at the expense of sounding like a jerk, I've made it my thing. I just have an interest in it. I took it as a challenge because . . . I wanted to take it deeper, and I wanted to master it and really know what the hell I was doing. And really know what the hell I was putting in people's skin.

Craftsmen like Edgar value the traditions of tattooing and the ability to produce the materials needed to tattoo. He mixes the pigments himself to create different colors of ink. This also illustrates how tattooists' value handmade, authentic, localized craft production. Others are dependent upon people like Edgar for the materials needed to produce a tattoo. By having an elevated position, craftsmen like Edgar have the time necessary to explore intellectual craftsmanship and innovation in their support work. Producing materials is a nostalgic throwback to the craftsmen of the past. It is based on the traditional way of doing things and following the DIY ethic of the occupation's predecessors.

Journeymen Tattooists

At the bottom of the craftsmen hierarchy are a subtype of craftsmen I call "journeymen tattooists." They are full-time tattooists who are technically competent, but whose identity and worldview differs from other craftsmen. Often, those who occupy this position are early in their careers, and they are still being socialized into the occupation. Usually, they have some knowledge of how machines work and a small theoretical body of knowledge about tattooing. A few have even moved into shop ownership. However, journeymen's motivations, goals, and rewards reflect their position at the bottom of the craftsmen hierarchy, as they differ from the expectations of established tattooists.

Journeymen report having great respect for the traditions of the craft. For example, some rely on imitation of the great masters. Many feel rewarded by adding their own touch to existing aesthetics. Joseph described this: "What I like to do is take something, a design that a master has already done, and try to put my little spin on it. Maybe I'll change up the color in it, or redraw something a little bit different, but keep all the basic guidelines that are in that tattoo. As far as, the eagle is going to be in that position, my wings may be a little bit different, my beak may be a little bit different, and it may not make sense, but that's just what I would do." Imitation with minor changes does not ensure tattoos align with the proposed rules of masters. There are numerous examples of tattoos with ship sails blowing into the wind or improper knots, and even incorrect seasonal elements in Japanese-style tattooing. Journeymen still learning the craft risk violating these rules when innovating based on a master's design.

While all tattooists seek compensation for their work, journeymen tend to value the financial reward above other rewards. These tattooists are more likely to be self-taught or to have had a loose, informal apprenticeship much shorter in duration than others. They understand the code of tattoo work but do not place a high value on it. Instead, they value tattooing as an opportunity to make money. Charles, a 32-year-old black tattooist, described his motivation for tattooing: "I've worked Walmarts, Targets, a lot of textile and industrial factories driving forklifts, delivering mail; I worked for the MTA [Maryland Transportation Authority] for a year driving the bus . . . I'm thinking like, 'Man, I'm getting paid $10 an hour, I work eight hours a day, I get a lunch break, so I'm only going to get paid for seven of those hours. My whole day is going to be gone for $70.' And I think to myself, 'I can do a tattoo in 20 min. for $80.'" Money is a motivating force for Charles. Edward, a 35-year-old shop owner, further elaborated this position as he explained customers to me: "I was born and raised in business, you know. I see no color, no creed when they walk through that door; I just see money. It's 'How can I get your money out of you today?' Now, that's the thought process that goes through. That's not the art part of it; that's the business part." Edward's account also privileges the monetary reward.

This practice of valuing money leads some to become conflicted about their identity as craftsmen. Glen, a 38-year-old journeyman, expressed bitterness about his past experience: "The shop that I was at the longest, it just got to a point where it was so, everything was so focused on money and just how fast you can get people in and out and get the most of their money in the shortest period of time. It just gets—it gets old after a while." For Glen, the emphasis on money facilitated a lack of enthusiasm about his work. He enjoyed making tattoos, but the valuing of money conflicted with his understanding of the code of tattoo work. Journeymen have not been fully socialized into the craftsmen hierarchy, and as a result, some of their values or ways of working contradict the established expectations craftsmen value.

Artists

The third type of tattooist is the artist. Artists have their own values and system of rewards. They orient their work around achieving artistic freedom and earning artistic capital. Many are committed to legitimating tattooing as an art form and often refer to tattooing as a fine art. Artists are more likely to have an art school background. Usually, their original career paths were in the conventional art world, and they gravitated toward tattooing as a way to make a living while still pursuing art. Artists typically apprenticed under craftsmen and then moved to art-oriented shops after paying their dues and developing a reputation among some tattooists.

Artists value having artistic freedom, which enables them to have more authority and control when designing tattoos. It is also related to their reputation among consumers. Clyfford, a 28-year-old with an associate's degree in art, said,

> Within the past couple years, I've started sort of asserting myself a little bit more in saying that this is the niche that I'm carving out for myself. This is what my tattoos look like. This is how I work. When I draw something naturally, this is how it comes out, and if that's something that interests you and you like it, then I'm totally into working with you, and we can do whatever you want. But if somebody comes to me and they're like, "Hey, my grandpa just died and I want this portrait of him, and I want it to look like a photograph," then I just don't do it, 'cause that's not what I do.

Clyfford's reputation for producing his style provides him with more control over clients. His style is a type of artistic freedom. If a potential client is looking for a tattoo that does not fit his style, then he chooses not to produce it. His position in the hierarchy grants him this freedom. He is less constrained by the traditions of tattooing and feels he has been rewarded with the freedom to make tattoos the way he wants to tattoo.

Most artists reported receiving training from art schools with the intention to work in conventional art worlds. However, many recognized limited opportunities and moved toward tattooing. Alan, a 42-year-old shop owner and body piercer, shared a typical story: "I had gone to art school and thought of becoming an art teacher and didn't quite finish school, and I ran out of money." Financially limited, and out of money for school, he became a body piercer and then a tattooist.

Artists noticed their passion early in life. Many attended art schools and developed their identities as artists prior to becoming tattooists. Margaret, a 30-year-old female tattooist, recounted a familiar story:

> I've been in art school for as long as I can remember. My mom, when I was younger, I think as early as eight, had me in art classes. Then for high school, I went to the Chick Webb School for the Arts; I studied multimedia and graphics and also painting and drawing... Then I went to MICA [Maryland Institute College of Art], and I studied there for three years, and I studied in illustration. So I guess it kind of got me geared more [toward] taking the art skills I acquired in high school and apply[ing] them to something that was more conceptual, where you convey an idea through this medium.

Those who gravitate toward being artists typically have advanced training in art. They choose tattooing as a commercial art where they can earn an income from some of their training.

Many artists became interested in tattooing when they experienced limited opportunities for symbolic and monetary rewards, or blocked career paths, in conventional art worlds. Margaret noted how the conventional art world is far more unpredictable for an aspiring artist than tattooing:

> Usually with galleries, you have to have a whole body of work. So you have to have at least enough to fill a wall, and that's a long bit of time, and you're gambling on whether or not people are going to buy your work. So you're already going to have to pay the gallery to exhibit your work, and then you only have 50 percent of the sales that you might have, and you've got this whole body of work that you have spent all this time making. So it's one of those things that you really have to have the income to facilitate the time off to make all this artwork so that you can exhibit it. So with tattooing, it's a lot more regular.

Instability and uncertainty over income in conventional art worlds pushed many with formal art schooling toward tattooing. Coupled with this is the desire to continue producing art. After having trouble finding consistent work, Brenda, a 30-year-old female tattooist, moved toward tattooing to continue growing as an artist after struggling in the conventional art world: "Tattooing was a way to use my degree, draw every day, because it was really important to me that I be in an artistic environment. I'm not going to be one of those people that has two degrees in art and is not going to use them. It's my passion, and that's my life, and I'm going to go with it; wherever it takes me, I'm going to go with it. But it was really important that I stay in an artistic environment, whether institutional, tattooing, or academic, or whatever." Tattooing allows artists to pursue art while avoiding the uncertainty found in conventional art worlds. Additionally, it enables them to retain their identity as artists and continue to produce art.

Aesthetics

Artists are responsible for pushing the boundaries of tattoo aesthetics by violating the rules of craftsmen. While craftsmen stick to time-tested guidelines, such as tattoos having a thick black outline, artists intentionally violate these rules to challenge what is possible and develop new aesthetics. When I was gathering data, the fad of watercolor tattoos was beginning to peak. They were often the subject of debate between artists and craftsmen. Artists viewed these types of tattoos as an aesthetic innovation. For example, Margaret stated, "I tend to really like things that are a lot more watercolory looking within tattooing. Things that I would approach a lot more like a watercolor painting than I would a very hard-line tattoo. I like it a lot more; I also like tattoos that are a lot more painterly." The watercolor style, based on watercolor painting, violates the rules of established tattoo aesthetics because it lacks the bold outlines

valued by craftsmen. The debate occurring around watercolor tattoos involves their violation of the established rules.

However, violating the traditional rules is also how artists establish their reputations. Producing new tattoos aesthetics enables them to earn artistic capital, creative freedom, and a following. Artists are keenly aware of this need to be innovative. Margaret explained,

> I want to have a style that people recognize and that people see is a Margaret piece. Because it's about exclusivity, it's about any business plan—when you want to have something become bigger than itself, it's [at] that point that it has to become an idea and has to be something that's a branding type of thing, and you have to constantly brand yourself. So having a certain kind of style that you're known for is a very good marketing-type tool. It also helps you do tattoos that you really want to do all the time and become more choosy about which kinds you do and don't do.

Margaret wants a tattoo aesthetic that other tattooists and consumers will legitimate through their recognition. This would earn her artistic capital as an innovator who extended the boundaries of what is possible. It also would establish her as the authentic producer of a style and the exclusive leader of that new aesthetic movement. By having a reputation for that style, she also would gain creative freedom.

Artists often depict tattooing as another medium of art. Within this medium, they explore the intellectual questions of the conventional art world. In speaking of her transition from art to tattooing, Brenda stated, "I figured that [tattooing] was a good way that I could challenge myself and go beyond the painting and the structure discipline. So you have all the discipline from being in the studio 13 hours a day, being in an exhibition area all day, and I was looking for a challenge to do something different. I've always loved it [tattooing]." These tattooists report having high satisfaction in being challenged to pursue creativity and grow as an artist.

In this position, they have one foot in the conventional art world and one in the world of tattooing. They sometimes have difficulty reconciling these identities, as Brenda described for me:

> I never thought of myself as a fine artist; I just thought of myself as a painter: I'm just a painter. I'm a painter who tattoos. Well now, I'm a tattooer who paints. They're interchangeable to me. So [with] a lot of people in the fine art world, there is this kind of—when you're dealing with galleries and institutions, some of them look at the tattoo industry as maybe a lower kind of art, or it's not as much appreciated or held in as high regard. I think that's just a lack of—I think it's just ignorance. And I think a lack of maybe being immersed in that industry;

they're just not aware of it. So they see it as something that's a lower form of art maybe, and that's just not the case.

Shunned by the conventional art world for pursuing tattooing and struggling to establish legitimacy among craftsmen for pursuing art, these tattooists occupy a distinct position between the two worlds.

For some artists, their reward is compelling the art community to be more inclusive of tattooing. Dorsey's shop is an art gallery with an accessory license to tattoo. He uses the gallery to hold monthly First Friday events that are open to community members.[54] It also legitimates his business to the local community. The entire front half of his shop can display art, and no one tattoos in this space. He described the space to me: "We have had everything from photographs to printmaking, like large prints framed really nice. I try to do [them] in Mays and Novembers; I try to hold [them] for students at the colleges . . . So this May, my class will have a show here. And it's nice 'cause, it's a segue into the real world of showing your art, and the teacher likes it, because everyone can be hands-on with me, and everyone's finals are held at the gallery. We've done that last year, [and] we are doing it again this year." One reward for Dorsey is to create an environment that is conducive for the distribution of art by providing a space for artists to show work. He has even taken on the title of gallery curator. As an art gallery, the shop attracts people who may be interested in art but who would not ordinarily visit a tattoo shop, bridging the gap between these worlds.

Artists also feel rewarded by producing tattoos that are honored with the title of art. It legitimates their identities as artists. Often, they exercise their artistic capital to control clientele decision-making and shape the form and content of their tattoos. They claim that tattoos they produce must uphold a degree of their artistic integrity and vision. For example, John Lee showed me an image of a tattoo he recently completed:

> Here's a tattoo that I just finished on a guy not too long ago. OK, this guy wanted an Avenged Sevenfold [a band] tattoo, so I started looking at all the artwork on the albums. Well, newsflash, the fucking artwork on their albums, it sucks. It's just fucking horrible. So his favorite song is called "The Beast and the Harlot." And I start looking it up, and I read the lyrics, OK, and obviously it's about the Whore of Babylon. So I say to him, "She rode into Babylon on a fucking seven-headed dragon, drunk on the blood of kings" . . . So I come up with, "Well, the arm's not big enough to have the seven-headed dragon, so let's do the devil with seven horns" or whatever it is. "Yeah seven horns, but your arm's not big enough to have it like riding." So OK. The devil is giving her a piggyback ride; she's carrying a goblet, which we have to infer is the blood of kings.

Separating himself from what he deems to be inferior art and using his artistic freedom, John Lee reinterprets the vision of the tattoo to produce something that is a product of his own creativity. Intrinsically, there is the satisfaction of producing a unique work of art. Accomplished artists benefit from a high demand for their skill and talent, meaning they can pick and choose their projects, work at their own pace, and produce tattoos in their own vision.

Many within the world of tattooing attempt to be innovators, but few are successful at becoming recognized for producing a distinct aesthetic. The conventional expectations of the public and the reward structure of tattooing constrain most artists. In other words, the public expects that a tattoo should look a certain way, and artists must temper their creativity to fit within these expectations. The legitimacy of their style is also the subject of debates, with some viewing it as a violation of traditions of tattooing. Artists manage the constraints between client demands and aesthetic legitimacy while also pushing the traditional boundaries of tattoo aesthetics.

Hierarchy among Artists

There is a hierarchy among artists that is based on skill, prestige, and pedigree. Some artists are the upper echelon of art shop tattooists, with exceptional pedigrees in both art and tattooing. These tattooists completed apprenticeships, often with well-respected and highly skilled tattooists. For example, John Lee completed a master's degree in publication design, which combines graphic design and creative writing, from MICA. Then he learned to tattoo and worked with several notable tattooists early in his career. He told me, "When we apprenticed, it was like the MIT of tattooing here: there was Eli and another guy named Vic, Aaron Cain, Seth Cefarri—names that if you Google, they come up. Shit, even I come up in the first five pages! These guys will go on for an hour if you Google their names. So I was basically just getting my PhD in tattooing, because those were the guys I was learning from." Working with notable tattooists provides these artists with exceptional training and a connection to exclusive networks. Often people cultivate their networks through experience in this world. Working with notable tattooists facilitates their growth and expands opportunities. Skill, pedigree, and network connections determine position among artists.

In some cases, artists establish working relationships with masters and legends to expand their networks. Alan explained, "I was fortunate enough to, [in] the shop that we started in . . . the owner of the shop came up underneath a well-known, a legendary tattooer in American tattoo history. He had been exposed at a younger age to going to these conventions and knew a lot of these old-school big-name guys from back in the day. So he had continued later in his life to go to conventions. So I was exposed to that when I first got into

it." Alan's statement is a claim to the legitimacy of his position. He has connections to a legend of American tattooing. Having this connection bolstered Alan's status.

Artists typically do not begin their careers at the top of the artists' hierarchy, since upward mobility is a reward associated with career advancement. Generally, those at the bottom of the artists' hierarchy have several years of experience tattooing, art school backgrounds, and are exploring tattooing as another medium and an avenue for income. Usually, artists begin by apprenticing and working in street shops. After several years of honing their craft, they seek work with other tattooists who define themselves as artists. Clyfford described his own experience:

> When I first got my first job at a tattoo shop, the people—I love the people, they were awesome, but the quality of work was not really what I was trying to do. So I worked there until I felt like I had, not to sound like an asshole, but outgrown it a little bit. And then, I'd move on to the next shop and try to find a shop with people [who] tattooed better than me [where] I could learn and grow. I worked there for a while, and I would, just kind of worked my way up the ladder until [now] I can work in a tattoo shop that's pretty much all custom and everybody here draws their own tattoos. Nobody really picks anything off the wall in here.

Climbing this hierarchy is a career-long process for many as their reputation, technical skills, and artistic vision grow. Following the code of tattoo work, Clyfford worked in a shop for several years and then moved to a shop with tattooists who had more skill than himself. In each shop, he gained experience and learned tricks of the trade from others who were producing tattoos a bit better than he did. The more time Clyfford spent working in shops and attending conventions, the more he was able to develop the connections that would enable him to make these transitions.

Shopless and Scratchers

The final type of tattooist are those whom I call the shopless. These tattooists occupy the lowest position in this world. Established tattooists deem the shopless and scratchers outsiders and unfit to work. What sets the shopless apart is that they work outside of established tattoo shops. Among the legends and masters, craftsmen, and artists, some define the shopless as scratchers. Shopless have their own sets of values and rewards systems. These values and rewards are an affront to established tattooists. The shopless threaten, yet also reinforce, the legitimacy of established tattooists.

Before explaining the shopless and scratchers, a few comments are necessary to clarify terminology. *Scratcher* is a pejorative term used to describe an

untrained, low-skilled tattooist. *Shopless* describes those who are relatively low skilled and who do not work in tattoo shops. A scratcher has low skill regardless of where they work, even if they work in a shop. Conflating *shopless* with *scratcher* ignores those who are producing low-skilled work in tattoo shops. While shopless tattooists are all scratchers, not all scratchers are shopless.

Shopless Tattooists

Shopless tattooists are typically self-taught, although some learn from friends. They tend to work in residences and lack connections with established tattooists. Often, shopless acquire equipment through internet retailers (eBay, Craigslist), pawnshops, or mail order. Margaret explained beginning her career as shopless: "The first tattoo kit that my boyfriend at the time and I bought, we got it off eBay. It was very ghetto. But what happened was, I wasn't being offered, or I was asking for all these apprenticeships and nobody would give them to me. So he [the boyfriend] was like, 'Well, you're a good enough artist, I'll just let you try on me in our house.'" Lacking connections to other tattooists, she attained a tattoo kit in a manner that does not reflect the honor of earning the title of tattooist through an apprenticeship. Like Margaret, some established tattooists start out this way.

Other tattooists describe these kits and machines as inferior equipment. According to Charles, "I've noticed if you get those cheap $30 or $40 machines—'cause I had a bunch of those things—they would run real good for a day or two, and then you'll have one problem and try and adjust it, and it'll just break." Without connections to established tattooists, shopless do not understand their tools and how to care for them and ensure they work properly.

By learning independently, shopless tattooists are not privy to the conversations that occur between mentor and mentee. Instead, they create their own solutions to problems and learn through experimentation (or making mistakes). For example, when learning about materials, 30-year-old Jacob explained he did not know some inks were unfavorable to use on certain skin types or what techniques were necessary to ensure that colored ink would produce the desired result. He had to experiment with both the technique of pushing pigment into the skin and finding a preferable ink. He claimed,

> For one, like I—say it [the ink] don't stick. I got a whole, probably like 50 colors of ink that's just generic. I will never touch [them]; I will give them away to somebody, like, "Here you can have these, like everything." [Just] 'cause the colors are there, it don't mean they work. That's the tough part of, the tough part of the tattoo business for me. You get all—[for] most people, their tattoo look good by the time they get home, the next few weeks. [Then] they call, "Jacob, my color gone." That's from messing with those generic inks.

Without the benefit of an experienced mentor, Jacob struggled to produce the desired effects in his tattoos. His issue was not just from using inferior ink. It was a combination of poor-quality materials and not learning the proper technique of coloring. This technique requires tilting the tattoo machine at an angle and using a circular motion to push the pigment into the skin. This is the kind of information mentors pass on to apprentices.

One reward for shopless tattooists is money. They benefit from an oversupply of people who want tattoos but who are unwilling or unable to consume them in a shop. Shopless undercut the monetary value of established tattooists' labor. Mason seemed to take this as a source of pride (and like he wanted to sell me a tattoo): "They'll [tattooists working in shops] do price quotes, some of them. But I'll always beat the price. And I tell 'em [customers] that too: I tell them [if] they call someone else and give better price, tell me, and I'll do it for cheaper. I usually charge about what half the shop charges. I can get away with doing that because I don't have the overhead that the shop has, and I don't have to give anybody a percentage of my money when I take it from them. When they pay me, they're paying me." The high demand for tattoos provides a market niche for the shopless. By charging lower prices, they keep all their profits, but they cannot make a living solely from tattooing, as the work is infrequent. Many shopless had other jobs, and tattooing was a part-time source of income to manage economic uncertainty in their own lives.

The second reward for shopless is creating a portfolio that may lead to contacts with established tattooists. Elaine, a 26-year-old female tattooist, began her career this way. After attending a tattoo school for two weeks, she was unable to find work. She then built a home tattoo studio and began to tattoo friends. She created a portfolio of reasonable quality that enabled her to find a position in a tattoo shop. In describing her experiences, she claims many tattooists began their careers this way:

> They [a tattoo website] interview tattoo artists all the time, and their question is, "How did you get started?" And I had looked when I first was starting, and I was obsessed with the site, and always reading the question every day. I would log in, look at the interviews, and read what that question said. And a lot of them were either similar to me, where they were like, "I couldn't get into it. I didn't know anybody and this and that. I just started tattooing my friends. I got really discouraged, 'cause I didn't know anything, and it was kind of [like] knocking on doors and finding things out here and there. I made a lot of mistakes. I did a lot of the bad tattoos, but here I am today."

Shopless report a lack of opportunities from established tattooists. In the hopes of receiving attention, some shopless continue to tattoo to learn the craft and

establish a body of work. This will demonstrate their skill to others. Ultimately, they want to attract the attention of established tattooist with their portfolios, as established tattooists control access to work in legitimate shops.

Shopless tattooists primarily work from their own homes or someone else's. This provides additional occupational hazards. For example, 22-year-old Mason posted Craigslist ads to meet potential clients. Then he screened the calls he would respond to and arrived at the client's house with all his tattoo equipment. One of his constant fears was meeting a troublesome client in their house. Another shopless tattooist, Jacob, made a tattoo studio in his basement. He stated his fear that tattooing out of his own home increased his likelihood of risk and victimization: "I might wind up doing somebody that I used to beef with back in the neighborhood, and I don't want people to know where I live at. Not to say it's a bad thing, 'cause I never really cause problems or trouble, but you never know. You never know. You really don't want nobody to never come to your house as far as business; anything can go down. That's any business. You don't want nobody to know where you lay your head." His basement studio has a glass showcase, racks of flash, an autoclave, and almost every imaginable piece of equipment that would be in a tattoo shop. Working in private residences provides shopless with an additional constraint: namely, the fear of troublesome clients who may harm them.

Other shopless tattooists also moonlight at tattoo parties. Tattoo parties are like Tupperware parties, except that instead of Tupperware sales, the reason for gathering is tattoos. At tattoo parties, there are food spreads, with hosts who usually charge a cover price at the door. Some hosts are more entrepreneurial and charge for beverages or plates of food. At the end of the night, the host usually receives a free tattoo, which is determined by the size of the party and the amount of money attendees have paid the tattooist.

Established tattooists disdain shopless tattooists. Working outside of a shop and lacking proper training compound their marginal position. Those working in shops are not fond of the extra competition. However, shopless tattooists still manage to have small clientele bases, because there is a high demand for tattoos.[55]

Scratchers

Scratchers occupy the lowest position in the social world of tattooing. All other tattooists dislike them, including other scratchers. They are a *folk devil*, a social construct used to define a group of people as a problem and warn others of their trouble. The use of the term *scratcher* is a form of status politics within this world, where established tattooists attempt to assert control over the occupation.[56] To reinforce their own position and legitimacy, established tattooists pin all the evils of tattooing upon the scratcher as a folk devil who can bring harm upon their world.

For tattooists, a scratcher can be anyone who does any of the following things: spreads disease; lacks the skill, talent, and knowledge to apply a tattoo; fails to apprentice; has unsanitary practices, poor customer service skills, or poor hygiene; does gang tattoos, smokes in the back of the shop, and so on. These are unfavorable characteristics that established tattooists do not want to represent their occupation. No one voluntarily takes on this label, and it is distributed on the basis of one's work (their tattoos and reputation) and the spaces where they tattoo. The label emerged from those who have taken the time to follow the traditions of the craft, and it is a means to distance themselves from those perceived to be inferior. When assigned, the term stigmatizes the activity, characteristic, or person. Often tattooists evoke it to legitimate or define their own positions within the skill hierarchy in relation to perceptions of others' inferior work.

Summary

This chapter explained the social organization of tattoo work. First, it emphasized the complexity of contemporary tattoo work by connecting it to the historical transformation of the occupation. Second, it developed a typology of tattooists based on their worldviews and orientation toward work. It illustrated how there are different identities tattooists might have, how those identities relate to their labor, and the reward structures and values attached to the different types. Moreover, it demonstrated a stratified system of labor reinforced by a cultural code that sustains cohesion. This emphasizes the value of traditions, or the ways tattooists have always done things. In other words, the past is central to how tattooists define their contemporary world and commit to action.

Members of this social world collectively produce these definitions of reality. The importance of tradition for tattooists is that it provides an alternative framework to understand contemporary society. It is clear tattooists value tradition. This characteristic is an alternative to forms of rationality found in many contemporary occupations. Tattooists instead value the accumulation of honor and experience as markers of achievement or success. As a community, this enables them to avoid the ways modern rationality has encroached upon many occupations.

2

Organizing Space

The tattooing in San Antonio in those days was half and half in shops and arcades. If you got on Houston Street, the cut was 50/50 and they would allow you a 6 × 8 foot space and build you a 2 × 4 railing. They'd try to get you up in the front of the thing so people could watch, and you could draw a tip in from the street.

—Bob Shaw

Tattooists have recurring patterns that structure their activities. These patterns help coordinate all the work necessary to produce and distribute tattoos. Sociologists refer to these recurring patterns of behavior as social organization. Members of social worlds are reliant on social organization, which helps them coordinate roles and allows people to carry out more complex activities.[1]

Tattooists are keenly aware of how the social organization of space affects their work.[2] As Bob Shaw's quote at the beginning of this chapter illustrates, tattooists are concerned with how physical spaces facilitate or constrain their labor. They invest a significant portion of their efforts in manipulating spaces to ensure that tattooing can occur. This involves tattooists acting as a performance team, collaborating to set the stage for action.[3]

Goffman understood society as comprised of the everyday interactions of people. Each day people create and act out performances on a multitude

of stages, attempting to fulfill the demands of various audiences.[4] The front stage is where the performance occurs. The backstage is where people prepare for performances, and audience members are not welcome to see what occurs there. Preparation in the backstage is necessary to pull off a convincing and credible performance when on the front stage. Just like Goffman's metaphor, the tattoo work is composed of a front stage and a backstage.

Much of the collective activity needed to produce tattoos occurs backstage. Clients and the wider public do not see the tattooists mopping, scrubbing tubes, making needles, fixing machines, mixing pigments, and any other dirty work needed to make tattoos.[5] Nor do they see the alteration of space, the machine building, the pigment mixing, the flash or tattoo design creation, or the distribution of materials needed to produce tattoos. All of this takes place backstage. By hiding this backstage, the tattooist can present themselves as a magical, masterful genius to clients on the carefully constructed front stage.

While the practice of tattooing has existed for thousands of years, the focus of this chapter is on its contemporary organization. It examines how tattooists organize their labor across the spaces of shops, tattoo conventions, and private residences as forms of collective activity. Each of these forms of social organization has its own characteristics that affect tattooists' work. Different sets of rules for each space alter how core and support personnel bundle tasks, reward structures and interact with clients. Each space is tied to different degrees of prestige, which further stratifies tattooists.

Traditional Approaches to the Social Organization of Tattooing

Traditional research understands the organization of tattooing through the lens of stratification.[6] In this perspective, cultural consumers classify styles of tattooing as either high or low art. Their units of analysis are the meanings cultural consumers assign to tattoos or tattooists. It is presumed that in the 1960s, an avant-garde of tattooists began to push the occupation in a different direction. This was the beginning of the modern Tattoo Renaissance.[7] Those observing this shift claim there were two types of tattooists: those who were street tattooists and those who were artists.[8] Inferred in these categories is the occupation's organization through class stratification.

On the one hand, street tattooists were known for producing a specific aesthetic of tattooing, best "characterized by agglomerate designs, often executed by many different tattooists, on a single client, which results in a 'collection' of conflicting styles, sizes and images."[9] Street tattooists usually replicated designs from flash. Their clients were typically working-class males or from the military. Many characterized street tattooists as motivated by the desire to make quick money, reticent to discuss their knowledge, and focused on eliminating competition for clientele.[10]

On the other hand, artistic tattooists are the outcome of the Tattoo Renaissance. These tattooists approached tattooing as one medium in which to explore theoretical and conceptual issues of the fine arts.[11] They also were concerned with reducing disease transmission and the public reputation of the occupation.[12] Instead of producing classic folk-style Americana tattoos, these fine artists produced large-scale, one-of-a-kind custom works inspired by aesthetics from around the globe. Often their clients were wealthier and had higher degrees of social, economic, and educational capital and a more sophisticated understanding of art.[13]

Contemporary scholars continue to depict tattooing as a world divided by high and low art.[14] These analyses tend to focus less on tattooing and more on the reception of tattoos or social reactions to them. This results in an oversimplification of this world's organization. By ignoring production and instead focusing on the reception of tattoos, these analyses rely on how people make sense of them as cultural objects. This overlooks the social organization necessary for tattooists to work. One way to move beyond the high-low art dichotomy is to examine how tattooists organize their labor across spaces.[15] There are three types of spaces used by tattooists: tattoo shops, tattoo conventions, and private residences. Each of these has different conditions that facilitate and constrain the production of tattoos.

Tattoo Shops

Over the past 100 years, the shop has become the preferred space to work among tattooists. Storefronts provide a public presence and a sense of legitimacy. Shops are where tattooists have the most control over their labor. Inside, a division of labor ensures people complete tasks relatively efficiently. Usually this hierarchy includes the owner(s) and, beneath them, several tattooists whose number varies from shop to shop but is usually five or fewer. At the bottom, are the apprentices and counter help; there are typically only one or two of these positions in a shop. Far more work must occur than tattooing people. Each of the people in these positions carries out bundles of tasks necessary for tattooing to occur each day.

Shop Ownership

The position with the largest material and symbolic reward is the shop owner. Being an owner is a right earned only after establishing one's reputation. Owning a shop is associated with upward mobility, increased responsibility, and affirmed status within this world. Some tattooists even expect that shop owners also tattoo. Clyfford explained this value: "I was taught from day one to never work for somebody that didn't tattoo. If I ever—my first boss was like, 'If your boss doesn't tattoo, then they have no right to be your

boss because they don't know how to do this, and they didn't do the work that you did, and they didn't put the time in that you did.'" Reflected in Clyfford's statement is respect for those who *have* earned the right to own a tattoo shop by working their way through this world and paying their dues. More importantly, this is about the value tattooists have for controlling their labor. Outsiders are not welcome to control tattooists' labor. This reinforces the importance of earning the right to own a shop within this world.

Owners are responsible for establishing a workspace conducive to attracting clientele. This involves creating an environment that appeals to the expectations of clients. Owners seek tattooists who will be able to develop their shops' public reputations. Attracting clients is essential for both getting paid and providing the necessary material to produce tattoos: skin. One shop owner, Edward, explained,

> We have a good reputation and a good name; there's a lot of people that want to work here. I've turned down seven tattoo artists already to work here, and they have 8 to 10 years of experience. There's just something about them, whether it be the quality of their work, or the quality of their attitude, or their appearance. Because even though we're—I look like a big, baldheaded biker, [but] it's still [about] an appearance. You know, I'm clean, I wear clean clothes, I smell good... Right now I'm very leery about adding people to the crew that we have right now because it's very well-oiled. It's seasoned, it's very well oiled, and it works very well.

Edward wants to maintain a cohesive environment. His concern is over how clients understand the shop's reputation, "whether it be perceived reputation, which is marketing, or actual word-of-mouth reputation. When you walk into a shop, you say, 'This place is really cool, it's really clean, it's really neat,' and you go out and tell your 10 friends that you had a really good time going to this place—'It's really cool, it's really neat, and it's really awesome'—and they walk in and see the same thing, and they see the good quality work, there's nothing that beats that." Establishing a reputation among consumers is one type of reward for owners. They often become preoccupied with developing reputations that attract more clientele, even if it means limiting the amount of money the shop can make. The stigma of a bad reputation is a reasonable concern for owners, since it can be difficult to shed.

Owners share a financial relationship with those in their shops. This relationship is like other service sector occupations, such as aestheticians, hairstylists, or barbers. Tattooists working in shops are not employees; rather they operate as independent contractors who rent space within a shop. This is a source of tension between tattooists and owners, who each have different expectations of behavior in the shop. Margaret, who is currently a tattooist, explained,

Most tattoo shops run off independent contractors, so it's very hard to regulate, when you hire an employee, the mode of your shop. Like we were talking about earlier with the timing issue [arriving to work before noon, when the shop opens]. They [tattooists] are independent contractors, they are supposed to be able to dictate when they come in and out, but at the same time, you have a business that you're running, you have an image. So it's really hard to find a group of people that are willing to, as much as they are a freelance person, concede to your image that you [the shop owner] want to convey.

As independent contractors, and like the professions,[16] tattooists are free to pursue labor on their own. However, owners also have a monetary stake in this relationship. It is in the owner's interest to have tattooists maximize their time at work. For providing a space to rent and a reputation, owners often require those working in their shops to forfeit 40–50 percent of all earnings. This is a flexible rule and negotiable depending on the relationship a tattooist shares with an owner. Usually, the longer they have been associates, the greater the percentage of earnings tattooists will keep. The situation depicted by Margaret presents a problem, since there are competing interests between shop owners and tattooists.

Coordinated Roles and Bundled Tasks

Within tattoo shops, support personnel organize appointments, clean, produce tools or materials, and control the front of the shop. This enables tattooists to focus on the task of tattooing. Support personnel occupy a distinct position, as their bundle of tasks requires them to be on both the front stage and backstage.[17] In the front stage, they function as gatekeepers who manage the relationship between the tattooist and the client. In the backstage, they perform the dirty work of tattooing: all the cleaning and scrubbing that often goes unnoticed by clients.[18]

A practical problem all tattooists face is interacting with prospective clients, and they design their shops to physically regulate interactions between tattooists and prospective clients. Edgar described his shop this way: "We knew that our set up would require somebody at the front counter (also known as a 'dummy rail') at all times, and what that does in our favor is that it puts somebody at the front who's going to greet you when you walk in the door no matter what." This person determines who will have access to the tattooists. A designated counter person is a gatekeeper and mechanism of social control.

As a gatekeeper, counter help manages the people who enter the shop by trying to determine their intentions. It is essential work because many of those who enter a shop do not get tattooed. One shop manager, 33-year-old Conrad, discussed the importance of having this position:

There's the people that come in who want to look at all the tattoos and talk about getting tattoos but never actually get tattooed. We kind of—there's an industry term for those type of people: we call them looky-loos. Those are the people who—that's probably the most, if there's any, what we would call kind of annoying person to have in the shop, it's those people . . . If you come in and you're acting like you want to be a client, and you want to get a tattoo, and you're just like pointing out everything on the wall asking us how much it costs and asking us if it can be done bigger or smaller. That's worthwhile time if you're actually going to get tattooed. But more times than not, the people that do that have no plans on getting tattooed that day or even a few weeks from now. They just want to come in and point at a bunch of things and ask you how much it costs. It's completely separate from coming in and being like, "Hey, I want to get that. How much does it cost?" [and then getting it].

Interacting with people who do not get tattooed is a time-consuming activity. Gatekeepers, such as counter help or apprentices, are essential for controlling the front of the shop and relieving tattooists of this work. Keep in mind, getting tattooed is often a special experience for clients. But for those who work in shops, it is a mundane, everyday activity.

Some shops employ a manager, either an ex-tattooist or tattoo insider, to conduct the work of running the business. Conrad, who possesses a BA in English and a full bodysuit of tattoos, fulfills this role. He described how he ended up in this position and what his current duties were:

I noticed, because the owners had [trouble with] ordering supplies and paying the bills and doing all the bank stuff and doing—just dealing with everything that goes into having a business, administrative and logistical stuff. I saw that [it] was not hurting but that they just didn't have time because they were tattooing as well; they were tattooers and piercers. So [with] how busy it was, they couldn't do that stuff all the time, and they didn't have [as] much freedom as when it wasn't quite as busy and they had time to do that stuff. So I approached them with the idea that I would like to do this, and full time, and I can make this business run better. I can make this run better. I can make this clean, as far as not—like when someone's like, "Oh, where's the this or this?" or "Has this been ordered yet?," there wasn't always a level of accountability with that kind of thing. So I was like, I can be accountable for that, and I can manage your business.

The owners/tattooists were busy tattooing most of the time. As their shop grew in popularity, they faced the problem of needing help with the support work that enables them to tattoo. For Edgar, "If I can come to work and deal with this stuff [tattooing] and not have to worry about 'Oh, I gotta pay the

BG&E [Baltimore Gas and Electric] bill' or any of the other bills, then I can have more of a focus on here." This work is secondary among tattooists, but it is essential work necessary to produce tattoos in a shop.

While some shops choose to employ a manager, the most common method of managing support work is to hire counter help or rely on an apprentice. Within the industry, counter help is typically female. In describing the tasks of counter help, Conrad stated,

> Counter, it's like any other—it's like any other nine-to-five-type job. You know, you get to work, you make coffee. You make sure all your, like, beginning-of-day stuff is done, and in the tattoo shop, that would be making sure the artists' stations are stocked and they have all the stuff that they need to make tattoos. We have our clean room, where we clean the tubes and stuff . . . So you put away the tubes and make sure that the stations are stocked, and you count out the drawer, you get everything—it's like getting the day ready. Then it's answering the phones and dealing with clients when they come in, making stencils for the tattooers. Having people fill out paperwork. Collect the money.

Those who work as counter help or apprentices have a bundle of tasks consisting of support work. Much like in a doctor's office, counter help manages the mundane daily tasks that are beneath the status of tattooists.

The gatekeeping function of counter help or apprentices is valuable because it allows tattooists to focus their efforts on tattooing. Speaking with potential clients is an interruption for them. Shop owner George, who is 39 years old, told me, "I just want to tattoo. I don't want to deal with the day-to-day-type thing upfront; that's what I got that dude on the counter for. Let him deal with all that, weed out all the riffraff. By the time he comes to me, all I'm doing is getting into my zone and tattooing. That's what tattooing is supposed to be; you shouldn't have to worry about all the rest of the stuff." Counter help allows the tattooists to remain focused on the task of applying tattoos to bodies. It insulates the tattooist as a special kind of person in the backstage of the shop.

In George's shop, counter help also consults with clients and steers them toward making decisions. This is not an uncommon practice. Counter help (or an apprentice) copies the design from flash using transfer paper. Then tattooists make minor changes to refine the designs, as during their application. For tattooist Charles, "When I would work in the summertime, I would get [to] my booth at 12 o'clock [p.m.], and whoever's working the counter would bring me a flash or design with a price on it and tell me where it's going at, so I would have to clean up, set all my stuff up. The person would come in, [you] put the design on 'em, and you do a tattoo, then as soon as you finish, they [counter help] bring you another one." Having counter help draw the designs keeps Charles in

the back of the house, where he can focus on the application of the tattoo to the client. This support work mediates the relationship between the tattooist and the client.

Exploited Labor and the Role of the Apprentice

Apprentices perform the same duties as counter help; however, they also perform additional tasks, such as cleaning up and setting up workstations, learning how machines work, studying the tattooists, and most of all, learning how to become tattooists. Unlike counter help, apprentices are typically unpaid labor, making them a valuable asset.

Traditionally, apprentices engage in forms of labor that teach them how to tattoo. One of their tasks was to make needles for the tattooists. In describing her apprenticeship, 25-year-old Laura recounts the amount of effort she put into making needles: "I did have to solder needles one time, which was very tedious, and I understand why we just buy them now; it's so much easier . . . You can buy the needle bars and the needles themselves unattached, and you use a soldering iron and flux and kind of like paint solder on there [the needle bar] and attach the needles. Which is cool, because you can get groupings that you might not necessarily be able to buy." Making a single needle can take a skilled tattooist between five to eight minutes and an apprentice much longer. Over the course of a single tattoo, a tattooist may use several needles. Producing multiple tattoos in a day might require dozens of needles. Making needles was (and, for some, still is) necessary but cumbersome support work. In describing his apprenticeship, Edgar sarcastically claimed, "I made needles. And if you don't like making needles, having somebody around to make needles is a really good thing." As exploited labor, apprentices learn the craft of tattooing by performing the least desired tasks in the shop. Importantly, and different from counter help, they can conduct tasks that involve the tools or materials used to tattoo.

Apprentices do not solely make needles, especially since most tattooists now purchase commercially produced, presterilized needles relatively cheaply. As free labor, they also clean up and set up tattoo stations, bandage recently finished tattoos, and handle the duties of counter help on top of learning how to tattoo. For apprentices, especially new apprentices, this can seem burdensome and belaboring. However, the repetitive work of an apprenticeship is supposed to teach the skill set necessary to become a tattooist.

The key distinction between the apprentice and counter help is that the apprentice is learning how to tattoo. During this process, they perform more forms of support work to advance their knowledge of tattooing. Established tattooists value this process, since it reveals a person's dedication and commitment—they are paying their dues, as Dante said: "I mean it's pretty much me just paying my dues. I'll sweep, mop, change the trash for the other

artists, change their paper towel rack and stuff, and if they need anything what-soever or if they are too busy and need help setting up, I, like, get their stuff set up or broken down after a tattoo. I'll do that for 'em. I clean tubes. Pretty much, I do whatever is asked of me, and it's all about payin' dues when you're an apprentice." As Dante claims, this is about earning the right to become a tattooist. Eventually, those who pay their dues will earn the right to perform activities that are closer to the act of tattooing, such as touching the parts of a tattoo machine or holding one. Eventually, if they continue to show their devotion and commitment to the craft, they will get to produce a tattoo.

Tattoo Conventions

Conventions have recently emerged as a second space to produce tattoos. In 1976, Dave Yurkew organized the First World Tattoo Convention.[19] Upon seeing the success of Yurkew's convention, the National Tattoo Association (at the time, the only professional association for tattooists) realized the lucrative potential and soon organized five major conventions a year.[20] By the 1990s, conventions increased in popularity, and entrepreneurs also began viewing them as increasingly profitable. Today, tattoo conventions are a staple of the tattoo world, and currently over 300 different conventions occur each year across the world.

Conventions are temporary gatherings occurring over the span of two to four days, usually in a city but also in smaller towns.[21] Typically held in con-vention centers, they feature training seminars, vendors of equipment, com-petitions, special guests, and performance art. Unlike other professions, tattoo conventions are open to the public.

Many are now commercially sponsored events, organized by entrepreneurs interested in profiting from the tattoo trend. Edgar explained, "Tattoo con-ventions aren't like shoe salesman conventions . . . They're not industry owned. It's like, you show up, and you rent your booth, and you sit there, and you make tattoos there. But there's a huge public presence." Since entrepreneurs own and operate these gatherings, and they are open to the general public, many tat-tooists expressed similar sentiments, implying that conventions have become commodified.

For attendees, conventions are opportunities to learn about, and become involved in, the culture of tattooing. By design, they provide an opportunity for attendees to have access to a lot of tattooists from around the country or world. Brenda excitedly told me, "If you're not familiar with tattooing or even tattoos, and you want to get immersed in this culture, go to a convention. They're fun, there's bands, there's music, there's food, drinks, and you can meet all kinds of awesome people, and it's a great way for the industry to social-ize with each other." With hundreds and sometimes thousands of attendees,

conventions provide opportunities to merge the gap between consumers and producers.

Tattooists most enthusiastic about attending conventions tend to be in the early stages of their careers (one to seven years). Conventions provide them with opportunities to learn about the craft from others and develop their reputations. Since tattooing there occurs in public view, conventions are spaces that allow for diffusion of knowledge and technique. Brenda stated, "At every convention there's a multitude of international, local, and other artists that come, and it's just a good way to, one, see what kind of tattooing is going on . . . 'cause you see these pictures in magazines, and you see all the pictures on the internet, but it doesn't do the tattoo justice, than if you're in the flesh watching this person create this amazing thing. And you see how they work. And you see where this tattoo starts. And you see how it's finished. It's a great opportunity to just study people you admire." Tattooists claim one of the best ways to learn about what they do is through observation. Conventions provide a setting where members of the public and other tattooists can interact.

Reputations, Rewards, and Artistic Capital

Conventions allow tattooists to interact with people they would not encounter in their daily rounds. Some can earn status among colleagues and the public by acquiring artistic capital at these events. Alan depicted the importance of earning artistic capital:

> You're sitting there tattooing, and there's hundreds and hundreds of people walking by and stopping and watching to see what you're doing, and looking at your portfolios, that are at your booth, and your banners are hanging up, and your names are there, and your shop name is there. That's how they really get to know who you are, and that's the best promotion. Some people might go and bring people to enter a contest, so they could just win something or get pictures in a magazine. That's some exposure [entering a contest], but it is not as much exposure as if you're working and had a booth there.

By tattooing at a convention, people earn status. Having members of the media, colleagues, and the public watch them tattoo increases and diffuses their reputation. Often crowds gather to watch legends, masters, and those at the top of the craftsmen's or artists' hierarchies work. Participation in conventions nets tattooists different types of status.

Entering contests can also earn tattooists artistic capital at conventions. In contests, a panel of judges evaluates completed tattoos. Entrants submit completed tattoos to categories: best black and gray, best traditional Japanese, best back piece, and so on. The judges award tattooists who have produced the best tattoos in each category. Alan described earning artistic capital among

members of the occupation and the public: "We used that convention circuit as a way to get our names out there. Get the shop name out there. Get our individual names out there. Get exposure in magazines, to enter the contests with the hopes of winning something that we could hang on our wall, and say, 'Hey, I'm an accomplished artist these are my credentials.'" Often accompanying these awards is recognition in tattoo magazines, which publish photographs of the tattoos and information about the tattooist. Receiving awards allows tattooists to symbolically display their talents to potential clients back at their shops, since plaques or trophies accompany most awards. Magazine coverage diffuses their reputation to a wider audience.

Support Work

Another purpose of tattoo conventions is to carry out support work. Most tattooists reported attending conventions to purchase tools and materials. Charles stated, "Whenever they [the tattoo convention] come to Baltimore, I'll go just to see what is going on and probably buy supplies [inks, machines, needles] that I normally would have to buy and wait two or three weeks for." Conventions enable tattooists to meet other support personnel and gather the necessary supplies for their work.

Part of the code of tattoo work values having personal relationships with those who make the tools and materials needed to make tattoos. Conventions provide the opportunity to meet and interact with producers of the materials. This develops tattooists' occupational networks. In discussing how he attained specific tattoo machines, Alan stated, "Well there's well-known machine builders that don't necessarily have a catalog, you just have heard about them. They set up at conventions, and they sell the machines at conventions, where you can actually meet them and talk to them and figure out how they do things. You hear by reputation [about] other tattoo artists who have used their machines . . . A lot of it is just through meeting people at conventions and trying their machines and doing it that way." Attendees can test out equipment or materials and engage in conversations with the producers. These exchanges solidify material relationships on a personal level. Interacting on this level facilitates distribution among tattooists, who value personal relationships. While these relationships are economic, they are also a form of resistance against the impersonal nature of commodity exchange in capitalism, since they connect producer to consumer in a personal manner. Moreover, it is not uncommon for tattooists to barter material goods, another avenue to resist the normative operations of material exchange in capitalism.

Occupational Socialization, Learning, and Skill Development

Many tattooists attend conventions to continue learning about their craft. Observing others tattooing or watching them receive tattoos are common

activities for attendees. Others participate in seminars, which are available on a range of tattoo-related topics. This is a type of support work that facilitates the production of tattoos, by ensuring that people can exchange knowledge about the craft with one another.

Observing tattoos at conventions exposes people to aesthetics and techniques. For example, Joseph described the experience of encountering an aesthetic he had not yet seen when he was a fledgling tattooist:

> At the time, what I was seeing was very limited flash, in kind of a subpar Baltimore tattoo shop. Flash and then seeing stuff that's in magazines—again, they were like biker-style tattoo magazines, so everything was pretty much cut and dry. Then I'd go to these conventions and start seeing this wave of biomech [biomechanical], or these portraits, or realism, and stuff like that. Stuff that artistically, I'm not attracted to do, but I can really appreciate the way they look, and the way they fit the body and stuff like that. Just seeing that kind of stuff. I was like, "Holy shit, people are doing tattoos like this. This is mind blowing. There's no black outlines, but it yet still seems like it's going to hold up over time."

The convention provided an opportunity to observe aesthetics not present in Joseph's shop or the magazines he was reading. While stunned to see different aesthetics, they also inspired him by expanding his sense of the potential of what was possible to tattoo. This led him to ponder questions of craftsmanship and the limitations of pushing aesthetic boundaries.

Observing tattooists working is essential for understanding the process of applying tattoos. It is a learning experience. Conventions provide a shared space to make these observations. Samuel used to travel to conventions to not only observe tattooists he admired but also experience them tattooing him. His observations are an embodied experience where he uses the senses of sight, sound, and touch to learn the techniques used on his own body. As he described,

> The techniques that people use, you have to see them. You have to see 'em in action to understand a lot of that. When I started getting tattooed by people that have been in the industry for a long time and that made really nice tattoos, I would just watch them and see how their needles were set up. And like how their machine sounded, and ran, when they were not hitting my skin and when they were hitting my skin. And I literally would go home and just tweak with my machines until I heard that sound again and then start tattooing with it and see if I could get [the same results] they were getting.

Hearing, seeing, and feeling the needle plunge into the skin is part of the socialization process that connects him to the traditions of tattooing and

venerated masters. As Samuel iterates, watching established tattooists shows him what his machine ought to sound like and what the effects should be. This is necessary because skill development in the craft of tattooing is hands-on and best transmitted through observation and experience.

Established tattooists understand the value of their knowledge to others as highly sought-after tricks of the trade. Some conduct seminars for a nominal fee at conventions. With the rise in the number of people tattooing, there is a supply of people willing to pay for this kind of knowledge. Mike, a 42-year-old shop owner, voiced that he regularly attended these types of sessions:

MIKE: There are some people in the industry that I look up to, and if they're in the area and they're doing a seminar, I'm more than happy to pay up $200 to sit in and listen to this person and talk about their experiences with tattooing. That to me is continuing education, and I'll do that all the time.

DAVE: What do they teach you?

MIKE: Different techniques; some of these guys work especially—strictly—with color, they're just color artists, and you go in and hear not only what inks they use and not only what kind of techniques they use, [but about their] needles, machines, all this stuff.

Established tattooists use their credibility to sustain the craft of tattooing. Independent of the state or bodies of oversight, these tattooists sell their hard-earned tricks of the trade to others. The convention is not simply a celebratory gathering where people earn status but also a gathering for occupational socialization and skill development.

Problematizing the Tattoo Convention

Many tattooists view conventions as problematic for work. This has become a source of tension among them. They expressed resentment toward the commodification of conventions by entrepreneurs. In an effort to resist this commodification and assert control, some tattooists have responded by creating tattooist-run conventions. Others view conventions as having unsanitary, undesirable, or unreasonable working conditions. Coupled with these conditions is a fear of financial uncertainty when tattooists do choose to work at them.

Cultural Exclusivity

Entrepreneurs currently organize most conventions. They are concerned with the profitability of the event. Seizing on the tattoo trend, these entrepreneurs are responsible for the increasing number of conventions over the past 25 years. As tattooing became more accessible to the public, conventions began to lose

their cultural exclusivity among the old guard. John Lee resentfully described this change to me: "We used to do a lot of conventions, it used to be different, it used to be kind of like an invite convention. There were certain big conventions throughout the year. Now, right now there's probably one Monday, in like East Armpit, Arkansas. It's probably the East Armpit Tattoo show and it's 'the greatest artists on earth will be there.' Which is such horseshit." For him, working a convention used to be an honor, signifying that you were a somebody in the tattoo hierarchy. Now he believes that anyone can work a convention so long as they pay the fees to set up a booth, regardless of their status within this world. John Lee continued, "It started changing, there was conventions everywhere, all the time, it didn't seem to carry the same weight as it did anymore. You'd go and there'd be like all these local shops at the convention. The idea of the convention isn't to have local shops; it's to have people from around the country and the world come. So we might go to Richmond [in the past] and behind us might've been like, Tin Tin [a master] from Paris. Now it's like, Clem from Petersburg. It's like, what's the point of having all the local guys there?" The expansion of conventions is a change that threatens members of the old guard. They nostalgically remember when they had more control over the occupation. Profit-driven promoters are more concerned with the number of booths or tables they rent, and how much they will make from the door, than exclusivity or honor among tattooists. Capitalist expansion threatens the traditions of tattooing by importing a new set of values into the occupation. This shift coincides with the increased popularity of tattooing.

In response to increased public presence and lack of control at conventions, some tattooists have attempted to create their own. Tattooists run these conventions. The organizers only invite tattooists and tattoo insiders. One of these is the State of Grace convention, which began as tattooists became frustrated with the expansion of conventions by entrepreneurs. Edgar proudly said that he attended this every year: "I go to State of Grace in San Francisco in October because it's a tattooer's convention. There's not a huge public, but it's, some of the best tattooers in the world are there, and I always have a reason to be there, and I try to get a little tattoo from somebody . . . the State of Grace convention doesn't have that huge public presence; it's really people travel from all over the world to be there, and it's incredible." These conventions emphasize the community of tattooists and are an attempt to reassert control over the direction of the occupation. However, their success has been limited, since they target tattooists and not the larger consuming public.

Working Conditions and Inhibited Production

Tattooists frequently claimed the working conditions at conventions constrain the process of production. First, the material resources and physical structure limit their productive capacity. With limited productive capacity, many feel

unable to work to their highest ability. Second, many are concerned about health and safety risks, since they cannot assert the same control over their workspace as they do in their shops.

Working at a tattoo convention involves traveling to a different workspace and transporting or procuring all the tools and materials needed to make a tattoo. As Samuel explained, "It's a lot of hassle to do a tattoo convention. You have to like—you have to be prepared, it takes a lot, you gotta pack all your stuff up. You gotta make sure you have every little thing that you need in a tattoo shop. You have to take it to the space with you, if you travel to do it. There's all that stuff you have to take with you, or you have to buy when you get there." For Samuel, the hassle of the convention involves having all the materials that you would need to produce a tattoo. Not having the ability to tote around every possible thing he might need limits his abilities. The things he might need could be as simple as a book he uses as reference material to design a potential tattoo for a client. Coupled with this, Samuel later explained the uncertainty of material rewards when attending conventions. Even though someone may earn symbolic rewards, which increases their status, packing materials, traveling, and losing money are constraining factors that discourage tattooists from participation.

Tattooists also feel constrained by the available materials at conventions. For example, to properly manipulate the skin during the application of a tattoo, tattooists usually position clients using massage tables or barber chairs at their shops. However, at conventions they must innovate with available materials. Kevin expressed discontent over this: "Of course, you don't have your chairs that can fold out or anything like that; you got plastic chairs [folding chairs] and [you] try to stack them up and get people to lay the right way. I mean, I work with two women and me. I'm handicapped. So I can't be carrying tattoo chairs everywhere. So you're just kind of screwed. I would rather just do everything in office." Lacking materials they are accustomed to using, some tattooists claim it is preferable to work in their own shops rather than grapple with these things that limit their productivity.

The openness of the convention further constrains tattooists as they contend with conditions that would not exist in their own shops. They create drawings or stencils on the spot, and sometimes without reference materials, in front of clients, who expect a tattoo right away. Complicating this further is that everything the tattooist does is on display to a public. There is no backstage where they can hide their mistakes, tricks of the trade, or methods of working. William explained,

> It throws you out of your element. You're out of your comfort zone. 'Cause this is my station! [*He smacks his hands on the tabletop of his booth in his tattoo shop.*] This is what I'm used to working with. I know where everything is. So if I need

to set up at a convention, everything is in a toolbox, I'm working off of the table. I have random people walking up and saying, "Hey I want a Natty Boh guy with a monocle looking like a zombie." I gotta find a way to draw that up on the spot and have it look perfect. Then I have to tattoo it perfect, without the best lighting, without my comfort zone. There's loud music going on. There's thousands of people walking by you, drinks in hand, spilling drinks on your tables, throwing drinks on your portfolio, kids running around. Like all these elements are thrown at you.

At the convention, the booths to tattoo are open to anyone in attendance. This is different from the tattoo shop, where partitions or walls separate spaces. As William, who is a 29-year-old shop owner, adamantly explained, there is a level of comfort working in his own space, where he can control several factors when applying tattoos. In his shop, he can regulate who has access to which areas, the noise, the lighting, and the number of people near him. Above all, he can take the time to create the tattoo designs that he deems worthy of putting on others.

These conditions lead many to avoid working at conventions. Established tattooists, such as 49-year-old shop owner Eli, believe that conventions limit the final product, the tattoo: "I always say—John Lee and I have always talked about it—you can work at about 75 percent of your capacity on the road. So the quality of your tattoos, the quantity of your tattoos, is going to be one quarter less than what would be here [in the shop]. So why would you choose to do that? Why would you choose to make less money and work harder, and get less of a result when you can stay here and be comfortable doing the exact same thing? It's just a no-brainer." While Eli cites quality concerns, the issue involves others' evaluations of his work. This could change his status. Others will eventually evaluate the kinds of tattoos he produces, and once those are out in the public, he has little ability to defend his reputation. Since tattoos are relatively permanent and the tattooist is rarely around to contextualize their production, a tattooist's status changes with each tattoo produced and each audience that sees it. Producing a lower-quality tattoo can easily lead to losing status.

With tattooists working in close quarters, some view conventions as health risks. While he continues to attend conventions to network, Edward, a shop owner, refuses to work at them. For him, the physical space increases the risk of disease transmission,

I hate 'em. I think they are unsafe . . . I can give you examples too. I will keep the names out of this one. I have—a friend of mine [who] is a very prominent tattooist in the area, she's wonderful . . . She went and tattooed another friend of mine [at a convention] and gave her five infections that you only get from

open-heart surgery. She was in the hospital for 62 days and had five tubes in her chest. The guy behind her [at the convention] was some piece of shit tattooist out of some other state and had no business tattooing, let alone being at the convention, and was putting all the nasty contaminants in the air, and put her in the hospital. I think they're tattooing too close. I think there's too much social interaction. If you're sitting there tattooing in the 10-by-10 booth, and somebody can lean over 3 feet into your booth, how safe and sterile can you make that? So I actually disagree with conventions.

This cautionary tale explains why conventions increase risk. In these spaces, tattooists lack the degree of control they have in their shops. As a response to the potential risk, some have chosen to not work at tattoo conventions.

Competition, Financial Risk, and Loss of Reputation

While the public pays a small fee to attend tattoo conventions, those who work at them also rent space from the organizers. Usually this fee is several hundred dollars. Coupled with travel expenses, many lose money simply by attending. In describing his frustration with conventions, William stated, "I lose my ass . . . 'cause the booths, they are expensive, the hotel fees are expensive, the food is always three times overpriced." These expenses further discourage tattooists from working at conventions.

Tattooists at conventions also navigate status politics and competition within the occupation. This is echoed in 29-year-old Frank's experience: "When I went to my first convention—tattoo convention—everybody had their tattoo-ink bottles turned around, so you wouldn't see what they have. If you had questions, they would be like, 'Well, I'm not answering any questions right now; I'm looking for customers.'" Turning ink bottles around so that observers cannot see the label allows the user control over their deeply held secrets. Refusing to answer questions for those who are not in the know further insulates their secrets from the rest of the world, even those trying to learn how to tattoo. Some believe this hard-earned knowledge provides them with a competitive edge over others in the skill hierarchy and competition for clientele.

With many potential clients attracted by entrepreneurs, tattooists at conventions compete for clientele. The rented booth functions as a makeshift storefront. These booths are densely packed next to one another. Those working must negotiate prices with potential clients within earshot of other tattooists. Clients have more leverage in the negotiation process (compared to in the tattoo shop), since they can easily shop for the best price in a public manner. This format increases competition between tattooists. Samuel claimed, "You get a lot of price shoppers at tattoo conventions. You get a lot of people who literally will walk, will ask you a price for a tattoo, and then

walk to the next booth next to you while you're sitting there watching them and ask for a price for a tattoo, and then walk over to the next booth and ask for a price for the same tattoo until they find the cheapest one." After I asked how far away the booths were from one another, Samuel continued, "The booths. They're touching each other. So it's like, this is usually like a table, about the size . . . like a standard folding table, and they're literally like, [there's] a little bit of a space, maybe a foot, and then there's the next table for the next artist. So there's not a lot of—if someone's asking you something, the person in the booth next [to you], he was probably listening to what's going on. So that kind of turned me off of it a little bit. It doesn't happen every time, but it happens a lot." For tattooists, price shopping undermines their authority and devalues their skill. Price shopping at these events is an affront to their competence, since they watch clients search for the cheapest labor rather than the style or quality of work they desire. This threatens tattooists' control over the value of their labor.

Occurring in public, client negotiations can even damage a tattooist's reputation. In front of other tattooists, Kevin's status and perceived competence were at stake when a client was not clear about his interests:

[The client] apparently wanted my coworker, who is an attractive young lady [to create the tattoo], and he came to me about a design. And I'm putting the stencil on him, and he's like, "No, it's gotta fit this." And I put the stencil on like 12,000 times, to the point where I'm just [*makes a face of frustration*]. Other big names in the industry were like, "No, that's straight." You can't expect the stencil for everything to show up, but dude, I know where that line is. Come on, it's a tribal. I can do that with my eyes closed. So he's all like, "Oh, it's gotta fit." And everybody is like, "It's fine, he's an artist he knows what he's doing, some people just draw this shit on people." Well, I was like, "Look, here's your money back, see you later." He came back like an hour later and was like, "Well, I'm ready for that tattoo." I was like, "I'm not fucking doing it." He was like, "Well, what do you mean?" I was like, "One, I'm pissed. Two, you're not going to get the best job, 'cause I'm pissed. So this is just going to be the worst experience for both of us." And he was like, "Do you think your coworker will do it?" I was like, "I don't know; you talk to her." So basically, he just wanted her to tattoo him but didn't have the balls to say that he wanted an attractive chick to tattoo him. He went and busted my balls and wasted my time when I could've been making more money doing something else better than this fucking tribal.

Despite numerous other tattooists confirming the quality of the work, this incident involved a challenge to Kevin's competence. This was particularly frustrating because it challenged his reputation in front of other established

tattooists. With no tattoo produced, this interaction resulted in a loss of time, money, and perceived reputation for Kevin.

Many resent tattoo conventions because of the constraints placed on them. Financial loss, and interactions with clientele seeking the lowest bidder, make these undesirable working spaces. William referred to them as "tattoo flea markets, 'cause that's essentially what they are. If you've ever gone to any flea market, you know that it's shoulder to shoulder. People running around just being arrogant assholes. People that smell fucking horrible, drunks, cheap-asses. You gotta deal with all that same shit at a tattoo convention. People think it's a free-for-all and because one tattooer does this, all of them do this." Invoking the analogy of the flea market, William is concerned about conditions that limit tattoo production. For him, they have become spaces with consumers who are looking for good deals rather than good tattoos. Samuel further described this sentiment, stating that,

> I don't think that—unless you're, quote unquote, a well-known, famous tattoo artist, the chances of you going to a tattoo convention and really making it worth your while and making enough money to pay for the travel that you made: the plane ticket, the place you're staying at, the equipment you had to get when you got there . . . A lot of times, it's either you break even or you don't [lose money]. It's one of those things where, if they're local, I don't mind going to them, but the ones I've traveled to and done, besides having fun, it's not really profitable for a guy like me.

The conditions of the tattoo convention are constraining forces. While tattooists may gain artistic capital or increase their reputation, there is too much uncertainty in their profitability and risk in attending conventions.

Private Residences

The final space in which tattooing occurs is private residences. Those working in private residences are shopless tattooists. Generally, established tattooists reject the shopless, since they have not apprenticed.[22] The shopless do not tattoo full time. Their motivation is earning additional income from the oversupply of people who want tattoos. Working independently, they undercut the value of tattoo labor. They exist because of a segment of clientele who are unwilling or unable to pay the prices asked by those working in shops.

Shopless face different constraints that are rooted in the spaces in which they work. Their largest obstacle is locating clients. Without a storefront to attract clientele or a large gathering at a convention, the shopless must seek out their own patrons. Their lack of training constrains their work as well.

Ultimately, established tattooists use this to further ostracize the shopless, viewing tattoos produced by them as inferior.

Reproducing the Environment of a Tattoo Shop

A home tattoo studio shares some physical similarities with a tattoo shop. Usually, they have the same materials found in tattoo shops. For example, home tattooists convert spaces by installing counters, floors, and even artwork on the walls. As 29-year-old current shop owner Tim, who was previously shopless, explained, "I also had like a whole second room set up in our apartment where I laid down some vinyl floor covering and set it up as like a little tattoo studio. So I would tattoo in the evening and deliver pizzas during the daytime." Later in the interview, he mentioned that his motivation for tattooing at this time was money, and it was a job that augmented his meager earnings. His setup of this space provided clients with a sense that Tim's tattooing was legitimate.

Home tattooists develop these spaces like tattoos shops. This enables them to have a degree of control over the space and ensures the space fits the expectations of clientele. In comparing his home tattoo space to a shop, Jacob stated,

> My basement is set up with all types of flash and things on the wall [to] make
> people feel like they in a real shop . . . I got a sonic machine, I got thermal
> copier, probably like 12 to 13 machines, probably like 40 supplies. I got a display
> case so people can just look at something and [to] make it seem like it's a big,
> big shop. [I got a] printer, scanner, computer—just about everything in my
> shop is in a tattoo shop or most tattoo shops, 'cause a lot of tattoo shops don't
> have really too much of nothin'.

For Jacob, the home tattoo studio involves constructing a space with the materials to make it seem like an authentic tattoo shop. At the same time, the space is organized to physically regulate human behavior. The display case in his basement is perpendicular to the wall, creating a physical barrier between the front area and the space where he tattoos clients. This is like many tattoo shops, which have a counter, or dummy rail, separating the front of the shop from the back.

Jacob even uses the printer and scanner for record keeping. He makes all his clients sign a waiver. One afternoon, I asked him what was on the waiver, and he replied,

> What's on the waiver? Basically, saying you must be this age, [show] ID. What's
> on the waiver? I ain't seen it in so long; I ain't used it in so long, 'cause I ain't
> really had no kids. Basically, like the health things—the health and the reason
> why you got to be a certain age. I can't think of what's on the waiver. You need

to initial; you have to initial two or three different parts going down the side. I wish I would've brought one with me. Then I take a picture of their ID, so if they come back complaining, I got a picture of their ID on paper with their waiver. So I'll give them a copy of the waiver, and I'll keep a copy for myself.

While not an official tattoo shop, Jacob replicates this ritual of established tattoo shops. This is not a legally binding contract. However, by having clients sign a waiver, he attempts to legitimize his authority over them. He later showed me a copy of his waiver, which was a standard form downloaded from the internet.

Shops, by having a storefront, are granted a greater degree of legitimacy by the public, regardless of their quality of work. Without a business front, those working in private residences are competing with tattoo shops for their reputation. The shopless advertise their services through social-networking sites, such as Facebook and Twitter, and internet forums, such as Craigslist. Despite their use of these methods, they still report that most of their clientele come from word-of-mouth recommendations. Jacob claimed, "That's the reason why I got a Facebook. Most of my clients come from Facebook. A friend'll tell a friend, and the next thing you know, I done did probably half of Baltimore city . . . Basically, word-of-mouth. Or I have business cards made, and I tell people to call me out. Like I said, most of the time, it's a friend of a friend. Flyers for some: you come spend this amount of money and bring two people, I'll give you 20 percent off or something like that." This process of locating clients is similar to that of established tattooists, since both develop a public presence and perceived reputation. Both rely on word-of-mouth recognition to locate clients. The difference is that shopless do not have the benefit of walk-in clientele.

Mobile Hustlin'

Most shopless are mobile tattooists, traveling to clients' homes (among my respondents, this was within the Baltimore metropolitan area). For them, work is sporadic and requires the management of several constraints that do not exist in other spaces of tattooing. Being mobile, they work in unfamiliar spaces and under less than desirable conditions. They carry a kit of materials with them to jobs that contains everything they will need to produce tattoos. Often, they meet their clients face-to-face for the first time just minutes before tattooing them.

Mobility allows shopless to provide services to a segment of consumers who would not ordinarily meet tattooists. They can reach people who are unwilling or unable to enter a tattoo shop and those who could not afford the prices in a tattoo shop. Mason, a shopless tattooist, stated, "I travel to people's homes most of the time when I'm doing it. And that offers a wide variety of people

getting tattoos. People who normally wouldn't want to go into a shop. Like, I tattooed a lawyer last week. I went to his house and tattooed him." Tattooing requires not only the effort of the tattooist but a cooperative client. Some consumers perceive tattoo shops as a daunting, intimidating, or a dismissive experience, while age or disease status excludes others. Being mobile, shopless tattooists can offer their services in the privacy and comfort of clients' homes.

Mobility also constrains the production of tattoos. For example, because shopless do not have the same opportunities to have a face-to-face discussion with their clients, they innovate to create tattoo stencils or designs. Phone conversations do not always translate well when developing a shared understanding of visual content. Mason expressed this frustration: "I'll usually talk to 'em on the phone about what they want. What size they want, and I'll even not do it if the person is too indecisive about what they want. If they don't know where the placement is or what size they want it—or even I have people call me that don't even know what they want yet; they say, 'I want to get a tattoo. What kind of prices do you have on tattoos?' I'm like, can you be more vague? What do you mean? What kind of prices do I have?" While these conversations initially facilitate production, they also lack the details that would emerge during face-to-face interaction. Tattooists in face-to-face negotiations have an opportunity to examine the client's body and skin, show them a potential design, and engage in a conversation about what the client wants in a tattoo. This allows them to determine how much a tattoo will cost. Shopless lack this information. These variables affect the time and materials needed to produce the tattoo.

Being mobile, these tattooists are reliant upon themselves to have all the materials needed to work. This is different from a shop or convention, where tattooists can buy, borrow, and store needed materials. Traveling tattooists create a travel kit with their tattoo supplies. Mason described the materials he usually totes around: "I've got a pretty large—it almost looks like a suitcase, it was actually originally intended for tools, and it opens up and I've got three different sections. It's like a big toolbox on wheels. It's got a handle that you pull up, and I've got all my stuff in there. Everything I'd ever need, like the cleaning supplies, inks, and machines; it packs into one little kit that I go around with." While Mason claimed it was easy to wheel right up to a client's residence and tattoo, there are many times he lacks the necessary materials to work effectively. He also usually carries a secondary power supply, a couple of extra machines, and an array of bulky shop lights. Even something as simple as poor lighting might make it difficult to tattoo.

Transporting materials also involves the transportation of waste away from the space. Billie, a 30-year-old black lesbian tattooist, explained, "I pack up all my equipment. I'm using all sterile stuff. I got my sharps container and stuff. I got a separate container [where] I'm throwing all my dirty paper towels away

and stuff. Everything's clean. Everything's neat. Nobody's in my way." Many shopless reported using medical waste companies to dispose of their used materials. These companies facilitate tattoo work by providing a mechanism for disposing of hazardous materials. In transporting equipment and working in unfamiliar spaces, there is an additional problem of maintaining conditions that are sterile enough to tattoo. Mobile tattooists also carry around supplies necessary to sanitize the spaces they are working within. Sanitation, or lack thereof, presents a threat to the client, the tattooist, and anyone who may be in the immediate area.

The Tattoo Party

Recently, tattoo parties have become popular as spaces for production. They are also a staple of the underground economy that operates in Baltimore. At a typical tattoo party, there are spreads of food, beverages, entertainment, and one or more shopless working. By the end of the night, and pending a successful event, the host can get a free tattoo. Tattoo parties are an attempt to maximize the profitability of the shopless' labor. As Billie explained,

> The one that I did where I made $800 was like, I think I did 20 people. I don't think anybody got anything that was less than $40 maybe. And then the other one that I made $1300 off of—that was actually a two-night party, and I did it for a really good friend of mine, because she always . . . she's really anal, so when she sets 'em up for me, she make sure people pay a cover price, 'cause she don't want anybody to show up and not actually get anything. She's gonna charge you to come. I'm gonna charge you for your tattoo, and she's gonna feed everybody.

Hosts of tattoo parties usually charge a $5–$10 door fee, which guarantees attendees a seat with the tattooist. Some entrepreneurial hosts charge an additional fee for plates of food, alcohol, and other beverages. While hosting a tattoo party is a hustle and part of the underground economy, it is part of the support work necessary to produce tattoos.

Billie told me that the job of hosting tattoo parties is a lot like being a club promoter. Not all parties are the same, and hosts attempt to attract enough people by creating events with different themes. George further elaborated on the different types of tattoo parties he had worked:

> Like, some people won't have jack; you just come over and hang out, and they might have some music on or they're watching movies, and you've got a guy in there that's doing tattoos. Some people go all out. I've been to parties where they've rented hotel rooms, they've rented halls. I did birthday parties / tattoo parties, toy parties—adult toys / tattoo parties. It's been weird. Like, over the years I've seen crazy shit . . . I did a stripper tattoo party before where they had

girls dancing. I told them I can't work in this environment. Booty is shaking here and I'm trying to [work], my lines are all crooked. I can't do that shit. He [the host] didn't even care, he was like, "We gonna have strippers and everything else." I'm like, "Dude, put me in a separate room or something." I'm not gay! What the fuck? I don't want ass shaking around me when I'm trying to tattoo, man.

Those working tattoo parties have less authority over the space. Depending on the setting, theme, and attendees, many factors affect their work. The experience of working a tattoo party can be chaotic or disorganized, and tattooists must cope with these conditions on the spot.

Tattoo parties place the burden of locating clients on the host. For shopless working parties, they are dependent on the host to not only advertise the event but create an atmosphere where people will spend money. Despite the efforts of hosts, tattoo parties have a degree of uncertainty and can have poor attendance. While some parties are successful, they are not always profitable. To offset potential losses, shopless working tattoo parties usually require a $200–$300 deposit. Billie described how she manages this issue: "You never know when a party is going to be booked correctly or planned correctly. The person hosting the party might be doing their part, but you still must rely on those people, to come and show up. So I've had people that will set up a tattoo party for me, that have paid their deposit, that put the word out there for me, they've invited everybody that they want to come, and like, four people show up. It's not the host's fault, they put the word out there, but they don't get their deposit back either." The number of attendees both constrains and facilitates the kinds of tattoos produced. A poorly attended party means there is time to create elaborate and expensive tattoos for clients. However, a well-attended party limits the tattooist, as they may only be able to spend about 30 minutes with each client. There is little time to negotiate the specifics of a tattoo since the shopless attempt to cycle through many clients. Shopless maximize their profits by producing small tattoos on as many clients as possible.

Even though hosts are responsible for organizing the tattoo party, the environment itself is not always conducive to producing tattoos. For the tattooist, they must contend with many issues that are not present in other spaces of tattoo work. These spaces have many people present who are eating, making noise, and moving about. They are unstructured, and those working tattoo parties must impose organization on clients. George explained,

When you go in, it's always chaotic. Everybody's walking around, nobody knows what's going on. So I would have a list. I would make it up on my computer, and it would say "Tattoo Sign-In List" to create some type of order in this chaotic commotion. 'Cause there's people all over the place, and you don't know who

you're dealing with, and you're in somebody's house. It made all the difference just having that list, so now I know who's going next. I know who is coming before that person or whatever, or they could switch places if you're not ready; it didn't matter to me.

George was one of the first, and most successful, at working tattoo parties in Baltimore. His attention to organization comes from years of experience (including failures) working parties. Often, the only person George would know prior to the tattoo party was the host. His efforts at organization were to combat the issue of working in unfamiliar spaces with new clients in a limited time frame and to maximize his profits.

Those working well-attended parties must rapidly produce small tattoos to serve attendees. They create each tattoo within a 30- to 45-minute window of time. In this time period, the client chooses a design. The tattooist then applies the tattoo, cleans their workspace, and finally, sets up for the next client. These constraints limit the form and content of the tattoos. George developed a method to manage these constraints:

> So I had rules, like anybody that I did a party for knew them: I'm not gonna do anything that's too big, but then I'm not going to do multiple tattoos on a person, unless the party is slow. If it's just like a handful of people and you want to get more than one, OK, no problem. But if it's a whole bunch of people in there, you get one tattoo, and you gotta keep moving, you've gotta go . . . Now by the time I'm finished doing all the rest of the people, [if] you're still here and you want something else, you can jump back in the chair. I'm trying to make all the money, maximizing [my time]. I'm not trying to do two tattoos on this one guy and then have somebody else be like, "Man, he's taking too long; I'm gonna leave."

As George shows, maximizing his profits is the key to being successful at tattoo parties. This means producing small, usually black-and-gray, tattoos with limited details in order to quickly move clients in and out.

Risk and Clientele

Shopless occupy the lowest position in the hierarchy of tattooing. Being outside of a shop and lacking formal training only compounds their marginality among established tattooists. While some shopless manage to have small followings of clientele, they have them because there are people who would not receive services in a shop. Working out of private residences and without a storefront presents the shopless with increased risk and uncertainty.

The potential of victimization is a concern among shopless, since they are traveling to clients they do not know and often carrying cash. Many attempt

to reduce their likelihood of victimization by avoiding specific areas or specific people. For example, Mason told me, "If I have somebody call me and they sound suspicious on the phone or they just, I get a bad feeling, there's nothing forcing me to go there and do the tattoo for them." However, being a cash business, mobile tattooists often take on jobs that knowingly present the risk of violence.

George, a current shop owner, has been physically assaulted traveling from clients' houses. Just after finishing a tattoo party, and with hundreds of dollars of cash in his pocket, he claimed,

> I had almost got killed. Some guys tried to rob me, and I got beat up. So when that whole thing went down and I got beat up and stuff, one of the guys was stomping on my hands. I still got scars and stuff all over my hands from that, and my hands was all messed up; my ribs were bruised and everything like that. I had appointments booked, and I couldn't do the appointments 'cause I couldn't use my hands. It was a real emotional time, 'cause at the time, my girlfriend didn't have a job, and I have baby daughter, and I've got bills, and I can't work. This [tattooing] is all I do. So I forced myself to go back to work by like the third week. I pretty much, I couldn't hold a machine. I had to go back to work. I had lumps on my head and everything. I was bandaged up and still doing tattoos. I had no choice; I had no health insurance or anything.

Shortly after this assault, George opened a shop in the back room of a beauty parlor. There, he had the added security of those at the beauty parlor. Working alone and traveling to clientele increase the risk of victimization among those who are mobile tattooists.

Summary

This chapter examined the efforts of tattooists to socially organize their labor. Its first contribution was explaining the dynamics of the spaces of tattoo work. Across these spaces, tasks are bundled differently among core and support personnel. The second contribution of this chapter was explaining how these spaces have different features that facilitate or constrain the process of production. The spaces of tattoo work influence the kinds of decisions tattooists make. Moreover, it illustrated the interdependence necessary to produce, distribute, and consume tattoos. For tattooists to meet clients, they need to develop spaces that enable these interactions. Much of the work of tattooists involves carefully coordinated actions with others.

A central theme involved tattooists retaining control over their labor. Across the three different spaces to work, tattooists are concerned with the degree of control they have in immediate face-to-face interactions with

clientele. They make decisions that will ease their work by increasing their degree of control in various work environments. At another level of analysis, tattooists are concerned with the degree of control members of the occupation collectively hold. Their responses toward working at conventions or in private residences demonstrate this issue. As tattooists move away from shops, they lose control over their labor. Additionally, in this process, entrepreneurs have capitalized on the contemporary tattoo trend by organizing conventions. Tattooists have responded with disdain and attempted to reassert their control over the occupation by developing their own conventions and spaces to work.

The spaces where tattooists work affect the ways they develop reputation, or status, within this world. Frustrations expressed by tattooists over conventions are not merely about entrepreneurs moving in on the occupation. Rather, it involves an old guard, seeing their systems of control altered. Further, among the spaces, the types of capital earned are not equally accessible. Across these three spaces, there are more opportunities to earn status or a reputation, develop artistic capital, and grow social networks in shops and at conventions. The shopless have the lowest degree of access to these forms of capital. Space, and its use, structures how tattooists work and functions to reinforce the social distance between the shopless and those defined as legitimate tattooists.

3

Careers of Tattooists

> As a little tiny kid, I can remember being
> hoisted up and sat on the dummy rail of
> a tattoo shop on Market Street in San
> Francisco. When other people took you to
> the zoo Gramps would take you to tattoo
> shops, to skid row. He took me to skid
> row and told me that if you don't work
> hard and knuckle down, this is where you
> end up. It's still one of my main motivating
> things, it's what keeps me out of the gutter.
> Grandpa gave me some real choice stuff.
> —Mike "Rollo Banks" Malone

Within the world of tattooing, Mike "Rollo Banks" Malone is probably best known for his flash designs. They have adorned the walls of tattoo shops across the world. What is interesting about his statement above is how Malone describes his early experiences with the world of tattooing. Like many of those interviewed, Malone encountered tattooing at an early age and developed an affinity for tattoos. Eventually, this early curiosity became a full-time occupation. Malone is describing how he learned about tattooing as a possible occupation. He is depicting his entry into tattooing.

When sociologists speak of a *career*, they are referring to a series of movements through an occupational experience.[1] The concept of a career initially depicted work experiences in the professions.[2] It emphasized upward mobility

within respectable careers (namely, doctors and other white-collar professions). Of particular importance were the ways workers conceived of their identities, the rewards associated with upward mobility, the pathways and measurements of achievement, and how people exited or left their careers.[3] Research on deviant careers explains the process of learning how to commit a form of deviance, searching for resources to commit these acts, learning motivations or techniques of neutralization to manage perceived stigma or identity, and exit.[4] Typically, exit from the deviant experience is not met with complete detachment from the identity: for example, when recovering addicts become treatment counselors.[5]

This concept of a career and its characteristics can explain tattooists' social world. Like other cultural producers, tattooists have careers. People enter the occupation, develop identities, learn the craft, manage horizontal and vertical mobility, and eventually leave the job. Importantly, and unlike the professions, tattooists' careers occur outside of formal institutions and organizations. Tattooists sustain their careers in an occupation that does not rely on formal education or credentialism. These characteristics are useful for understanding how people sustain a living in advanced capitalism.

Tattooing seems to share some of the characteristics of a deviant career. For example, there is not always upward mobility between positions, and there are not well-defined pathways of career advancement. Despite lacking these characteristics, tattooists have a cultural code that emphasizes a traditional, established way of doing things. This code dictates a set of expectations for how tattooists should move through the occupational experience. This is distinct from respectable careers, as tattooists rely on their cultural code to reduce uncertainty and instability in their operations rather than formal rules and organizational structures. While not all careers within tattooing rigidly adhere to this code, tattooists report similar movements through their occupational experience.

This chapter moves sequentially through the occupational experience. It begins by explaining how tattooists understand their choice to pursue tattoo work. Then it depicts the types of opportunities to learn the occupation, highlighting their relationship to the prestige hierarchy. The next experience involves the acquisition of tools, an interactive process requiring tattooists to develop and rely on their networks. It then explains mobility. This chapter ends with a brief discussion of career exit among tattooists.

Occupational Entry

There are several ways tattooists enter the occupation.[6] Preceding entry are three related experiences that involve identity development and learning that tattooing the body is not only possible but profitable. First, all interviewees reported

having some passion for producing art prior to becoming a tattooist. Similar to many respondents, Laura had this interest early in life: "Drawing has always been something that I was interested in and something that I've done since I was a kid. So before I wanted to be a tattoo artist, I wanted to get into animation, so drawing's always been there." Later in life, she realized these art skills may provide a viable income through tattooing.

A passion for art at a young age led many tattooists to develop an identity as an artist early in their lives. Several respondents reported receiving encouragement from parents, peers, and schools to pursue art. This led them to focus on their skills as artists within conventional institutions. As Billie claimed,

> By the time I hit high school, and people saw my capabilities as far as my artwork and everything... Like, the cool thing about Calloway High was the first year they opened was my freshman year. So you know, we had a mascot, but we didn't have an actual logo for a mascot. I designed all that stuff. I designed the school's postcard. I designed the T-shirts for like, the football team, the dance crew, the senior T-shirts. I painted this huge mural in one of the stairwells...
> I've done a lot of stuff to contribute to the school and the growth of the school, and because of that, a lot of people were like, "That's Billie; she's the artist."

While Billie pursued art, just like other tattooists, she conceived of her identity as an artist prior to knowing tattooing was a possibility for work. This conception provided her with a framework to understand the world as an artist. Later in life, many tattooists reported confronting the problem of making money from creating art.

The second experience preceding entry is learning that tattooing is a possibility for the body. Many of those interviewed also mentioned having an interest in tattoos—usually early in life—prior to wanting to tattoo for a living. Their interest coincided with early exposure to tattooed people and realizing tattoos can alter the body. Clyfford depicted how throughout his childhood, adolescent, and teenage years, tattooing was present in his life: "My great uncle . . . was in World War II. He had a bunch of tattoos. So I had seen them since I was little kid, and I just thought they were super cool. But I never gave really much thought to it; I just thought it was neat. And then as I got older, I got into like punk rock, and skateboarding, and hard-core music, and all that kind of stuff, where you see more people that are tattooed. And like, the people that you're looking up to have a lot of tattoos, and I was around it a lot more." Clyfford's exposure to tattooed people is a common story among tattooists. As indicated, he looked up to a war veteran, members of bands, and their fans. Many tattooists described experiences, at an early age, with family members or people they respected who had tattoos. Not only were they exposed to tattoos, but some also developed a fascination. Henry, who is 35,

was always a bit nostalgic when describing his experiences. He told me how he became interested in tattooing: "I remember, I don't know if you do, the first really tattooed person you ever saw was like, fucking amazing! It was just like, what was up with that guy?" That first heavily tattooed person provided Henry with intrigue and a curiosity about tattooing. Among those who are now tattooists, exposure to tattooed people allowed them to make the connection between their interest in art and understanding tattooing as an activity where they could use their skills as artists.

The third experience involves the desire to learn how to produce tattoos. Many, at least initially, experimented with tattooing as an activity or hobby. For example, as Clyfford proudly exclaimed, "I tried to tattoo myself a couple times when I was like 14 or 15, and I got my real professional tattoo on my 18th birthday. I had been bugging this guy for like six months before, when I was just 17, telling him that I wanted to do tattoos." Clyfford was not a trained tattooist at that age, nor did he know much about tattoos. Only later did he realize there are practitioners who tattoo people for a living. His encounters with an established tattooist would lead him to an apprenticeship.

Learning that tattooing can be profitable is essential for pursuing it as an occupation. Many were unaware of the material rewards attached to the activity, since they initially viewed it as an artistic hobby. It was only after they realized that there were material rewards attached to tattooing that they understood it as a career option. This understanding occurred as tattooists made the connection between their interest in learning the activity and that people are willing to pay money for tattoos. For Eli, "I guess from 12 or 13 until my high school days, I had this fascination with 'em [tattoos] and never figured it would be a career. I kind of felt it will be a means to an end as opposed to a career, and it ended up becoming a career." Learning that tattooing was profitable, they also understood, or found out through experimentation, that producing tattoos required a specific skill set. Usually, they realized this when their tattoos did not conform to the expectations of consumers. They eventually sought out established mentors who taught them how to tattoo.

Other Blocked Career Paths

Some people's entry was preceded by blocked career paths in other worlds. This included frustration with low-wage service-sector jobs, which offered little upward mobility and financial security; limited schooling or training; feelings of alienation in respectable careers; and the uncertainty of material rewards in conventional art worlds. Tattooing became an alternative to avoid these conditions.

A lack of upward mobility in other forms of labor preceded many people's entry. These people were unable to find work with a reasonable wage. Samuel, a 34-year-old tattooist with 12 years of experience, entered the occupation this

way. After dropping out of high school at age 16 with no GED and little experience, he had limited options. He bounced between several jobs at fast-food establishments, and by age 21, he was working at a pizza shop and, as he claims, "pushing around a skateboard." For Samuel, "I was making pizzas. And one of the guys I was making pizzas with was in a band with a guy that owned a [tattoo] shop. And he put in a word with him, and I met the guy two nights later at a bar, and he was like, 'Come in tomorrow, man. Let me see some stuff.' So I did." After years of low-wage service work, Samuel entered tattooing to provide increased financial security, lacking the credentials required for other forms of employment.

Similar to Samuel, several tattooists reported restricted career choices due to limited resources for continued education. Tattooing became a more secure alternative to other career aspirations. As Elaine explained, "Originally, I had wanted to be an animator. But I couldn't afford . . . I got accepted into some really great art colleges, but I couldn't afford the student loans." Many tattooists had artistic aspirations but were financially unable to pursue them. Alan had a similar story. He pursued three years of art school and then did not have enough money to continue the track toward becoming an art teacher. He stated, "I started working full time doing piercings, and when I wasn't piercing, I would sit and watch the guys tattoo. So after a while, they were starting to get busier and busier with the tattooing, 'cause tattooing was also getting more popular. They asked me if I wanted to try it out, because I have the art background and I used to really pay attention." Alan learned to tattoo while he was working as a piercer. Through regular and sustained contact with tattooists, the opportunity to learn how to tattoo emerged. For Alan, the movement to piercing occurred because he could no longer afford to attend art school. Relying on his art background, he was able to use those skills to become proficient at tattooing while also working as the shop's piercer.

Leaving conventional careers or abandoning conventional aspirations to pursue tattooing is not uncommon; some have even left the professions. The most notable historical example is Samuel Steward, the legendary Chicago tattooist, who left his position as an English professor, after 20 years because of begrudging the monotony of teaching introductory English classes.[7] Similar to Steward, John Lee left a prominent position as an advertising designer when he became frustrated with the doldrums of a corporate job. After years of producing corporate art, John Lee felt unfulfilled and overburdened in his position. In his free time, he began trading his art for tattoos with Eli, which eventually led to an apprenticeship and job:

> I was getting tattooed by Eli, and then I started trading artwork to him for tattoos, and then we became friends . . . So in my corporate job, I had been getting the runaround about them writing me a job description that would actually

encompass what I did. Considering what I did far outweighed what I was required to do. In other words, you know you're supposed to do x, but you do $x + x + x$. I was getting screwed. That's how I got into it. I just, the corporate line could not be toed any longer, and I burned a few bridges probably too, and my vocabulary gets a little indignant sometimes when I'm agitated [*laughs*].

For John Lee, a trained artist with a master's degree in public design, tattooing became an escape from the daily grind of the corporate world. Importantly, his transition to the occupation occurred because he possessed contacts with established tattooists. These initial contacts facilitated the choice to pursue tattoo work.

Finally, others enter the occupation after facing uncertainty in conventional artistic production. Brenda became a tattooist after having trouble securing work in the institutional art world. She described the reasons for her entry into the occupation:

> I got hurt on the job. I was—actually, I got injured helping my sister out. I fractured my tibia and tore my ACL. And I was doing art installation at the time. So doing art installation requires a lot of intense labor. You know, heavy lifting, climbing really high ladders, going up on lifts. It's very physical, moving walls, building walls, all that jazz. I wasn't able to do that while in recovery time, and I thought I would be able to, but through the multiple surgeries and the recovery time of that, it was just—it was affecting my ability to do those jobs effectively. So I worked for the Baltimore Museum of Art. I was recovering the whole time and learning to tattoo at the same time. Because I needed a backup, because I didn't know those jobs aren't exactly stable when it comes to the long term. So it's, you work a lot and [then] you're off, and then you work a lot and then you're off. So I wanted, I needed, more stability.

On the one hand, Brenda noticed the problems of making money within the cycles of the institutional art world. That is, making money relies on art shows or installation art, and artists often find themselves having extended periods of time where they do not get paid. Tattooing is not a steady income with a weekly paycheck, but the pay is far less sporadic and unpredictable than installation art. On the other hand, her passion for art pushed her toward tattooing. In the evenings, she worked as an adjunct instructor of art classes at a community college. Tattooing enabled her to continue pursuing conventional art while also providing an income.

The connection between art school training and tattooing has increased in the last 20 years. A larger proportion of tattooists now have art school backgrounds. Unable to find work in their desired fields or areas of training, for artists, tattooing becomes a viable alternative. Of the 31 tattooists interviewed,

12 possessed an art school degree, had completed several years of art school, or were currently pursuing an advanced degree in art. Some, like Clyfford, even had tattooists encourage them to pursue art school.

> I went to art school for two years, actually. Like I said, I started my apprentice-ship when I turned 18, which was the summer before I was supposed to start my first year at college. I told my boss, "I got accepted to college, and I'm supposed to go to art school, if it's going to interfere, or you don't think I should do it, I won't go, 'cause I want to be a tattooer." Luckily, I was working with a guy that was like, "No, man, you got into school. That's a good thing, and go to school and we'll work your schedule out."

While Clyfford was set on becoming a tattooist, his art training helped him move through the ranks of tattooing, and he now works in a custom tattoo shop.

For tattooists, there is a process to choosing this line of work. Everyone mentioned first having some interest in art during their lives. Through this interest and exposure to tattooed people, they were able to make the connec-tion between their interest in art and tattooing. After having an interest in learning how to tattoo, tattooists also learned that there was a large market for tattoos. After deciding to pursue tattooing as a job, they must then figure out how to learn the craft of tattoo work.

Opportunities to Learn the Craft

Once a person decides to become a tattooist, they face the problem of learn-ing the necessary skills. Established tattooists regulate the opportunities to learn by controlling access to apprenticeships and selecting mentees because of their personal traits or characteristics. The result of this gatekeeping is that there are three ways people learn how to tattoo. Initially, many learn by exper-imentation on themselves, friends, or family. Eventually, some locate appren-ticeships through their contacts with established tattooists. Finally, those unable to locate a mentor continue experimentation.

Several tattooists reported that their first opportunities to learn occurred through experimentation. This happened before they made contacts within the world of tattooing. Many were interested in tattooing and experimented by tattooing themselves, friends, or relatives. In reflecting on his first tattoo, Mason told me,

> We were in the basement of my parents' house. This machine sounded like shit. I didn't know how to tune it correctly yet; to get it to run, that's as far as I could get it. The machine ran, and it was workable, but I didn't know all the little ins and outs. And those little things help now. I put the stencil on him, and he's shaking. and I got my hand [ready]. I'm nervous, and I do the first little line, and

he fucking screams. I think, "I'm going too deep," and the whole time I'm doing it, he's like, "You sure you're not going too deep, dude? It really hurts." And he's hurting, and I'm sitting there trying to do it. It took like nine hours for a little tattoo that shouldn't've took more than 45 minutes. He came back the next day, and I did a little bit more and tried to figure it out and fix it.

Of those who reported experimentation, they quickly realized their skill sets did not match their expectations. While they had seen tattoos before, they did not understand how to create them.

The next opportunity to learn occurs through apprenticeships. This coincides with the fledgling developing associations with established tattooists, demonstrating they are a viable candidate for an apprenticeship. Most commonly, apprenticeships occur when an established tattooist recognizes potential in their clients. Ben, a 32-year-old tattooist, told me this is how he received an apprenticeship: "I brought some of my artwork in [to a tattoo shop], and I wanted to get [a tattoo,] something pretty specific. And the guy there really liked my stuff, and he asked if I ever thought about tattooing, and I totally kind of did, but I never really had the opportunity to go and do it, and [I] just kind of went for it. So I hung out, did more artwork, did some airbrushing, and I started working on designs for him and then just kind of gradually got into it full time." While Ben had the opportunity to learn how to tattoo, others who search for mentors find it a daunting process. This is because established tattooists tend to reject people they do not trust.

Many attempt to locate apprenticeships by showing their portfolio of their talents to prospective mentors. This tactic is usually unproductive, as established tattooists are skeptical and wary of newcomers. Henry struggled to locate a mentor who would offer an apprenticeship using this method: "Getting an apprenticeship was difficult. I took a portfolio of artwork to tons and tons of other tattoo shops. Everyone I could think of, and this was going back 10 years ago. So some people said no politely. Some people said no less than politely for sure. It was difficult." Henry eventually succeeded in finding an apprenticeship. Like others, establishing contacts with tattooists was an important part of locating an apprenticeship. This is because established tattooists select apprentices based on their personal characteristics.

Having contacts with established tattooists does not ensure an apprenticeship offer. Even people who actively participated in the tattoo world as support personnel were not always able to secure apprenticeships. For months, Elaine worked the front desk of a shop, hoping it would facilitate an apprenticeship. She claimed,

I was always trying to show them that I could draw and [doing] anything they asked me to do. I was basically their personal assistant. Set them up, broke them

down, did all their stencils for them, all that kind of stuff. And then one of the artists started dating this girl, and she got an apprenticeship in like a month. So I was super pissed off about that and wound up leaving. Because it was like, "Oh, so you're having sex with this girl, and she does nothing, and she just gets this apprenticeship, whereas I've been busting my ass trying to show that I'm an equal in this industry, and nobody wants to give me the time of day."

Elaine's experience reflects the difficult nature of attaining apprenticeships. It also reveals the gendered nature of tattoo work—which men have historically controlled—and the exploitation of women. Mentors can select whomever they want to apprentice. This occurs because there is an oversupply of those wanting to learn the occupation and established tattooists control access to each opportunity.

While many search for apprenticeships, there are a select few people who make contacts within the world of tattooing at young ages. These are usually the descendants of tattooists. Being the descendent of a tattooist provides opportunities that most do not have. Two of the classic examples of this are Bobby Shaw and Larry Shaw, the sons of the great Bob Shaw.[8] Bob Shaw, born in 1926, was a well-known American tattooist who apprenticed under Bert Grimm. Shaw was a former president of the National Tattoo Association, and he tattooed from 1941 until his death in 1993. This also occurred with Filip Leu, who is the son of a tattooist and is himself a third-generation artist. In both cases, children of tattooists were able to have contact with established tattooists early in their lives. This facilitated their career paths.

Since established tattooists act as gatekeepers for apprenticeships, they control who has access to entering the occupation. Established tattooists, influenced by the code of tattoo work, believe apprentices should earn the right to become a member of the occupation. The combination of the over-supply of those who want to learn how to tattoo and the cultural code leaves many apprentices vulnerable to exploitation. For apprentices, much of their day involves performing menial labor for no pay as they earn the right to become tattooists. Being in the same space as established tattooists allows apprentices to be privy to conversations or exchanges of ideas about tattooing. In this world, apprentices pay their dues in exchange for learning a skill and occupation.

Often apprentices perform a wide range of support work. This generally includes: handling food and drink orders, serving as a driver, running errands on behalf of the shop, purchasing art supplies, taking out the trash, cleaning stations, stocking stations, cleaning the shop, and performing whatever other kinds of labor their mentors can imagine. Apprentices are valuable for tattooists, who would rather tattoo than scrub toilets, sketch small designs, take phone calls, or maintain the storefront. Within this world,

these activities are rites of passage that reaffirm the boundary between tattooist and subordinate.

In one of our conversations, Henry expressed to me that he had a particularly exploitive apprenticeship. There was "the obstacle of getting the apprenticeship, and then you get the obstacle of dealing with these shitty people, making you do shitty things, being exposed to an environment of less than savory people for sure." Not only was he expected to perform the duties of the apprentice, but he also had to serve as a driver for two of the tattooists. His duties included picking both tattooists up for work in the morning and taking them home from work, usually after a night of inebriation. As he continued, "It was an absolute nightmare. I had to do everything, everything, for those people; they took full advantage of me. It was in a less than savory shop for sure; the owner was a crack addict. The people were flighty. I had to drive them around. I did everything they said." Most tattooists who went through apprenticeships reported the challenges of learning a new craft and having to perform menial or derogatory tasks to demonstrate their loyalty. Over time, and as the apprentice pays their dues, they earn the right to perform tasks more closely related to the act of tattooing.

Apprentices face problems of craftsmanship, and an experienced tattooist can help them navigate these issues. This individualized learning occurs as the apprentice improves their skill set. Even when they are able to produce a small tattoo, the apprentice is still reliant on their mentor. For example, Kevin had this experience: "I did my first tattoo within like the first six months of it [starting an apprenticeship]. But I wouldn't consider myself a tattoo artist by then. 'Cause I was a tattoo person; I wasn't really the artist yet. I could do a tattoo, but I really wasn't honed in skills or anything like that. I could do a tattoo and make it look decent. Like, you could go home, and you're not gonna go, 'Oh, this is the worst thing ever.' But yet, I wasn't to the point where I fully understood things." Distinct in Kevin's account is his separation of his identity as a "tattoo person" from tattoo artists. As an apprentice, he is not a tattoo artist yet; he is learning the craft. His account reinforces the boundary between those who have earned the title of tattooist and those who have not.

The final possible opportunity to learn is pursued only after one fails to locate a mentor. Such tattooists find opportunities through continued experimentation. They are self-taught, a stigma within the world of tattooing, but some eventually gain a following of clientele. In 1980, shortly after graduating high school, Eli joined the military, where he began to teach himself how to tattoo: "I had the opportunity in the military to have a lot of possible subjects. So I basically started with a homemade tattoo machine, pecked away at that for a little while. And then when I got out of the military, my brother worked on a jobsite, and one of the guys on the jobsite had a start-up tattoo kit. And I basically took over that and looked for an apprenticeship and

couldn't find one, and moved to Hawaii looking for another apprenticeship and couldn't find one there, and ended up teaching myself." This was part-time work, and Eli's opportunities occurred because of access to a clientele base from the military. For many like Eli, continued experimentation occurs because there is an oversupply of people who want to tattoo, a large demand for tattoos, and a lack of opportunities to apprentice. At the time he began to tattoo, Eli already had a strong background in painting. Tattooing helped him earned extra income and was a vocation that used his art skills. He did not view this as a viable occupation until several years later; his entry into the job coincided with historical circumstances. Eli entered the occupation on the cusp of the widespread popularization of tattoos (the 1990s).

All people who enter the occupation must have an opportunity to learn how to tattoo. Opportunities arise from shifts in the market, social locations, and acquaintances. Those who enter the occupation typically find their first opportunities through experimentation. After concluding that tattooing is a skill not easily learned on their own, many search for mentors who will give them a chance to learn how to tattoo. For those who are unable to locate mentors, their opportunities to learn are through continued experimentation.

Methods of Training

Not all mentors or opportunities to learn are equal. Mentors have different degrees of prestige, embeddedness in networks, and techniques, which stratifies fledgling tattooists. Who someone apprenticed under is a resource from which the fledgling tattooist can draw for legitimacy or sought-after rewards. Mentors with the highest degrees of prestige often possess networks with those who control rewards and distribution systems. Those mentors with less prestige are unable to pass on such contacts to their apprentices. This limits the apprentice's access to channels for mobility. The method of training, and prestige hierarchy, have profound effects on a tattooist's career.

There are four methods of training. First is the formal apprenticeship model. In this method, the apprentice earns the right to be a tattooist. This method functions to eliminate competition, maintain control over occupational membership, and honorifically pass on the tradition. Casual apprenticeships, which have a semiformal means of training, are another model. These apprenticeships lack the rigid structure and are shorter in duration than formal apprenticeship but still emphasize the importance of tradition. Casual apprenticeships provide trainees with just enough training to create a basic tattoo. Another method of training involves attending tattoo school. These schools charge fees, and those who attend them face occupational stigma, as they are not considered to have earned the right to be a tattooist. The final method of training is to be self-taught. Such tattooists have the lowest prestige. Often,

they are unable to find work in tattoo shops, and when a shop owner does become interested in their services, they undergo an abridged apprenticeship.

Formal Apprenticeships

Formal apprenticeships are bound by the traditional code of tattooing. This form of training rejects the modern capitalistic enterprise of measurable and standardized objective certification. Instead, it relies on personal instruction from a mentor. It is paternalistic, and the apprentice defers to their mentor. These apprentices learn the traditions of the craft, which they uphold through honor, dedication, suffering for learning's sake, and delayed gratification. Those who find a traditional apprenticeship devote years of their lives to a single mentor. This is the most prestigious method of learning how to tattoo.

The length of the formal apprenticeship typically ranges from three to five years. Some mentors may demand a longer period of training. Often, these mentors have contacts with those at top of the tattoo world and those who control symbolic reward systems. For these apprentices, upward mobility within the world of tattooing occurs early in their careers because of their mentor's prestige, networks, and skill.

Rooted in the ethics of Bushido, craft, and art, the Japanese method of training epitomizes the traditional apprenticeship model.[9] It is traditional in Japanese culture for professions, artists, and craftsmen to employ apprentices to maintain their crafts and the mentors' legacies. Restated, Japanese tattooing is deeply rooted in following tradition. In this model, the apprentices work and live in the home of their mentor. Learning a skill and a philosophical approach to work is the compensation for their labor. Apprentices spend much of their time learning the traditional, established way of doing things. For many years, the apprentice must conduct tasks daily, such as grinding pigments for ink or making needles, repeating the task thousands of times until they have perfected their craft.

Some of the best contemporary examples of this model are the Horiyoshi and Horihito families of Japanese tattooing.[10] For example, here is a description of the apprenticeship process used by the master Horihito:

> The apprenticeship demands a remarkable combination of patience and determination. The first two years of such an apprenticeship might be spent grinding *sumi* ink, which is traditionally used for all black and gray coloration in the tattoo. Thus the apprentices spend these years acquainting themselves with the bare, elemental aspects of the most fundamental facets of the tattoo, in the process of quite literally teaching the body "the utter exhaustion of constant practice." Furthermore, this ink should (ideally) be ground daily; the apprentice shoulders the more cumbersome tasks for his or her master such as running

errands, cleaning the house, or performing whatever chores are necessary around the house, in addition to the already strenuous demands of their technical training and their more academic study. But this extends beyond the more mental or intellectual demands; for example, in the Horihito family, apprentices are required to shave their heads, to *physically* display the austerity of their spiritual devotion. Finally, in what may seem the most substantial sacrifice by American standards, members of the Horihito family turn in their earnings at the end of the day to their master. Though food, lodging, and transportation are provided while they are within Horihito's studio, allowances for free spending are necessarily quite minimal.[11]

This description exemplifies the traditions of Japanese tattooing and the relationships apprentices share with their master. As a representative of their master's artistic legacy, apprentices must demonstrate reverence. This method of training is the most valued among tattooists; it defines the process and its traditions as sacred.

Generally, formal apprenticeships in the United States begin with the apprentice performing the menial labor necessary for the shop to function. Once the apprentice demonstrates mastery of this work, they take on more complicated tasks, which progress toward tattooing. Alan described this process:

> A proper apprenticeship should not be easy. A proper apprenticeship [involves] someone who's definitely got talent and ambition, and they've proven that they want to be in this industry for their life as a career choice. They work out something with the shop where they start doing all the grunt work: the cleaning, the running errands, everything from the bottom up, cleaning the toilets, mopping the floors—anything that the artists ask for. Basically, that's their job in the beginning. Then they spend a lot of time drawing, and they spend a lot of time watching the artists and learning the different techniques and stuff. When the time comes for them to practice, they will bring in one of their friends as a guinea pig, and under supervision, they'll do a tattoo. A small simple tattoo, and it goes from there. Once that is executed, well, they're given a critique, and they have more stuff they need to focus on. And if they do well, they continue to practice on people, until they are at a point where their mentor feels it's OK for them to start working on customers, and they'll start working on customers. The entire time through the apprenticeship, they're not getting paid. They're basically earning what their end product will be like. We're teaching them something that's gonna provide for them for the rest of their lives.

Alan's comments about the process of this model reveal the traditional way of doing things. The mentor slowly guides the apprentice through the tasks that are necessary for a tattoo shop to function. Each apprentice begins with

small tasks where they pay their dues to advance while learning the craft. As the apprentice masters simple tasks, they take on more complex activities to carry out, which happen to be closer to tattooing a person. In a paternalistic manner, they eventually earn the right to tattoo or are forced out of the occupation. Alan also notes that talent and ambition are two qualities that he looks for in apprentices. Talent and ambition alone do not lead someone to become a tattooist. Rather, it is the combination of talent, ambition, and paying dues that earn someone the title of tattooist.

Formal apprenticeships are the most valued type of learning method in the United States. Usually, mentors expect these apprentices to work under them for several years while learning how to tattoo Some even sign a contract with their mentor, assuring them of loyalty and devotion for a desired amount of time. Kevin told me he had been piercing for 20 years and tattooing for about the last 8. I asked how long his apprenticeship in tattooing was. He replied, "For tattooing, it was like about, I would say like 5 years . . . So between the 8 years, there was the trial-and-error days, and of course once you learn, you think you don't have to listen to anybody anymore. It's like once you got your license, it's like, 'I know how to drive,' and then you back into something . . . And like I said, it was like 5 years for—in my contract for my apprenticeship, it says a good 5 years of supervision." While contracts may dictate the number of hours or years needed to complete the apprenticeship, there is often the tacit agreement that the apprentice will remain loyal to their mentor for many more years. This limits uncertainty by alleviating problems of learning the craft too quickly, reducing competition in the market by ensuring Kevin does not open a shop elsewhere, and allowing the mentor to profit from teaching Kevin how to tattoo.

Kevin also learned the traditions of the craft in his apprenticeship. He learned to make needles and fabricate parts for tattoo machines and even build his own machines. He had to carve acetate stencils (a technique that is now obsolete), draw with charcoal and pastels, and paint in watercolor. These activities contributed toward the growth of Kevin's skill and instilled in him an appreciation for the techniques of the past. He explained to me, "I've actually done an acetate pressing, like the acetate carving tattoo with the charcoal [powder] and all; it sucks . . . You wipe it once with the charcoal, it's gone. So you gently blot to make sure you still got a line and stuff. It was hell. They definitely had it harder back then." As Kevin described using these techniques, I could sense how he felt honored to know that he was carrying the traditions of the craft with him.

The traditional apprenticeship is the most prestigious method of training. It stands out from other methods of learning because it emphasizes the passing on of tradition. It is a symbolic rite of passage when the apprentice's identity honorifically transforms into that of a tattooist. Mentees in this model often associate with their mentors for the duration of their careers.

Casual Apprenticeships

Most tattooists trained through casual apprenticeships. Casual apprenticeships have an abbreviated period of training, usually around six months. These have no formalized guidelines or written contracts, and there is less focus on learning every aspect of the craft. Instead, supervision of the apprentice occurs until they can produce a basic tattoo. The burden of learning is on the apprentice, who learns by watching established tattooists, assisting them, and asking questions.

Already working in a tattoo shop, Tim explained how he turned his position as a piercer into a casual apprenticeship:

> I just asked questions about everything, like, "How are you doing that? Why are you doing that?" And I think I always kind of knew where the threshold was of like, asking questions and being annoying. I would do stuff for 'em. Like, shit that they didn't want to do. "Cool, you don't want to clean that equipment up? Tell me how to do it." So I just kind of learned hands-on. It developed into a really loose apprenticeship. There was never any terms or contract or anything like that, it was just kind of like just me being there and soaking it all up.

Like formal apprenticeships, the established tattooists keep their knowledge closely guarded. However, in this model, the casual apprentice is responsible for probing established tattooists to learn the occupation. They learn through their own initiative to seek out information.

It is typical for casual apprenticeships to involve unstructured learning. Often casual apprentices become monetary assets to shop owners once they can produce a basic tattoo. Samuel explained,

> I went through about a six-month apprenticeship, if you want to call it that. It really wasn't. The guy was in a band, so he was always on tour, so I just kind of tatted a bunch of friends and a bunch of clients for cheap . . . I'm not kidding you, man; it wasn't really an apprenticeship. I mean he let me work at the shop and kind of showed me how to do things, but he was gone all the time. I bought a set of machines, and I had to sit down at the table and put them together until they worked, and as soon as they worked, I could do my first tattoo. I mean, I literally had pieces of what makes a machine up, like all the stuff was just in pieces. So I had to put it all together, not knowing what I was doing, and try to make it work. And three or four tries later, I finally got it to fire up, and it worked. And I think the next day, I brought in one of my friends and tattooed 'em, and it was horrible. It looked like crap, and it still does. He still has it.

While Samuel asserts that he did not learn how to tattoo from the shop owner, he did provide the shop owner with the ability to continually keep the doors

open. As Samuel's account indicates, it is unclear whether he was an apprentice, tattooist, or some other personnel. The casual apprenticeship does not have the same rites of passage as the formal apprenticeship, in which someone's identity changes from apprentice to tattooist. Instead, the casual apprentice is a monetary asset, and a public rite of passage does not occur.

For the casual apprentice, the burden of learning is on their shoulders and not their mentor's. They realize there is more to learn about the craft. Many expand their occupational networks to build up their skill set. However, navigating this cultural hierarchy is challenging because they do not have connections to established tattooists. The knowledge they seek is hard fought and easily lost—something established tattooists closely guard. Frank depicted his struggle to meet established tattooists: "I remember I went to The Electric Tattoo Company [located about six miles away] one day, and I asked them a few questions, just trying to learn further, trying to find a source or something. Like, where can I go to better my work? Or what type of ink do you use here? And they totally told me that they couldn't tell me that. They wasn't going to tell me anything. I was just like, 'I just want to make it better. I'm not even in your district, so how can I be taking your business?'" Frank is also black and was asking questions around white-owned tattoo shops. This denial of access dispels outsiders, providing established tattooists with a supposed advantage in the market. Those who went through casual apprenticeships often described similar struggles to expand their networks. Only after developing their networks, or an established tattooist taking interest in them, were they made privy to these tricks of the trade.

Not learning the intricacies of the craft is an experience reported by many in casual apprenticeships. Market dynamics facilitate this, as casual apprentices are initially exploited labor. Many lack the training or skill to be confident and competent. Joseph explained, "It was a brief apprenticeship. I learned how to assemble a machine and learned how to do quick small tattoos. I learned how to make needles and kind of mix a couple pigments here and there, just very basic stuff, just enough to get me in the door at a tattoo shop. And then once I got into the tattoo shop, the first tattoo shop, that is pretty much where I learned that I was in way over my head." Many, like Joseph, struggle. This is because the craft of tattooing is complex, and it is difficult to learn in an abbreviated period with partial information and a small amount of experience. Once they possess the ability to produce simple tattoos, the casual apprentice becomes a financial resource who rents space from shop owners.

Many eventually realize casual apprenticeships leave them with a limited skill set. After moving to Kentucky from Baltimore, Margaret finally found a casual apprenticeship in what she called a biker shop. The owner decided she might be able to tattoo after reviewing her portfolio. In this apprenticeship, she found herself producing small tattoos the first week she was in the shop.

She explained the experience: "Like, he wasn't a good artist. So when I would ask about certain needle groupings and things like that, he was like, 'Oh, don't worry about those, you don't need to use those, just use these.' I saw so much that I wasn't doing that, once I got engrossed in the field, I was like, 'This isn't working for me. I want to move further.'" While eager to learn the craft, she grew frustrated, as she was not learning about the kinds of things she was seeing among other tattooists. As a casual apprentice, and much like in Joseph's story above, this opportunity to learn stunted her growth. Eventually, she found a more structured apprenticeship in Maryland under Tim, who at the time was an established tattooist. It is not uncommon for these tattooists to seek additional training when they understand their skill deficit.

In the world of tattooing, information is scarce, and other methods of learning involve watching another tattooist work, feeling a tattoo produced on yourself, or gaining the trust of an established tattooist. Answering questions is a risky proposition for the established. Providing information may give others access to tools, knowledge, or tips that were once difficult to acquire, threatening the market and position of the established tattooist.

For many who trained through casual apprenticeships, their growth depends on developing networks of associates who are willing to divulge their knowledge. This means having an awareness of who has exceptional skill, who they can befriend, and how those people might be able to contribute toward their growth. This seems to come through one of two strategies. The first is to become a keen observer of this world who can ask the right people the right questions. Edgar noted that he used this strategy to learn more about the occupation: "I watched a lot of tattoos [be done]. I asked a lot of questions. I tried. I learned how to make a statement. And I learned how to make needles. And I learned how to build tattoo machines. And I asked as many questions as I could, and I still ask questions every day." The second strategy involves becoming a client of established tattooists. Samuel described this strategy as perfect for allowing someone to familiarize themselves with the feeling of a tattoo being produced but also to have a conversation with an established tattooist: "I got tattooed over the years by a lot of people, and they were all really nice and said if I had any questions, or wanted to know anything, to talk to them about it. So I would get tattooed and shoot the shit with them and find out little tricks of the trade and listen to their machines and watch how they did everything and kind of just critique 'em while I was getting tattooed, to like, learn a little bit more. That's how I kind of grew in[to] tattooing." As the quotes above indicate, Edgar and Samuel needed to cultivate relationships where they could learn more about the craft. Continued growth and learning was their burden, an outcome of the casual apprenticeship model.

Selecting Apprentices

Due to the oversupply of people who want to be tattooists, it is not difficult for established tattooists to find willing apprentices. As gatekeepers, established tattooists grapple with the problem of selecting apprentices. Eli explained how public misconceptions contribute toward this problem: "I probably get an apprentice question a week—people wanting apprenticeships. I just met a guy on the airplane the other day that was asking me for one. It's not hard to find people wanting to do it; it's hard to find good people who you're willing to train." I asked if this had only recently become a common question, and he replied, "No, this is been going on for years. Everybody thinks it's an easy buck. An easy way to make a living, and they'll just step into it and learn how to tattoo and get rich. And it's not that way!" Eli's frustration centered on the differences in values between established tattooists and those who do not fully understand the occupation. For him, outsiders see it as an easy buck, but to insiders, it is more than just a way to make a living. Eli's frustration reflects established tattooists' interests in protecting their control over the occupation.

Mentors are powerful gatekeepers and can deny people entry into the occupation. Glen explained to me how he understood the apprentice model: "Not only was it kind of [to] pass technique in tradition down from one generation to the next, but it was also kind of a way to keep all the douchebags out of tattooing. If you started an apprenticeship, and they found out you are a douche, you wouldn't be tattooing anywhere near them." The selection of apprentices is necessary to also ensure the occupation is composed of people who are skilled and dedicated to the craft. Established tattooists can filter out those with poor attitudes or a lack of passion or who are otherwise uncommitted.

Established tattooists typically do not offer apprenticeships to people off the street. Instead, they recruit from their existing networks, often from their own clientele. Potential mentors can evaluate these clientele for their trustworthiness, honesty, and interest in tattooing. In other words, it enables tattooists to select apprentices who are more likely to have a dedication to the craft. Eli expressed this to me while tattooing a client: "I would hope that after they did their apprenticeship, they would stick around awhile. Didn't always prove to be the case, but it's kind of a business decision in that regard because you don't want to spend the time and the effort teaching somebody your trade just to have them become competition as soon as they learn it. Which happens quite a bit." Just as he finished speaking, the client described having the same problem: "Our businesses are so similar, 'cause in the framing business, it's the same exact thing. Be careful how you apprentice people because you want—I spent years training your ass; now I want years making money off your ass. And instead, they take your knowledge and go, and now they're competition right down the street." Eli continued, "That's how it is, and you hope that . . . you

just hope that by me giving you the keys to a business and a career, that you'd appreciate it enough . . . It's not always the case, but the majority of [the] time, if you did your homework from the beginning, you picked the right person for the apprenticeship, you kind of knew already that they were going to stick around. John Lee and Eric have been here 16-plus years after their apprenticeship, and that's almost unheard of in this business." These comments indicate that mentors expect apprentices to abide by the traditional code of tattooing, which values loyalty. Their loyalty ensures mentors receive monetary rewards, and it reduces competition in the market.

Attending Tattoo School

Since gatekeepers control apprenticeships, some enter the occupation through alternative means. One of these methods of training is tattoo school.[12] Tattoo schools undermine the code of tattoo work since they emphasize credentialism over experience. People who attended tattoo schools struggle to earn equal status among established tattooists. They become unworthy, since they have paid money to learn the craft, instead of honorifically earning that right. They dishonor those who have earned their title as tattooist, since they merely purchased it.

Generally, established tattooists view tattoos schools as financial scams. They believe disreputable people create schools to defraud fledgling tattooists out of several thousand dollars with the promise of teaching them how to tattoo. Alan claimed, "There some shops that don't really care about the industry, and the craft, and the artwork. And they're going to take your money to teach you like a school, and they're going to take you in for maybe two to three months or something like that for $5,000, and they'll probably give you some cheap equipment, show you some basics, and send you on your way. That's just the way for them to make more money, but that's very frowned upon by the better professionals in the industry." Tattoo schools allow anyone who has enough time and money to call themselves a tattooist. Schools devalue the honor of established tattooists and disrupt the control they have over the occupation.

Elaine attended a tattoo school after becoming frustrated with the lack of opportunities she received to learn the craft. She attended art school with the intention of being a tattooist. Flustered at how established tattooists controlled apprenticeships in Virginia and after seeing others receive apprenticeships she felt she deserved, she eventually enrolled in a tattoo school using her husband's GI Bill benefits. She stated,

I wound up reading this magazine, and I saw in the back of it they had an ad for a tattoo learning center. I knew that the industry hated these places, and they said they were scams and that you can't learn basics in two weeks. "They're just

bullshit. Nobody will respect you if you go to one of the schools," so on and so on. At this point, I figured something is better than nothing and I found out that I can get a military grant to go to the school. So I figured, "What have I got to lose? It's not like it will set me back; if I go there and it's a scam, I come back just as green at it as I [was] before."

Despite having an art school background, she encountered difficulty finding work after attending tattoo school. Established tattooists in shops stigmatized her because of this method of training. This prevented her from working in shops with respected tattooists. Instead, she was only able to secure work in a lower-end shop owned by a nontattooist who simply profited off those working for him.

The Self-Taught

With a limited number of apprenticeships, learning independently becomes a viable alternative for some people. This usually begins with fabricating rudimentary tools and experimenting with them. Eventually, they view these tools as the source of their poor-quality tattoos, and they seek out equipment from purveyors. Without the benefit of a mentor, the self-taught learn how to tattoo through experimentation.

Many begin as self-taught, learning how to tattoo as they profit from the experience. These people, at least initially, primarily tattoo friends or family members. Within the tattoo world, the self-taught have the least amount of prestige attached to their identity. Established tattooists marginalize the self-taught, as their skill set and tattoos do not reflect valued aesthetics. Established tattooists view the self-taught as exploiters who are motivated by money and have not earned the right to even possess the title of tattooist.

Self-taught tattooists fulfill a market niche within the world of tattooing. They are usually shopless and fill a void between demand and those willing to work under specific conditions. There are many prospective clients who want tattoos but are unable to attain them from shops. These clients cannot afford or are unwilling to pay for the services of established tattooists, or they cannot receive a tattoo in a shop due to age or medical conditions, as examples. Jacob explained these characteristics of being self-taught: "It's [tattooing's] just something I do really on the side. Like, I do auto body work most of the day or just mechanical work. Other than that, this is just something [where] somebody call me up, 'Jacob, can I get a tattoo?' 'Sure.' They set up a time, you go with it . . . I started [tattooing] back in '98. In '98, I went to Job Corps, so everybody was in the rush of trying to get tattoos, but we didn't really have nobody to do 'em. A lot of people [who] want [tattoos] don't really have no money." Jacob tattoos to earn extra income. He is exploiting a market niche consisting of those who will not get a tattoo in shops. Stigmatized by those

working in shops, these tattooists struggle to make contacts with established tattooists. This limits their access to information and ensures they continue to learn through experimentation.

Self-taught tattooists present a threat to established ones. The latter believe they bring negative attention to the craft. Just like those who attended tattoo schools, the self-taught become stigmatized among established tattooists. Richard, a 35-year-old tattooist who is still new to the occupation, told me, "I've had other shop owners that, back in the day when I was tryin' to learn, I'd ask 'em a question and literally [they] would turn their back on me because I guess there're that old-school mentality. You know, 'You're not worthy of the knowledge like that.' So I, you know, just figured out trial and error." Positioned as an outcast, viewed as unworthy, and subsequently lacking networks with established tattooists, Richard continued learning on his own. After purchasing DVDs and continuing to experiment, he eventually earned Mike's respect. Noticing his potential, Mike offered him an apprenticeship, but this was only after letting Richard continue to experiment for many months.

Acquiring Tools and Materials

Those who enter the occupation must acquire the tools and materials needed to produce tattoos. This begins once someone decides to start experimenting with tattooing. As they continue to pursue tattooing, they learn more about the various kinds of tools and materials available to them. Central to this process is the development of networks that enable access to several types of tools and materials.

Many who begin to experiment with tattooing fabricate primitive tools. This work involves repurposing accessible materials for tattooing. When Jacob explained his first attempts at tattooing, this was apparent: "What I did, I went on and just bought some India ink, some sewing needles, and I had erasers. So I started off—first, I start tattooing myself, with the Indian ink and sewing needles. But with the sewing needles [*motions with his hand, indicating a problem holding them*]. I took an eraser off a pencil, used that like as a grip, so I could have something to hold onto. So I started from that." It is not uncommon that the materials to produce a rudimentary tattoo can be repurposed from household items. Many other tattooists reported comparable stories of their first experiences tattooing. While these are not the ideal materials, the construction of them reveals the resourcefulness of the self-taught.

After experimentation and primitive fabrication, tattooists reported realizing they needed better tools. They needed conventional equipment to make tattoos in less time and with more skill. Many were able to purchase everything needed through the internet or mail. Often, people refer to this equipment as a "tattoo kit." These kits include materials needed to apply a basic tattoo: a

tattoo machine, inks, stencils, needles, tubes, a power source, ink cups, stencils, and occasionally instructional materials. As they increase in price, they include more materials. Some of the pricier tattoo kits include multiple machines, instructional DVDs, and occasionally autoclaves and sharps containers.

Those who began with a tattoo kit reported that the tools themselves were problematic for producing tattoos. Dante, who is now an apprentice, purchased one of these kits after experimenting with a homemade tattoo machine: "I had a starter kit that I got on eBay [*laughs*], and that was a bad mistake . . . Well, the starter kits are pretty much only good for—pretty much anything 'made by China'; it's made just to look like it's made [cheap]. I personally think that they are only made to just scar the skin and just make a really shitty tattoo altogether." Like Dante, most established tattooists claimed these kits were inferior and inadequate for tattooing. Novices or the self-taught, who do not have contacts with established tattooists or a body of knowledge about tattooing, are the primary consumers of these kits. As Dante stated, what he now knows as an apprentice enabled him to understand the problems with the "tattoo kit" he used when he experimented.

Those who make contacts with established tattooists benefit from access to equipment and occupational knowledge. Ben benefitted from contact with tattooists who educated him about machines and tools:

> When I started out, I didn't really know what to buy, so I had people that I work with kind of guide me as far as what to get. As I worked with different people, they had different equipment and I tried some of them out. Some of the equipment they had and some of the colors and whatever—I could find out what I liked or didn't like, and how that fit into my workflow. A lot of it's personal preference. They can see how you try a lot of different equipment and different supplies, and you find out what you like and what you don't for the style of tattooing that you do, and then you work off of that.

Contact with established tattooists is essential for learning about tools and materials. The broader their networks, the more access tattooists have to various machine builders and producers of other materials.

Tattooists do not settle on a single machine or type of ink. As their careers progress, they encounter many different tools and materials. Many, like Brenda, are continually learning about what kinds of machines or equipment are available to them:

> I think the best thing I learned from equipment and tattooing equipment especially is from the people you work with, and the people that tattoo you. When I'm interested in getting a new machine or new products, like, I'll feel out everyone in the shop, "Hey do you like this? Have you used this before? How do you

feel about this machine? What you think about that machine?" and get their advice. Because a lot of times you may not be familiar with the specific machine builder or how their machines run, and you're not sure, so you don't necessarily want to buy this fancy expensive machine if you're not familiar with who built it or how it runs . . . A lot of times, tattooers are always interested in acquiring different machines and getting rid of ones that they have 'cause they have gazillions of them. Or they're just—that machine hasn't met their desires, and they're looking for something new, so that we're constantly selling and bartering and trading stuff back and forth to each other.

As described, the search for tools is dependent upon their contacts with others. Brenda also noted the secondary market among tattooists for bartering, trading, and selling machines to one another. These exchanges enable them to try many different machines.

The code of tattoo work dictates that people attain tools and materials from reputable sources. This means purchasing from established tattooists. Clyfford explained to me, "I buy certain colors from certain companies 'cause I like them. There's a couple of old supply companies that have been around since the '70s, and the people are true blue. They love this industry and care about it, and that's who I give my business to . . . There are companies that have been doing this for 30 years, and they're still run by the same guy. Philadelphia Eddie owns one with his wife, and they still run it, and they're in their 70s." Clyfford chooses to purchase materials from specific companies. These are companies that have earned a reputation among tattooists for being legitimate or credible within the world of tattooing. This selective purchasing keeps outsiders from exploiting the craft and reduces uncertainty over the materials.

Upward Mobility

Similar to other occupations, tattooists aspire for upward mobility. This occurs after one attains an understanding of the pathways of mobility within this world. As tattooists learn this system, they strategically select their networks to facilitate their movement. Upward movement between shops, or into ownership, provides tattooists with access to different material and symbolic rewards and is associated with increased freedom and control.

The first type of upward mobility observed involves movement between shops. For many, there is an ardent desire to grow as a skilled practitioner. Often tattooists begin in shops where their skill level matches the relative skill level of other employees. As their skill increases, they eke out rewards, such as increased payment for their services, greater freedom, and more respect among colleagues.

Some tattooists seek upward mobility as they begin to understand that their career aspirations seem limited. They view themselves as being underemployed

and not able to continue growing. For example, Margaret, who previously described her struggles in Kentucky when trying to learn how to tattoo, experienced this underemployment early in her career: "I only did like these spot-job tattoos. I wanted to do such big pieces, and I wanted to find out about more, and he [the owner] just was like, 'No, you don't need to know those things.' It got to a point where we were kind of grappling about my worth at that point, because I was making a lot more, and I was there a lot more, and he just wouldn't give on how much he was willing to give me, and I felt like I was being used at a certain point. So I left." At the bottom of the craft hierarchy, Margaret strived to produce more artistic-looking tattoos. Unfulfilled and lacking creativity in her work, Margaret quit her job and moved back to Baltimore. She eventually found work in the shop owned by Tim, a tattooist she admired for his artistic skill. In discussing why she moved on, Margaret stated, "I want certain kinds of clientele to come to me eventually, where I'm basically doing tattoos that I want to do on a regular basis. Not necessarily having to dip into a certain kind of style that I'm not psyched about doing but [that] I'm doing because they want it and I have to make money. I want to eventually be a lot more choosy about what I take on and if I do want to go outside of my normal style." Importantly, Margaret's story reveals her understanding of the cultural reward system among tattooists who are artists. Upward mobility allowed her to begin forming a distinct artistic style. Once refined, she could become selective regarding the kinds of tattoos she produced. She would feel rewarded by this sense of artistic freedom and the ability to make a living without having to rely on clients who want small tattoos.

The second type of upward mobility within this world is movement into shop ownership. Tattooists generally view shop ownership as a goal, a point where they can reap the benefits of being a business owner. This includes the freedom of being one's own boss, increased monetary rewards, and the ability to select who they work with. Kevin explained,

> I think it's everyone's ultimate goal to be your own boss. Not to take any shit from anybody. To be like, "I don't want to come in on Tuesday; I'm not coming in on Tuesday" . . . Surrounding myself with people that I respect and enjoy working with. I have final say; if I don't like you, I don't want you screwing with my work. Like if everybody else is like, "This guy isn't working out," then I'll be, "I'm sorry, man, you have to go. I don't care how good of an artist you are; if you're causing turmoil for all my other artists, then you're going to have to go. It has nothing to do with your work or anything. It's just your personality."

Most of the tattooists I spoke with were like Kevin. They aspired to become small business owners. The aspiration to be a small business owner is not something distinct to tattooing, but part of the American dream.

While some aspire to own a shop, the code of tattoo work dictates that they must first pay their dues and earn the respect of their peers before moving on to shop ownership. Violations of this rule are a source of frustration among established tattooists and owners, who believe others have earned this right. Angrily, John Lee told me about this. He presented it as a problem of the craft: "I'm sure you may have even been to shops where guys said they have been tattooing between three to six years and they own the shop. Total fucking horseshit! That is poisoning the craft. And to be a dick, if you're staying in Maryland and Delaware and Pennsylvania, I know all those motherfuckers that've opened shops and they shouldn't have opened shops. They didn't—they have not paid their fucking dues . . . It becomes this greed thing . . . It has become a problem; people think suddenly that they deserve more, but they haven't put enough into it yet." Established tattooists attempt to discredit those who have not paid their dues. They claim others favor the material rewards of shop ownership. They are exploiters, as John Lee stated, because they violated the code of the occupation.

Some claimed they were not interested in moving toward shop ownership. They tended to see shop ownership as a burden. Dorsey explained, "I've been tattooing for 14 years now, and I didn't want to open a shop for a long time. Because it seemed like a lot of extra headaches. It seemed like I made as much money as the owners with less on me, and I didn't want to do it until I was established in the community. 'Cause I like the old ethics of like, you don't tread on someone's toes. I'd rather know everything I want to know about it before apprenticing for two years and then opening up somewhere down the street from somebody else." He viewed the day-to-day activities that make a shop possible as a burden. Owners become responsible for ensuring support work occurs, finding counter help, paying the bills, and so on. They also are responsible for managing the tattooists in the shop and depend on them to do their job and to not jeopardize the shop's reputation. Due to tattooing's recent growth in popularity, opening a shop also comes with the risk of encroaching upon someone else's territory. Foreseeing these problems makes ownership seems cumbersome. Despite Dorsey's claim that ownership seems like too much of a burden, he recently became a shop owner.

Even though there is a rigid code about shop ownership, some tattooists choose to violate it. Tim, who had been tattooing since 2001, opened his shop when he was 23 years old, just 4 years after becoming a tattooist. In hindsight he admitted, "Yeah, I was kind of young. I had a lot of people tell me not to do it. Saying I was way too young and that I didn't know what I was doing. And I was like, 'Well that's exactly right: I'm young and I'm dumb and I don't have shit to lose. So let's do it.'" As a violator of the code, Tim initially struggled to attract tattooists trained through apprenticeships to his shop. Instead, he relied on recruiting his own apprentices (like Margaret) and those who were

traveling between shops. His movement into shop ownership occurred, in part, because of his frustration with finding an enjoyable workspace.

Shifts and Transitions

During the tattooist's career, there are many shifts that can occur. There are few positions at the top, limiting upward mobility among tattooists. Due to these circumstances, there is a large degree of lateral mobility and downward mobility. Additionally, others experience transitions that interrupt their careers as tattooists. These are often temporary situations, and many return to tattooing after a period of days, weeks, or months.

Career Shifts

The first career shift involves conducting the same activity in different places.[13] Tattooists generally undergo a great deal of lateral movement throughout their career. For example, Ben spent five years moving between shops: "I started in this area actually, over in Blissville, I worked in a shop there for about three years. Then went to another one for about six months or so. Then went to California and did it for a little over a year and half, and then I came back here. So I've just been kind of moving around and traveling and working different spots." Tattooists commonly reported these types of horizontal shifts. Traveling is part of the culture of tattoo work. Historically in the U.S., tattooists frequently traveled. Even some of the great American tattooists typically did not stay in one location for extended periods of time.[14]

Many tattooists have a desire to travel and see the world. They can do this because tattooists also have a skill that members of almost every society desire. They can also transport most of the materials needed to produce tattoos with relative ease. Additionally, location is not always central to their career advancement. As William stated, "It's my passport. It's—it can take me anywhere, anywhere that tattooing is socially acceptable, then I can go and tattoo." Dorsey, for a two-year period of his career, lived as a traveling tattooist, selling handmade flash around the country, "I went on a road trip with a buddy of mine across country and we stopped in like Albuquerque. We stopped in several different cities, and I had more money in my pocket when I got there [the end destination] than when I left after paying for gas and everything, 'cause it just facilitated it with selling some flash designs. Then we might do some tattoos in San Diego and go to the Hollywood Tattoo Convention and go to Vegas—you can kind of jump around like that if you're into like the vagabond lifestyle." Some tattooists pursue this lifestyle, stopping in places for a brief period before moving to a different area of the country or world. The more connections a tattooist has, the more shops they can guest spot in across the country.

Another way these lateral shifts occur is when conflicts over the material rewards arise. Glen has moved between several shops during his career as a tattooist. When I first met him, he had recently relocated to Classic Tattoo after a confrontation with the owner of the shop where he used to work: "He and I had a disagreement recently, and we parted ways . . . He accused me of stealing, and I didn't steal shit. Since then, I found out through his wife that he's back out on a crack binge. So more than likely, he took the money, and she found the discrepancy, and he just didn't want to admit that he had taken it. So he put it on me. Since then, she has a protective order against him, and he's no longer allowed in either one of the shops." For Glen, this conflict over money prompted his search for work in a different shop. These conflicts arise because much of tattooing is cash based.

A final way this shift occurs is through a conflict over values. Several tattooists cited their desire to be in a shop where they respected the owners and their coworkers. Likewise, they wanted the same in return. Often, they tolerated less than desirable working conditions until a more reasonable opportunity allowed them to move between shops. Brenda explained why she made such a move: "It was a necessary transition. Not everyone opens shops for the right reasons, and sometimes you find yourself working in places that you might not want to be forever, but they are a chance to pay your dues, get some experience, learn some hard lessons to learn, and use [what you learned]. Learn them quickly and move on. All experiences aside, you learn a lot from 'em, good or bad." In this case, Brenda simply cut her teeth until she was able to make a transition that would place her in a shop with coworkers and an owner who had similar values. Much of the conflict that facilitated Brenda's transition stemmed from the orientation to her work. She viewed the original shop as an atmosphere that focused on money and not a passion for the craft. Brenda wanted to find a working atmosphere where she could be around others who would inspire her to be creative.

New Activities

A second type of shift occurs as tattooists take on new or different activities. Often, this involves carrying out support work in addition to their regular duties as a tattooist. For example, Edgar began learning about pigments used to produce tattoo ink while he was a tattooist. He then produced and distributed his own brand of inks. Similarly, many machine builders are tattooists, interested in the mechanics of machines. Eventually, some learn to produce high-quality machines, each specialized for the demands of the user. These kinds of people, while tattooists, also take on other kinds of support work that facilitate this world's existence.

Another way they take on additional activities is when tattooists apply their tools and knowledge to a qualitatively different kind of tattooing. When

tattooists produce realistic nipple tattoos for women who have undergone reconstructive breast surgery, it is qualitatively different from the artistic tattoo. Eli explains how he made this shift. He stated, "Now I'm kind of into another project that is something completely new. That I kind of created a niche for, and that's tattooing nipples on women that have had breast reconstruction from breast cancer, and they had the breast removed. And so I work in hospitals—Annapimore, Saliswark, Cumberdeen, and Westbridge—doing realistic nipple tattooing on women in need, too." After I asked how he got into that kind of work, he continued,

> It was a breast surgeon here in town who had tried to do the tattooing, and [he] had his nurses attempting to do the tattooing, and the results were really poor. [He] had the wherewithal to realize that they couldn't do it effectively and contacted me to see if I would come in and repair the ones that they had done. And then I did that, and I guess some of my medical training in the military enabled me to have the tools I needed to have. You know, a good bedside manner and patient rapport and things like that. That I could speak to people professionally and carry myself in a way that was acceptable in the medical field. So this guy asked me to come on and help, and I was able to do that, and now [its] blown up into a completely different business than I ever dreamed it would. Pretty much all I do now is nipple tattooing.

This career shift is rare within the world of tattooing. Eli moved on from artistic tattooing to this medicalized form of tattoo work. This is not considered a form of upward mobility, since Eli is no longer producing artistic tattoos, realistic nipple tattoos are not comparable to artistic tattoos, and it largely is seen as crossing the boundary into the medical world.

Temporary Transitions

Tattooists also experience temporary transitions. These are periods where they leave the world of tattooing, only to reenter it within a few days, weeks, or months. A common temporary transition occurs when tattooists cannot locate a space to work. For example, after attempting to retrieve his tattoo equipment from a shop, the owners of the shop reported Samuel to the authorities for theft. Complicating this matter, the owners also called other shops in the area, instructing them not to hire Samuel. For the owners, this eliminated, at least temporarily and spatially, competition from Samuel. More importantly, it tarnished his reputation in the area. Samuel remarked that he briefly stopped tattooing to avoid contact with his former associates, "Not really quitting for a while, but just taking a break from it for a while 'cause of all the stuff that we had to deal with, with the Vermillionsburg shop. That just really tore me up. I didn't really want to go back to the places that I was at

previously or the towns that I was at because of the sheer fact that those were the places those owners had the shop still. So there was that weird thing where they might've came knocking on my door. I just didn't want to deal with it." In response to this incident, Samuel was unable to find work in the same area and ended up moving to Maryland, where his reputation was not known. Eventually, he met Edgar, who convinced him to work at the Electric Tattoo Factory.

Tattooists experience another type of temporary transition when they are physically unable to produce tattoos. These temporary transitions usually last for a few days and are the result of occupational hazards. Tattooists repeatedly lean over clients, hold machines, and look closely at skin. Many reported problems with their hands, backs, and eyes because of these activities. Brenda said, "I mean everybody has different problems with their hands. The heavier the machine, the more damage it can do. The vibration causes carpal tunnel, it can accentuate tendinitis, it can do all these things. So you have to know your limitations on your hands and your body and respond to that—or else you're going to limit your career in a significant way if you don't listen to what your hands are telling you." Brenda takes time off from work when her pain is too severe and has switched to using a rotary machine for shading, which is much more forgiving on her hands. These solutions have helped alleviate some of the pain. Despite having physical problems with the act of tattooing, none of the tattooists reported wanting to leave the occupation.

The third type of temporary transition experienced by tattooists is because of substance use and addiction. Dorsey experienced downward mobility in such a transition. Despite seeking out breaks to cope with his addiction, coworkers pushed him to continue tattooing:

> I did drugs for a minute—for like five years in the middle of my career. And I maintained a job for a while, and then I didn't. I've tattooed in the projects for drugs. Like, once I got real bad, I didn't want [to be] working in shops, and I wanted that downgrade. I've had a shop once tell me like—man, like I was saying, "I gotta go; I gotta straighten my life out." [They told me,] "We understand that you got issues, but you're on time and you do good work." And I was like, "Dude, you don't understand that I am like shooting drugs into my neck in your bathroom." They were like, "Well, that's a little extreme, but . . ." Like, they didn't want me to go, which was weird. But I just try to keep morals about that kind of stuff, I don't want clients seeing me like that, so I've fell into some dark times at a point. And coming out of that, I wasn't sure what direction I wanted to go, but it was a short break. I really can't stay away from tattooing.

His downward mobility involved becoming a shopless tattooist, working for heroin. He then spent several months as a roofer and successfully became clean. While 3 of the 31 tattooists interviewed reported heroin addiction, it is

not a characteristic associated with tattooing. Rather, Baltimore is a city with a long history of a disproportionate rate of heroin use among its residents.[15] All 3 of those who reported such addiction experienced issues with it early in their tattoo careers, which coincides with the age-graded use of substances.

A final type of temporary transition is due to the need for personal growth. Eli, a tattooist who has been working for nearly 30 years, had taken several temporary breaks during his career. He often described these as necessary transitions to avoid burnout. Each time he left coincided with his desire to pursue other forms of artistic production. He explained, "I've had breaks . . . I had the jewelry thing for a while. And then I started doing the fish illustrations and got away from tattooing as a full-time job for a few years. I did that kind of stuff for a while and then got back into it [tattooing]. And then now I'm doing the breast cancer thing, which has gotten me away from doing this kind of [artistic] tattooing and has gotten more into that kind of [medical] tattooing." Like many of the others who experienced temporary transitions in their career, Eli expressed that he always came back to tattooing. These kinds of transitions were creative excursions away from tattooing.

The draw to return to tattooing is part of the code of tattoo work. Tattooists tend to view their work as a calling. For them, tattooing is the occupation they were destined to do. As Brenda told me, "People say that you don't find tattooing, it finds you." Many continue to pursue tattooing because of this ethic. It is a sentiment reflected in Samuel's description of why he continues to tattoo:

> There'll always be something telling me that I should be doing tattooing. There's always going to be something that . . . Like, I don't think I'll ever stop doing it completely, but I don't think that I could do for the rest of my life. It's too much wear and tear on my body. I mean, I have to wear glasses now, which I never had to wear. That's all because of tattooing. 'Cause I can't see close-up because of the years of staring at stuff. Now it's all blurry, and my eyes shake, and my back is shredded from 11 years of doing it. It's easy to be like, "Yeah, man, I want to go sit at a desk and work on computers or something." Which is fun. It's good stuff, but at the same time, I don't know what I'd do if I wasn't doing a little tattooing at the very least.

Samuel claims that he continues to tattoo because of his passion. As he states, he does not know what he would do if he was not tattooing, at least occasionally. This demonstrates the way tattooists value their work, a characteristic defined by their code.

Exiting Tattoo Work

Eventually, and for several reasons—health, poor skill, inability to make money, being forced out, pursuing a different career, or eventually, death—tattooists stop producing tattoos. Sociologists refer to this type of transition as a career exit. Little is known about career exit among tattooists, as scholars tend to focus on entry.[16] Some of the tattooists I studied will exit before the end of their working lives; however, it was not possible to observe this, since they were all currently in their careers. Their discussions of exit were merely speculation about their future. To understand exit, this section pieces together statements from tattooists with historical documents about legends and masters who have exited their careers.

One type of career exit occurs when tattooists fail to gain a following. This occurs among shopless who experiment. In describing experimenters, Mike stated, "Almost 99 percent of the time with these scratchers, . . . they'll get a kit, they'll tattoo their friends and family, and after that runs out, it sits on the shelf and they don't pick it up anymore." These are people who experiment with tattooing but fail to develop a clientele base, or the enthusiasm wears off after a few weeks or months.

Exit occurs for some tattooists and apprentices by force. These are people who are forced out of the occupation after failing to make acceptable progress in their careers. For example, an apprentice who fails to show dedication or who does not complete the apprenticeship process will no longer be a member of the occupation. Even established tattooists grapple with this issue. Sometime after completing this study, one of my key informants revealed to me that one interviewee was no longer tattooing. Apparently, the shop owner and others in the shop had a falling out with this person. While their clients liked them, their peers did not think they were qualified. As a result, this former tattooist is pursuing a different endeavor.

Not all those who work in this world completely move on from being a tattooist. There are several who identify as "ex-tattooists."[17] The ex-tattooist relies on their former position within the world of tattooing. They do not fully exit the world of tattooing because their former identity as a tattooist is central to their changing career path.

Disproportionately, ex-tattooists come from one group—legends and masters. Legends and masters are able to stop tattooing but continue to subsist on their accomplishments within the world of tattooing. Notable tattooists such as Don "Ed" Hardy and "Crazy Philadelphia" Eddie Funk have had careers as ex-tattooists. Ed Hardy founded Hardy Marks Publications in the 1980s and has had an extensive career writing about tattooing. He also had a sordid relationship with Christian Audigier that produced a well-known clothing line—a relationship that Hardy now laments on. Most notably, he

continues to produce art for major shows and give lectures about the history of tattooing.[18] Crazy Philadelphia Eddie owned a supply company, a type of support work for the occupation. These are people who have used their social and symbolic capital to trade on their reputations as ex-tattooists both within the world of tattooing and as members of other spheres.

Summary

This chapter examined the series of movements tattooists experience. First, it depicted the ways that people learn tattooing is a possibility: they had contact with tattooed people, made the connection between art and tattooing, and understood the commercial appeal of the activity. Second, this chapter explained how the development of networks related to tattooing and career progression. As they began the learning process, aspiring tattooists continued to make contacts to advance their understanding of the tools, materials, and techniques of the craft. Finally, this chapter illustrated the types of mobility experienced among tattooists. Taken together, all of this illustrates how someone is socialized to develop the identity of a tattooist.

The careers model also demonstrates the ways tattooists survive in advanced capitalism. They prefer a model of social organization that values experience in the occupation. Experience in this world is not something that is easily reducible to objective criteria. There are no time clocks, objective measures of accomplishment, or formal rules for career progression. Rather, careers are based on how embedded a tattooist is in networks that control career development and the social estimation of honor others assign to them. There are not even public acknowledgments of career advancement, aside from earning the title of tattooist. This amounts to people relying on a system of honor and prestige to develop their careers.

4

Legal Consciousness among Workers

> Even though tattooing is illegal in New York, I treat it like it's legal; I work in the daytime, regular business hours.
> —Thom DeVita

Law is a form of social control that regulates human behavior. In the case of modern tattooing, laws emerged in response to the perceived health threats and moral degradation it would bring to communities. Laws regulating tattooing vary between municipalities, and communities enforce them when they consider it a threat to social order. These laws are significant because they affect how people carry out the activity of tattooing.

Scholars have regarded law as an organizing characteristic of cultural production.[1] For sociologist Richard Peterson, laws and regulations dictate the kinds of relationships people have and shape the activities that people carry out: "Law is not a neutral structure but is a resource that may be used to gain and consolidate power, shaping the nature and content of popular arts in the process."[2] This perspective emphasizes the consolidation of legal power within culture industries. It views laws as a dominating, and looming force over systems of production.[3] Existing literature emphasizes how law shapes forms of social organization in culture industries and how it also shapes the decisions made by cultural producers.

While legal standards exist within the world of tattooing, workers are not simply passive agents in this process. Instead, those producing culture possess a body of legal knowledge. This knowledge is known as *legal consciousness*, or "the ways in which people understand and use the law. . . . [It] is the way that people conceive of the 'natural' and normal way of doing things, their habitual patterns of talk and action, and their commonsense understanding of the world."[4] People learn legal consciousness through their experiences with the law. For tattooists, it becomes a set of meanings through which they understand their world and structure their actions. The legal consciousness tattooists have is part of their cultural worldview. Thom DeVita's quote at the beginning of this chapter reveals his legal consciousness.

It is difficult not to notice legal consciousness among contemporary tattooists.[5] In shop after shop, tattooists tell cautionary tales about how tattooing was not always legal, and that it could be prohibited again. A common practice, occurring in ritualistic fashion, is to have clients sign a waiver of liability before any tattooing takes place. In both cases, law becomes a frame of reference through which tattooists understand the world and how to act toward others. Tattooists' understanding of law structures their activities, but they also use the law in ways that seem natural and normal.

Legal consciousness is a dynamic process that empowers tattooists, existing as both a framework for people to clarify their social world and a set of resources to draw on to inform behavior.[6] In fact, legal consciousness is "produced and revealed in what people *do* as well as what they *say*."[7] When people sign waivers, tattooists are employing a form of legal consciousness. Tattooists employ this consciousness when they claim you need to be a certain age or that tattooing is or is not protected by legal statutes. The signing of a waiver is a symbolic ritual for tattooists to gain a degree of control over their clientele in the process of production. Likewise, stating the legality of an act is a means to gain control over the social interaction. In these examples, tattooists' use of legal knowledge shapes sets of relationships. This chapter explains how law shapes the occupation and how members of the occupation use their knowledge of the law as a resource.

Perceptions of Legality and Historical Interpretations

Tattooists often claim their craft was not always legal. They tend to view themselves as outlaws, renegades, or pirates who pursue an income outside of conventional channels. This narrative implies that there were once strong legal codes prohibiting tattooing—this occurs even though tattooing in some form, has existed in many, if not all, societies throughout history.[8] The significance of this statement is that it defines the relationship that tattooing shares with

the modern state. In recognizing the law in such a manner, it elicits a form of legal consciousness. It implies law is an oppositional force to tattoo work.

Making Sense of the Law

Tattooists have a cautionary tale about the historical role of law on the occupation. It tells of how the state once forbid tattooing or reserved the practice for stigmatizing criminals. While there are many variants of this tale, Eli's depiction includes most of the general elements: "I mean, in Russia, it's always been associated with criminals. In Japan, with the Yakuza. It's always associated with criminals. You know they mark criminals in history with tattoos to set them aside from the general public [with] something they couldn't remove." This narrative is typical of those describing the historical relationship tattooing shares with the law. It is employed to defend the legitimacy of the practice today by separating contemporary tattooing from its past. It is a narrative widely circulated among tattooists.

Conversations about tattooing's current relationship with the state reinforce these ideas. In a contemporary variant of the old tale, Brenda noted, "Good tattooers don't forget where they came from, and a lot of people have struggled in this industry to get it to where it is, and I think a lot of people fucking forget that, because it wasn't always legalized." This suggests that tattooists have a responsibility to ensure they self-regulate to avoid sanctions from the state. Taken together, Brenda's and Eli's warnings recognize the ability of the state to constrain the production of tattoos by controlling, limiting, or regulating the occupation.

There is some historical evidence supporting these tales. Ancient Greece reserved tattooing almost exclusively for punitive purposes, marking slaves and prisoners of war. Even Xerxes ensured that captives at Hellespont received tattoos marking them as outsiders—a form of state-sponsored corporeal domination.[9] This control over the body also occurred in pre-Edo Japan, where the state defined tattooing as a form of disfigurement, deeming the practice criminal. While considered a criminal act, tattooing was also a form of punishment reserved for criminals and outsiders.[10] Similar to Japan, punitive tattooing in Imperial Russia was a historical form of social control used by the state. During the reign of Peter the Great, the Russian state used tattoos to mark deserters of the army and criminals.[11] Even Nazis tattooed those in extermination, concentration, and labor camps, using them as simultaneously a stigma and a symbol of bureaucratic record keeping.

Considering this history, it is not surprising that contemporary tattooists recognize the role of the state to constrain tattooing and that they want to separate themselves from this past. In this perspective, law dictates the kinds of cultural production that can occur. This cautionary tale describes tattooists

as outlaws, suffering at the behest of a centralized state whose interests are in dominating and suppressing the occupation or other people using the tools of the occupation. It implies that this suppression transcends both feudal and modern societies. This serves as a frame of reference for contemporary tattooists to understand the current legal status of the occupation.

Tattoo Bans

There have never been federal laws regulating tattooing in the United States. However, several states and municipalities have enacted regulations, including tattoo bans. Usually, people hastily enacted bans as a response to public concern over the potential danger tattooing posed. In part, success in enacting these bans was a result of tattooists lacking the legal experience to mount effective challenges.

Recently, in the United States, tattooists have been able to remove several tattoo bans at the state and local levels. These jurisdictional bans typically prohibited tattooing unless conducted by a trained practitioner for medical purposes. Lacking a medical justification and necessary training, these bans forced tattooists underground or out of the jurisdiction. Most of them began in the early 1960s. During the late 1990s and early 2000s, people challenged or changed these laws. Not only did these bans confirm public fears over the health risks of tattooing, but they also affected the ways the tattooists organized. In particular, these regulations shaped the practices conducted in shops, such as an increased focus on sterility, health, and safety.

In 1961, there was a hepatitis outbreak in New York City. People blamed the outbreak on tattooing, and officials quickly enacted a ban within city limits. Over the next two years, Massachusetts, South Carolina, and Oklahoma would ban tattooing statewide (see table 4.1). While people blamed tattooing for spreading infectious diseases, these bans reflected a larger collective focus on health and safety in society.

Three contextual factors coincided with the advent of tattoo bans. First, the 1950s and '60s in the United States was a time of enthusiastic support for medical solutions to social problems. In the 1950s, many medical advancements solved troubling conditions. Scientists developed a vaccine for polio and artificial heart valves. Penicillin was mass produced and widely accessible. This enthusiasm for medical solutions to problems spilled over into the 1960s as the U.S. Food and Drug Administration approved the birth control pill and vaccines for measles and mumps. In this increasingly health-conscious society, people became more aware of potential health risks. This awareness included those around tattooing. This historical context also sets the stage for the public's fear of diseases with no clear medical solutions. Second, in the 1960s, New York City was experiencing an epidemic of its own as the number

Table 4.1
State and local tattoo bans

Place	Year created	Year lifted
New York, New York	1961	1997
Massachusetts	1962	2000
South Carolina	1962	2004
Oklahoma	1963	2006
Key West, Florida	1966	2007
Hermosa Beach, California	2007	2010

of diagnosed hepatitis cases increased. The *New York Times* reported in 1961, "Of the unusually high number of 1,491 hepatitis cases in New York so far this year, 243 were of the serum type, which is transmitted by direct blood infection. At least thirteen cases, the Health Department said, were traced to tattooing."[12] A mere 5 percent of serum-type cases were related to tattooing. Amid this reported rise in the frequency of hepatitis cases, the Health Department of New York City determined that one young man had died from hepatitis, which he had contracted from unsterilized needles used to produce a tattoo.[13] At the time, tattooing seemed to be further complicating this unmanageable disease problem, and the city health department clarified peoples' fears by noting a single case directly related to tattooing. Not surprisingly, tattooing was easy to peg as a health risk, as news stories began to circulate linking the practice to the spread of infectious diseases, like hepatitis. The third factor associated with these tattoo bans was the media attention surrounding the New York City hepatitis outbreak. During the 1960s, of 20 articles about tattoos that appeared in the *New York Times*, 8 were about the hepatitis outbreak and the citywide ban on tattooing. With national media producing stories about the risk to public health posed by tattooing, other states and jurisdictions became concerned.

Overall, early tattoo bans were the result of public fears about disease transmission. These changes occurred in the legal sphere and outside of the world of tattooing. In the aftermath of these bans, tattooists began to reinvent their public image by adopting more stringent health and safety procedures. They were adapting to changing conditions. This is evidence of legal consciousness emerging within the social world. As an occupation, tattooists collectively began to recognize the kinds of legal forces that would jeopardize their income.

Within the Confines of the Law

While officials enacted bans, the Tattoo Renaissance had already begun. This featured young tattooists entering the ranks of the occupation with college or university art degrees. As they entered, a new type of legal consciousness developed among tattooists. It emphasized working within existing legal frameworks. In this form of legal consciousness, the law is a game that people play to achieve desired ends.[14] There are winners and losers, and in this way, tattooists began to maneuver strategically to work within the legal system and achieve their own interests.

The Challenge for Legalization

To have bans removed, tattooists used their legal consciousness to redefine the problem. They argued, first, that bans were unconstitutional because they violated freedom of expression laws and, second, that health risks were manageable with sterile conditions and practices.[15] The argument for the former was that tattooing is a form of art and it deserves the same protections as other forms of art. They claimed tattooing is expressive content; therefore, it deserves protection under the First and Fourteenth Amendments. Concerning the second point, they claimed trained tattooists could prevent the transmission of diseases using proper precautions—that it was relatively safe when tattooists used acceptable methods to prevent the spread of blood-borne diseases.

One of the first attempts to challenge civil prohibitions in New York City reveals how tattooists used their legal consciousness to play the game of law.

Spider Webb (born Joseph P. O'Sullivan), a tattoo artist from New York with a Master of Fine Arts degree and a keen eye for mischief, operated a studio in Mount Vernon, NY, just beyond the jurisdiction of the ordinance that prohibited tattooing in New York City itself, but close enough to ensure a steady stream of customers. In 1976, [15] years after tattooing had been made illegal in the city, he produced what was almost certainly the first ever performance piece to use tattooing as its medium, mixing equal parts political satire, activist manifesto and artistic jab at the social and artistic institutions of 1970s New York. In defiance of Section 1706(4) of the New York Health Code, Webb set up an impromptu tattoo studio on the steps of MoMA [the Museum of Modern Art] and proceeded to tattoo a female tattoo artist called Shadow, irritating local police offers (many of whom, he remarked, were tattooed themselves) but delighting an assembled throng of journalists and reporters. . . . Webb staged the stunt knowing he would be arrested, planning to challenge any eventual prosecution by claiming that tattooing was an artistic practice, and that banning it was an infringement of his constitutional rights to free speech as conferred by the *First Amendment*.[16]

Webb's challenge occurred with an understanding of the legal system. He believed the First Amendment would protect his protest art as symbolic speech and that his arrest would be unconstitutional. Webb's unsuccessful case, *People v. O'Sullivan*, eventually reached the New York Supreme Court, who explained their decision as follows: "Whether tattooing be an art form, as suggested by the defendant, or a 'barbaric survival, often associated with a morbid or abnormal personality,' as suggested by four Justices of the Appellate Division . . . we do not deem it speech or even symbolic speech."[17] While unsuccessful, Webb attempted to use his legal consciousness to achieve a desired outcome. Around the same time, other tattooists began to use law to challenge prohibitions or perceived injustices.

After the failure of defining tattooing as expressive content in New York, the practice was still in jeopardy. Even if it had been determined that bans were unconstitutional in accordance with symbolic speech laws, prohibitions could remain if tattooing was considered a public health problem. *Yurkew v. Sinclair* is the quintessential case for decisions upholding tattoo bans to protect public safety.[18] Dave Yurkew was the organizer of the First World Convention of Tattoo Artists in 1976 and president of the North American Tattoo Club.[19] After his applications to rent space at the Minnesota State Fair were rejected in 1978, 1979, and 1980, Yurkew filed an injunctive relief.[20] He claimed the state fair was a public forum and the decision to deny him rental space was a form of unconstitutional censorship. The district court upheld the decision to deny the application, stating that "prohibition of tattooing at the state fair is rationally related to the protection and preservation of the health, safety and welfare of the fair patrons . . . refusal to allow plaintiff to tattoo patrons at the Minnesota State Fair is not unconstitutional."[21] This case demonstrated again that free speech was not enough to have tattoo bans removed. It showed that evidence would need to demonstrate that the public health risks were minimal. Despite efforts to work within the legal system, tattooists were not able to mount effective challenges. It would take another 20 years for them to redefine tattoo bans as a contributing factor to the problem of disease transmission.

Even though outright bans on tattooing existed, they were usually ineffective, as they were difficult to enforce. In New York City, tattoo shops continued to operate under semiclandestine conditions.[22] In places like Massachusetts and Oklahoma, a side industry emerged, consisting of shopless tattooists.[23] The unintended consequence of these bans was that the public's exposure to health risks escalated. In the 1990s (amid the peak of the HIV/AIDS epidemic), medical professionals and tattooists became increasingly concerned that unqualified persons tattooing and lackluster conditions of sterility contributed to the spread of diseases.[24] This provided tattooists with an opportunity to mobilize their legal consciousness and redefine tattoo bans as the problem.

In New York City, Mayor Giuliani noticed the increase in the popularity of tattooing. Demand existed, and tattooing was technically illegal and unregulated in the five boroughs. He grew concerned about a deregulated industry being a health risk to the public. Subsequently, officials established standards for sterilization, needle disposal, record keeping, inspections, lighting, and ventilation.[25] In 1997, it was again legal in the five boroughs. Legalization solved the problem of shops operating in a clandestine manner without oversight, reducing the likelihood of disease transmission.

In Oklahoma, professionals blamed shopless tattooists working out of homes for a hepatitis B outbreak in 2004.[26] Further, the Oklahoma Board of Health was growing concerned about the increasing number of hepatitis cases, noting that 34 percent of those infected also had at least one tattoo. Outright bans became defined as the public health problem. Oklahoma tattooists worked with state agencies to establish health and safety protocols. For these tattooists, developing rules and regulations through the state not only protected the health of consumers but also defined shopless tattooing as illegal. In a reversal of previous actions, the decision to remove these bans was again based on concern for public health. Tattooists used their understanding of health and blood-borne pathogens to define shopless tattooing as the problem and took advantage of a favorable political climate to inform the state and establish laws that protected their enterprises.

In Massachusetts and South Carolina, tattooists continued to fight bans as violations of freedom of expression. For these tattooists, lawyers, and enthusiasts, tattooing was an expressive act that involved carefully coordinated intentions between the consumer and producer. As such, they argued tattoos were more than just objects or merchandise for sale; instead, they were a kind of symbolic speech.[27] John Parkinson wanted to receive a tattoo from Stephan Lanphear without having to leave the Commonwealth of Massachusetts. They filed a complaint with the Superior Court of Massachusetts. Even though this case emphasized speech rights, they also argued for establishing health standards. With the help of the American Civil Liberties Union, they successfully challenged the Commonwealth of Massachusetts, overturning the statewide ban in 2000. In the decision, the Commonwealth determined that the tattoo ban violated not only the First Amendment but also article 16 (the right of free press) of the Massachusetts Declaration of Rights. This decision was important for defining tattoos as expressive content protected under the law.

In 1999, Ron P. White created a video for local media of himself producing a tattoo in the State of South Carolina. Agents of the state arrested and fined him.[28] Recall from earlier in this chapter how making such a media spectacle around the production of art was the same tactic of protest used by Webb on the steps of the MoMA. White, like Webb, was unsuccessful in challenging

the South Carolina Supreme Court. In the 2002 decision, Justice Waller dissented, explaining,

> In my opinion, White's conduct in creating tattoos is a form of art which is entitled to the same protection as any other form of art. If a painter who creates an image on a piece of canvas has created a work of "art" thereby engaging in "speech" worthy of *First Amendment* protection, I see no reason why a tattoo artist who creates the same image on a person's body should be entitled to less protection. In my view, whether or not something is "speech" protected by the *First Amendment* cannot focus upon the medium chosen for its expression.
>
> Although the majority cites several cases which have held that tattooing is not "speech," those cases were decided in an era when tattooing was regarded as something of an antisocial sentiment.[29]

White, like his predecessors, used his understanding of the law to challenge prohibitions on tattooing. As evidenced by Justice Waller's comments, previous prohibitions presumed public sentiment was dismissive of the practice. Justice Waller defined tattooing as protected speech, yet the state refused to. This meant tattooists needed to find another avenue to change policy. Senator Bill Mescher, of the state legislature, introduced a bill that would amend the South Carolina Code of Laws prohibiting the tattoo ban. After passing both the Senate and House, on June 17, 2004, Governor Mark Sanford signed Act 250, which defined safety standards and legal codes of conduct for tattooing. Tattooists were thus successful in using their legal consciousness to play the game of law by contacting members of the state legislature to introduce an act that would amend the South Carolina Code of Laws.[30] Spider Webb opened the door for this legal consciousness, but it took nearly 30 years for tattooists to effectively use this knowledge to legally protect their craft.

Opening a Shop: Zoned Out of Sight, Out of Mind

While the legality of tattooing has been debated in numerous court systems, it has never reached the federal court system, so communities have turned toward civil law to enforce tattoo bans. They rely on health codes, business law, and zoning to regulate the existence of tattoo shops. Tattooists use their legal consciousness as a resource to navigate varied local laws. Since tattooing is relatively unregulated by the federal and state governments, local ordinances are the strongest mechanism of formal social control. Zoning laws are the primary mechanism used by communities to restrict tattooists from opening shops or facilitate the closing of existing shops.

Often, tattooists expressed frustration over these civil codes, which they understood as an effort at prohibition. John Lee noted this sentiment: "I mean, I'm not going to tattoo kids. I'm a baseball coach and a soccer coach.

For six or seven years, I was a fucking scoutmaster, for crying out loud. I have a master's degree. I'm a homeowner. I've been married to the same woman for 20 some years and no straying. I'm a better person than the guy who owns a fucking whatever store that's selling Four Loko to kids. But I can't have a tattoo shop?" This is a common sentiment among tattooists. Denial by the city council, county council, or the state to open a shop leads tattooists to feel unwelcome in communities. One way to interpret John Lee's comments is that he just wants to have a little bit of dignity and legitimacy as a worker who contributes to society. This involves his ability to carry out his labor on his own terms, or what sociologists would call his autonomy.

Those who have opened shops reported encountering a bureaucratic, legal labyrinth. Typically, civil laws prohibit or minimize the existence of tattoo shops through a series of not-in-my-backyard zoning codes. Even when laws allow for tattoo shops, owners contend with the interests of local community members, who often view them as unscrupulous businesses. Owners employ a form of legal consciousness by working within established channels to navigate codes and comply with the community members' demands.

Baltimore County enacted zoning laws with morally-laden legislation that permits tattoo establishments only in areas designated for adult businesses. In 1998, Baltimore County enacted Bill 29, article 4B. This act categorized tattoo shops as adult businesses, along with adult movie theaters, strip clubs, adult book and toy stores, body-piercing shops, and massage parlors. Tattoo shops could only operate in a manufacturing heavy (MH) zone or where a previous adult establishment existed, and they had to be at least 1,000 feet from a school. In a 2003 revision, all adult establishments also had to be at least 1,000 feet from a house of worship, a park or recreational facility, a library, a day care or childcare center, or a residentially zoned area and at least 2,500 feet from another adult-themed establishment. These regulations effectively eliminated the potential for tattooists to open a shop in most areas of the county. While not explicitly stated, community members viewed tattooing as an issue of public morality.

The City of Baltimore views tattooing as an issue of public health, enforcing both health codes and zoning laws. Here, an owner must participate in a series of legal processes. To begin, they must find a properly zoned location to open a shop, in either a manufacturing, B3, or B5 zone.[31] Then they must pay $1,000 to schedule a hearing for approval with the Department of Planning's zoning board, which can take over a month to occur. Conrad described how "just to have that hearing, not knowing whether you're going to get it or not for tattooing in Baltimore," fills potential owners with uncertainty. Community members can attend these hearings and express their distaste, delight, or whatever other thoughts and feelings they have about a small business opening. Once receiving approval from the zoning board, the shop owner must

schedule a health inspection with the Bureau of Ecology. Pending approval from the health inspection, the soon-to-be owner then applies for a tattoo license from the Department of Health. Despite these efforts, a tattoo shop may only receive conditional approval to open its doors. The process thus involves a series of stages, and any stage can result in failure for the prospective shop owner.

Owners report that this is a daunting process. Each stage is an obstacle. Alan described this problem: "You have to find a location that is already zoned, or you have to go through a battle with the local governments and like neighborhood associations to try to get zoning. Which they are very resistant to. Because a lot of the people in those power positions are pretty conservative, and tattooing has a checkered past in our heritage or culture." While it is likely that board members treat tattoo shop openings no different from other businesses, owners of shops report that community members are often outspoken in their attempts to prevent shops from opening. As Alan continued, "This shop [building] was already zoned for tattooing. It didn't work out for them [the previous owners went out of business] . . . So we kind of came in and got the place from the landlord, and we were already zoned for it. But even though we were already zoned for it, people from the neighborhood association found out that we were trying to open a tattoo shop, and they tried to stop us from opening." Alan employs his legal consciousness by working within existing legal frameworks. By choosing to open in a retail space previously approved for tattooing, he used his knowledge of the legal framework as a resource to play the game of law and achieve a desired end.

To further his case, Alan designed his shop to also function as an art gallery—a valued community resource. His intention was to use the space to host art shows. He also knew of a loophole in the law. Alan was able to attain primary permits as an art gallery and a secondary permit to tattoo only on the second floor of the building: "We had space on the first floor to do a gallery, so we opened an art gallery featuring monthly shows by local and national artists. Some were tattoo related, some were just artists in general: photography, ceramics, paintings, drawings, pretty much anything. So we were trying to open the eyes of people who had a predetermined view of what tattoo shops were like. They thought that they were, like, biker kind of shops, and we showed them this very, kind of contemporary artistic version of the tattoo world." By applying for primary permits as an art gallery, Alan used his legal consciousness to manipulate the law in a manner that would enable him to open a tattoo shop under the auspice that its primary purpose was as an art gallery.

Navigating these legal frameworks is an obstacle that shop owners face. Owners and tattooists often exchange stories about the difficulty of opening a tattoo shop. These stories function in two ways. They are a claim that sustains a narrative that it is nearly impossible to open a tattoo shop. This dissuades

other workers from thinking about shop ownership, protecting owners from increased competition. These stories also provide a common experience of marginalization, further reinforcing the boundary between tattooists and members of other social groups.

Some tattooists do exchange their legal consciousness with others, but it is often a closely guarded secret. Dorsey, who recently opened a tattoo shop, consulted with a close friend and shop owner who suggested employing a lawyer. As he recalled, "I called a lawyer, met with him, discussed; he told me what kind of zoning to look for." Fortunately, the lawyer had strong connections to one of the neighborhoods, and he helped Dorsey forge ties with local business owners. Dorsey continued, "My lawyer said I should first go to Jack the barber—he has full sleeves [tattoos covering his arms] and knows guys from Atlanta back from when I was first starting to tattoo, and I know their names. He's a good conversationalist [and the lawyer told me], 'That's my barber; he'll talk to you.' So I went in and got a haircut, and then he told me about some other people to talk to, so I would just track down the business owners, and everybody seemed to like me and like the idea." Dorsey's strategy to navigate the complex legal codes was to rely on the expertise of a lawyer, who advised him to establish ties with local business leaders. The knowledge to contact a lawyer came from a trusted associate who had been through the process of opening a shop. Among tattooists, this knowledge is hard fought and easily lost. This is a form of legal consciousness employed by shop owners to navigate civil law.

The need for a lawyer or a complex body of legal knowledge occurs because of the ways communities use zoning codes to limit the presence of tattooing. Eli explained,

> With [Baltimore] county councilmen and legislation, they took us to court for zoning issues. Which seems to be the number one tool that municipalities use against businesses like the tattoo business or unsavory businesses, so to speak. They use the zoning as their tool to get you out. So if they want you there, they'll tweak the zoning regulations in your favor. If they don't, they'll tweak the zoning regulations against you. It's the easiest way for them to just deny you access by saying you don't fit into the right zone. You fit into a manufacturing zone, and they stick you in an area where there's trucking companies and it's just [vehicle] traffic in and out and nobody walking. [That] makes it impossible to run a business, in a place like that. So they'd tweak those regulations in their favor to keep out who they want.

Eli currently owns two shops and has been a shop owner for over 20 years in the area. He has experienced multiple shops closing as the result of changing zoning laws.

The outcome of civil law is that the distribution of shops is uneven across the metropolitan area. Some places are prone to have more shops than others simply because owners cannot open elsewhere. Brenda elaborated on this:

> A lot of times, that's where you see tattoo shops: really close to one another. Because the zoning is regulated a certain way where you can only open up in certain places, and that's tricky because you don't want to open up a shop right down the street from another shop or on the same block or even in the same plaza. I mean, you see it. It's not because they intentionally want to open up a shop right next to you; it's because that's the only place left that the zoning is going to allow you to do it.

This clustering of tattoo shops increases competition within smaller parts of the metropolitan area. The overarching legal framework of zoning codes structures the competitive and cooperative relationships that tattooists share with one another.

To escape the competition, tattooists seek spaces that permit their shops to operate and that will not intrude on the territory of others. Some choose to locate in less desirable areas to attract customers—those that contain spaces zoned for adult businesses. Mike explained how this affected his shop: "I opened up this space—had I known a little bit better about the area, I might've reconsidered. I didn't really have too much trouble here. I know Sandwich Shoppe Inc. has had some problems [adjacent shop and recent victims of an armed robbery]. Like I said, it was a notorious drug neighborhood, and there was a lot of crack dealing out here. Something I wasn't aware of until I was actually in the spot and after that I had already signed to a two-year lease agreement, so I was kind of stuck [between] a rock and a hard place." Being stuck in this area limited Mike's visibility to the public. Frank, who is employed at a different shop across the city, aptly stated, "I mean look at us: we're in the middle of the fucking boulevard where people live across the street. We're not in the business district. It's a fucking mechanic shop next door, and it's a church [row houses converted into a church]. It's like they stick us where we can't be seen." By limiting the visibility to the public, clientele become more scarce.

The ways zoning codes affect tattooists shows how the imprint of law affects their work. While zoning restricts the placement of shops, tattooists are keenly aware of how this shapes their interactions with colleagues and clientele; hence it is a form of legal consciousness. Additionally, tattooists and shop owners employ their legal consciousness to play the game of civil law.

The Official Health Code

Once a location has been found and a shop has been legally cleared to open, shop owners in the city must also attain certification from the Baltimore

City Health Department. Despite the national focus on the health risks of tattoos during the 1960s, tattooists in the City of Baltimore were already working under different constraints. On June 15, 1953, Arthur Price, then mayor of Baltimore, signed City Ordinance 757. This extended the city's regulatory laws over tattooing, which previously had only prohibited minors from being tattooed, branded, or permanently marked. These regulations mandated that tattooists obtain a license from the commissioner of health and that "tattooing when and wherever practiced in Baltimore City shall be done under such sanitary conditions as deemed by the Commissioner of Health to be necessary to prevent the transmission or occurrence of infection and to protect the public health."[32] While only in place in the City of Baltimore, it has implications for workers and their legal consciousness across the metropolitan area.[33] This code was in direct response to an Armed Forces Military Control Board investigation that concluded that at least six people stationed at nearby Bainbridge Naval Training Center had contracted jaundice from a city tattoo shop in late 1952.[34]

To open a tattoo shop, the Baltimore City Health Department requires a health license. These licenses, renewed annually, cost $100. Health department officials award licenses after a shop passes an official inspection. In describing the health inspection process, Dorsey told me, "They just needed to make sure you had the right sinks, a working autoclave, a couple other pieces of equipment, like some of my tubes or something. Make sure you had probably, like, a cleaner—Madacide, it kills everything; you spray it, wipe it down, [and] 10 minutes later, it is supposed to kill any kind of blood-borne bacteria." A moment later, he reflected on this statement and said, "I have my health department inspection, and we're totally good on that, but a lot of that is still riding on the honor system. In a lot of places, there is nobody coming around checking, so we're upstanding, but I can't say that every shop in Baltimore's doing all the right things to keep their shop clean and disease-free." Receiving this license simply means that a tattoo shop has the equipment and facilities to make a sterile work environment. It does not mean all workers or employees always practice sanitary tattooing.

The Health Department does not ensure that tattooists practice behaviors that reduce the risk of disease transmission. Tattooists are responsible for maintaining sterile conditions. In fact, the Health Department lacks the ability to enforce its own rules regarding certifications. Dorsey continued to explain this process: "They don't come around or anything like that. So I mean, I don't doubt that somebody will get motivated at some day to be like, 'We're going to make laws for this.'" I asked if they came every year, and he replied, "No. I actually don't know. I meant to check that. I might need to renew it. [He looks up at the inspection permit hanging on the wall.] Oh yeah, mine is expired [laughs]." Despite these legal codes and the officials who enforce them, it often becomes

the responsibility of tattooists to ensure sterility through self-regulation. Formal regulations do not actually affect tattooists' labor.

While zoning laws and health codes exist in different places, there are some areas that have neither for a tattoo shop. For example, in Anne Arundel County, just south of Baltimore City, there are no zoning or health codes. As Edgar explained, "Anne Arundel County doesn't have any laws at all. At all. You could hang a sign out front that says, 'Expert motherfucking tattoo artist, 28 years' experience' and get the box in the mail and, like, [know to use the] 'pointy end first,' I guess. And go to town on people." This has resulted in a cluster of tattoo shops operating south of the city but within the metropolitan area. While Edgar explained his position on the issue sardonically, it shows how some tattooists work in the absence of the state, when it becomes their responsibility to self-regulate.

Policing Deviants: Managing the Threat from Scratchers

The law is also something that established tattooists use to empower themselves over scratchers and shopless. Scratchers and shopless are a problem because they undercut the value of established tattooists' labor, siphoning away clientele. For a few weeks, Brenda noticed that several new clients arrived at her shop asking to get their tattoos fixed. She explained, "There's some local female tattooer in Dunnsville that's working out of her house whose—I got some new clients that came in, and I'm fixing her work. I don't know who she is or what she's doing or why, but she's definitely hacking people up, and that kind of worries me." Edward referred to them as "the kitchen magicians, the basement butchers," who are a poor reflection of the occupation. These kinds of experiences and definitions sustain the boundary between established tattooists and scratchers and shopless.

Established tattooists attempt to quell this threat by using their knowledge of health regulations. Technically, scratchers would be unable to obtain a certificate from the Department of Health because they would not have the business approvals from the zoning board or inspections from the Bureau of Ecology. Some tattooists in Baltimore City use this knowledge to report scratchers to authorities. However, the overburdened Department of Health largely ignores the problem. Generally, like Mike, tattooists were apathetic toward the Department of Health: "It's a fine line between legality and who is going to enforce it. No one, nobody is enforcing it. The Health Department says they want to crack down on such things, and you know I pay the Health Department yearly for my licensing. And you know, every time I go in there, they say, 'Well if you find out somebody is working out the house, give us their information.' Instead of them going out and actually doing any of the proper tracking down and stopping [it]." While there are legal restrictions, these seem to only apply to licensed tattoo shops. Scratchers continue to operate across

the city with impunity. For those working in shops, it is necessary to have legal paperwork entitling them to tattoo. Reporting scratchers to authorities is a tactic that often yields few results.

Resistance, Law, and Marginality

A final type of legal consciousness among tattooists involves resistance to legal codes. This consciousness occurs when people cannot work within the legal framework and must make do with whatever resources are available.[35] This often entails working outside of the legal code to overcome inequities of power in the design of law. For tattooists, resisting the law emphasizes a justness or fairness that could not occur under the current legal framework. This justness or fairness is part of the code of tattoo work. Tattooists and support personnel engage in behaviors that insulate their world from outside influences, such as law, ensuring its independence.

Rumor and the Protection of Business Interests

One way tattooists resist the law is to employ an artificial legal code. This is a tactic of deception and dependent on the naïveté of those unfamiliar with the law. Shop owners often discuss the difficulty of opening shops. This narrative frames the process of opening a shop to fledgling members, stating that it is nearly an impossible task and thus discouraging the newly socialized from opening their own businesses.

Zoning was restrictive, but there is a pervasive belief in the tattoo community that it was previously illegal to tattoo within the city limits. Between the 1970s and the late 1990s, only one shop operated within the City of Baltimore. Many tattooists believed it was illegal to open a shop within city limits, and the only operating shop existed because of a grandfather clause. Archival research of the Baltimore City Code and oral history tell a different story.[36] There was never a city prohibition or law preventing new shops from opening. This rumor was so persistent that most tattooists and tattoo collectors continued to insist that shops could not legally open in Baltimore City until the late 1990s.

George explained how he learned of the supposed grandfather clause for that one shop: "He got grandfathered in because he actually had that spot downtown before they changed it into the block and all that. That's how long this guy's been run[ning]; well, his shop has been around. So I was talking to the people down [at] the zoning [board]; they was like, 'Yeah, that's why he's the only shop down there. He got grandfathered in.'" This implies that the city, at some point historically, did not permit tattoo shops to open. Additionally, it places the blame for not being able to open on the city and its prohibitive government. While this story makes sense to tattooists, its

resonance relies on the tattooists' own misunderstanding of the legal frame-work. Likely, the owner of that shop created this rumor to protect his con-sumer base in the city and reduce competition. It was a form of resistance to existing laws that used rumors to mislead prospective shop owners.

By the late 1990s' tattoo boom, many tattooists began to view the city as an untapped market. Some queried officials about the possibility of opening within city limits. Despite the dubious rumors, they found out that open-ing shops within the city limits was not illegal; it was just an arduous pro-cess. Conrad claimed, "There hadn't been a shop, a tattoo shop, that had been opened in Baltimore City proper for a pretty long time. I think it may have been over 30 years. So no shops had been opened . . . because in Baltimore City, you have to, like, petition for a use and occupancy licensing for certain things." Once the first new shop opened, 16 more also opened their doors over the next decade.

This rumor was so pervasive that many tattooists stretched their interpreta-tions to infer that institutional gatekeepers intentionally denied tattooists the ability to open shops. In recounting his experience of telling others that he was going to open a shop, George claimed, "Most of the people [other tattooists] around there was like, 'You're not gonna get this permit.' I was like, 'Why? I already did the groundwork, found the right zone and everything.' And they were like, 'The city just don't give out permits for tattoo shops.'" Despite the actual legal code, tattooists' frame of reference from the rumor became their collective reality. Mike, who opened a shop within city limits, explained, "They [tattooists] were open [operating] under the guise that it was difficult [to open a shop], the zoning board wouldn't allow any. It was just a misnomer that some of the tattoo people around town thought the zoning board wouldn't allow tattoo shops [to] open up in Baltimore City." This rumor enabled one shop to establish a monopoly of operation within the city, forcing all others into the surrounding suburban communities. Circulation of this rumor shaped the forms of action that other tattooists engaged in. It reveals how resistant legal consciousness becomes when embedded within the culture of tattoo work.

Forget the Official Codes

Even though there are health concerns about the practice of tattooing, it seems there is minimal risk of public endangerment. Tattooists have fostered a culture that values self-regulation and independence. In other words, tattoo-ists resist the law through their desire to be independent. This value system is a form of legal consciousness that involves tattooists trying to maintain inde-pendence from the state and modern capitalism. It leads to the formation of channels for action—in this case, self-regulation.

There is a lack of systematic regulation for tattooing in the United States. Several agencies have defined some aspects of tattooing, although there are no

official mandates. The Food and Drug Administration (FDA), the Occupational Safety and Health Administration (OSHA), and the Centers for Disease Control and Prevention (CDC) currently define the risks of tattoo work. Each has its own set of concerns, but none have tried to enforce a code. This results in a resistant legal consciousness among tattooists that seeks to avoid official forms of social control.

The FDA is primarily concerned with the types of objects used in the tattoo process, emphasizing a consumer-safety stance. Officially, it "considers the inks used in intradermal tattoos, including permanent makeup, to be cosmetics. . . . The pigments used in the inks are color additives, which are subject to premarket approval under the Federal Food, Drug, and Cosmetic Act. However, because of other competing public health priorities and a previous lack of evidence of safety problems specifically associated with these pigments, FDA traditionally has not exercised regulatory authority for color additives on the pigments used in tattoo inks. The actual practice of tattooing is regulated by local jurisdictions."[37] It further warns that "although a number of color additives are approved for use in cosmetics, none is approved for injection into the skin. Using an unapproved color additive in a tattoo ink makes the ink adulterated. Many pigments used in tattoo inks are not approved for skin contact at all. Some are industrial grade colors that are suitable for printers' ink or automobile paint."[38] These statements place the burden of safety on tattooists, consumers, and local municipalities. Aside from rare disease outbreaks, these claims imply those who make inks are unscrupulous in their choices of materials.[39] This backward logic presumes ink producers may unintentionally harm consumers. If this were the case, then more tattooists would be out of business. These statements send contradictory messages to tattooists and consumers. One the one hand, the FDA insists that tattooing is relatively safe, while on the other, it warns consumers of the danger of adulterated inks tattooists may be using. This exemplifies why it is important for tattooists to self-regulate.

The FDA further insists tattooing can be harmful and that it is the consumer's responsibility to reduce risk: "No specific FDA regulatory requirement explicitly provides that tattoo inks must be sterile. However, CDC recommends that ink manufacturers ensure ink is sterile and that tattoo artists avoid contamination of ink through dilution with nonsterile water. Consumers also should be aware of the health risks associated with getting an intradermal tattoo."[40] Despite the FDA's lack of control, those who make tattoo ink accept this burden on their own. Regardless of this, many tattooists, such as Edgar, already have immense pride in carefully selecting materials for tattoo inks. For Edgar, making ink involves an ethic of self-sufficiency and independence from formal institutions. His focus is on becoming a master of inks. He is concerned with knowing what will be going into peoples' skin. He ponders questions like, How long will this color last in the skin? Are there materials that could be

harmful in it? This work keeps federal agencies away from the occupation. As Edgar claims, "I just like to keep it low-key, you know what I mean? That's my whole everything about [it]; I just want to be low-key 'cause I don't really—I don't want to have that kind of public perception. I just want to make tattoos and make some ink; that's it." He bears the responsibility for producing inks that will minimize risks to clients and keep tattooing off the radar of regulatory agencies.

While the FDA does not regulate the machines, needles, and inks, some of the sterilization equipment falls under its regulations. This is because tattooists rely on machines and chemicals that are designed for the field of medicine. For example, the FDA must approve any autoclave, which is a medical device used to sterilize equipment. It also approves cleaning agents found in tattoo shops, like Cavicide or Madacide-1. To increase sterility, tattooists adopted these materials from the medical world, a world the FDA oversees regulations.

The CDC is primarily concerned with disease prevention. This means preventing the transmission of blood-borne pathogens (BBPs), such as the hepatitis B virus (HBV), hepatitis C virus (HCV), and human immunodeficiency virus (HIV). The CDC recommends training in BBPs to protect tattooists from exposure and to reduce the likelihood of cross-contamination. Again, there are no official requirements. This suggests the necessity for tattooists to self-regulate.

Only OSHA provides a formalized federal regulation for tattooists to protect them from workplace hazards. According to OSHA, "Employers who have employees with reasonably anticipated exposure to blood or other potentially infectious material (OPIM) are required to provide the hepatitis B vaccination series at no cost to the employee."[41] Employees are free to decline this offer if they submit the appropriate paperwork. Even tattooists vaccinated for hepatitis B can still contract other infectious diseases, such as HCV and HIV. No tattooists or shop owners mentioned this law during my data-gathering process.

While the FDA, CDC, and OSHA create various recommendations, it is clear the burden lies on tattooists to self-regulate. Of the 31 people I spoke with, all but 2 (the shopless 2) had BBPs certification. Many view this certification as an aspect of becoming a competent professional. As John Lee explained,

> So my blood-borne pathogen stuff, or CPR, or things like that—it's your responsibility as a tattooist to fucking know that shit. You have to know that shit. And I guarantee you, 90 percent of the people you talk to don't know what the fuck you're talking about when you say that. Do they know how volatile hepatitis is? How long can hepatitis live within that [points to the carpeted floor], on the ground? Six weeks! Am I going to get AIDS from this tattoo? I can say,

"Absolutely not." There's not enough blood transfer. AIDS is not … AIDS can't live out of a host for very long anyway. It's a weak virus. Hepatitis—six weeks on the floor. That shit is fucking bad news.

Later, he described the sense of pride he feels when others notice how conscious he is about the prevention of disease transmission:

> People always say to me, "Well, God, you use a lot of gloves." I say, "Well I just touched this, do you want me to touch you now?" Even though it looks clean, and it probably is clean, but I just touched that, or I got blood on my hand and I throw my glove out to go do something else. I'm glad people notice that when I'm tattooing. You're supposed to notice that; you should be noticing that. I go through 1,000 paper towels, I go through a shitload of gloves, almost as if I'm wasting 'em, but I'm not. 'Cause I don't want you to get sick from getting tattooed from me. My tattoo should be, like, for the rest of your fucking life, awesome.

As evidenced, established tattooists are constantly concerned with maintaining a sterile enough environment to tattoo. They understand this as a responsibility of the occupation, along with being knowledgeable about disease transmission. Most willingly take courses in BBPs, and many routinely take refresher courses. Being a competent self-regulating worker is part of the tattooists' worldview, and it is a form of resistant legal consciousness.

Not only do tattooists self-regulate, but embedded in their daily routines is the concern over reducing the transmission of diseases. For most tattooists, cleaning their workspaces is a ritualized activity, occurring multiple times throughout the workday. In discussing his cleaning patterns, Kevin claimed, "I always get there a half hour early just to sterilize everything that I use. Like, clean all my tubes and my piercing equipment and get all that stuff ready. I clean off my counters again. I clean off all my bottles. I clean off everything. It's basically just cleaning. And of course, at the end of the night, clean everything again at night. One cleaning after every tattoo I do, but basically, I want to give everything a wipe down and all." I mentioned how he was quite precautionary, and Kevin snapped back, "Yeah, 'cause if someone cross-contaminated one of my jars or something like that, it's like, 'Yeah, thank you, hepatitis.' I'm not saying it's going to happen, but I'd rather be safe than sorry." The activity of cleaning is a ritual in his day. Tattooists view sterility as a collective problem of the occupation. They are not oblivious to the past: the implementation of tattoo bans because of disease outbreaks. In this perspective, imprinted on the contemporary daily practices of workers is the history of legality around tattooing.

With little to no official standards, tattooists feel pride when they exhibit cleanliness. This pride refers to their own satisfaction in their efforts (personal, self-worth) and how others define their actions as dignified or morally

righteous (social). Kevin depicted personal pride or self-worth in the account above. In showing this kind of pride, Kevin defines his actions in terms of the code of tattoo work and fulfilling his obligations as a tattooist. Social pride involves interacting with other people. Importantly, it involves the social reaction of other people. Many tattooists reported feeling social pride when clients described the cleanliness of their shops or workspaces. Dorsey described this: "The highest compliment ever is when nurses and stuff that come in—and they won't always tell you they're nurses—but they'll get tattooed. Or they'll . . . scope it out first, and then they'll make an appointment. And you know, when they say, 'Hey this is one of the cleanest shops I've ever been in,' or, 'You're doing everything right,' and they know what to look for, so that is always good." This is social pride, which involves being able to show clients that he is skilled at keeping the shop and his work area clean. Feeling this sense of pride legitimizes self-regulation among tattooists. Tattooists are quite aware of the desire for cleanliness, and they have pride in taking the precautions to reduce the transmission of BBPs.

Scratchers and Illegal Tattoos

Tattooing tends to attract younger people. Historically, tattooists have managed the problem of youth hanging out in and around their shops. Many shops post signs stating: "You must be 18 to be tattooed." Usually, they refer to it as a shop policy or law for the naïve. For tattooists, this resolved the problems of haggling with minors and, more importantly, parental disapproval.

In the State of Maryland, only Baltimore City has a prohibition against tattooing minors.[42] Approved in 1953, this mandate prohibits tattooing minors, even if they are able to furnish parental/guardian consent. Regardless of this law, minors are still able to attain tattoos. This occurs because there is a large market of minors who want tattoos. Tattooists and shop owners tap into this market. Laws regulating the tattooing of minors are difficult to enforce, because tattooing occurs behind closed doors.

Tattooists employ resistant legal consciousness when they knowingly tattoo minors in the city. Frank, a tattooist in his mid-20s, told me his entire shop tattooed minors for several years: "They passed a law that we couldn't do 16-year-olds anymore. And that's what took a lot of our money. I say that because it took about $10,000 out of each of our pockets. Because those kids was pouring in here like that, they used to just get names [tattoos of names written in script]." They continued to tattoo minors until the shop owner informed them a new law prohibited the practice. Authorities were beginning to crack down on the shop owner, and he decided to scale back their activities. Ironically, by tattooing minors, this shop was providing that group of consumers tattoos by trained tattooists, who provided a safer, cleaner environment than shopless tattooists.

The unintended consequence of the prohibition of minors is that they must find other places to obtain tattoos. Usually this means locating shopless tattooists who are unskilled. For established tattooists, this poses a dilemma. Some employ a resistant legal consciousness to frame their behavior. The tenets of their occupation involve providing a safe, clean space for tattooing. Charles explained this dilemma and how he resisted the law:

> I felt so sorry for a group that came in. It was this old lady, and she brought two grandkids in. The girl got a tattoo, but the grandson couldn't get one, and they were just getting just their parents' names, 'cause their parents passed away, and the grandmother was paying for 'em. So I felt so sorry for the young guy, 'cause he wasn't old enough to get it done in the shop, that I gave him my address and stuff, and like, "After work, you can come past; I'll set up a little station in my living room, and I'll do the tattoo for you," 'cause it was just their mother and father's names.

The dilemma that arises is about providing a client with a quality service. Many believe that home tattooists are not capable of producing quality tattoos or they tattoo in less than sterile conditions. Though his actions were technically illegal, Charles chose to resist the law. This dilemma was about the morality of providing a memorial tattoo for a grieving son. Knowing how easily this teen could obtain a tattoo from a shopless tattooist, Charles viewed his resistance as morally necessary.

Summary

This chapter depicted different forms of legal consciousness among tattooists. Law both facilitates and constrains their work. Clearly, tattoo bans and zoning restrictions limit the spaces tattooists can carry out their work. At the same time, the general lack of oversight has facilitated tattooists' emphasis on self-regulation and independence. The experts—tattooists—create the rules of the game for the occupation. These actions occur because tattooists are active agents employing forms of legal consciousness. They show how tattooists subjectively understand the law and then structure their activities based on that understanding.

Merging the production of culture perspective with legal consciousness literature creates new insight in both fields. This moves the analysis of the relationship between law and cultural production to understand how the imprint of law is both a structure for action and a resource that cultural producers manipulate. Research on legal consciousness tends to emphasize the ways in which workers define and act upon grievances related to various forms of

exploitation.[43] While some tattooists expressed grievances, their form of organization does not rely on contracts that can be legally disputed. Instead, their experiences with the law involve contention with the state or community, who attempt to use the law to prohibit the craft, or the deployment of law as a strategic resource within the world of tattooing. Despite relying on traditions and a code of ethics, tattooists incorporate forms of legal consciousness into their labor.

5

Ties to Conventional
Institutions and Ideas

It's [tattooing's] the only form of human
expression we have left that has magic to
it. Everything else is just academic.
—Mike Bakaty

The quote above illustrates the value tattooists have for independence. It states
that tattooing has a special quality of being magical, separating this world
from other social spheres, which are merely academic. For Bakaty, tattooing is
magical because it becomes an escape from rational and scientific explanations
of the world. He puts tattooing in a special place, independent of other insti-
tutions or social spheres. However, as scholars have argued, art worlds do not
operate in isolation from other spheres.[1] Rather, they are often intertwined
or connected with, but not a product of, other social spheres. In contrast to
Bakaty's statement, and like other art worlds, tattooing intersects with other
social spheres. This chapter focuses on these overlapping boundaries.

Artistic Autonomy and Tattoo Work

When sociologists speak of *artistic autonomy*, they are referring to the uncou-
pling of art from religious institutions in capitalist systems. In particular, they
are depicting the historical transformation in which art, and its production,
stopped being controlled by religious institutions.

Sociologist Max Weber noted, "Under these conditions [of capitalism], art becomes a cosmos of more and more consciously grasped independent values which exist in their own right. Art takes over the function of this-worldly salvation, no matter how this may be interpreted. It provides a *salvation* from the routines of everyday life, and especially from the increasing pressures of theoretical and practical rationalism."[2] In this shift, art takes on symbolic value as an escape or refuge from the domineering forces of rationality and capitalism. This presumes a vivid and distinct boundary that separates art and artistic production from other spheres of social life.

However, as sociologist Anne Bowler has pointed out, art is not autonomous from other spheres.[3] To begin, she notes that there are markets for art—it has commercial value. For markets to exist, there must be systems to produce and distribute art. The organization of these markets influences the systems of production and distribution. Therefore, a clear boundary separating art from the economic institution in capitalist societies does not exist.

Moreover, she claims that as a commodity, art takes on new aesthetic values, often tied to status and power within the market.[4] In other words, class and status hierarchies, based on power, affect the production, distribution, and consumption of art. Therefore, we should view "art as a sphere always connected with but not simply reducible to other social spheres."[5] As a commercial art that has its origins in folkcraft, tattoo work is affected by other social spheres and processes, such as capitalism, politics, racial divisions, and gender dynamics. This chapter explains how these spheres intersect with the world of tattooing and their effects on tattooist's labor.

Art? Craft? Ties to Institutional Art

Over the past 35 years, many scholars have claimed that tattooing has increasingly become part of the institutional art world.[6] They argue this was the result of the Tattoo Renaissance, which began to occur around the 1960s. This narrative implies that tattooing was independent until this point. However, a critical analysis reveals that tattooing has had a relationship with institutional art worlds since at least the early 1900s in the United States.

Several early tattoo masters attended art schools.[7] The renowned Chicago and Milwaukee–based tattooist Amund Dietzel took art classes at Yale.[8] He is regarded as one of the old masters of tattooing whose style significantly contributed toward American tattoo aesthetics.[9] He was an avid painter, someone who continued to attend art classes through the 1920s, developing skill in both artistic and sign painting.[10] Dietzel was a legend whose art shaped the craft of tattooing for over a century.

Dietzel eventually met Samuel Steward (a.k.a. Phil Sparrow), whom he would mentor in the 1950s. Later, Steward mentored both Don "Ed" Hardy and Cliff Raven, two of the central figures of the Tattoo Renaissance. Art historian, tattoo enthusiast, and senior lecturer Matt Lodder depicted the continuity of imagery produced by Dietzel and Hardy. After analyzing two different skull and eagle paintings, created by Dietzel or Hardy, Lodder concluded, "This perseverance of tattoo designs through time is not a mere stylistic affectation. Tattooing is primarily taught by way of apprenticeship, with techniques and attitudes carefully and studiously passed down from old hand to fresh blood (it is irresponsible at best and impossible at worst to learn to tattoo well without the guidance of a careful mentor), and learning to tattoo by way of a hands-on apprenticeship with a well-respected tattoo artist necessarily remains a matter of pride in the industry. As such, design tropes (as well as flash and tattoo machines) are passed from master to apprentice."[11] These paintings share similarities in composition and subject matter, even though they were produced nearly 75 years apart from one another. Hardy's differs in that it shows influence from the southern California weirdo art scene. Lodder concludes that the continuity is because of the ways tattooing is passed on through apprenticeships. The difference between them reflects the aesthetic movements that Hardy and Dietzel were influenced by. This reveals that their tattooing was not independent of other art worlds, including institutional and pop art.

Ideas from the institutional art world can also be seen in tattooing from the early 1900s. Louis Morgan, a San Francisco–based tattooist, claimed that "tattooing is not low or degrading when practiced as art for art's sake."[12] Morgan claims tattooing can be "art for art's sake," a reference to the French saying, *l'art pour l'art*. This phrase emerged among aesthetic movements during the 1800s that claimed art served no other purpose than simply being art (recall Weber's understanding of art in capitalism). Morgan implies that tattooing, just like institutional art, has an intrinsic value separate from political, economic, or religious institutions. He is also separating modern tattooing from those spheres responsible for art that is low or degrading (or lacking artistic sophistication), such as tattooing practiced among "uncivilized" peoples and punitive tattooing. Such a claim—borrowed from aesthetic movements of the institutional art world—infers that the modern tattooist is a special type of practitioner who is involved in producing art.[13]

Another way the boundary of tattooing overlaps with the institutional art world is found among tattooists. For example, the British master Sutherland Macdonald, preferred the title of tattooist over tattooer. As a person producing art, Macdonald viewed himself as a professional and avoided labels that would associate his work with the trades. For him, the latter would place his

status alongside skilled craftsmen, and the former would define him as an artist.[14] Many American contemporaries of Sutherland made this distinction.[15] Some depicted themselves as professional tattooists, and others referred to themselves as professors of tattooing, such as Professor Jack or Professor Charlie Wagner.[16] These uses of language were not adopted by all tattooists, nor were they uniform, but they were an attempt to establish professional legitimacy based on the kinds of language used in institutional art worlds.

The use of this language occurred prior to the Tattoo Renaissance. Scholars assert this shift in language, from *tattooer* to *tattooist* or *tattoo artist*, demonstrated ties to art worlds, which occurred as a result of the Tattoo Renaissance.[17] Yet historical evidence indicates that tattooists were already using this terminology. It is entirely possible that many tattooists, just like Dietzel, trained in formal art and relied on tattooing as one form of commercial art to survive.[18]

In this study, 12 of the 31 participants had at least some art school training. Of those 12, 4 had attended postsecondary art school but had not completed a degree: 1 was currently pursuing an AA degree in fine arts, and 3 others had left school to pursue tattooing. Two of the participants attended specialized high school art programs but did not pursue postsecondary education. They believed their artistic background was sufficient. Only 6 of the participants had art degrees: 4 possessed AA degrees in an art-related field, 1 held both a BFA and an MFA, and another had a BFA and an MA. A total of 18 participants had some postsecondary training in art, though only 10 had completed their courses of study. This evidence shows that tattooing is not suddenly merging with institutional art worlds. Rather, tattooing has shared a relationship with institutional art worlds for many years.

(Re)Producing Social Order

A familiar narrative found in newspaper articles, and scholarly research, declares that tattoos are not just for bikers, sailors, the military, criminals, or (insert some other deviant group).[19] These narratives claim the meanings of tattoos rapidly changed as members of the middle classes increasingly adopted them from the 1990s into the 2000s. They imply that tattooing is tied to systems of stratification and that tattoos serve as symbolic markers of social class. Research shows that members of the middle classes adopted tattoo aesthetics and meanings that aligned with their own values and beliefs.[20] Tattoos were symbolic markers that reproduced their identities and class positions.[21]

This is akin to Tia DeNora's depiction of music in constructing identity and social order.[22] For her, music is not simply a cultural product of social organization. Rather, it is also a mechanism for creating order. Music frames emotions, bodies, identities, and intimate encounters for its consumers to act

upon. In this perspective, music can be understood as organizing perceptions of the world and the actions people carry out. This same logic can be applied to tattooing.

Tattoo consumers' identities are shaped by, and reproduce, the existing social order. This is because tattooists rely on social expectations, which shapes the form and content of their labor. In other words, the form and content of tattoos are tied to social expectations of consumers and producers. Some tattooists are keenly aware of how their work reproduces racial or class-based identities. Tattoos reflect the conditions of their production. Hence, they created tattooed bodies that are visual reproductions of the social order. The awareness of this demonstrates how tattooing overlaps with other social spheres.

High-Society Tattoo Fads

One way that tattooing has reproduced the social order is by reinforcing class boundaries. In the late 1880s and 1890s, Europe and the United States experienced a fad of tattoo consumption among elites.[23] Some of the earliest adopters in this fad included the Prince of Wales, Lady Randolph Churchill (and much later, her son, Winston), King George V and King Edward VII (United Kingdom), Czar Nicholas II (Russia), and Prince Henry (Prussia).[24] Elites paid much higher prices for tattoos, preferred the term *skin tinting* instead of tattooing, and had tattooists produce their family names, crests, monograms, symbols of wealth and status, scenes that depicted elite life, and animals. All these images represented their position in the system of stratification.[25] They were symbolic markers buttressing their positions and identities.

Some of these adopters attained tattoos from Hori Chyo of Yokohama and Sutherland Macdonald of London.[26] Multiple generations of families might travel to get tattoos from the same master. For example, over many years, several members of the British royal family visited Chyo in Japan.[27] Those who visited Macdonald's shop were treated to a luxurious studio located on Jermyn Street—a high-end shopping district for men.[28] A different kind of tattoo existed among elite consumers. It designated knowledge of the arts, ties to family lineage, the ability to visit tattoo masters across the globe, and leisure.

Around the same time period, the "father of modern criminology" Cesare Lombroso was examining tattoos among criminals.[29] For him, tattooing was a sign of atavism, therefore it should only exist among those who are insensitive to pain, such as criminals and other biologically inferior savages. In his depiction of the elite fad, he noted, "The taste for this style is not a good indication of the refinement and delicacy of these English ladies."[30] Even though he could not fully explain the elite fad, his comments reflect criminological knowledge about tattooing at the time and thus the significance of elites adopting a practice that was considered low class. It is evidence of tattooing overlapping with systems of stratification.

Like all fads, the enthusiasm for skin tinting among elites eventually faded.[31] Several changes coincided with the shift in taste. Most importantly, in the late 19th century, tattoo machines were created, and a new culture formed around their use.[32] Tattoos could now be produced more efficiently, since tattoos made by machines required less time and effort than hand tools and damaged the skin less. In a sense, the craft itself changed in a way that made it more difficult for elites to define tattoos as a form of leisure consumption. There were also broader cultural changes occurring. During the late 19th century, there was a rise in traveling circuses and carnivals. Scholars estimate that by the 1920s, there were hundreds of people traveling as heavily tattooed sideshow "freaks."[33] They made money from being ogled. This is representative of the narrative around tattooing changing. The overall culture in the United States and Britain began to define tattooing in terms of its deviance. The practice also declined in popularity among members of the military, especially sailors, who were once core consumers. Just after the First World War ended in November 1918, tattooists began reporting these declines. This led some tattooists to claim that military men had lost their masculinity and that they had become cake-eaters or sissies.[34] People's tastes changed, and this coincides with other societal changes that affected the occupation.

Of course, this decline would be short lived among servicemen. As the United States entered the Second World War, and membership in the military increased, tattooing once again became more widely adopted. Places like Hotel Street in Honolulu became hotbeds for the craft. Tattooists claimed there were thousands of servicemen visiting the legalized brothels, tattoo shops, or bars each day.[35] Such institutional changes (U.S. involvement in World War II and millions of young men joining the service) enabled tattoos to become more widely adopted. However, their adoption mostly occurred among those in the services.

Middle-Class Appropriation: Reclaiming a Familiar Symbol

By the early 1960s, tattooing was beginning to become more accessible. Tattooists such as Cliff Raven, Spider Webb, Jamie Summers, and Ed Hardy (who all had fine arts degrees) became the leaders of the Tattoo Renaissance.[36] They incorporated the aesthetics of contemporary art movements into tattooing. These aesthetics appealed to people from the upper and middle classes. Around the same time, the second wave of the women's movement was beginning to coalesce. One theme of this (largely college-educated and white) movement addressed control over the body—a characteristic of becoming tattooed.[37] Also, during this time popular icons such as Janis Joplin, Peter Fonda, Ozzy Osbourne, and Cher were known to be tattooed. Wider cultural changes made tattooing more accessible.

Accompanying these changes were new definitions of tattoos. They became countercultural symbols of resistance, claims over bodily rights, and marks of middle-class values and identities. For some, being tattooed stood for a countercultural resistance, which coincided with shifting political and social views. As mentioned, women adopted tattoos as a mechanism to claim control over their bodies. According to Lyle Tuttle, who tattooed Janis Joplin, the singer once took the stage and declared that "people who get tattooed like to fuck a lot!"[38] This inspired many women. Educated, middle-class tattoo consumers also saw an increasingly diverse array of tattoo aesthetics offered by tattooists that appealed to their tastes.

As more members of the middle and upper classes adopted the practice, they began to construct meanings in which their tattoos were marks of distinction.[39] Two discourses began to operate in the world of tattooing.[40] Members of the upper and middle classes attempted to control the production of knowledge by distributing a discourse in tattoo magazines that reflected their position. It stressed that tattoos were an art form and legitimated upper- and middle-class tattoo wearers by placing them in opposition to these of the lower or working classes. This binary is further evidenced by claims that tattoos are not just for bikers and sailors anymore. Among tattooists, this discourse produced a division between those with art school backgrounds and those without them.

By the 1990s and 2000s, it became clear that tattoos produced on middle-class consumers reflected their own cultural logics and identities. These consumers legitimized their tattoos by choosing designs that were symbolic representations of their values or beliefs.[41] This distanced them from the deviant other. Tattoos also became a way for middle-class men to reclaim their masculinity.[42] Suffering from a presumed loss of status that occurred during the cycle of rights movements throughout the 1960s and '70s, middle-class men in the '90s and 2000s, reaffirmed their status by adopting working-class symbols, such as tattoos. Both of these examples reflect a class-based consciousness about identity.

Cumulatively, the effect of the Tattoo Renaissance was that tattooing became more accessible, increasing its diffusion among social classes. A new consciousness emerged because tattooists exposed a wider audience to the practice. Consumers also found ways to distance themselves from the assumptions and stereotypes that associated tattoos with the lower classes and tattooing's troubled past.[43] In this way, other social spheres—class dynamics—are related to tattooing.

The Reproduction of Racialized Bodies
and Systems of Segregation

Studies addressing changes in tattooing overemphasize a dominant white perspective. Few studies have accounted for the racialized dimensions of tattooing, and no research has depicted tattooing as a practice for reproducing a racialized social order.[44] Some tattoos produced are ideological symbols that identify, classify, stereotype, organize, and reproduce racialized bodies.[45] Tattooists make aesthetic decisions based on presumptions about their clients' tastes, available material rewards, resources, symbolic rewards, and position within their social world. These become a set of constraints that limit the form and content of tattoos. By limiting aesthetics, some tattoos become marks to reproduce racial order on the physical body.

In one of the earliest efforts to depict ethnoracial differences among tattoos, anthropologist Alan Govenar documented how the political, economic, and cultural constraints affected the types of tattoos produced among Chicanos in the urban barrio during the early 1980s.[46] For those lacking financial resources, amateur hand-poked tattoos were produced. The imagery in these tattoos was often familial or religious (pachuco tattoos), reflecting strong ties to both institutions. For those who could afford professional barrio tattoos, the traditional rules of tattooing were violated as tattooists innovated. These tattoos were created using a single needle point instead of a needle grouping and were characterized by their depth of shading, monochrome color palette, and realistic imagery. The barrio tattoo resembled its conditions of production, ultimately reproducing the Chicano barrio identity.

A similar process occurred in Baltimore City. Black tattooists, whose consumers are largely urban and black, worked under quite different sets of political, social, and cultural constraints than white tattooists. Not only did black tattooists disproportionality work in economically depressed areas, but they faced political struggles within the world of tattooing, which excluded them. Their tattoos are a racial project that reproduced racialized bodies and identities.[47]

Aware of the racial demographics in Baltimore, I presumed that I would meet black tattooists. Yet in shop after shop, I noticed most tattooists were white men. I began asking trusted informants if they knew of any black tattooists. The mostly white tattooists responded with bewilderment and the occasional sneer. One even sarcastically responded, "What, are you starting some kind of a comedy routine?" Many insisted black tattooists did not exist in Baltimore unless they were scratchers. Eventually, I met Billie, who helped provide me with access to black tattooists. She told me there were two shops in the city and one in the suburbs that primarily employed black tattooists. After meeting these tattooists, it became clear that their work was tied to the systems of politics, race, and class operating within the city.

Billie suggested I find George, one of the more established black tattooists, who owned a shop that catered toward an urban, black clientele. In George's shop, everyone is black, with the exception of George, who is a multiracial, first-generation immigrant from the Caribbean. Upon meeting him and those he worked with, it was clear that client expectations constrained their work. George told me, "The bread-and-butter stuff is hearts, roses, rest-in-peace designs. There's always somebody getting capped up or [who] died, or they want their rest-in-peace design, angel wings, and that's pretty much the basic [tattoos]. And names, you're always going to be doing names, no matter or however you slice it . . . We're in a black neighborhood, ain't nobody coming in here wanting any Japanese stuff." Consumers have specific expectations from their own experiences of what a tattoo ought to look like. They often reference the types of tattoos seen on their friends, family, and acquaintances when deciding on their own tattoo designs. Much of George's tattooing—memorial tattoos, cursive names, hearts, and roses—reflects the political and economic circumstances of his clientele, subsequently reproducing urban, racialized bodies. As he states, nobody is demanding Japanese-style tattoos, an aesthetic associated with tattoo collectors who study Japanese art and who are often from the middle and upper classes—and largely, white.

The taste and financial limitations of clients is a constraining force for these tattooists. Often, they make decisions about their work that appeals to consumer's tastes. This means appeasing clients and not the world of tattooing. George continued,

> Most of the people that we're catering to, they don't have money . . . When you work in a city environment, and you work—I gotta use the word *hood*—you work in a hood-type environment, your clientele base is different. Also, it structures your tattoos differently. Like the biomechanical-type stuff, or a lot of the skulls and stuff like that, we're not doing that shit here, man. They're not into that type of stuff. So your clientele is totally different. Like some of the stuff that I really want to do as an artist, I won't be able to probably do 'cause my clientele base is different . . . It [the market] structures the way your work is done and the type of tattoos you do.

When George describes the neighborhood, he is depicting the outcome of residential segregation in Baltimore. For him, "hood" tattoos reflect decades of redlining, wealth inequality, and residential segregation. Tattooists working in this environment receive limited material rewards and are constrained by the aesthetic decisions of their clients. By producing aesthetics that do not appeal to a wider array of clients, these tattooists shape the urban black body and its identity. As symbolic forms, these kinds of tattoos are discursive projects that reproduce racialized bodies and identities.

Many white and established tattooists devalue this urban aesthetic. Even Elaine, a white tattooist who works in a shop that caters toward a mostly black clientele, admits this aesthetic does not appeal to her. In explaining the kinds of tattoos she tends to create, she claimed it was based primarily on "A lot of Boog flash. A lot of Chicano flash. Like pretty much what we have up there [*points to a large rack of Chicano and script flash*]: the 'laugh now, cry later' faces, half-naked black girls with big boobies, pit bulls, just that kind of thing. I don't know what to call it. It's just kind of gangster." She depicts the aesthetic consumed by her clients as different from mainstream tattooing. The "laugh now, cry later" faces she referenced can be traced to the legendary fine-line tattooist Freddy Negrete, who, along with Good Time Charlie and Jack Rudy, was central to the growth of the East LA tattoo scene—which was urban, Chicano/a, and featured prison-style aesthetics.[48] Elaine distances her identity as a tattooist from these kinds of tattoos. She views herself as a traditional American tattooist who needs to work her way into a different shop, and that she is currently working to build a portfolio.

Among white tattooists, those producing this urban aesthetic represent a tattoo outsider, or other. Edgar poignantly describes how race and the urban, black aesthetic have become a site of contention within the world of tattooing: "It is reflected in kind of having like an underclass of tattooers out there. There's an effort being put forth, or production being put forth by—I can't remember the name of thing, but that's their focus. Their focus is like, 'We're the urban tattoo convention' so it's like, it just, it sounds weird to me because they want to say black, but they can't really say black. And so it's—the way I read it or interpret it is that it's just another way to distance yourself from something else rather than be all-inclusive and solid in tattooing." Edgar's statement reflects his position of racial privilege within tattooing and Baltimore. In this position, he has considerable contempt for those attempting to produce aesthetics that the wider world of tattooing does not value. Edgar does not even recognize the domination white tattooists tend to have over this world. What is at stake involves control over aesthetics.

This concern over aesthetics is further evidenced in John Lee's description of working at his former tattoo shop: "That shop, when we were there, it was 90 percent black people, the whole neighborhood is black. There's five white guys, and they work in that shop. So everybody [the consumers] is black, and the subject matter was pretty hip-hoppy. Lots of guys want their hands, the necks tattooed, which we would not fucking do." For John Lee, there is a clear symbolic difference between mainstream tattooing and the aesthetics desired by black clientele. His account devalues the labor of those who produce tattoos in the urban or black aesthetic. In John Lee's perspective, these aesthetics violate the rules of the craft.[49]

Tattooists working in these shops grapple with this as a constraint on their careers. By producing these aesthetics, they become outsiders among established tattooists, creating a racial divide within the occupation. Frank has experienced this multiple times in his search for work at shops run by established white tattooists. He claimed, "You run into racism. Now it's not that heavy, but you do run into it. I've ran into it several times . . . because I've heard, 'We're not looking for your type of artist.' Or, 'We're just not hiring,' during the season when there's like thousands of people that work there, and [there] was a 'help wanted' sign, and they would be like, 'No, we're not looking for help anymore.'" Regardless of Frank's skill, the financial constraints of those he tattooed and the aesthetics in his portfolio limited his career. Inevitably, his portfolio appeared as nothing more than urban, ghetto, or gangster to established white tattooists. When they evaluated Frank's portfolio, their assessment did not account for this context of production.

Tattooists, who produce these aesthetics feel excluded from the mostly white-dominated tattoo world. As Billie exclaimed, "I'm like, 'How come we can't get the same recognition that Caucasian artists get?'" As evidenced, the material and symbolic reward systems for black tattooists are not equal to those for white tattooists. This coincides with the historical processes of residential segregation. This separation is tied to the larger social forces that divide people by race and class across the cityscape.

Breaking the Glass Needle: Negotiating Gender

Gender surfaced in the world of tattooing in two distinct ways. First, it involved the creation of tattoos that reproduced distinctly gendered bodies.[50] People understood tattoos as a symbolic resource for the wearer and their identity. Tattooists described making conscious decisions to ensure tattoos would aesthetically align with their understanding of gender performance and client expectations. Second, among established tattooists, females reported gender discrimination, from both customers and colleagues, as an added constraint. However, they also noted that being female provided some advantages when interacting with clientele. Overall, there is a dearth of research that examines the significance of gender within art worlds, and when scholars of tattooing do focus on the subject, their work turns to the consumers and their resistance.[51]

Among male tattooists, it was clear the consumer's gender influenced the process of production. Several of them reported designing images for female clients that were softer, cuter, and brighter than those intended for men. Tim even stated, "With women, for me early on, it was kind of easy to assume that all women wanted nice, feminine, soft things. So your mind kind of goes there when somebody says something. Now I just ask them, 'Do you want this like, girly?' or 'Do you want it like, more aggressive looking?' 'Do you want it to

be like, cute and soft?' and I'll ask guys the same thing." Tim produced tattoos that reinforce a person's gender performance.[52] This knowledge is a constraint but also a shortcut based on stereotypes about gender. This shortcut facilitates Tim's work by allowing him to cater to the aesthetic desires of clientele. While he might not always be correct, he does structure his labor around the kinds of aesthetics that he expects will appeal to different genders. This is learned through experience working with clients, and it enables tattooists to eliminate potential avenues for action that might be poorly received.

These assumptions about gender are not particular to the world of tattooing. Rather, tattooing is influenced by the system of gender and its social expectations of gendered performances. When asked how he determines the kind of tattoo a person wants, Joseph responded, "The young college jock is probably gonna want some sort of tribal tattoo. Or again, something that's going to be a little bit more masculine or sports oriented or something like that. Where the younger female is gonna come in and she's going to want the flower/ribby thing on her ribs, with little squirrels and stuff like that just to kind of pretty it up." Later in the interview, he claimed,

> Women, most women, always want that cute, small-as-possible, cute, fancy, "is this gonna make me look sexy?" tattoo. Whereas the men are gonna want that hard, aggressive, masculine tattoo. It's very rare that I'll do something soft on a man. Not too many men will get a full sleeve of flowers, per se. Even though there's nothing wrong with it, and I think it would look really good and masculine; it's just a lot of men just don't think that way. They want to be the tough guy and wear the tribal and the skulls and stuff like that.

Designing a tattoo that is too feminine or masculine could lead to additional work if it does not meet the client's expectations. These kinds of shortcuts facilitate the production of tattoos. At the same time, they also reproduce gendered and sexualized bodies. Tattooing, and the aesthetic decisions tattooists make during the process of production, are influenced by expectations of gendered aesthetics and performances.

For the men in the study, conversations about gender or how being male affected their work never occurred—a privilege attached to their status. However, all the women interviewed mentioned the significance of their gender. Often, they described being treated differently when interacting with clients and other tattooists. Brenda, the most educated and established female tattooist interviewed, was also the most outspoken about this:

> The one obstacle I've seen the most is just being treated with the same level of respect as a male tattooer. Or even with clients—like, you come in, and you're sitting at the desk, and they just automatically assume you're the receptionist

if you're female working in the shop. I don't know how many times I've seen people look through the portfolios and be like, "Oh, which guy did this?" It's like, "Oh that's Brenda's." And they're like, "Oh, really." [*dramatically makes a contemptuous face and turns her head the other way*]. Or you see one person, you see another tattooer look at someone else's portfolio, and it's a guy's, and they'll be like, "Oh, it's great." Then you see them look at a female's portfolio and find out she's a female, and they're like, "Oh, she's OK." So I see that on and off, and that's in the art industry, the same way, but not as bad as the tattoo industry, that I've experienced. So I think there's a little bit—I think females actually have to work a little harder to prove themselves and gain respect in the shop.

For Brenda, being female affects the amount of respect garnered from clients and colleagues. Respect is a reward that affects careers within tattooing. All the female tattooists interviewed reported they had to pay more dues than their male counterparts.

Female tattooists not only navigate the constraints of the world of tattooing but also carve out a space in a male-dominated world. Brenda explained,

The person they rag on most is the chick. If she's having a bad day, it's like, "What are you going to do, cry now?" It's like, why do they always assume every female is gonna go cry in the corner when they get upset? I got a lot of that when I first started working. Where they'd push you, and push you, and try to make you cry. Just to see you cry. I just think that's so silly. I mean, yeah, you need to rise to the level of people just fucking with you, because that's just kind of the way this industry is. Like, you have to be tough, and you can't let people walk all over you, and you have to stand up for yourself. So I think that sometimes females get, get extra shit just because of that, because the males are trying to see if they [females] can fucking hack it, see if they can fucking hang. So you see a lot of that too, and it's important, if you're female and you're in the industry, to not break down, stand your ground and not give in to the bullshit, and hold your own, and prove that you're not this whiny, sensitive little girl [but that you] can hack it in a tattoo shop.

Brenda's outspoken nature on gender within the tattoo shop shows a remarkable degree of resilience. Her experiences and depictions of working in shops were similar to the ways that female tattooists spoke of their labor. These women show not only this resilience but also a degree of resistance toward the cultural expectation of the tattooist as a male and the domination of this social world by men.

When interacting with clients many reported being female provided them with both benefits and drawbacks. On the one hand, clients discredited them, and they faced overt sexual harassment. As Brenda described it,

I've had clients tell me they are only interested in me tattooing them because they wanted to look at my tits. So that was interesting. I've had people, very loyal clients, refer me to their friends [saying], "She's a female." And several of them were so, I guess, narrow minded in their view of women tattooers and artists that they actually refused to get tattooed by a female. The minute they recommend, "Oh I have this great tattooer, and they do really good work. It's the best work on my body and you should really go to them. They've got good prices, and great shop, and she's a female." "Oh, she's a female? Well, I don't want to get tattooed by her." I've heard that one a lot. Yeah, so it's like that kind of sexualized stigma that women have always had to deal with in one way or another.

Female tattooists noted that some clients treated them as if they were not as skilled as their male counterparts.[53] This devalues their labor and constrains their productive capacity.

Some mentioned that being female also provided them with opportunities the males did not have. Being female tattooists endowed them with qualities, characteristics, or abilities assumed not present in their male counterparts. Elaine viewed being female as a characteristic facilitating the recruitment of clients: "I think it gives me, most of the time, an advantage dealing with clients. 'Cause I think women see it as, 'Oh, it's a girl tattoo artist.' So they feel more comfortable with me. Then I think some men find it interesting: they're like, 'Oh, I want that chick to tattoo me.' It's like almost a novelty kind of thing." Multiple people reported the same interactions with clientele. Margaret and her colleagues had discussions about being female:

> I think it opens me up actually to clients. Paul, one of our tattooers here, he says, "You know, it's a win-win with being a woman. Women are more inclined to be with you [choose you as a tattooist], and men are more inclined to be with you." A male just feels more at ease. They don't feel like they're competing ego-wise or [in] intensity. They feel a lot more comforted by being tattooed by a woman. Even if you're pushing just as hard as somebody else with a tattoo machine, they feel like you have a lighter touch. So it's nicer; they're more relaxed. With women, they're more inclined to expose body parts to you; they feel more comfortable.

Gendered stereotypes provided female tattooists with an advantage around some clientele. They also mentioned that other tattooists would be the ones that held the women back. Despite the value clientele may associate with their work, it is presumed the world of tattooing would hold them accountable for being female.

Often, female tattooists were tasked with clients who had been labeled troublesome by their male counterparts. Becoming troublesome occurs when a prospective client shows undesirable characteristics or traits in the eyes of the

tattooist (i.e., indecisive, uncomfortable, asking too many questions, uncertain, wanting images redrawn—behaviors that complicate the tattoo process). Male coworkers often passed off these troublesome clients to Brenda: "[Some] people are really uncomfortable with men tattooing them, or whatever their personal reason is, and they prefer someone who may be more calming, more nurturing, or [it's] just that they prefer a female tattooing them. Maybe because their husband or her boyfriend doesn't want a man tattooing them, or maybe they've not had good experiences with aggressive male tattooers in the past, so they actually prefer females." Despite being given the troublesome clients, being female can be an asset in pursuing an occupation in tattooing. As Brenda indicates, she appeals to clientele who are uncomfortable or unwilling to be tattooed by a man. This demonstrates the significance of gender performance as tattooists interact with clientele. Importantly, this world is not completely separate from other social processes.

Crafting Identities

Tattooists are also concerned with how their labor produces troubling or problematic identities in other spheres. They are preoccupied with how their work may affect someone's life trajectory. For many, it is an ethical value they consider when working with clients. This means avoiding placing tattoos in highly visible places (such as on the hands, neck, or face) unless the client is already extensively tattooed and avoiding tattoos that clearly convey or celebrate deviant beliefs or associations (Nazi symbols, gang imagery, harm to others). They refer to these as job killers, invoking the stigma associated with any kind of tattoo that discredits the wearer and cannot easily be covered.[54] This perspective is developed from the occupation's collective past experience with these types of tattoos. Tattooists attempt to shape clientele decision-making to avoid having to produce these kinds of marks.

I once asked George if he worried about how others reacted to his client's tattoos. His primary concern was facial tattoos: "I really don't condone facial tattoos. Morally speaking, that's kind of like a catch-22 for me. That is where I probably would say, 'I'm just doing it for the money.' But as far as you're an adult and if you want to tattoo your face, that's your prerogative to tattoo your face. But mainstream America has not accepted people tattooing their faces." I responded, "What is the moral dilemma?" George continued, "I know at the end of the day, you ain't getting hired on no regular job with a tattoo on your face. I'm thinking to myself, 'I'm messing up this guy's life' . . . We're still not accepting people that look a certain way. We're not ready for that yet. So even though I do the tattoos, in the back of my mind, I'm like, 'Well this dude is just jacked up.' Like he ain't going nowhere, he might be working in a warehouse or something for the rest of your life, man, unless you've got your own business or something."

As George continued, he became remorseful, speaking in a subdued voice with a slower pace, elaborating his own experiences with a specific memorial facial tattoo:

> It's just the facial stuff that I got issues with. And probably sometimes the content of what they decide to get. Like, there's this younger guy I did a tattoo for, and he was of legal age to get a tattoo, but I know he's young, and he's making a bad decision. He wanted me to [put] four bullets, hollow points, coming down his face. Now this was some stupid shit. Four hollow points on your face, dude. Now his reason for this was weird. His friend got shot four times. So he decides he wants to put four bullets coming down his face. So I tattoo the four bullets on him. And a couple months go by and I'm driving, and I see the guy walking down the street, but he's dressed up. Now this guy, from the couple times I've seen him, was never dressed up, always in street clothes. He was dressed up, he had a little shirt, a tie, so I knew something was up. So I slowed down to ask him, and I'm in my car, and I'm like, "Hey. What's going on? What's up man?" It's like, "Yeah man, I got a job interview." And I'm laughing in my mind, 'cause the funny thing about it was he had a Band-Aid across his face. He had a Band-Aid covering—like, it was so obvious that he was trying to cover up the tattoo.

The moral dilemma for George was about producing a tattoo that would stigmatize his client. While the client sought him out to produce this tattoo, George still carries the burden of knowing he was the person who produced this memorial tattoo. By producing the tattoo, he knows he has harmed the client's long-term potential. People discussed this issue in every shop I visited. Tattooists were concerned with how their labor might affect their consumer's identity in a way that that would significantly alter that person's life trajectory.

The concern for producing highly visible tattoos demonstrates that tattooists understand their clients as possessing a future identity. Tattooists are preoccupied with how tattoo decisions may affect a client's future identity in weeks, months, or years. Even tattoos that represent the kinds of characteristics people celebrate in the contemporary United States (like love) are met with suspicion. For example, some tattooists caution against creating tattoos of a partner's name. This concern is magnified when relationships are new, the people involved are young, or the tattoo is in a highly visible location. Nevertheless, a quite common tattoo involves the name of a lover or something to represent that lover. Joseph explained his concerns:

> The only thing that I would try to shoot down is, say, if someone young wants to get something dedicated to their boyfriend or girlfriend of three months. I did this a lot, and I used to get in trouble with some of the other shops by turning

work down, 'cause some 18-year-old kid wants to come get his girlfriend that he's only known for three weeks on his neck. I refuse to do it. I think that's a bad move . . . Well, the way [I] look at it is, "Fine, I don't have to live with that. I didn't potentially ruin this kid's life." Not only is he super young to have a neck tattoo, but chances are, you're not gonna be with this person forever.

Like many tattooists, Joseph recognizes how his tattoos may affect his client's future. In this case, there is a fear that the tattoo will produce an identity that does not align with the wearer's romantic interest forever. Supporting Joseph's understanding is folklore among tattooists that implies that name tattoos are evidence of a failing relationship or the precursor to a relationship's end. Joseph's concern is about how that tattoo might shape future romantic relationships.

Some tattooists report having to talk people out of getting specific tattoos, or refuse service, because of location or design choices. They are wary of producing images that are offensive or damaging and that can harm the future identity of the wearer. Also, they fear that they themselves could develop a reputation for producing those images, which could bring trouble to their lives. For example, being known for producing gang tattoos is likely to draw more gang members to your shop. Brenda explained to me,

It's one thing to appropriate symbols, but if you don't know where the symbols come from, and the context in specific settings, it can get you into a lot of trouble. Like, if you ever get locked up. I try to tell people this. I'm not saying you might get locked up, but you never know what happens in life and if you're going to be in a certain situation. You don't want a swastika on your chest, or you don't want a spider web with a black widow in it, because you're not a white supremacist. Maybe you're of color—do you want that on you? I mean that could get you not only beat up on the street; it could get you killed in prison, or it could get you attacked by someone else. Someone else could see that and be offended and jump you. So it's stuff like that you have to consider [the] meaning [of] and why you're putting it on you. Certain tattoos in many situations can get you in a situation that you really don't want to be in. And then that's like a brand in life; it's not like you can just get rid of it.

Notice the shift in language from "tattoo" to "brand in life." Central to Brenda's depiction is an understanding of how a tattoo can become a stigma that shapes future identities across social spheres.

A few minutes later, Brenda returned to the topic of tattoos designs or locations having a negative effect on a novice client's life. She claimed that tattooists have a moral responsibility to steer novice prospective and current clients from harmful tattoo choices:

You don't want to give somebody a tattoo that might prevent them in the future from doing whatever they need to do. So you've gotta feel them out, like, "What you going to do for your profession? Do you have any ideas? How heavily tattooed you want to be?" There are social consequences and stigmas that exist that can affect your life indirectly and maybe you just don't understand and you're not old enough or mature enough to rationalize these decisions. So it is the tattooer's responsibility to say, "Hey, I'm not going to put that on you right there because you don't know where you're going to be in 10 years, and I'm not going to carry that burden around with me, 'cause that's not cool. I'm not going to give you a tattoo that means something that could get you in a bad situation." It's not just about you and making money. It really does affect them in a significant way. So you have to have the moral responsibility, I think. I mean, some people [tattooists] will throw anything on you, and they don't care. They don't give a shit, but I certainly do. I don't need that karma coming back to affect me in any way.

As she elaborated on why she would turn clients away, she depicted how tattoo choices may lead someone into future deviance. The novice client may not fully understand the social stigmas surrounding their tattoo choices. Brenda and many other tattooists who refuse this type of work tend to frame their reasoning as a moral decision. They bear the burden of marking another's body, and the marks they make may significantly alter a person's life course.

The responsibility tattooists place on themselves for steering client decision-making demonstrates how aware they are of normative expectations for the body. The world of tattooing does not create these social expectations. Instead, the cultural values belonging to the wider society permeate the world of tattooing. It becomes a constraining factor on the content of tattoos and where people choose to locate them on the body. Tattooists are quite conscious of how these factors may affect a client's future identity in other spheres of society.

Summary

This chapter examined how tattooing is tied to other spheres of social life. It is not a completely independent world. Rather, ideas and practices in other spheres influence the world of tattooing. The institutional art world, systems of racial segregation, class stratification, and gender discrimination all affect the decisions and activities of tattooists and their clients. The result is that tattoo choice, aesthetic, placement, and design, do not simply belong to the social world of tattooing or the individual. Rather, larger social forces weigh upon the decisions of cultural producers and consumers.

Moreover, this chapter shows many tattooists' commitment to conventional beliefs and values in the United States. They are clearly concerned with

the types of identities their labor produces. Their comments about the profound effect a tattoo can have on someone's identity and conception of self illustrate this. They adhere to the American dream by recognizing how tattoos they produce could inadvertently harm someone's life trajectory. These concerns are about how the presence of tattoos affects someone's freedom and the accumulation of property.

6

Sources of Contention

A question often asked in the shop by those unaware of the treacherous undercurrents and byzantine workings of such a world was: "Do you guys have a union?"

Such a question always amused me. To think there could be any common basis of agreement or co-operation established among a crew of cut-throat operators, jealous "artists," and fiercely independent artisans would be as impossible as trying to get all American doctors to charge only twenty-five dollars for an appendectomy. In the tattoo jungle there could never be any trust established among them. Each is a little world to himself, convinced he is the best of all, that his techniques outshine all others, his machines are the most efficient, his flash the absolute best, and his work the most enduring, colorful, and effective.
—Phil Sparrow

Tattooing is easy to do badly, difficult to do well. The personal experience of the tattooist is of enormous importance, and so is the collective experience from other tattooists, past and present, from whom one learns habits and methods which are valuable, and tricks, short cuts and failures which must be avoided if the highest standards are to be maintained.
—George Burchett

The quote from Phil Sparrow (born Samuel Steward) above implies that tattooing is an isolated type of work—that tattooists work independently of one another, rarely interacting or exchanging ideas because of their egotistical worldview. His statement ignores his own experiences. In the same book this quote is drawn from, he documents how he learned to tattoo from Amund Dietzel, interacted with clients, and attained tattoo equipment from others.[1] In a world with few formal rules, his comments reflect the problem of social organization and managing change.

Approaching the problem of social organization from another perspective, Burchett's statement illustrates a different interpretation. His reflects the interdependence necessary for tattooists to carry out their craft. He claims tattooists are reliant upon the cumulative knowledge they share—their collective experience. Predecessors negotiated this cumulative knowledge, and it reveals the deeply held cultural traditions of the occupation. Contemporary tattooists are merely standing on the shoulders of giants. This helps their work because there is an established system of practices.

One way to understand how tattooists sustain their social organization is through the rules of the game. Tattooists generally agreed upon these rules as the way to do things.[2] The rules facilitate cooperation between tattooists (and other workers), providing some degree of stability and order. However, they are also a source of contention. Since these rules are not fixed, nor written and stored as part of institutional processes, they can easily be debated, altered, forgotten, and even changed over time. Regardless of what the rules of the game are at any point in time, tattooists must navigate those rules to carry out their work. Both the Steward and Burchett quotes above depict their experiences negotiating the rules of the game.

Since tattooing lacks strong professional associations, formal organizations, and legal restraints, it should be highly susceptible to change. However, the occupation is in fact resilient and slow to change. This is because tattooists have rules that are rooted in tradition, and they are socialized to these rules through their predecessors. In other words, action is predicated upon habits and traditions or ways of action that become ingrained patterns of doing.[3] These rules are not static and are subject to negotiation as tattooists adapt to change. This chapter examines how tattooists experience and negotiate sources of contention around defining, producing, or reproducing the rules of the game and their social organization.

Craftsmen, Artists, and the Old-School Ethic

One source of contention occurs between craftsmen and artists. It involves their different orientations toward work, values, and reward systems. Recall from chapter 1 that craftsmen value traditions, or the established methods or ways of

doing things. Artists value creative freedom and challenging the limitations of tattooing. Craftsmen and artists do not have the same orientation toward work. The contention between them is about defining the rules of the game.

Throughout the 1990s and 2000s, more trained artists sought out tattoo work. Possessing an understanding of artistic capital, they were aiming to push the boundaries of tattooing to gain artistic capital. This resulted in the emergence of several new aesthetics (photorealism, realism, biomechanical, trash polka, watercolor, neotraditional/new school) and techniques. In producing these new aesthetics, artists sometimes negated existing knowledge about tattooing, violating the rules of the game that craftsmen value.

Craftsmen claimed these new fine art tattoos were not technically competent. They believed artists ignored the conventions craftsmen value. Craftsmen claim their methods and techniques are superior because they have stood the test of time. Conrad described this issue as it related to interacting with clients:

> There might be some things in tattooing that are becoming more popular that, like, tattooers don't always agree with. I have to give you an example. It's like, it's become really popular in the last two years for, say, colored portraits, and people get the really detailed colored portrait–type stuff. Which, those kind of tattoos really don't make very nice tattoos. They just don't hold up technically. Like technically, as a tattoo, they don't hold up as well as something that has like a nice bold black outline and is visible from 10 feet away and will last for 40 years, looking like what it's supposed to look like. But people [consumers] really love the color portrait stuff right now.
>
> So the obstacle is that someone comes in [to the shop] and says they want a color portrait ... We're not going to compromise our integrity to do something just because we want to make a buck off of this person who wants a color portrait, but we don't want to lose them as a client. To say, like, "Color portraits are stupid; it's a shitty tattoo"—we're not saying that to them. So the obstacle is, we need to learn the best way to explain to them why a color portrait might not be the best idea and explain to them in a way that [makes sense when] they don't understand the technical side of tattooing ... In keeping up with that, [we're] trying to keep our integrity and do what we know is right and what we think is right in the community but not completely off-put those people that want those things. It's almost like [we] try to educate them as much as we can without, (a), giving away all the technical knowledge we do but, (b), try to make them realize that this might just be a fad or that these color portraits may not be the best thing you want. This Sailor Jerry Eagle is going to look much nicer as a tattoo.
>
> It's the way of like, getting around that and explaining that without making it seem like we're assholes and explaining it without it sounding like we're just saying, "Hey, we just don't want to do this for you." 'Cause that never sounds good.

The problem is not that portrait tattoos are new but that craftsmen do not accept the techniques used to produce contemporary color portrait tattoos. For craftsmen, the techniques used to produce the Sailor Jerry Eagle tattoo have stood the test of time. These techniques require a thick black outline with shading, color, and skin providing depth. The outline separates segments of the image, preventing colors from running together, or looking blurred with one another. Black pigments stay in the skin the longest and ensure that it still appears as an eagle rather than a potential blur of faded colors in the future. This is the established way of doing things for craftsmen.

The contention is that color portrait tattoos do not rely on the same techniques. Portrait tattoos require a high degree of skill, talent, and knowledge to produce. This occurs because portrait tattoos do not need thick outlines, which functions to guide the tattooists through the application process. This innovative method of application violates the established method craftsmen agree upon. Portrait tattoos often place colors next to one another, which craftsmen believe means they will blend together or fade over time. Kevin once learned this lesson while tattooing a client: "When they [established tattooists] tell you not to put certain colors by each other, and you run 'em, and the next thing you know they're all smeared together and you're like, 'That's why.' So it's like, 'Oh, they told me that for a reason.'" Craftsmen argue that portrait tattoos will not last over time. Artists want to create new aesthetics. Attempts to create new aesthetics often challenge or push the limits of what is possible with existing tools, materials, and knowledge. This means occasionally violating the rules craftsmen value.

However, craftsmen do not reject all innovations on the grounds of violating tradition. One of the reasons artists can push these boundaries is that a wider range of pigments has become available. Until the 1960s, tattooing relied on relatively few colors. When the Tattoo Renaissance occurred, there was a demand from art school–trained tattooists to expand the color palette.

In late 1968, Don "Ed" Hardy, then a fledgling tattooist and graduate of the San Francisco Art Institute, began to work under the tutelage of Zeke Owen. He described the shop as advertising one of the most sophisticated color palettes in all of tattooing: "When I got to Zeke's in Seattle, the sign across the front of the shop read EIGHT BRIGHT COLORS. Eight colors, a full palette—only a very few shops in the world offered that. I wanted to go even further."[4] At this time period, the only way to have an expanded color palette was "to sleuth around to get the pigments. The tattoo suppliers had some okay stuff, but you really had to contact the pigment manufacturers . . . You would buy dry pigments, mix them with various ingredients in a blender, and cook them on the stove."[5] The process of turning pigments into usable tattoo ink was time-consuming and required considerable knowledge. His account

speaks to how limited tattooing was half a century ago and how tattooists have adopted useful innovations.

With demand increasing for more colors, a market emerged for specialists to profit from producing ink. This was a lucrative market, especially for those who could produce hard-to-find, new, longer-lasting, brighter, or safer inks. Exceptional producers quickly became highly valued as support personnel. This market is not a source of contention, yet it is clearly innovative because it breaks the traditions of tattooing. These innovations became widely accepted because they broadened the possibilities for all tattooists.

Due to interdependence, another source of contention between artists and craftsmen involves the values associated with the production of tools—namely, tattoo machines but also inks and other items—used in tattooing. Variation within the division of labor allows people to specialize in many different forms of support work. One of the most valued types of support work is machine building. Brenda and Clyfford, who are both artists, explained its value as they describe their machines and their relationships with machine builders. Brenda said,

> I think it's more common to get custom-built machines . . . Normally, they'll build a machine that is specified to run badass liners, or really soft black and gray shaders, and if you're looking to emulate that kind of work, then you're paying attention to the machines they're building and why, and you ask them questions. Like Nick, at Screaming Eagle Tattoo, the owner. He builds machines, and he's getting really into it with what he's doing. And he's really interested in the cutting-edge technology of how far he can push something and design something. So he's really interested in the creative component about building a machine, the creative side of what you can and cannot do with it.

And as Clyfford put it,

> I can call him [his machine builder] and be like, "Hey what's up, Seth [Ciferri]? It's Clyfford. I need a shader that's gonna push big grouping mags [a large needle grouping for shading or coloring tattoos]." And he will be like, "OK, cool." And he will make me something that will run exactly the way I want it to. He will sign it or whatever, write something on it, [to] make [it] personal, but there's once again this personal relationship between me and this person where I can say, "This is the tool that's allowing me to do my job. I need a good tool. You make good tools. Now we have this deal, and I can take that deal on to me and my customer."

Both state they personally know who builds their machines and demonstrate a reliance on others. They clearly value machine builders and have established

ways of doing business with them. The significance of these statements is that neither of them is producing their own equipment. Instead, there is interdependence among support personnel and artists.

Craftsmen understand this relationship quite differently. On the one hand, it is an economic relationship. The machine builder, as a specialist, can sell their skill or knowledge in this art world. On the other hand, craftsmen view this as violating their own code. They value and honor being able to themselves produce the materials needed to tattoo—machines, inks, needles, and flash. For them, there is honor in understanding the intricacies of the craft and its traditions. Many craftsmen, such as Edgar, express resentment toward novices and artists who do not hold the same values: "Like, what would you do if you don't know how this thing works [picks up a tattoo machine]? So it just, it is surreal to me that there are people tattooing that don't know how to make needles, mix pigment, or fix their own machines. It's absolutely surreal to me. I don't want to be the old guy here, but if you can't, like, if you can't fix your everyday tools, then something is weird." His dissatisfaction expresses the values that craftsmen have toward their tools and equipment. For him as a craftsman, all tattooists should know how their equipment operates, and those who lack this knowledge should not be in the occupation. In other words, competent tattooing requires mastery of the tools and materials, not just applying them to people.

Undergirding this idea is a value for producing things by hand. This is an escape from the depersonalized nature of producing and distributing goods in capitalism. It also is evidence of how craftsmen construct a historical narrative about tattooing. Joseph stated, "It is the way that tattooing is supposed to be, you know: you're supposed to build this stuff with your hands, you're not supposed to have machines built for you. All these mass-produced machines, they are lacking the quality and care that one person is going to put into the machine when he is putting it together himself." This narrative supports craftsmen controlling the production of machines as a transcendent history. It states that machine producers should create tattoo machines by hand, because that is the way it has always been done. It rejects the capitalist notion of production of goods lacking a connection to their producers. Artists and novices often establish long-term relationships with craftsmen who produce tools and equipment by hand. These craftsmen are powerful gatekeepers who provide others with access to tools and equipment.

The Old-School Ethic

One mechanism for maintaining control over the rules of the game is the old-school ethic. This ethic is a cultural perspective that emphasizes work as a calling, honor through tradition, personal relationships, the appreciation of handmade objects, and noncommercial exchange. The ways tattooists talk

about their work demonstrates these values. Joseph explained this passion as a calling: "A lot of people don't know that tattooing completely consumes the person. At least it does for me. Like I said before, this isn't a job. This isn't something I do to make money—I live and breathe the craft of tattooing. Once I got into it, I fell in love with it, and I've never looked back, and I take it serious. To a lot of people, it is just a tattoo, just a mark on their body; it might be a fad. Where to me, it's not just a fad; it's everything." For Joseph, tattooing consumes his essence and being. The old-school ethic frames tattooists' understanding of their labor as dedication to a craft. While tattooing is a commercial art, the old-school ethic emphasizes a dedication to the craft as a calling.

This old-school ethic also denotes the importance of traditions. Tattooists earn honor through their work by following the traditions of the craft. Likewise, it can also stay the same or be lost depending on a person's actions. When I asked John Lee how long he had been tattooing, he reframed the discussion to depict his own honor:

> How long you've been tattooing is sort of a strange question. To me it should be like, "How long have you been doing tattoos or working in tattooing and been able to give something back?" Like corporate R&D, you need to put something back into it [the craft], instead of just running out and saying, "Hell, I deserve more than 50 percent; I can't get a raise, so I should go open my own shop." 'Cause you know what happens then: then you got all the headaches; you still ain't making any more fucking money because you have all the overhead now, and you're watering down stuff into becoming this petty competitive stuff, and shit-talking about other shops.

The honor of the old-school ethic involves valuing contributing toward the craft. At the same time, this code denounces money as a motive. Moreover, John Lee maintained that it is dishonorable to violate the rules of the game. As he stated, those who move into shop ownership too quickly bring a host of problems upon themselves and the occupation. Importantly, his statement illustrates that earning status in the world of tattooing involves honor, which is part of the old-school ethic.

Many older tattooists have earned respect in this world. In some cases, such a tattooist was the innovator of a specific tool, ink color, or some other device that advanced the work and craft of tattooing. In other cases, they earned respect because of the time they spent tattooing, which gives them the status of being the knowledgeable elder. Without public promotions, titles, or other displays of honor, novice tattooists occasionally fail to understand why someone has the respect of their colleagues. This happened when Frank attended a local tattoo convention and pondered why a bunch of people were watching an older man produce what he thought was a basic tattoo: "I've seen the

guy tattooing and his work was—I wouldn't say mediocre, but it wasn't what I thought it was going to be. It was like, he was just doing basic work, and everybody was huddled around him going, 'Oh, that's such and such,' and I was like, 'He's not really doing anything.'" The crowd gathered around the man was not there to solely evaluate his work. Instead, this tattooist had earned the right to command their attention. This older tattooist was honorifically elevated not because of his contemporary skills, but because of his contributions in the past. Frank's lack of understanding reveals that the old-school ethic is a cultural code not equally accessible to all tattooists. It demonstrates that people learn about code through participation in this world.

Recently, the increase in the popularity of tattooing has threatened the old-school ethic. Part of the code involves keeping the tattoo world insulated from outsiders. As tattooing's popularity has increased, entrepreneurs have begun to exploit this world. Tattooists have reacted to this increased attention by feeling threatened. Clyfford best summarizes this sentiment in depicting his membership in this world:

> One of the frustrating things is that I feel like for whatever reason, when I was 18, I got let into this club, and I don't know why that happened. Maybe it was because I was a nice kid. Maybe it was because I was really enthusiastic. Or maybe it was because I worked hard. Whatever. There's millions of people like that in the world, but for whatever reason, I got let into this secret club of dudes that have been doing this secret thing since time began. It's changed over the years and eons and centuries or whatever, but it's still like this little cool little secret club that these dudes do. Now that I'm in it, and now that I'm 10 years into it, now I want to protect it. I see it get run by people with capitalist ideas, or people that don't tattoo that come in and they want to make money on it, and they're pointing fingers, and the governments are starting to be like, "Wait a minute, you assholes haven't paid taxes in 15 years." All these people are now converging on it: reality TV shows, broadcast TV stations. All these people are like, "Holy shit! Where have you guys been?" And it's been that way [hidden] because we kept it that way, it's been protected, we didn't want any of that.

At the core of Clyfford's statement is the idea that outsiders who do not understand this world threaten tattooing and its traditions. Many tattooists had stories similar to Clyfford's. For them, there is a duty or honor in upholding these traditions as sacred. By upholding these traditions, tattooists able to resist change. Maintaining traditions is part of the old-school ethic, which is deeply rooted in sustaining order through honor and tradition.

Tattoo Museums

Another way that tattooists maintain control is by owning their history and its narratives. In this world, one way to earn status is by possessing machines, flash, and other objects that belonged to predecessors, especially if masters or legends owned or created them. Some, particularly tattooists in the twilight of their careers, have established large collections of historical pieces and memorabilia. A few have elaborate collections they call tattoo museums. There are currently 21 tattoo museums in the United States.[6] These collectors possess enough honor that it enables them to develop networks to attain these valued objects.

Tattoo museums are like other art museums in the sense that they contain collections of objects and are open to the public. However, they differ from conventional art museums. What makes tattoo museums distinct is that they are usually situated within a tattoo shop. While this may seem like a mundane distinction, it is central to the old-school ethic of tattoo work. Tattooists completely control these museums, ensuring their ability to be the sole curators preserving the history of the occupation. Tattooists, and not outsiders, have control over the narrative, which defines the historical trajectory of the occupation. The sets of meaning they create reinforce the old-school ethic and justify a history of the traditions of the craft. In other words, tattooists develop sets of rhetoric that explain and legitimize their occupational history through these museums.

Museum owners often describe the collections as saved from certain destruction. Only because of the dedication and tireless work of a few people—who deeply care about tattooing—were they preserved. For example, in describing the process of attaining August "Cap" Coleman's equipment after his death, Kathy Maguire explains, "Coleman's gear was rescued by Johnny Walker—and I use the word rescued, because in Coleman's will, little of his small fortune was left to the family. If Walker had not stepped in, this tattoo gear may have been thrown away by bitter family members."[7] This collection eventually came into the possession of Pops and is on display in his tattoo museum in North Chicago. The narrative demonstrates the old-school ethic because it shows tattooists honoring tradition and constructing a collective memory.[8] As Pops explains, Johnny Walker (who worked with Norman "Sailor Jerry" Collins in Honolulu during the 1960s) stepped in to take Coleman's tattoo gear to honorifically preserve the legacy of a master.[9]

Not all these museums are open to the public. Mike Skiver, whose Pennsylvania museum tragically burned to the ground in the spring of 2016, closed his museum to the public several years prior. Kevin told me that it closed because of Skiver's frustrations with members of the public. The final incident involved a person leaning on a display case, shattering the glass. The museum was still accessible if someone had the right networks within the tattoo world. Skiver

would open his museum to known insiders or people vetted by trusted associates. These were not the only eyes who could see the museum collection. At some tattoo conventions, Skiver would display portions of his collection. Often, accompanying the object on display were thorough explanations of what or how tattooists used it. Just like Pops, Chuck Eldridge, and Lyle Tuttle, Mike Skiver is a tattoo insider and has become preoccupied with protecting the cultural history of tattooing.

Tattoo museums are one way of maintaining the old-school ethic. With museums, tattooists attempt to sustain their collective memory independent of outsiders. This enables tattooists to create narratives that frame and present history through their eyes and not those of wandering academics, news reporters, the public, or other outsiders. Control over these historical narratives is part of the old-school ethic. Simultaneously, this ethic reinforces the importance of history and tradition among tattooists.

Scratchers: Folk Devils of an Occupation

Another source of contention in this world involves the rules of defining who is and is not a tattooist. Tattooists use the term *scratcher* as a pejorative to describe several different types of unwanted behavior or characteristics. No one defines themselves as a scratcher. Instead, it is a term used to define and delegitimize an other who established tattooists perceive as a threat to the occupation. The concept of a scratcher depicts a specific kind of other, a folk devil. This folk devil personifies all the characteristics that established tattooists define as evil.

Folk devils represent a deviant social type or category of deviants.[10] As a social type, members of society construct this category. They do this to warn others of the folk devil, who is a disruption or threat to conventional values or beliefs. They are a symbolic representation that personifies the threat to values and beliefs, and they are typically far less dangerous than the rhetoric used to describe them. For tattooists, it is a label applied to those who do not represent the values and beliefs that tattoo workers are supposed to hold—upholding the accepted standards of the craft. When I asked tattooists what a scratcher was, I received many different answers. Every answer was always disparaging. The scratcher, while not an actual person, is a social construct used to designate a deviant other and police the boundaries of acceptable tattooing. Collectively, established tattooists align themselves against scratchers or the threat of behaviors associated with scratchers.

Scratcher folklore is a public conversation and reaction to low-quality or unskilled tattooing. It reaffirms the values of tattooing by expressing an appreciation or affinity for the craft of tattooing and paying one's dues. Scratchers have failed to honorifically earn the right to be a member of the occupation. In

a personal conversation, a tattoo expert and self-described "grumpy old fucking biker" tattooist defined scratchers: "They don't got a fucking clue what they're doing. They're scarring and messing people's skin up, and basically, they don't want to pay their dues, like a lot of young people today. They want to do [tattoos], but none of them want to fucking pay their dues." Clearly, established tattooists believe scratchers do not value the honor component of the old-school ethic. Scratchers have not earned the right to be equal because they have not followed the traditions of the craft.

There is not a universal definition of a scratcher. When tattooists use the term, they are referring to many practices or characteristics. Everything—from poor bathing habits to rudeness to smoking in the smoking in the shop—was associated with scratchers. This is not an exhaustive list. As tattooists explained the characteristics of the scratcher to me, it became clear that there are a wide variety of meanings associated with the construct. As Mike explained it, "I'm pretty much old school as far as that's concerned, about messing with my livelihood. [There] is no reason for me to come down on any . . . First off, all those shops that are doing it [tattooing] the legitimate way anyways—that are licensed and they're doing it . . . I would love to say numerous bad things about the scratchers, but they keep us in business too." According to Elaine, "One of the major gripes that the tattoo industry [has] are what they call the scratcher shops, or the low-end shops, the dirty shops; they hate them. They want to set their shops on fire." Mason detailed his own experience: "I carry around a sharps box. Like in a doctor's office when they're done with the needle they throw it in the . . . but some people don't, these scratchers; they don't take the effort to dispose of their stuff properly." George showed me a tattoo produced by a young man working out of his house. The tattoo was an image of a basketball with the words "HOOP LIFE" arced around it. Not only were the letters crooked, but the outline was shaky, the ball was not round; some of the lines were too deep, some too shallow, and some looked like the tattooists had been connecting the dots: "So this is one of the scratcher dudes. Now that is a hot mess. It's crooked bad, man."

All these accounts define the behavior or characteristics of the scratcher as a problem. Elaine and Mason depicted characteristics that are potential threats to the occupation collectively: one public panic or disease outbreak could lead to a tattoo ban.[11] George, Mason, and Mike all described ethical issues of tattoo work. All these stories are about who has the right to do what to whom and when. In the larger picture, as a category, the scratcher symbolically represents everything that tattooists do not want to be associated with. Tattooists use the term to marginalize those who contribute to tattooing's public reputation in a manner that is unfavorable.

Marginalizing the other by using the term a scratcher is valuable for tattooists. They employ it to police the boundaries of the occupation by declaring

what types of tattooists and tattoos are acceptable and those that are unacceptable.[12] As a label, it is such a stigma that many tattooists (even those who were likely once scratchers themselves) attempt to defer from it. Elaine regularly read interviews of established tattooists, and she described how many began their careers. In her description, many began as scratchers: "Ideally, he was the scratcher when he first started. 'Oh, I tattooed outta my house.' A lot of people were like, 'I tattooed in my house for a year or two, and [when] I got big enough, I got into a shop.' The people love them because their work is so good right now. But if they would've met them at that stage, they would've wanted to set their face on fire." Central to Elaine's claim is that many established tattooists once struggled to become members of the occupation. Since many struggle to become members of the occupation, it is useful to denote who is unqualified using the term *scratcher*. As she stated, many tattooists probably began their careers as scratchers, but in their positions now as established tattooists, they do not apply the label to themselves. Instead, it applies to those who are currently scratchers.

Several of those interviewed admitted to initially learning how to tattoo through experimentation outside of a tattoo shop. By the time I met them, each had learned vocabularies of motive to distance themselves from their former identities as scratchers and to justify their behavior.[13] For example, Richard claimed that he refused to take money early in his career: "It took me like three years [of tattooing] before I started making any money and that was in . . . it was on my own, and on that, I made sure that I wasn't gonna go out there [and] be one of these scratcher types." By making this claim, he distances his identity from the scratcher, who exploits clients by providing inferior tattoos for profit. This is a denial of injury, claiming that he only tattooed for profit once he became established.[14]

Frank was initially self-taught, and he spent two years working as a scratcher. Saving face, he depicted his past as a self-fulfillment tale.[15] In his perspective, it was necessary to become a scratcher to learn the skills to be employed in a shop. As he claimed, "I started when I was say about 19, and then when I was 21, I started professionally working here. You really don't count practice. I did so many tattoos as practice, I didn't even count 'em, because they were so mediocre, and like, this was the first tattoo I did on myself right here [*shows me a tattoo on his forearm*]. I've been telling myself I'm gonna do it over, but this was the first one." During the early years, Frank was working out of his house and traveling to clients. His story is not uncommon, as some tattooists who are now successful were once scratchers. He separates himself from the label by claiming that those were just his practice days. His practice on himself, friends, or associates occurred without input or help from established tattooists. Frank and Richard were both unable to initially locate an opportunity to learn from an established tattooist and became scratchers. They were not permanently

ousted from tattooing because of their previous behavior. Rather, they temporarily suffered the consequences of breaking the rules until they were able to make contacts with people who could teach them the code of tattoo work.

With the recent rise in the popularity of tattooing and increasing accessibility of tattoo equipment, people use the term *scratcher* to police the boundaries of acceptable tattoo work. As Edward explains, the internet has enabled many to access the tools without earning the right to possess them: "The other thing is like eBay and shit: with all these shit [for] the scratchers, the kitchen magicians, the basement butchers that just order shit up off the internet because they have a credit card, and that gives us a bad name." Those who apprentice or train through the traditional methods have restricted access to tattoo machines, needles, and inks. As they show dedication to the craft, they honorifically earn access to these materials. Scratchers get access to these materials without having to earn that right.

Tattooists use *scratcher* to depict a marginal outsider within their social world. The scratcher is a folk devil. This folk devil allows established tattooists to claim authority over the skill hierarchy by pinning all the evils of tattooing on the scratcher. The scratcher, whether real or imagined, reaffirms what kinds of behaviors or characteristics are appropriate and what kinds are not acceptable.

Innovation and Adoption

A final source of contention among tattooists involves innovations. The concept of innovation describes the process of how ideas or objects spread among groups of people, organizations, or institutions.[16] Those ideas or objects that are widely diffused are innovations. Not all objects or ideas become innovations. Some fail to ever gain support, and others become adopted but the enthusiasm for them wears off quickly.[17] Innovations tend to have support over a long duration of time. This is because they offer solutions to practical problems. Potential innovations cause tattooists to reflect upon, and occasionally refine, the rules of the game.

In tattooing, there are two types of innovations. The first are aesthetic innovations. Several previous studies have specifically focused on the aesthetics of tattooing.[18] Aesthetic innovations alter the images of tattoos, and some create different genres or styles of tattoos. This type of innovation focuses on the outcome of the tattoo process. People interpret the tattoo and claim that tattoos made through a similar process or with similar aesthetics tend to fit within a specific style. Out of aesthetic innovations, public discussion ensues for recipients to make sense of them. A large part of this discussion occurs between consumers, who debate the value of genres. This kind of innovation involves the reception of aesthetics by understanding how consumers make sense of tattoos.

The second type are material innovations. Material innovations involve the objects used in tattoo work. These can be new objects or reinterpretations of old ones. Often, they are efforts to solve a perceived problem of the craft, from the mundane (lighted magnifying glass attachments for tattoo machines to increase visibility) to the serious (separate ink cups for each customer to prevent the spread of blood-borne pathogens). Innovations change the process of producing a tattoo. To understand the innovation, people must alter the rules of the game. For example, tattooists widely adopted separate ink cups, but this only occurred after a consciousness developed about the potential for cross-contamination and the spread of blood-borne pathogens. The rules of the game changed to reflect this understanding of disease transmission. Now it is an expectation that all tattooists use separate ink cups for each client.

Over the course of this study, tattooists showed me many different potential innovations. Some even elaborated on the problem of implementing these innovations. Most were impractical, and people already had existing solutions that stood the test of time. Edgar collected a lot of objects throughout his career. Since he made inks, he sold or traded them with a lot of different tattooists. This resulted in a collection of tattoo-related stuff, some of which were potential innovations. After finding a new object, he was excited to tell me about its value to the occupation:

> It is not like there's a new way of inventing the wheel every month, or every year, but you certainly want to; you certainly want to keep an eye out for advancements and improvements, without only sitting there waiting for the next advancement or improvement to come out. If you're always looking for, like, the next magic weapon or the next magical thing in your toolbox, then you're not being in the moment and working on that tattoo right now. 'Cause you're still just like, "Oh, man, I can't wait to get the new [thing]." And people are always inventing all kinds of new crap. Shit we don't need, like little lights for your tattoo machine, [so] you can see better. Or there's so much crap, I don't even—do I have any crap? [*He begins to shuffle through a drawer and pulls out a lighted magnifying glass that attached to a tattoo machine.*]

As Edgar claims, new tools will not save a tattooist's career. Those preoccupied with new tools are not learning the skills to be an effective tattooist. For Edgar, it is not a new tool that will improve a person's craft; rather, improvement will come from learning the time-tested knowledge of the occupation.

New tools also present tattooists with new problems. Tattooists are still working within the existing rules of the game. Adopting new tools means there are no well-defined rules for how to act toward them. Tattooists must create rules of the game around these new objects.

In 2000, the first pneumatic tattoo machines were available for purchase. People heralded these machines as a revolution in machine design. Instead of relying on electricity, air pressure turned a crank. Attached to the crank was the needle bar. In general, these machines were lighter and quieter than the age-old standard coil machine. Two tattooists, Alan and Tim, mentioned experimenting with pneumatic tattoo machines with the intention of adopting them. Tim used them for a brief period of time, and then decided he liked his coil machines more. Alan never used one, but his reason for not adopting the new technology revolved around the lack of established rules of the game. He explained,

> Someone developed some pneumatic machines. And a crew of guys were doing these amazing color realism [tattoos] with these pneumatic machines. And I thought that there was something about the machine itself that made it different, because only the people who are using them were doing these certain types of tattoos. And it was basically a new revolution, or a new movement within the tattoo world. I went to the seminar by one of these top realism artists to learn more about the machines. Like, if I should invest my money into this machine. Because it's not just the machine; it's a machine, a compressor, tubes, regulators—a few thousand dollars versus $300 for a typical coil machine. And I learned that he actually stopped using those types of machines, because not a lot of people used them. And if he was traveling to a convention and the machine broke down, he couldn't just borrow a part to fix it. He was kind of out of luck.

With no evidence that this new machine improved the tattoo and few experts, this potential innovation was not adopted. The enthusiasm wore off when many found they created new problems, such as locating materials. Pneumatic machines have not disappeared, but they never matched the initial enthusiasm. This enthusiasm was about a group of tattooists producing color realism tattoos, an aesthetic change at the time. People incorrectly directed their attention to the tools and not the techniques used to produce these aesthetics. Importantly, this narrative illustrates the problem of developing rules of the game to manage new tools. Tattooists stuck with the older tools because they knew who would be where with what objects and when in order to make the machines operate. Pneumatic machines were a risk, since tattooists might not have access to the right materials to use them. For people to adopt pneumatic machines, the workforce (especially support personnel) and the way tasks are bundled would have to change.

Tattooists are not entirely resistant to material innovation. It does occur but usually without radically changing the structure of the workforce or altering the methods of the craft. People tinker with existing and accepted parts of

the craft. Through this tinkering, they attempt to change the craft. For example, Brenda described her own experience doing this:

> Me and my husband make our own stencil stuff. We took the recipe off some preexisting known recipes but just tried to change them a bit, changing the ingredients . . . I'm interested in it from a painting perspective of pigments and binders and what can make a good quality tattoo ink versus another one, but that's like a lot to take on right now. So the only thing we really make right now that we love is our stencil stuff to apply the stencils with. We use a recipe that most tattooers know, but we kind of made it a little more organic, so we changed the ingredients a little bit so that less chemicals are in them.

While they modified the recipe to include less processed materials, the stencil stuff still falls within the traditional parameters. This does not radically change the tattoo work. Instead, it is a minor change that alters a small element of the materials involved in the application process. Additionally, Brenda noted the difficulty of creating a tattoo ink. As she stated, it is interesting work, but it was also the kind of project she was unwilling to commit her time to. Material innovations do happen within tattooing. However, these changes are small and incremental in nature rather than massive. This is because it is difficult to radically alter the bundling of tasks and social organization of the workforce.

Some tattooists noted the recent renewed interest in rotary machines. When I gathered data for this research, there had not been widespread adoption of rotary machines, but enthusiasm was growing among tattooists. Many have since adopted rotary machines. Rotary and coil machines have existed for over a century, but people traditionally preferred coil machines. This was because the machining on traditional rotary machines was not as sophisticated, making them problematic devices to use. Recent advances in mechanical engineering have produced refined rotary machines leading more tattooists to adopt them. Alan once explained this transformation to me:

> Rotary machines have been around for a little while; they're a little different. Not a lot of artists like them, because I guess they weren't refined. People weren't too serious about them, so they never put a lot of engineering into them, but that's changed. The difference is, like, the coil machine has resistance and meets resistance against the skin when it enters the skin, and it can slow down, and it can bog out completely depending on how you have it set. Whereas the pneumatic machines and the rotary machines have consistent throw each time. Like, they'll always hit the same exact depth with no resistance, resulting in a more consistent, even, I guess, tattooing style.

These rotary machines offer a different "throw," or force of the needle, a characteristic based in the physics of the machine in action. They eliminate a problem of the traditional coil machine. With rotary machines, the needle depth and the amount of force are the same for each stroke when the needle hits the skin. This occurs because the needle bar attaches to a mechanical gear—hence the name rotary machine. This makes tattoo work easier by reducing the uncertainty of the throw. Traditional coil machines are more sensitive, as ink thickness, skin resistance, circuit repetition, needle size, speed, springs, and coils can all affect the throw, which can all be manipulated independently of one another. The name "coil" comes from the electromagnetic coils that complete a circuit against the force of the spring. Tattooists using coil machines often spend years developing a working knowledge of them. Something as simple as adjusting the gauge of the spring or size of the needle will alter the throw. Coil machines are far more complex to manipulate because of the ability to adjust multiple variables to produce different effects. Knowing all this, and understanding how to manipulate it, takes valuable time. By eliminating these variables found in coil machines, the rotary machine reduces the amount of labor involved in producing a tattoo and ultimately de-skills tattoo work. Some tattooists have adopted rotary machines, which is evidence of a change as people move away from a tool that is far more complex to use.

One way to interpret the move to rotary machines is that tattooists are losing control over the tools and the processes of their work. This makes it a threat to the occupation. For example, one of the most well-known rotary machines is the Cheyenne Hawk. A German company that manufactures medical technology makes this machine.[19] This represents outsiders capitalizing on the production of tools needed to tattoo. Tattooists are losing control over the production and distribution of some of their tools. It also shows how the boundaries between tattoo work and other spheres are becoming more fluid.

The potential benefits rotary machines offer seem to outweigh the loss of control. In fact, they may provide tattooists with more control over certain aspects of the tattoo process. As Margaret explained, "You can change the voltage through the power supply, but you can't change the give in the needle basically . . . There are benefits to it: I think that you can get a lot more variation to it and how you use them. This is convenient because it runs off cartridges instead of a tube and the needle configuration. This machine has specific cartridges made for it, so that you can screw them in and out. So you only need one machine per person." Her first statement about the "give" in the needle is a substitute for throw—the design of the rotary machine limits her capacity to control the throw. However, the rest of her comments depict practical problems. Tattooists typically need more than one coil machine to produce a single tattoo because they need to use more than one type of needle

grouping and more than one type of ink. Coil machines have variations in their throw or needle force, and they pair with specific sets of tasks and needle groupings. With rotary machines, the only variables that can change are the voltage, which affects the frequency of needle, and the types of needles used. Rotary machines solve the problem of needing multiple machines to complete a tattoo. This simplifies several variables present in the tattoo process and at the same time de-skills the labor of tattoo work. From a critical perspective, the adoption of rotary machines also means that people can master one of the tools much more quickly than in the past.

Despite the recent resurgence of interest in rotary machines, there are few material innovations widely adopted among tattooists. Many continue to rely on methods that have stood the test of time with minor variations. This occurs because of the traditional, old-school ethic, which reinforces the established way of doing things. Tattooing remains resilient to innovations because of this cultural code.

Summary

The focus of this chapter has been on the ways tattooists negotiate change and create stability within their world. Sources of contention are critical for understanding the conflicts over meaning that affect a social world. Even as rapid changes encroached upon these tattooists, they were resilient in maintaining their culture. Despite lacking formal organizations or centralized structures of power, tattooists create stability through their shared culture. This occurs because their shared culture is deeply rooted in the traditional ways of doing. In other words, tattooists rely on their traditions to sustain cohesion and manage conflicts internal to the occupation.

The conflict between artists and craftsmen centers around the two sets of symbolic reward systems and who controls them. Conflict between established tattooists and scratchers—tattooing's folk devils—defines the boundary between legitimate and illegitimate activities associated with tattoo work. Debate also exists in defining the types of objects or ideas that resolve the practical problems of carrying out tattoo work. In each of these internal conflicts the old-school ethic, which emphasizes tradition and the established way of doing things, is integral to maintaining a degree of continuity among tattooists.

7

External Threats
and the Maintenance
of Boundaries

Culture is imbued with traditions but
traditions change over time. There is
always a new mix of culture happening.
Sometimes this mix can be strange and
the change is inevitable. Cultures also
mix and this is not inherently bad. . . .
When people don't study, the mix is bad.
Tattoos will always change over time but
without knowledge, this is pointless.
—Horiyoshi III

As enthusiasm for tattooing has grown over the last few decades, interest from
outsiders has increased. This has resulted in more tattooed bodies, more peo-
ple choosing to become tattooists, and an increase of entrepreneurs who seek
to profit from all things tattooing.[1] Tattoo culture has become commodified
by these entrepreneurs and started to produce for the wider culture. These
are external forces that threaten the world of tattooing.[2] Despite these forces,
tattooists and tattoo workers have been quite resilient in adapting to these
changes and thwarting outsiders. This resilience is because of the mechanisms
tattooists developed to sustain a degree of continuity in their world. These
mechanisms include the construction of authentic tattoo traditions around

the ownership and exchange of material goods, as well as folklore that reinforces the old-school ethic.

Increased Presence among Publics

One external threat affecting tattooists is increased media attention. It occurred in two stages. Initially, there was the growth and segmentation of the magazine industry. Following this were reality television shows about tattoo work. These both exposed tattooing to more audiences, ultimately altering tattoo work.[3]

Segmented Publics and the Magazine Industry

Over the last 35 years, tattooing has become increasingly available to publics through printed magazines. During the 1970s and '80s, the few tattoo magazines in existence contained reprinted photographs of tattoos submitted by their producers and advertisements in the last dozen or so pages. They contained little discussion about the actual craft. Instead, they used images to visually show the types of tattoos others created. Of all the magazines produced during this time, only one, Don "Ed" Hardy's *TattooTime*, investigated tattoo work. This was a radical shift, as it sought to understand and explain the art and craft of tattooing for tattooists. It only ran five issues (1988–1991).

Between 1990 and 2010, the number of tattoo magazines increased, with magazines oriented toward different segments of tattoo consumers. An early division occurred along the lines of social class.[4] This was a binary division of tattoo aesthetics—art/highbrow or biker/lowbrow. Art magazines like *International Tattoo Art* or *Tattoo Advocate* discussed tattoos through a middle-class perspective that emphasized cultural distinction.[5] They lacked advertisements from supply houses and focused on the fine art of tattooing. Biker/lowbrow magazines like *Tattoo* and *Tattoo Revue* contained ads for supply houses, discount pornography, stories from tattoo collectors, reproductions of flash, and coverage of tattoo conventions.

These magazines contained different discourses, which emphasized a class-based division in tattooing. The effect of this segmentation was that it reinforced a high-low dichotomy within the world of tattooing. It pitted those at the bottom against those at the top, the street shop tattooists against the fine artists, and the refined consumer against the lower-class consumer. They distributed a set of cultural representations for people to navigate.

As the popularity of tattooing increased throughout the 1990s, publishers seized the opportunity to produce more magazines. Increasing segmentation occurred as they oriented themselves toward specific publics. A few of the magazines currently available are *Tattoos for Women*, *Tattoos for Men*, *International Tattoo Art*, *Skin Art*, *Tattoo*, *Flash*, *Tattoo Revue*, *Urban Ink*, *Skin and*

Ink, Tattoo Magazine, Tattoo Energy, Rebel Ink, Tattoo Life, and *Inked: Culture, Style, Art.* While this list could be much longer, it is enough to illustrate the increasing segmentation. For example, *Urban Ink* advertises itself as a "tattoo magazine for people of color." *Rebel Ink* intends to appeal to those who want to resist mainstream society through goth and punk fashion, while *International Tattoo Art* constructs an image appealing to the sophisticated and artistic consumer. Publishers design each magazine title to appeal to specific segments rather than the broader category of all tattoo consumers.

More recently, magazines like *Inked: Culture, Style, Art,* which first appeared in 2008, began to appeal to lifestyle consumerism. *Inked's* pages contain advertisements for everything from cars, liquor, and fashion to music and Las Vegas shows. Included in *Inked* are photo essays of tattoo scenes in trendy, hip places like Williamsburg, New York. While *Inked* is about tattoos, it features corporate-sponsored advertising intended for hipster sensibilities, content that was not previously prominent in tattoo magazines. As a cultural product, *Inked* epitomizes how the culture industry has seized tattooing. This magazine flaunts consumerism to a segment of young, hip, and trendy tattoo consumers.

The orientation of magazines to segmented publics further complicates their purpose within the world of tattooing. To push sales and appeal to wider audiences, magazine content is geared toward segments of consumers. Some magazines oriented toward male consumers increasingly feature scantily clad women posed in a seductive manner on their covers and throughout their pages. Kevin expressed his frustration with these images: "Clearly, they're using women to sell these magazines. Like, hot tattooed chicks on the cover is going to pique young men's interest . . . And if you notice, they'll show, like, guys covered in tattoos, and you'll see him once in the magazine. And then you see a chick with a small thing on her hip and it's like five pages. It's like, 'Oh, there she is again, and there she is again for this one little tattoo.'" While Kevin is overexaggerating, his comments reflect a critique that tattooists have of these magazines. They often emphasize the display of sexualized female bodies over tattooed bodies and how the magazines are for collectors of tattoos and not tattooists. Later in the conversation, Kevin added, "It's just a bunch of women showing their asses, and it's marketing genius but, yet, it kind of screws us." Featured stories, while interesting, do not contain topics tattooists collectively face. Instead, they are stories designed to sell magazines to publics interested in tattooed people—a different segment of the public.

Tattooists have responded to the issues of segmentation and content orientation by creating and distributing their own media. An early example was *TattooTime.* More recently, *Tattoo Artist Magazine (TAM),* a quarterly publication like a trade journal, appeared in 2003. As Clyfford described it, "It was started in response to tattoo magazines getting bought out by bigger companies

and including less-than-perfect tattoos." This publication is different from other magazines, as it discusses the work of tattooing. Clyfford continued to describe *TAM*: "They're all really amazing, accomplished tattooers all across the world. They all got together and decided to make this publication . . . This magazine will have, like, techniques in it; it will have people teaching, like, giving step-by-step how they do this or that." As a publication, it is more focused on issues that concern tattooists.

For example, an article series titled Machine Theory was a discussion that appeared in several issues of *TAM*. Notable machine builder Seth Ciferri was featured as an author. In the first issue of *TAM*, the opening Machine Theory piece included a hand-drawn image of a tattoo machine frame that was a cross between two different frame styles, followed by the words, "What is this? Liner? Shader? Neither? Why?"[6] The column then solicited responses, with the winner receiving a small prize. The intent was to engage readers in a discussion about a machine frame that does not clearly fit within tattooists' existing categories. The second issue of *TAM* featured the responses and a discussion written by Ciferri.[7] Unlike other magazines, this content was for tattooists. Early issues featured not only interviews with tattooists but also instructions for different art forms, history lessons about the imagery used in forms of tattooing, profiles on emerging aesthetics and genres, artwork by tattooists, and a set of tales from Mike "Rollo Banks" Malone. As a response to the problem of the magazine industry's consumer-oriented segmentation, tattooists developed their own materials.

Aside from *TAM*, other tattooists began to assert control by independently publishing books and magazines. Some were hardcover books documenting the art of a specific tattooist or group of tattooists, reminiscent of coffee-table art books. Grime's *Two Year Autopsy* documented roughly two years of his artistic career, including his tattooing. Other works involved specific information about tattooing. In 2001, Guy Aitchison, one of the leaders of the biomechanical aesthetic, released *Reinventing the Tattoo*. Included with the book was an instructional package containing a DVD with a series of how-to videos. Even more recently, in 2015, Ash Davies produced the first issue of *Best Intentions Tattoo Magazine*, an independent production geared toward tattooists. Demand has remained consistent for materials produced by tattooists for tattooists, as evidenced in the reissuing of *TattooTime* in 2012 and the reprinted collection of the first five issues of *TAM* in 2011. In the face of increasing segmentation and the content orientation of magazines, tattooists responded to this threat by printing their own media.

Television Becomes Reality

By 2005, several networks, most notably A&E, had produced reality television shows about tattoo shops. The first shows featured client and tattooist

interactions and primarily appealed to middle-class sensibilities, emphasizing the symbolic meanings or stories behind each client's tattoos. Later shows, such as *Ink Master*, were reality television competition shows, with tattooists tested on various skills, and judged against one another. These shows followed a predictable reality television format by focusing on the most dramatic story lines or characters, often overemphasizing interpersonal conflict. Importantly, they distributed constructed versions of tattooing to audiences each week.

Every tattooist I spoke with commented on how these shows affected their work, especially their interactions with clientele. These television shows present clients with narratives that are edited versions of the tattoo process. Often, they differed from what tattooists actually do. For Samuel, "the worst part about the first bit of reality television involving tattooing is the huge false sense of reality that it gives people." Samuel is referring to how clients fail to understand the time that goes into producing tattoos or the limitations tattooists have with the selection of materials. Eli explained why they frustrated him: "TV shows hurt you a lot in the respect that on a TV show, you walk in, and the guy says, 'I want to get a dragon sleeve.' And the guy behind the counter says, 'OK yeah, I'll be back in about a half hour, and I'll have it ready for you.' He comes back in a half hour, and he's got this two-foot dragon he drew in 20 minutes. By the end of the show—it's a half-hour show—the guy's got a sleeve. And people see that and they think, 'Wow, I can go in and get a sleeve today.'" Even though television shows promote tattooing to the public, they distribute a constructed version that leads some clientele to have unrealistic ideas of the tattoo process. For those who have spent time in tattoo shops, a full sleeve tattoo would take multiple sessions over days or weeks to complete.

Tattooists now must also manage client's understandings of their work. This complicates the process, since tattooists and support personnel interact with clients who assume they are experts in the craft. Conrad explained how some clients use technical jargon of the craft but do not understand what it means:

> You have a lot more, like, weekend scholars on tattooing. People that like, watch all the TV shows and, like, watch a couple YouTube videos of some how-to tattooing. So they walk in the door thinking they know as much about tattooing as the people that work here know. So they come in throwing around terms and talking about needle groupings and talking about this and that and qualified technical aspects of tattooing, but they don't know what they're talking about. They're just repeating what they saw on the TV show or what they saw in the YouTube video. They don't know the actual craft of it. They don't know the craft. They just know some keywords.

These clients become problems for tattooists to manage. Tattooists have to worry about not only producing tattoos but also carrying on a conversation

with people who assume they know as much as the experts. Increased access to information about the craft results in narratives about tattooing that do not reflect the tattooists' reality.

With tattooing discussed across publics, tattooists worked to defend the values of their occupation. Many rejected these shows, claiming they inauthentic representations primarily focused on profiting on the trend of tattooing. This conflicts with the values of the old-school ethic. In speaking of *Best Ink*, a tattoo competition show, William claimed,

> I watched that cocky rock star bullshit. People want to be on TV and get their
> 15 minutes of fame, and tattooing is always going to be popular. It's always going
> to be something that is a staple in the American economy. What they're doing
> now, I feel, is that they are just raping it for everything they possibly can to make a
> quick buck off of it. And then they're out the door when their 15 minutes of fame
> is over, and on to the next fucking, whoever's doing the next Tae Bo® exercise, or
> this diet plan, or this bitch had nine fucking kids, let's make a TV show about her,
> or that shit . . . So the second that first show on tattooing popped up, everybody
> wanted to get in on it. They were just like, "We have the potential to make a lot of
> money and make a lot of people look like assholes right here. Let's fucking do it."

Television shows specifically threaten the old-school ethic in two ways. First, tattooists understand participants on the shows as having ego, or putting themselves above the craft. Tattooists tend to understand those who are ego-driven as people who have not paid their dues appropriately to build their career and reputation. Second, those participating in the shows are competing for money and working with outsiders. These participants are willing to put money before their passion. Many of the tattooists interviewed expressed views like William's—they feared that the culture industry exploited the world of tattooing, threatening the core values of the occupation.

For others, popularity, public exposure, and culture industry reproduction demystify tattooing, causing it to lose its magic. In other words, part of what made tattooing enchanting or magical was that it was not as accessible. Clyfford lamented,

> I think that the biggest tragedy that has hit this industry is the rise of the popu-
> larity of it. I think that tattooing used to be a world that you had to seek out.
> If you wanted a tattoo, maybe you had to go someplace that you weren't very
> comfortable with, and you had to go out of your circle to go find [it]. There was
> a certain respect for tattooers, because you had to go through all this crap just to
> find them. Finding somebody, and when you find somebody that does work that
> you like, and it's really good, then there's a certain respect there that I feel like
> has been lost.

And then on the tattooer's side of it, there's been a flood of people across the last 10 years that are like, "Oh, well, I don't want to work in an office. I want to be a tattooer. I love this *Miami Ink* show, and those guys party all the time, and I'm gonna be a tattooer 'cause that means I can party all the time." It's just gotten saturated, and the people that are in it that really care about it, that will be here forever and would've been here without any of that stuff, they're still here. They're just now surrounded by all these idiots that don't care about it; they didn't put the work in.

I don't want to sound like a grumpy old man because that's not who I am, but it kind of sucks. Kids will come in here and ask for apprenticeships, and they have no tattoos. And I'm like, "Well, where's all your tattoos?" And they're like, "Well, I don't want to have any; I just want to do 'em" . . . Like, how could you possibly think that you have the right to do this to somebody if you don't even know what it feels like? What are you going to do when somebody is getting their ribs tattooed and they're freaking out and crying and screaming and they don't know what they're going to do? You can't even talk to them because you don't know what they're going through. It's really something that, like I said before, if you're going to do this job, you need to live it. That is what it is: you're going to be covered in tattoos because you love tattoos.

By providing people with access to tattooing, the culture itself loses a degree of mystery and intrigue. This conflicts with the old-school ethic that values traditional ways of learning about tattooing or becoming involved with it. Additionally, Clyfford noted that many people want to be members of the craft, including those who lack a passion for it. These people want to become involved for all the wrong reasons: partying, money, fame—the values many tattooists have sought to separate themselves from to legitimate their occupation.

The significance of the magazine industry and reality television is that both are external threats that altered how tattooists work. In response to the increased public attention, tattooists developed sets of meanings to manage these threats. To manage the increasing segmentation of the magazine industry and the lack of content oriented toward them, tattooists developed their own mechanisms of publishing. As television shows became popular tattooists employed the values of the old-school ethic to dismiss media constructions.

As the popularity of tattooing grew, entrepreneurs, who were outsiders, increasingly viewed it as a profitable industry. These outsiders wanted to profit from all things in tattoo culture by commodifying it. For tattooists, the concern was over the production and distribution of materials or equipment needed to conduct their work. They viewed entrepreneurs as challenging the collective values of the occupation, since they disrupted control tattooists had over the means of production.

A New Era of Professionalism

The 1960s were marked by the beginning of the Tattoo Renaissance, a transition in the occupation that featured more tattooists who were trained at universities and art schools, pursuing tattooing as a medium.[8] Those most often associated with this movement began their careers in tattooing sometime between the mid-1950s and mid-1960s.[9] Those involved sought to establish professional associations to increase their public standing. Two key events occurred surrounding these efforts.[10] First, those running National Tattoo Supply founded the National Tattoo Club of the World (later renamed the National Tattoo Association). Second, Dave Yurkew organized the First World Tattoo Convention of Tattoo Artists and Fans, an event associated with the North American Tattoo Club. Both show how tattooists asserted control over the occupation to improve their reputation in the public.

Concerning the former, National Tattoo Supply, founded in 1974, became the most dominant supplier for at least two decades. Their success involved profiting from the distribution of equipment. National Tattoo Supply had a business philosophy that avoided traditional advertisement, and they only sold equipment to known professional tattooists. They excluded outsiders from buying tools and materials by only selling to known tattooists. While earlier suppliers inspired this ethic, National Tattoo Supply pushed for complete control over the means of production.

Recall that notable tattooists created supply companies in the 1920s and '30s. Many of them also advertised their wares in the backs of popular magazines that appealed to men, such as *Popular Mechanics*. Even later suppliers like Milton Zeis (who sold supplies from 1951 until his death in 1972) would peddle their tattoo equipment to anyone.[11] National Tattoo Supply's effort to corner the market was a response to suppliers like Zeis. It was an attempt to separate professional tattooists from all others by limiting access. To dominate the supply industry, National Tattoo Supply gave dues-paying members of the National Tattoo Club discounted prices, pulling them away from rival suppliers.[12] To further limit access, they conducted reference checks to determine who was a trained tattooist. This protected the possession of tattoo equipment as an honorifically earned rite of passage.

While National Tattoo Supply was attempting to limit access to the world of tattooing, the North American Tattoo Club was pushing the occupation in a different direction. Dave Yurkew would host the First World Tattoo Convention in 1976. Prior to this event, tattooists did gather and share ideas. In fact, there were even several tattoo clubs that held meetings. However, these were generally small groups of tattooists who associated with one another.[13] The First World Tattoo Convention was the first organized event open to all tattooists—and the public. It provided a new forum for the diffusion of

tattooing. Yurkew's convention went on for five years. Seeing the potential of tattoo conventions, the National Tattoo Club—now known as the National Tattoo Association (NTA)—began to host their own events, typically a week removed from Yurkew's.[14]

The convention organized by Yurkew centered on changing the public image of tattooing and creating a codified set of ethical guidelines for the occupation. In attendance were Cliff Raven and Spider Webb, who were associated with the Tattoo Renaissance and had university training in the fine arts.[15] An article in the *Chicago Tribune* about the convention stated,

> "Tattooing isn't what people think," said Yurkew. "It's not all drunken sailors and carney men with dirty needles. Those days are all gone and tattooing is a legitimate art form. Many of us think of ourselves as serious artists, and we intend to upgrade the image and educate the people so they know tattooing is a safe, decorative practice. It's not nutty or sick. It's art for the sake of art." And for the sake of reputable tattoo artists who want to clean up the profession, Yurkew organized this convention to form a guild and establish bylaws and a code of ethics.[16]

The effort to change the public image addresses a collective problem of the occupation. It reveals that tattooists wanted to have the authority to judge safety and show that the practice was neither immoral nor psychologically deviant. Additionally, Yurkew references tattooing as a legitimate artistic practice. This is a significant shift in language, defining tattooists as serious artists. Moreover, he claims that tattooing is art for art's sake, or that it is an independent artistic activity. The goal of establishing a set of guidelines for the occupation is a step toward having a formalized code of occupational ethics controlled by tattooists. These efforts show how key figures of the Tattoo Renaissance addressed occupational problems by calling for both professional and artistic independence.

In 1979, the NTA held their own national convention. Following these meetings, the NTA sent surveys to its members, soliciting input on the occupation's goals and future directions. They summarized the data as follows:

> The outcome was that you wanted conventions, every year. You wanted contests and wanted them judged by all attending. You wanted the club to continue along with the newsletter. Fans could join only if they were already members. If new ones wanted to join they had to be recommended by 2 tattooists in the club and have at least 4 tattoos, send in photos of themselves and the name or names of their tattooists. Artists who were already members could remain members any new tattooists wishing to join had to send in photos of their work, their business card, photo of themselves in their studio or the studio they worked in and they needed to be recommended by 2 artist members.[17]

The NTA began developing professional standards. They claimed authority over judging tattoos at contests, controlling the symbolic reward system among tattooists. They also created restrictive standards for who could be a member of this association. The significance of these contributions is that the NTA contributed toward the growing degree of occupational independence in the industry. NTA would remain the dominant association throughout the 1980s and '90s in the United States.

Health, Safety, and Self-Regulation

By 1992, some tattooists began to form other types of professional associations. While tattooists always valued self-regulation, the Alliance of Professional Tattooists (APT), founded in 1992, was the first association intended to promote the issue of health and risk-reduction practices among workers. Originally located in Glen Burnie, Maryland, a suburb just south of Baltimore City, the organization was initially composed of a few tattooists, and medical professionals, interested in reducing the risks of blood-borne diseases. The organization still disseminates information and offers a course on the prevention of disease transmission in tattooing. Medical professionals—such as Kris Sperry, MD, chief medical examiner for the Georgia Bureau of Investigation—worked with the association to create these initiatives. This effort was an attempt to solve a collective problem of the occupation. On the heels of the AIDS epidemic, tattooists became concerned with their public image—their supposed dirty work—and needed to promote an image of health and risk-reduction practices.

The APT is a voluntary association. It lacks political power, and much of the substance of its training is available through the Red Cross or any number of health organizations. Edgar grumbled,

> The APT is kind of, in my opinion, it's—it doesn't have any teeth. It's a group you belong to to give yourself some credibility to the public. Where you can put a sticker on your front door that says you're a proud member of the Alliance of Professional Tattooists, but it doesn't, they don't . . . If it comes down to it, [if] you've got a litigation issue in your state where the legislators [are] trying to pass some sort of, anything to do with tattooing, they're not there to help you. They're not there to lobby, because [of] the way the organization is set up. The only thing they do, the only thing they offer anyone aside from some fake credibility is that you can take a PDTT [Prevention of Disease Transmission in Tattooing] course through them.

The APT's formation and continued efforts reveal how tattooists respond to collective problems. In this case, they sought to defend their world as unproblematic through a professional association. Despite the absence of formal

regulations, tattooists collectively protect their business interests and their occupation's reputation in the public. Without professional associations lobbying on behalf of tattooists, the occupation remains in the margins of formal institutions and organizations.

How tattooists understand the role of public reaction as a threat to their occupation demonstrates their value for occupational independence. Many fear officials will regulate or control their work in response to a disease outbreak or unsafe practices. Tattooists believe it is necessary to self-regulate to keep the state or its agents from poking around their business. Margaret emphasized these fears when she told me, "I hope that the government really stays out of tattooing, because it's something that I think, right now, it's such an artist-based community, to where we have such a kinship, and we of course want to look out for public safety. I have taken [training courses on] blood-borne pathogens, CPR, all of those things . . . Certain mandates are fine, but I really hope that it doesn't go too over the top, because it has—for instance, in hair, there's asinine regulations that really just boil down to [the state making] a buck." As she explains, tattooists are dedicated to protecting tattooing from outside forces, who may introduce cumbersome regulations. In the absence of official mandates, Margaret, like many other tattooists, believes interference from the state would disrupt her independence. Training to reduce health risks helps tattooists maintain independence by avoiding state intervention.

Contested Distribution

Tattooists traditionally relied on close-knit networks to distribute tools and equipment. These networks maintained boundaries between insiders and outsiders by only distributing equipment to known tattooists. However, this model of organization changed as entrepreneurs began producing and distributing tattoo equipment to anyone who could afford it. These entrepreneurs were savvy businessmen who sought profit from a growing industry. Remarkably, tattooists responded with the old-school ethic, which supported their ability to maintain control over the distribution of tools and equipment.

Traditional distribution of tools and supplies involved localized craft production. For over a century, there have been supply companies in tattooing. However, occupational insiders owned these companies. This model involved the exchange of goods, but it emphasized earning the right to possess them. Personal contacts and insider status were essential in this system. Entrepreneurial exchange emerged as a consequence of tattooing's growth in popularity. Entrepreneurs introduced a commodified market for tattoo equipment. Entrepreneurs also had little connection to the history and culture of tattoo work. The most notable change was that they did not rely on localized craft production to produce and distribute their wares. This model of distribution

violated the code of tattoo work and limited the degree of control tattooists have over the distribution of equipment.

According to some tattooists, entrepreneurial companies are profit motivated and have little respect for the traditions of the craft. John Lee described the different values tattooists and entrepreneur-owned distribution hold:

> I try to keep it all in the family if possible. Yes, I do buy needles occasionally from a supplier that I know is a fucking shithouse. It's fucking up in New York City, and they just, they would sell to your fucking six-year-old kid. Everything else, I pretty much—like my pigments, and my machines, my tubes, everything I use. My tubes I use were manufactured by us. I manufactured some equipment years ago, and I still have all of it. So that's what I use. So I really try to keep it close to the heart. That's the way I tattoo. I don't just buy shit haphazardly all over the place. That stuff, that eBay stuff from China and those $25 machines, that's the crap, and that's the stuff that's really causing trouble. That's the stuff that the schmoes are getting a hold of and really scarring people up [with] and causing health problems and bringing undue attention on those of us who follow the correct path.

The entrepreneurial model of distribution emphasizes selling tattoo equipment regardless of its perceived quality, for profit from anyone who could afford it. John Lee believes this violates the code of tattoo work and that it is a dishonorable way to distribute equipment. It gives outsiders who have not earned the right to possess tattoo equipment a relatively easy path to attaining equipment. He noted that he tried to keep things "in the family," or within the traditional networks of distribution.

Others fear the products provided by entrepreneurial supply companies may not be safe. They worry that entrepreneurial producers do not rely on the body of knowledge that tattooists have collectively generated. Like many other tattooists, William stated, "You have a lot more people thinking they're making good products when they're not. They're importing shit from China. It might not necessarily be just the components that they're using, but it could also be that they could have mercury in the solder, or lead in the pigments, or anything. When you're doing subpar ordering and you're trying to counterfeit a product that we use, something that's going into her skin, and you're cutting corners like that . . . They just want your money. It's a major problem." When tattooists make their own products, they know exactly what is in them. Among tattooists, there is a shared trust and time-bound body of knowledge about products and their safety, despite the lack of formal regulations. People develop personal contacts with the producers of these products, whose honor and reputation within the tattoo world is on the line. However, entrepreneurial supply companies do not face the same kinds of risk as individual producers.

As entrepreneurial supply companies have increased in number, the market for supplies has become flooded with machines, needles, pigments, power supplies, and other materials used in the tattoo process. This has increased the availability of equipment, allowing outsiders to have easier access. Mike described these changes: "Back when I started you just couldn't get [equipment] and have it come to your house. It just was impossible. Now everybody is doing it, and people are doing it in their homes, and that's how they're making money. So they'll [entrepreneurial suppliers] sell equipment to anybody and not care that these people are jacking people up. And that really should come back on the supplier, but who's going to enforce that? They're just turning a dollar, man. These are business types just getting in on a good thing." Mike's concern centers on the changing value of tattoo equipment. Many others echoed this concern, indicating the deeply held symbolic value among tattooists in opposition to the monetary value among entrepreneurs.

According to some, the combination of large supply companies, unscrupulous shop owners, and the internet allows tattoo equipment to fall into the hands of the untrained. For Mason, "A guy that just picks up and buys a kit for 250 bucks on eBay—'cause that's how much they are . . . You get ink. You get needles. You get a shitty machine, and you get all the basic needs. They even give you a disk for flash, different pieces of stuff, and transfer paper . . . And some Joe Schmoe'll buy the kit online, and it's easy 'cause you can get 'em from anywhere. You figure they would not just sell them to anyone, but a 15-year-old can get a credit card and buy it online." Mason is describing one of the more expensive tattoo kits. Some of these kits sell for as little as $20, making the tools affordable to anyone who has access to the internet. This contrasts with the high-quality hand-built tattoo machines produced by those working within the occupation, which generally cost between $300 and $500 and do not include anything (needles, tubes, inks, methods sterilization, drawing materials, and flash) other than the machine itself. Inexpensive tattoo kits are mass produced. This is a direct offense to the old-school ethic of tattoo work, which favors handmade goods.

Before these kits, acquiring the equipment needed to produce a tattoo was an expensive, and time-consuming, process. One needed to seek out tattooists, gain their trust, and learn where to locate equipment. Now entrepreneurs sell kits online to anyone who can afford them (as of this writing, Walmart .com sells one for $26.99). George depicted how this has affected the process of becoming a tattooist:

Nowadays, you can just go on the internet, and it's [tattoo kits are] just readily accessible to anybody. So that being the case—and China is flooding the market with all kinds of stuff, so there's price gouging and everything going on. They're competing, and the prices of tattoo equipment have dropped to the point where

it's retarded cheap. So you can just get a kit, it doesn't cost a lot, the price now is not an issue for you to get good equipment. Like, that whole homemade tattoo machine thing, that's pretty much almost played out completely. If you're working in your house and you have a homemade tattoo machine, you need to get your ass whipped. You can go onto eBay and get a machine for $20. A tattoo machine for 20 bucks—what the fuck is going on? So that means that leaves the door open for anybody to start doing tattoos. Before, the price of the equipment was a barrier. Like, if I'm 16, where the hell am I getting $150 to buy a tattoo machine and then $200 to buy power supply? So that kind of, like, slowed you down. It wasn't going to stop you but slowed you down, because you don't have the money to buy that stuff. Nowadays, anybody can get a kit.

George is explaining that tattooists have lost some control over the networks of distribution. Prior to the influx of entrepreneurs, tattooists were able to set prices, and control who could or could not have access to the tools, by simply denying them. When entrepreneurs moved into distribution, they were not bound by the same cultural codes and instead sold less expensive equipment to anyone who could afford it. Hence, these entrepreneurs removed some of the barriers to attaining equipment.

In general, many of those working in tattoo shops feel frustrated. This frustration stems from a collective sentiment that outside interests threaten their system of tradition or honor. This source of tension is clear in Brenda's account:

> I just feel like all the people that don't . . . Just the people I've worked for that did own shops [and didn't tattoo] just didn't understand that it was more than just about money. And they would try to do things that were counterintuitive to the integrity of the industry, like selling supplies to people that aren't trained. It's absolutely horrible to me to do that, and some of them do. They treat it as this commercial industry where they're just putting out supplies, ordering them, selling them to the public, who requires no training. That is wrong; it should not happen. I don't believe that is helping the industry at all. So they're really concerned with money and not about integrity. They just don't understand; they haven't put in the time to understand the industry fully, and what it entails.

Those tattooists like Brenda who have apprenticed and become established view this from a position of privilege. In their eyes, only trained tattooists have the right to possess tattoo equipment. Most of those interviewed sided with the old-school ethic. They demonstrated this by resisting entrepreneurial companies and purchasing from tattooists or tattooist-owned suppliers. Again, tattooists responded to an occupational threat by invoking their code, which values control over the means of production.

Mechanistic Production

Traditionally, tattooists fabricated much of their own equipment, tools, and materials. Increasingly, the mechanical production of tattoo equipment has replaced human effort. This occurred because entrepreneurs were able to produce inexpensive needles. Tattooists contend that the craft of their work has begun to disappear as machines are replacing human effort. At the same time, these changes have enabled tattooists to maximize their labor.

Making needles is a painstaking, monotonous process. It involves using a jig to organize small needle points into a grouping, soldering that grouping together, soldering that grouping onto a needle bar, and then sterilizing it. It is a tedious job that requires patience. In the late '90s, high-quality needles that were mass manufactured became commercially available. Needles no longer needed to be individual works of human craftsmanship. Instead, tattooists could purchase them prepackaged and sterilized. John Lee explained why he switched to purchasing needles: "You're wasting your time [making needles]. You can buy a needle for like 25 cents. Why sit there for 15 to 20 minutes of your life, wasting it, when you can just buy a needle for 25 cents? It's pointless. You can't beat these guys on their pricing at all ... I made my own needles until a few years ago." Of all the tattooists interviewed, none made needles regularly. Some occasionally made an infrequently used or odd-sized needle by hand. Mechanistic production has eliminated the mundane and repetitive labor of making needles. Despite this shift, people did not report feeling alienated but were relieved that they could focus more on applying tattoos than the craft of tattoo work. This marks a distinct shift away from the traditions of the craft.

Some tattooists were concerned that the craft of tattooing was disappearing. They believed that as mechanistic production replaced human effort, people would forget the traditions of tattooing. They viewed making needles as a part of becoming an expert in the craft. Glen lamented that "it's [making needles is] an art form within itself. And it's really kind of dying. Just out of necessity. There's just very few people that still make their own needles, because it's so difficult, and it's so time-consuming. You know, it just—once you start getting busy, any time that you're not tattooing, you're just kind of losing money." Some who have recently become members of the occupation have never produced needles. Glen continued, "I haven't made, I've never made a needle. I would like to though. I would like to at least once." This reflects Glen's statement that the craft of tattoo work is beginning to disappear. The culture of tattoo work is disappearing as mechanistic production replaces human effort.

Despite how this craft of tattooing is being threatened by mechanistic production, many still want to make things by hand. For example, Edgar stated, "Like anything else it's like, I wanted to learn how to make needles, and I

wanted to learn how to mix pigment, and I wanted to learn—I wanted to learn how to take care of my own tools. It means a lot to me to be able to do that. Because what's the point today, you can buy anything you need?" Edgar's comments illustrate how deeply workers value having a human connection to their craft. In general, tattooists have been resistant to changes facilitated by mechanistic production. This is because the values of tattoo work are instilled in the old-school ethic, which favors localized, authentic craft production.

Increased Knowledge Diffusion

Few avenues traditionally existed to diffuse information about tattooing. Most of this occurred through mentorship, letters, word-of-mouth, or conversations in shops—and more recently, at tattoo conventions and through magazines. Books and videos simply did not exist aside from the minimal materials produced by a few distributors.[18] The lack of accessible information prevented many from entering the occupation. In depicting when he first started tattooing in the mid-'90s, George said, "Like, when I first got into it, it was really kind of like you had to be in. It was kind of like a gang-type thing: You had to be initiated. You had to be in. Nobody is telling you anything about tattooing." Established tattooists controlled the occupation and regulated membership by limiting its access to outsiders. Tim depicted how they valued this information: "The guys that were doing it back in the old school, it was the mentality. It was like a guarded mentality. Like, 'We have to keep this sacred. We have to keep this ours, and we're only gonna teach people who we want to teach.'" This control limits access to trade secrets often only exchanged with trusted associates.[19]

As the industry around tattooing grew, some seized opportunities to diffuse information about the craft. They created how-to books, DVD guides, internet videos, message boards, and websites. Many of these are publicly available, leaving tattooists with little control over who has access to this information. Mediums such as YouTube provide anyone with an internet connection access to what once were closely guarded secrets. Mike stated, "You can watch somebody on YouTube do a live tattoo, one of these artists that you maybe look up to. You just get on there, type his name, and just watch him tattoo. And a lot of times, they'll have, like, a camera on their glasses, or right on their heads. So you're really, really in close, watching what they're doing." This helps spread tricks of the trade and improve the skills of many tattooists. However, because this involves making the craft available to anyone, it violates the old-school ethic. Tim described this source of contention: "There's more information sharing, and there's people writing books and DVDs and things like that, so it's not as guarded as it used to be. Some more traditional tattooers that I talk to are pretty salty about that. They're very much about the tradition of keeping it sacred and keeping it something that we don't talk about." For established

tattooists, these new mechanisms of information diffusion present a threat. No longer are they keepers or guardians of their craft. The occupation loses its control and ability to assign a meaning of sanctity or sacredness, where tattooing is honorifically passed on through tradition. If these traditions are no longer relevant, then members of the occupation cannot claim to possess special expertise passed down, honorifically, from mentors.

Authenticity and Tradition

When threatened by change, tattooists have been resilient in maintaining their distinct world, and its boundaries. This occurs because of the old-school ethic, which values authenticity.[20] Authenticity is "an idealized representation of reality," or the "credibility or sincerity of a performance and its ability to come off as natural."[21] Authenticity, or authentic cultural representations, are produced as people define the quintessential elements of their group culture.[22] They engage in a symbolic economy with a "network of commodified signs, social relations, and meanings" being created, distributed, and consumed.[23] Sociologists are concerned with the processes used to create and define authentic meanings as a reality for social groups.

Concerning tattoo work, tattooists invest in creating, distributing, and consuming authentic representations of their culture. This preoccupation involves determining what is authentic. They do this through their identities, provenance ownership of tools or machines, sources of information, and values or beliefs. Authenticity is a symbolic resource that correlates with status in this world. It is a type of resource tattooists draw on to demonstrate their status among others. These representations are a source of contention that they continually define or redefine.

Many tattooists establish their authenticity through their abilities as a craftsman. Being a skilled craftsman means possessing the skills and knowledge to fabricate many of the tools or materials needed to create a tattoo. Those who possess more skill in fabrication generally have more prestige. For example, Kevin always proudly described his skill as a craftsman: "I learned how to make my own needles. Which unfortunately, a lot of guys don't know nowadays. They just know to make a phone call: 'Hello Eikon,' [or] 'Hello Mytho [both are supply companies]. I need this and don't know how to do it.' I spent like six hours a day in the garage at his [mentor's] house, learning how to make these things." Kevin depicts his identity as being more authentic than others because he, unlike them, understands the craft of tattooing and demonstrates his ties to its history.

Some objects take on special qualities in tattooing. They become special because they are associated with higher degrees of authenticity. For example, tools, flash, or machines produced or owned by legends and masters have more

authenticity. Joseph specifically named the builders or former owners of his tattoo machines: "My machines [are from] Seth Cefarri, who is a tattooer from Baltimore. Jimmy Whitlock, I really like his machines; he run runs a supply company out of Florida. I got a couple machines that were built by Mike Malone and Sailor Jerry, some of the guys that I consider masters." Noting who made or owned his machines is a way of indicating authenticity and tradition. Machines that are traceable to specific legends and masters, or notable builders, are important for demonstrating authenticity. They take on a special quality within the tattoo world. Joseph's possession of them is a measure of his authenticity.

Once tattooists become familiar with the old-school ethic, they begin to assign additional qualities to machines. Joseph explained the values of his tattoo machines:

> Yeah, they are all handmade. I have one that was a mass-produced machine, that I kind of tinkered with so much I don't really consider them the builder of it anymore, just because I've taken it apart and put it back together so many times that it kind of lost its mojo from that person ... I think it is something that's just a little bit more—it is the way that tattooing is supposed to be. You know, you're supposed to build this stuff with your hands. You're not supposed to have machines built for you. All these mass-produced machines, they are lacking the quality and care that one person is going to put into the machine when he is putting it together himself.

Notice that machines are not just a tool to Joseph. Instead, he assigned values to them that align with the code of tattoo work. These values are reflections of the deeply held traditions of tattoo workers. Who built the tools and how they built them affect the values assigned.

Clyfford elaborated on this by contrasting handmade machines with those produced in factories: "You buy a machine from a factory that nobody's ever touched: it's a sterile, chrome piece of something. When you hold a piece of iron that has file marks on it because somebody sat there in front of the TV filing this thing down and shaping it and making it look cool, then it's got a soul. It's like musicians and their guitars." As Clyfford described it, machines produced in the factory lack that special quality of having a soul, or human touch, whereas handmade machines are personal because they reveal the efforts used to create them. "Having a soul" is that magical and special human quality tattooists assign to machines. Those machines with a soul epitomize authenticity.

Machines can possess special qualities because of the personalized networks that tattooists establish with one another. These networks involve exchanging cultural objects that reflect tattooists' values. Samuel describes the importance of these networks:

These guys [machine builders] basically put it together the way that they would tattoo with it and ship it out to you. Some of 'em even use it [tattoo with it] for a little while, like a couple days or a month. And then they'll ship it out and make sure that it's good and that it runs good, and they'll tweak it here and there. Besides that, when you buy machines like this that are from an actual artist, if you have problems with it, if it's not running the way you want it to, 9 times out of 10 you can send it to 'em, and they'll tweak it to the way that you want.

As an object, the machine symbolizes a relationship that is not reducible to economics. Machine builders take pride in the quality of their equipment as they tune and rework their machines. There is honor in being able to craft a tool that others rely on. The handmade machine represents a connection to an expert or master. As an object, it is specialized, personalized, and authentic. As a tool, it connects the user to the mind of its creator.

Figure 7.1 represents how tattooists understand the authenticity of machine ownership. At the top of the chart are the most authentic ways one can obtain a tattoo machine, and at the bottom are the least authentic. Those deeply embedded in the culture of tattooing are the most likely produce and/or own more authentic machines. The most authentic ways to acquire machines involve close connections to human producers.

It is possible to show the value of authenticity in ownership by observing the ways tattooists describe acquiring machines. Edgar enthusiastically showed me the machines he owned. Some he made, and others he traded for, and still others he purchased. His description demonstrated the value tattooists place on having a personal connection to a human who crafted the machine:

Virtually everything I own is handmade. Because I either, I've visited people in their workshops and made my own machines—like this one. [*Edgar begins to pull several tattoo machines of a drawer to show me.*] I made this one. I made this in the spring. I made this, oh, about 2009. I made this in the fall of 2009 at this guy Aaron Cain's house. I made this at my friend's; I went out to visit my friend Seth

Degree of authenticity	Means of machine attainment and production
High	Handmade personally
	Handmade and buyer shares a personal relationship with the maker—the machine was attained through noncommoditized means
↑	Handmade—the machine was purchased
↓	Purchased from someone who previously owned a handmade machine
	Factory produced but manipulated by the owner to customize the machine
Low	Generic factory-produced machine purchased from a large supply house or off the internet as part of a "tattoo kit"

FIG. 7.1 Authenticity of machine ownership

[Ciferri], and I made this. He's the first guy to make tattoo machines in bright-pink colors, just because no one ever did it before. Because it wasn't macho, and so he was the first one that did it. So I figured if I was gonna make one at his place, I should make it pink. And just pretty much everything else I have, I've either made myself—there's not a lot that I haven't made. Like, I made this one, and I made this one, but everything else in this drawer someone else's made for me. [*He opens another drawer, and there are at least 20 tattoo machines in it. Then he opens several other drawers stocked with just as many tattoo machines.*]

Notice how Edgar describes having a high degree of authenticity and position within the networks of exchange. The entire conversation involves him showing me the value of handmade objects and the personal exchange relationships he shares with others. Tattooists embedded within established networks can attain the machines considered the most authentic, often avoiding financial exchanges to attain them. Those not embedded within these networks must purchase their way into ownership.

The importance of establishing networks enables tattooists to avoid the commodification of their world. After Edgar showed me his collection of tattoo machines, I remarked that it must be a financially valuable collection of machines. He sniped back,

I don't buy tattoo machines . . . I've traded with people over the years, or I go to somebody's workshop. If somebody comes to my workshop, we mix colors. If I go to someone else's workshop, we build a machine, or in some cases, some people I've never met—I literally just, I'm like, "Hey, are [you] up for trade?" If I use any kind of social thing like Instagram or Facebook, and if I end up communicating with somebody I know—"Man, I really like that machine"—they might off the bat just go, "Hey, well, are you up for trade? Could you send me some colors, and I'll send you this machine?" I don't get to paint as much as I'd like to, so a lot of times, I'll trade for painting. I'll trade colors for a painting or might trade colors for a machine.

Edgar's comments reveal the personal ties he established with other tattooists. The value of the objects he possessed was in the relationships he shared with others. While people exerted labor and exchanged objects, money was not the basis of this transaction. Instead, they relied on bartering, often justifying this as the traditional way of doing this, which has enabled tattooists to avoid the full effects of capitalism in their relationships with one another.

Trading allows tattooists to establish networks of exchange that are resilient to the forces of capitalism. In describing his custom-made machines, Dorsey told me about a recent agreement he made with a local machine fabricator: "I like these very functional but decorative ones. Norm Wright is the guy that

made these. Like, they're very well made. [*He shows me several machines.*] But he also goes in with a Dremel and makes these sick little patterns on them and stuff, so they're all custom and personalized. He is building two machines for me 'cause I did his back, and we won best back piece in Baltimore [*shows me a picture of the full back piece tattoo on the wall*]." Instead of receiving money for his labor (full back pieces cost thousands of dollars), Dorsey's compensation was two handmade tattoo machines from a well-known machine builder. The value of these machines is not easily reducible to money in this type of relationship. Those machines were an exchange for a tattoo, a type of cultural good, which is priceless in capitalism.

Others demonstrate their authenticity by collecting tattoos from notable people within the world of tattooing. When describing learning about tattooing, Joseph told me about his experience with Dave Fox, a well-known contemporary tattooist from the Philadelphia area: "I think that's probably where I learned the most, was by watching somebody tattoo me. The actual best part, or the best advice I ever got, was from an artist, Dave Fox up in Philadelphia. I was at a convention up there. I got tattooed by him; I got tattooed on the side of my neck, so I couldn't really see what he was doing, but he just moves so fluently, and precise, and I could just feel what was going on, and I knew that he was knocking it out of the park basically." Joseph was simultaneously admiring and critiquing the skill of this tattooist. As an admirer, he defined his position within this world by having a distinguished tattooist work on him. As a critic, he learned how another works by feeling and hearing his technique and performance. Moreover, his neck bears marks produced by the hands of a contemporary master. His neck demonstrated that he was consuming tattoos from someone whom other tattooists hold in high regard—that he was in the know as a tattoo consumer and tattooist.

These methods of demonstrating authenticity also occurred when tattooists told stories about their time spent with legends or masters. Clyfford once met the late Philadelphia Eddie and told me a story about hanging out with him:

> I think this guy, Philadelphia Eddie—he's an old historical tattooer from Philadelphia. I met him at a convention one time, and it was really cool, 'cause we were just kind of sitting at the bar, just talking about whatever. Just hanging out. And he told me that tattooing was one part being a good tattooer and one part being a good entertainer. Being able to talk to people and figure out where they're going, and where they've been, and tell 'em stories, and make sure that when they're coming to get a tattoo from you—they're sitting in your chair for four hours in pain, but [you're] trying to make that a good experience so that when they leave, they're excited, and they're like, "Aww man, I just had so much fun even though it hurt like hell the whole time. That was really cool."

As a story, this demonstrates that Clyfford had a relationship with one of the legends of tattooing. It is a claim of his connection to the history of American tattooing. This story ties Clyfford's experiences to a legendary tattooist, demonstrating his own authenticity.

Occupational Folklore

Tattooists use occupational folklore to diffuse their cultural beliefs or values. *Folklore* is information that common people share with one another, and the platform for its dissemination is everyday life.[24] Folktales supply a common frame through which tattooists can interpret their work or experiences.[25] Each folktale has some element of truth, and each one addresses problems of the occupation. Tattooists use folklore to address health hazards and occupational risks and workplace cohesion, as well as to construct a shared history and marginalize outsiders. Through this oral tradition, tattooists and shop owners defend the occupation from collective threats and resist change. Folktales serve the purpose of maintaining social control by telling people about the rules within this world.

Like some other occupations, tattoo work presents some risks to participants. Tattooists are primarily concerned with reducing the risk of disease transmission. Every tattooist I spoke with mentioned this issue. One type of folk narrative among tattooists that addresses this problem is the cautionary tale. In describing his worries about blood-borne pathogens, William told a version of this tale:

> I mean, to think about all the people that I've tattooed . . . all the people that I've tattooed that weren't honest on their consent forms that have had it. That scares me. I also get tested every three months for hepatitis because of what I do for a living. There was a girl I tattooed a couple of years ago that openly told me she had hepatitis. Like, when we were done [with] the tattoo. And I was a little bit pissed off because on the consent form it clearly asked [about that]. So I politely told her, "Look, you lied on your consent form; that puts me at risk. You got tattooed knowing that you had a communicable disease; that puts me at risk. And now you're telling me after the fact. I am respectfully asking you to not step foot in my shop again, ever. I don't care if you get tattooed by another artist here. I will not tattoo you, now or ever," because she put me at risk.

William tells this story as events that happened to him. Many different tattooists have told me many variants of this tale. The details change in each version, but the basic structure of the story stays the same. It claims anyone can be a risk to your life and livelihood, as well as a risk to those in the shop and the larger collective of tattoo workers. It is a lesson about treating every client as a potential

health risk. It emphasizes the importance of having a work routine that focuses on cleanliness and conditions that reduce the risk of blood-borne pathogens.

A second type of narrative used by many tattooists are tales of dysfunction. These address the problems of comportment within the workplace or other social settings where tattooists are present. On the surface, tales of dysfunction are told to maintain worker cohesion and discourage tattooists from developing egos. More importantly, they are about upholding the traditions of tattooing. The essential quality of these stories is about the honor of the occupation and adhering to the old-school ethic. There are variants, but the general story is similar to what Edward told me: "You have these wonderful elitist-style tattooists, or again, these rock-star-style tattooists; they're going to do what they're going to do, and you're going to pay what they want, or you can fuck off and go somewhere else." The majority of those interviewed had some similar tale of meeting or knowing tattooists who had big egos, or those who thought of themselves as rock stars. Implied in this narrative is that the egoistic or rock star tattooist has not paid their dues. As a result, they tend to view tattooing in terms of financial exchanges instead of other values. This type of tale warns that tattooists must take the proper steps to progress in their career within the traditions of the craft.

Another version of the tale of dysfunction involves the problematic worker who disrupts the shared culture of the shop. Mike claimed, "I hate to keep going back to the egocentrics, but I don't like people coming in here with an inflated ego, thinking that their shit don't stink. That they're only going to do a certain kind of tattoo. I don't care what kind of level of tattooing they are [doing]. If they're phenomenal, I don't need somebody with a head that's that inflated to fuck up the karma of the shop." Not only are shops disrupted, but so are places like tattoo conventions. In discussing why he has begun to stop attending so many tattoo conventions, Ben claimed that egoism drove him away. Whether it was disrupting a shop environment or making tattoo conventions competitive, the common culprit was those with big egos. These narratives state a value orientation toward the craft of tattooing. Simply put, these tales claim that fame and fortune are not part of the traditions of tattoo culture.

An additional variant of this tale involves the skill of the tattooist. It also functions as a warning to novice tattooists. Several interviewees claimed there is an arrogant phase that occurs at the beginning of careers. Novices—still trying to understand the skill hierarchy—misrepresent or misunderstand their own skill levels. The tale is about developing the capacity to be self-reflexive and critical. Several tattooists told me a story like this one from Dorsey:

> Then there was like an arrogance phase, when I felt like I was doing it right 'cause I had like the low self-esteem, the lack of confidence. Like, you overcompensate with cockiness almost. I was like, "I'm awesome at this." So I kind of empathize

with—'cause I know guys that are newer in their careers, they get real full themselves, and tattoo artists are ego-driven fools . . . Like, I try to stay pretty humble. I'm pretty confident; I know that people like my work, but I can get better. And I don't think I'm the shit. I think I'm just doing my job.

This tale is a warning about learning the skills of self-criticism and self-awareness necessary to grow as a tattooist. As a form of folklore, it addresses the socialization of new members and defines their position in the social hierarchy. The tale conveys the message that a dedicated tattooist works on their craft rather than talking about themselves. Like the other variants, it conveys the values of the craft.

A third type of folklore employed is the contemporary legend. Contemporary legends establish a connection with notable tattooists. These stories address attachment to the history of tattooing. Most importantly, they disseminate a value of dedicating oneself to tattooing and preserving its culture. Several told stories of their time spent around older tattooists. One story told by Edgar is representative of this:

> There was this tattooer, and he died a few years ago; his name was Mike Malone. And he was the guy who, he basically—when Sailor Jerry [Norman Collins] died in '73, three people were offered Sailor Jerry's shop. We wouldn't even know who Sailor Jerry was without this event happening. We really probably would not know who he was, and you and I would absolutely not be having this conversation if this didn't happen.
>
> But when Sailor Jerry died, he left, he had told his wife in a letter that he wanted Ed Hardy to be offered his shop first, and Zeke Owen or Mike Malone after that [and if all three refused, to burn the shop down]. Ed Hardy was in Japan realizing a lifelong dream to tattoo in Japan. He wasn't coming back for anything. He thought he would be there for years. Zeke Owen was just kind of traveling. He had just gotten to San Diego, and the last thing he wanted to do was go to Hawaii. Why would he go to Hawaii? So it was up to Mike Malone, and he decided to borrow some money, and make this commitment, and buy the shop from Jerry's widow, Louise.
>
> And the one thing—I'm just trying to tell you who he was, because I think what he has to say is really important. And he, he went on to making his own contribution to tattooing in his own right. We have some of his flash downstairs on the bio room wall. Like up top there, that's a painting by him [*points to a painting on the wall*]. That little skull jammy, with the roses, is a painting by him. He made, he painted a lot of flash over the years and sold a whole lot of flash and a whole lot of paintings and a lot of tattoo machines that—he just kind of built them by hand off of a frame that he bought from one of the suppliers I told you about.

He would say to, he would always say to the people he tattooed—like, people who had no idea they were getting tattooed by this guy who, in a lot of cases, he'd be working in a street shop, and eventually he closed that shop [Sailor Jerry's old shop] and moved to the States, and he lived in Minnesota for a while. And people would come in and be like, "Oh, I just want to get a tattoo" from this old guy sitting in the chair. And he would always say, "Take care of your tattoo, and your tattoo will take care of you." It's like, if you really put a lot of thought into it, it doesn't mean anything, but it's a really nice polite little thing to throw somebody out the door with. And I think that's always stayed with me ever since I heard him say it. And in turn, you have to do the same thing with tattooing. You have to take care of tattooing, and you have to be good to tattooing, because tattooing will take care of you.

Narratives like this elicit a sense of shared history, a common understanding of the traditions within tattooing. Explicitly, the tale is about taking care of tattooing. Implicitly, it is about understanding all those involved, because you never know what someone did for the craft of tattooing. In this case, Mike Malone preserved much of Sailor Jerry's legacy. This implies that workers should treat tattooing as a sacred craft.

Summary

Like other occupations, tattooists must respond to external threats and clarify their occupational boundaries. External threats have caused tattooists to reflect on the rules of the game and modify them to retain control over their culture. A central concern of tattooists were the effects of changes brought about by the increasing popularity of the practice. At the core of this discussion was the co-optation of cultural representations. Many feared the occupation was losing its magic or its authenticity.

As many tattooists showed, they valued the old-school ethic. It is employed as a response to external threats to clarify the boundaries of the occupation. Tattooists' constructions of authenticity and folklore are mechanisms to sustain their boundaries by transmitting beliefs and values to members of the occupation. These characteristics of the old-school ethic reveal that tattooists rely on the past to cope with contemporary changes. Their culture, which is deeply rooted in tradition and honor, manages the effects of change. Compared to professions, which are often forward-looking for the next solution, the tattooist's worldview may seem illogical or irrational as a method to attempt to protect their occupation. However, this chapter illustrated how for tattooists, looking toward the past is a viable avenue for creating continuity in a changing world.

Conclusion

Continuity and Change

> In America we have no great traditions
> or long history. Part of tattooing's attrac-
> tion and strength is that it harks back to
> ancient systems of handcraft and oral
> transmission. Its very funkiness is a great
> asset to us in this streamlined world.
> —Don "Ed" Hardy

There is probably not a more well-known contemporary from the world of tattooing than Don "Ed" Hardy in the United States. While most are acquainted with his art, which has been featured on popular culture items, he was one of the most prolific writers and scholars of tattooing throughout the 1980s and '90s. His comment above is reflective of why tattooing has achieved such attention in contemporary society. It hints at the key features of tattooing's social organization. Contemporary tattooing uses a small business model of organization, with its members valuing a code of conduct based on tradition. As Hardy indicates, its key features seem to be anachronistic in contemporary society, which is rational, efficient, or as Hardy claims, streamlined. Yet it is tattooing's traditions that provide us with fulfillment, enchantment, and joy in a changing world.

Collective Activity and the Other End of the Needle

Moving beyond understanding the people who get tattooed is not an entirely new idea, as a few scholars have examined the process of determining what is

art or the documentation of material culture and its history.[1] Yet few have ventured toward understanding how tattooists collectively produce their social world, or their day-to-day reality. I did this by depicting culture as a social process. When facing change, tattoo workers continue to emphasize localized, authentic craft production based on their cultural traditions.

As a form of collective activity, tattooists construct their social world and create a degree of stability. Borrowing from interpretivist sociology, people learn sets of meanings about the world from others, then use those meanings to engage in social action.[2] Those meanings deemed useful are passed on to members of their world.[3] Social worlds exist because people create routine methods of action, ideologies, divisions of labor, systems of rewards, and cooperative relationships to solve practical problems.[4] Simply put, social worlds are the shared cultures of groups that exist through collective activity. For tattooists, this means having agreed-upon ways of doing things.

Take for example the different reward systems employed by the craftsmen and the artists. No one enters the occupation aware of these systems, how they operate, and how to achieve status within them. They must learn them through socialization to the occupation. These systems are not static, but tattooists have generally agreed-upon rules that dictate how to earn status. For artists, there is value assigned to aesthetic innovation or having artistic freedom. Craftsmen value the time-bound traditions of tattooing and the great masters. While there may be disagreement between these two orientations, they illustrate different sets of meanings people use to understand their work. These reward systems further demonstrate that tattooists are constantly engaged in efforts at meaning-making to negotiate the rules of the game. Collaboration and interdependence are part of what tattooists do to make their world operate. Otherwise, status, career progression, mobility, and socialization would never be achievable.

By examining the other end of the needle—tattooists and their social world—I have understood tattooing as a form of collective activity. A process-oriented perspective enables us to shift the focus to see all the people needed to create, distribute, and interpret culture.[5] In the social worlds perspective, people construct reality through their ability to learn meanings, self-reflect, and understand themselves in relation to other members of society.[6] Through this process, they become socialized as members of the social world, which has an agreed-upon order.[7] This order is constantly negotiated, but significantly, it requires social interaction to learn these meanings from others. My work on the social world of tattooing is akin to findings in studies of music, which focus on the ways people experience their membership within a music world and the active agents in shaping their reality.[8] Producing tattoos requires not only interaction with others but an understanding of how the world of

tattooing operates. Recall how scratchers struggled in this world due to their lack of interaction with established tattooists.

Independent, Localized Craft Organization

Tattooing relies on a form of social organization that values tradition. This model of organizing work provides insight for scholars, the public, and critics of capitalism. Scholars have examined a wide range of topics related to work. However, their research tends to focus on white-collar professions and formal organizations, or the service sector, working poor, or underground economies.[9] Tattoo work represents a middle ground between these two orientations. Research on the professions is concerned with how the demands of rationalism and career credentialism have led to a decline in the ability of workers to remain independent.[10] Scholarship examining the working poor or underground economies has focused on the transformations of capitalism (declining unions, removal of social safety nets, neoliberal policies, low wages), which have led to a lack of well-paying or meaningful work. Both traditions feature similar themes: the inability of workers to retain control over their forms of organization, and their independence, in capitalist systems.

Despite not having professional associations, unions, or a strong set of legal codes, the occupation of tattooing has retained a significant degree of independence. This occurs because of their cultural code—the old-school ethic. This code, rooted in tradition, provides tattooists with values, beliefs, expectations, and evaluations of labor, as well as sets of rewards. Tattooists sustain independence by exerting this code as a form of control over the occupation. Tattoo work emerged at precisely the same time that other forms of labor were losing their independence and traditions due to rationality.[11] The social organization of tattoo work provides one example of how an occupation can, through culture, retain its independence in advanced capitalism.

Tattoo work represents one avenue through which people can resist rationalization.[12] This is why it should be no surprise that tattooing has increased in popularity over the last two decades. Tattoo work requires the physical copresence of producers and consumers. Unlike other kinds of goods produced in capitalism, the consumers and the producers of tattoos share a personal and human interaction to create a tattoo. Tattooists also organize their world in ways that are not easily reducible to formal rationality. They rely on experience or achievements and not credentialism or formal education.[13] This is a kind of resistance to the rationalization of jobs and consumption. Tattoo workers illustrate how people can carve out a living and avoid some of the disenchantment experienced in other careers. Potentially, tattooists show us how

members of other occupations may find ways to organize that resist forms of formal rationality through independent, localized craft production.

Resilience to the Forces of Capitalist Production

Since the Industrial Revolution, sociologists have been concerned with the kinds of problems that stem from changes in capitalist systems.[14] In general, their concern has been about how changes brought about by capitalist systems dominate and/or dehumanize social life. Changes resulting from capitalism lead people toward feeling lost or a sense of worthlessness. What is interesting about tattooists is that their world has a degree of resilience to these forces.

Tattooists' distinct way of life and making sense of the world is an alternative to formal capitalism. The ways tattooing is socially organized, and the types of values or beliefs tattooists hold, demonstrate this alternative. A feature of their world is traditional action.[15] Their form of social organization values experience and honor over formal education and credentialism. As such, it provides an alternative system for finding meaning in this world. Importantly, it reflects a humanist approach to the production of cultural goods. Tattooists show this value in how they talk about their work. These narratives depict a resilient occupation that thrives on existing in the margins of formal institutions. As an occupation, tattooists have been successful in managing change and sustaining their cultural system as an alternative to credentialism, dehumanization, and disenchantment.

Tattoo workers do not entirely escape the forces of capitalism or modern society. Much of their time involves defending their world from these conditions. For example, untrained home tattooists, or scratchers, are a problem that threatens the lifestyle of tattooists, as they disrupt the market. Scratchers exist because entrepreneurs, not immersed in the culture of tattooing, understand there is a profitable market for the services of tattooists. Tattooists have been resilient despite the threat this may pose toward their occupation. The ways they have exerted control over their tools and notions of honor—ideas defined by the old-school ethic—demonstrates this resiliency. At the other end of the needle, a considerable amount of tattoo work involves upholding these traditions when there are threats to the occupation.

These traditions are also resistant to some of the values associated with the production of cultural forms in capitalism. Tattooists collectively value the humanist qualities of production. Members of the occupation report an alternative to the capitalist trend toward feeling alienated from the objects one produces, uses, and consumes. This is best stated by Edgar, who explained why he preferred to trade handmade objects with people: "I think there's also a part where you become friends with somebody. And sometimes, and some days, I'd rather have something in my possession that is made with love and care, and

years of experience, than some cash. And I think sometimes that's what people want in return." He values the love and care imbued in an object over materialism and mass production of goods for a wide audience. He notes how those with years of experience produce objects with a special kind of value. Edgar contrasts this value set with money in his pocket, demonstrating that he would rather enjoy the humanistic qualities of an object instead of its material value.

One key insight is that tattooists prefer personal relationships. As Edgar's statement above indicates, he would rather own an object that he can associate with the qualities of its maker. In this case, he wants to have machines and art that people made with passion instead of mass-produced objects and designs. Among other tattooists, the most coveted objects are handmade machines produced by friends, machine builders, or tattooists. These machines reflect the characteristics of their creators, as they are one-of-a-kind tools tied to the person(s) who produced them. These values provide a humanist alternative to capitalist production.

Tattoo work remains an industry dominated by small businesses. Large organizations, rationality, devaluation, and de-skilling of labor were not prerogatives of owners or workers. Instead, people focused on establishing small work groups and creating localized, authentic networks of exchange. Units of measurement like hours, wages, or salary are not relevant to the tattoo process. Instead, there is the outcome, a tattoo, and the total cost or time of its production is not reducible to standardized or uniform measures. The lack of uniformity and standardization represents resiliency to the forces of capitalism and their effects on production.

Moreover, tattooists rely on looking to the past to manage change. They do this by using the old-school ethic, their cultural code, which values the traditional, established way of doing things. In other words, when confronted with change, tattooists are not forward-looking. Instead, they refer to the past collective experience of the occupation to manage changes brought about by capitalism.

A Final Comment

In reviewing literature on tattooing, I noted some similar patterns.[16] Repeatedly, studies sought to explain the motivation to become tattooed or the meanings associated with tattoos. It became clear that the scope of existing research limited itself to the tattoo—the outcome of the process of tattooing. I became interested in how tattooists survived. This led me to the question "How do marginalized occupations organize in advanced capitalism?" My interest was in understanding how tattooists carve out a living.

By shifting the research question to the other end of the needle, I was able to examine the collective process of tattoo work. This moves the analysis

beyond the social psychology of tattooed individuals, and the meanings social groups construct around tattoos, to viewing tattooing as jointly produced, requiring people to collectively engage in defining their world. Tattooists act as individuals, but the sum of their actions sustains their world.

While tattooing may seem like an exceptional case, it is like many other occupations and professions, too. All occupations have some type of cultural code that delineates training and socialization, values and beliefs, divisions of labor, agreed-upon rules of the game, systems of hierarchy and career advancement, and preferred methods, and all are reliant on the wider culture of a society.[17] The difference is how tattooists define these aspects in their world. One afternoon, Kevin emphasized this similarity when he said, "I was talking to a kid the other day who was talking about doing an apprenticeship at another shop. I was like, 'If you ever get a chance, and you can swing it, go for it. There's no job like it.' And I use the word *job* loosely because, I don't see it as a 'job' job; I see it as, like, a way of making a living at something I really enjoy."

Appendix A

Methodology

This study began by seeking an answer to the question, "How do marginal occupations organize in advanced capitalism?" I arrived at this question after reading literature on tattooing and through my own experiences with this world. While many studies described the meaning of tattoos, it was clear that few sought to understand the work of tattooing. Despite its recent popularity, little is known about this work (unless you are a tattooist). My study examined tattooing as a form of work and tattooists as an occupational group that navigates the forces of society.

Study Design

This research was qualitatively driven but used quantitative measures. The qualitative data consisted of interviews and personal observations. Observational data documented the patterns of work and interactions I witnessed occurring among tattooists. Interview data provided the perspective of tattooists. Meanwhile, quantitative measures geospatially mapped the distribution of tattoo shops and measured the structural features of where tattoo shops were geographically located. To date, this is the only study statistically documenting every legal tattoo shop in the United States. By using different types of data, this research gathered a more complete picture of tattooing.[1]

This research used a flexible theoretical orientation, guided by key questions. In this process, I visited the field, gathered data, and continually attempted to understand it by leaving the field and speaking with other scholars. Only after gathering information and rethinking its sociological significance was I able to hone in on the theoretical and conceptual significance of the data. To conduct

research in this manner, I used a set of supplemental questions, which guided the data gathering process without imposing a theoretical model on the study. These questions were

- How was the business founded and what is the history of it?
- What causes the failure of a business?
- What are the connections that shops share with the community?
- What are the contexts of the business for identity change?
- How do tattooists and shop owners create community?
- At what juncture in their lives did they decide to become involved in tattooing?
- How do tattooists and shop owners attempt to change their occupational standing?
- How do small businesses cater to diverse publics?
- How do occupations manage change?

These questions guided the collection of information, since this study uses a combination of historical, observational, interview, and quantitative data.

Qualitative Data

Thirty-one tattooists participated in in-depth interviews. I used open-ended questions, and the interviews were loosely structured. This allowed for the freedom to explore additional topics as needed, including using probing questions for additional information.[2] Though there was a list of 15 questions on the interview guide, I did not ask all the questions in the same order in each interview. This kept the interview process free-flowing and organic, allowing interviewees to tell their stories. There was 1 refusal among the 32 persons asked for an interview. The refusal came from a shop owner who was too busy to participate in a lengthy interview but who still allowed me to interview and observe tattooists working in their shop. The sample contains 2 apprentices and 9 shop owners. Two shop owners owned more than one tattoo shop.

The interviews lasted between 41 minutes and 200 minutes, with a mean interview time of 92 minutes, a standard deviation of 32 minutes, and over 47 hours total time. Interviewees chose the time and location of all the interviews. Most selected their tattoo shop as the site for the interview. However, two interviews were in local eateries, and one at the public library. Data gathered occurred until reaching a point of redundancy and saturation.[3] I recorded interviews with a digital voice recorder and downloaded to an external flash drive for storage. Removal of all identifying information from the interviews took place during the transcription; this included assigning pseudonyms to participants.

While working, I approached shop owners and asked if they would be willing to participate in the research study. I then asked to solicit tattooists working in their shops for participation and spend time observing the daily patterns in the shop. Of the shops selected for participation, only two shops refused, both because they believed it would be too much of a constraint on their work. One of these shop owners refused upon finding out the depth of data gathering. At the other shop, the owner was suffering from health complications, and being short-staffed, the employees had other obligations. The acceptance rate for participation among shops was 12 out of 14. To ensure representativeness, I selected participants from three different positions in the tattoo labor hierarchy: owner, employee, and apprentice.[4] I collected at least two interviews from each tattoo shop—one with the owner, and one with an employee. Only one shop is the exception to this, as only one tattooist worked there.

After transcription and the rewriting of field notes, the data were analyzed. In this process, I coded data by their content and the types of information they contained. Later, the collections of coded data were reexamined to find key themes. Key themes were determined by selecting the data that allowed for the elucidation of theoretical and conceptual ideas.

Access to the Field

As a sociologist, tattoo collector, and native of Baltimore, I possess a degree of cultural capital that provided me with greater access to this world.[5] As a former resident of Baltimore, I have a connection to the city. One of the consequences of my personal history is that I am part of a small network of people connected to tattooists in Baltimore. This provided me with a greater degree of credibility. Throughout the research, it was common for tattooists to draw connections between our lives, since we could often discuss our mutual friends, acquaintances, cultural events, or lifestyle experiences that occurred around the city.

Additionally, I am a tattoo wearer, with visible tattoos in a sleeve style on both of my arms and one of my legs. These tattoos imbue credibility with tattooists. I am not someone who has just one or two small tattoos that are easy to hide; this demonstrated to others that I am fully committed to being tattooed as part of my identity. Related to this, the person who produced my tattoos is well respected among many of the tattooists and shop owners in the city. When asked who did my tattoos, the response commanded some degree of authority, demonstrating I was in the know. This provided me with another mechanism to demonstrate credibility.

Throughout this project, I have relied on several key informants. These informants helped me sift through the information that is known about tattooing. This process often involved me trying to understand academic articles or what my data meant, then having discussions with key informants about

these sources of information. This research would not have been possible if a dynamic relationship did not exist between myself and several informants.

Researcher Issues of Fieldwork

One implication of interview research involves remaining objective in observations throughout the process.[6] The intent of my inductive approach was to keep an open mind and accept anything that could be meaningful data. As someone who is a regular tattoo client, in this area, I had the additional burden of ensuring my research did not entangle with my personal life in ways that could harm participants. Tattoo workers in this city already have their own political, business, and social conflicts. It was important to remain uninvolved in these conflicts, even after conducting my research.[7]

The observations of the researcher limit any qualitative project. Researchers can only record what they see and only present the information they view as pertinent to the study. After combing through interviews and creating a working theoretical model of the tattoo world, it became clear that some of the interviewees were more knowledgeable about this world than others. Typically, these were the shop owners, who often had more time, experience, and prestige in this world. These people were able to explain tattoo work with much more depth than others.

Several interviewees later became key informants through this process. I had frequent contact with most of the key informants, even years after gathering data. They helped steer this project in the correct direction. Most have been helpful in locating information that only tattooists know. Others have been relied on to confirm and disconfirm my interpretations of data or events. This process made certain that I was not misunderstanding the data and that I was representing the tattooists appropriately.[8]

Historical Data

Historical data were collected from publicly available sources, including newspapers, magazines, tattoo books, academic books, academic research, specialist tattoo magazines, and tattoo museums. These were invaluable sources of data that I used to illustrate the context of the tattooists' world. While some were secondary sources, their inclusion in this research enabled me to depict various historical time periods and the changes affecting the occupation of tattooing. They augmented data gathered for this study.

Statistical Data

The quantitative database contained information used to construct a sampling frame for tattoo shops in the Baltimore metropolitan area. According to the dataset, there are 73 tattoo shops in the metro area, or 0.7 percent of the total

population of tattoo shops in the United States. I selected a cross-section of these shops for observations and interviews. While most studies on tattooing enter the field and conduct convenience samples, this research uses quantitative data to construct a sampling frame for the gathering of qualitative data.[9] This was a purposive sample aimed at collecting data from a wide range of work sites based on census tract data.[10] This method avoided issues of representativeness, as I could sample across the social world without the restrictions of particular networks or scenes.

Statistical data supplied measurements of the size and scope of the tattoo industry. I located statistical information on all enterprises identified as tattoo shops. Using the Statistical Package for the Social Sciences (SPSS) and ReferenceUSA, I created a dataset of all tattoo shops in the United States. ReferenceUSA is a data and information collection group, with a business database that organizes information on businesses from existing records. This database tracks tattoo shops by the Standard Industrial Classification (SIC). Tattoo parlors have their own SIC code. It was not possible to use the North American Industry Classification System (NAICS) because it does not provide a separate code for tattoo shops.

The dataset created consists of over 9,434 cases, each case representing a tattoo shop in the United States for the year 2010. This dataset currently contains information on the following variables: ZIP code, metro area, number of employees, square footage of business, years in existence, and the amount paid for rent or lease. I merged this data with ZIP Code Tabulation Areas (ZCTA) data from the 2010 and 2000 U.S. census. Data from the 2010 census used to construct demographic measures were socioeconomic status, age, urbanization, family presence, gender, and race. The 2000 census contained the data for a measurement of military presence. This process was repeated for the shops in Maryland at the census tract level in the year 2010. Using the same method, I created a second national dataset for the year 2014.

The strength of my approach is that data provides the research with greater generalizability. It allows for comparisons between tattoo shops in Baltimore, and the national dataset. These data provide an illustration of how the occupation is distributed nationally with respect to the demographic characteristics of where tattoo shops are located. This dataset provides a context for tattoo work by illustrating the structural and demographic features found in different environments. This allowed for a structural interpretation of differences among members of the workforce.

Appendix B

Breakdown of Participants

Name	Shop	Age	Gender	Race	Ethnicity	Education	Income
Dante[*][‡]	Eternal Ink Tattoo	21	Male	White	Italian/German	High school	None
Richard	Eternal Ink Tattoo	35	Male	White	Italian/Irish	GED	$7,000
Mike[†]	Eternal Ink Tattoo	42	Male	White	Irish/Native American/Italian	AA (videography)	$20,000
Dorsey[†]	The Gallery	36	Male	White	German/Czechoslovakian/Irish	High school, working toward AA	$70,000
Henry	The Gallery	35	Male	White	Italian	BS	$20–30,000
Joseph	The Gallery	36	Male	White	German/Irish	High school and military	Enough to get by
Edward[†]	Classic Tattoo	35	Male	White	Italian	High school, trade schools (building and ground maintenance, bricklaying, construction)	$90,000
Thomas[*][‡]	Classic Tattoo	34	Male	White	Irish/Polish	High school, some college	Broke
Glen	Classic Tattoo	38	Male	White	Italian	Some high school, some college	$60,000, reports 75%
Elaine	Slingin' Ink	26	Female	White	Italian/Polish	AA (visual arts)	$12,000
Gina[◊][‡]	Slingin' Ink	20	Female	Black	African American	High school	$12,000
Billie	Slingin' Ink	30	Female	Black	Hispanic	Some college	$25–30,000
Laura	Altered Images	25	Female	White	American Mutt	High school	$35–40,000
Jacob	Shopless	30	Male	Black	No	GED	$14,000, plus income from other jobs
Mason	Shopless	22	Male	White	Italian/Irish	AA (accounting)	$20,000, plus income from other jobs

Name	Shop	Age	Gender	Race	Ethnicity	Education	Income
Frank[±]	Turning Point Tattoo	29	Male	Black	Unknown	Some college	$21,000
Charles[±]	Turning Point Tattoo	32	Male	Black	African American	High school (art magnet program)	$19–20,000
George[‡‡]	Turning Point Tattoo	39	Male	Multiracial	Spanish/Indian, raised in Caribbean	Some art school	$50,000
Eli[†]	Olde Tyme Tattoo	49	Male	White	American	Some college, military (six years)	$250,000
John Lee	Olde Tyme Tattoo	47	Male	White	N/A	BFA MA (publication design)	No answer
Ben	Pair A Dice Tattoo Studio	32	Male	White	American Mutt	AA (computer graphics)	$30–50,000
Brenda	Pair A Dice Tattoo Studio	30	Female	White and American Indian	Dutch/Cherokee/German/French/Norwegian	BFA, MFA	$30–40,000, not including teaching income
William[†]	Pair A Dice Tattoo Studio	29	Male	White	German/Not sure	High school	Refuse
Alan[†]	Sacred Tattoo	42	Male	White	Irish/Austrian, ½ unknown	Some art school (three years)	$93,000
Clyfford	Sacred Tattoo	28	Male	White	Irish American	AA (fine arts)	$40,000
Kevin[±]	Tattoo Palace & Altered Images	34	Male	White	Mutt	Kicked out of high school	$40–60,000 prerecession (2008); now $30,000

(continued)

Name	Shop	Age	Gender	Race	Ethnicity	Education	Income
Edgar[†]	The Electric Tattoo Company	48	Male	White	Don't know	BA (English)	Unreliable answer
Conrad[◊]	The Electric Tattoo Company	33	Male	White	American	BA (English), some master's work (literature)	$35,000
Samuel	The Electric Tattoo Company	34	Male	White	Chilean, but identifies as white	GED	$35–55,000
Margaret	Rising Phoenix Tattoo	30	Female	White	Mutt: Irish/German/ Native American	High school (art magnet program)	$45,000, only $25,000 from tattooing
Tim[†]	Rising Phoenix Tattoo	29	Male	White	Mixed Anglo	High school	$100,000

* Apprentice
◊ Shop manager
± Shop piercer
† Shop owner

Acknowledgments

There are far too many people who have contributed to this work than can be acknowledged in this section. Being a work on cultural production, it is important to note that there are many people behind the scenes who have made contributions, even some who I will never meet. To all those who are in some way involved with the production, distribution, and consumption of this work, I thank you.

Several people have made significant contributions and provided direct feedback throughout this process. To begin, Ashley K. Farmer and Whitney DeCamp have done far more work than the credit they will receive here. Both routinely provided feedback, entertained my musings, and helped guide me to clarifying ideas. This research would have never begun without the encouragement of Anne Bowler and Tammy Anderson to pursue this subject. Benigno E. Aguirre, Joel Best, Heather Zaykowski, David Posthumus, and David G. Bromley significantly improved this project with their insightful feedback and suggestions throughout the research process and on various versions of the manuscript (or underdeveloped ideas). Chapter 4 would never have developed to be about legal consciousness if it were not for Kevin F. Daly's suggestions during data analysis. This list could probably be much longer and include everyone who contributed even the smallest amount to the production of this work but were still vital to completing it (such as Nate Christiansen and Samantha Riley, who watched my dogs while I had the privilege of presenting this work at conferences).

Peter Mickulas, who saw potential in this manuscript has been a wonderful editor. He has helped me resolve multiple issues. Importantly, he provided valuable feedback and nudged me in the appropriate direction when necessary. The two anonymous reviewers should know that their detailed comments vastly improved this project, and I am appreciative of their efforts.

Of course, this project would not have been possible without the participation of the tattooists. They are at the heart of this work. All those who welcomed me into their shops, let me collect data, and showed me their world deserve special recognition. I thank the key informants who have helped me and the people I met who continued to tell me about tattooing. I wish you could be publicly recognized for your contributions, but know that your indelible marks now go beyond skin. It is the tattooists' stories that inform us. They are at the center of transforming bodies and making this world a beautiful place through their creativity.

Notes

Introduction Tattooing for Beginners

1 Pew Research Center (2010).
2 A dummy rail is a physical barrier preventing clients from moving into the tattoo-ist's workspace. Smaller sized shops initially used these, and people could lean on them and observe the tattooist at work. Some modern shops have a counter that serves the same purpose. Tattooists still call these counters "dummy rails."
3 Some shop owners may own more than one shop, but these shops do not operate on the characteristics of formal rationality found in chain businesses.
4 Perrow (1986); Kanter ([1977] 1993); Hughes ([1958] 2012); Pavalko ([1971] 1988).
5 Dunnier (1999); Venkatesh (2006).
6 Descriptions of tattooing as a sign of pathology are in Lombroso (1896) and Lombroso ([1876] 2006). Parry (1933) followed Gustave LeBon's ideas of herd behavior in psychology to depict the elite fad of tattooing in the late 1800s. Anthropological work, like Sinclair (1909) attempted to depict tattooing as a practice of the uncivilized other.
7 Irwin (2001); Kosut (2006b); Vail (2000).
8 See Lane (2017) for an extensive review and critique; see also Lane (2014).
9 Griswold (2013) explains how culture is an active social process. See Alexander (2003) for a depiction of the difference between reception studies in art and the examination of the production and distribution of art.
10 See Jennings, Fox, and Farrington (2014); Ruffle and Wilson (2017).
11 Early connections to pathology are in Cesare Lombroso's ([1876] 2006) attempts to connect tattooing to atavism. For continued attempts to link tattooing to criminal-ity, see Jennings, Fox, and Farrington (2014); Rivardo and Keelan (2010); Stirn and Hinz (2008).
12 Grumet (1983); Lemma (2010); Steward (1990).
13 Bell (1999); DeMello (1995); Kosut (2000); Irwin (2001); Thompson (2015).
14 See Atkinson (2003b); Crossley (2005); Kosut (2000); Pitts (2003); Rosenblatt (1997); Sanders (1988); Vail (1999).
15 Sanders (1988, 1989a).
16 Armstrong (1991); Atkinson (2003b); Martin and Cairns (2015); Roberts (2016).

17 Atkinson (2003b); Irwin (2000).

18 Atkinson (2003b); Irwin (2000); Sanders (1988); Thompson (2015).

19 Atkinson (2002, 2003a); DeMello (1993); Mifflin (2013); Pitts (2003); Sweetman (1999); Thompson (2015).

20 According to Jones (2000), the Roman word *stigmata* originates from the Greek root word *stizein*, which denoted those who had been tattooed. Various transmissions of this root word into other languages reveal it generally means "to prick, sting, stitch, or mark." See also Gustafson (2000); Richie and Buruma (1980); Taylor (1998).

21 Taylor (1998). See also DeMello (1993); Gustafson (2000); Schrader (2000).

22 Taylor (1998).

23 Carswell (1958); Govenar (2000); Gustafson (2000); Nikora, Rua, and Awekotuku (2007); Sinclair (1909).

24 Coe et al. (1993) discuss tattoos as symbolic markers of group membership in the military. Vale and Juno (1989) specifically discuss modern primitives, who do not limit themselves to tattooing. Tattooing for them is just one form of modification to express themselves (see also Govenar 1988).

25 Atkinson (2003b); Coe et al. (1993); Orend and Gagne (2009); Phelan and Hunt (1998).

26 DeMello (2000); Halnon and Cohen (2006); Irwin (2003); Irwin (2001).

27 Irwin (2001).

28 DeMello (2000); Irwin (2001).

29 Kosut (2006a); Orend and Gagne (2009); Polhemus and Proctor (1978).

30 Kosut (2006a).

31 Aguirre (1988); Best (2006).

32 Polhemus and Proctor (1978).

33 Polhemus and Proctor (1978); see also Kosut (2006a).

34 Polhemus and Proctor (1978).

35 Sanders (1989a).

36 Rubin (1988). See also DeMello (2000); Kosut (2014); Tucker (1981).

37 Tucker (1981); Rubin (1988).

38 DeMello (2000); Irwin (2001).

39 Kosut (2014). See also Sanders (1989a).

40 Kosut (2014).

41 Becker ([1982] 2008); Crane (1976); Peterson (1976).

42 Of particular interest are the identities formed at work (Hughes [1958] 2012; Pavalko [1971] 1988), the performance of their roles (Hochschild 1985; Kanter [1977] 1993), the relationship between work (or lack thereof) and stratification (Davis and Moore 1945; Marx 1978; Mills [1951] 2002; Venkatesh 2006), its effects on gender and the life course (Jacobs and Gerson 2004; Peterson and Morgan 1995), and the management of personnel (Gouldner 1954; Perrow 1986; Weber 1946).

43 Becker ([1982] 2008); Berger ([1967] 1990); Berger and Luckmann ([1966] 1967); Fine (1983); Fine ([1996] 2009).

44 Berger ([1967] 1990); Berger and Luckmann ([1966] 1967).

45 Becker ([1982] 2008: 34).

46 Becker ([1982] 2008).

47 Becker ([1982] 2008).

48 Crane (1976).

49 Becker ([1982] 2008: 25).

50 Becker ([1982] 2008: 29).

51 Cooperative relationships in this context does not mean that all people agree upon every detail of an art form all the time, or that there is no competition between them. In the context used by Becker ([1982] 2008), it means that people within art worlds generally agree upon several key elements of the art or craft.

52 Peterson and Anand (2004).

53 Bowler (1994: 249–253).

54 Griswold (1981); Peterson and Anand (2004).

55 Ewick and Silbey (1998).

56 Sanders (1989a) similarly used this framework, however his research focused on answering the question of how tattooists determine what is art. My study focused on elaborating the complex cultural world of tattoo work.

57 Rubin (1988); DeMello (2000); Irwin (2001); Vail (1999).

Chapter 1 The Social World of Tattooing

1 Kitamura and Kitamura (2001).

2 Kitamura and Kitamura (2001).

3 Myles (2015); Parry (1933).

4 Parry (1933: 44); Myles (2015).

5 Myles (2015).

6 St. Clair and Govenar (1981).

7 Related to the nomadic lifestyle are two factors. First, many tattooists around the turn of the century were working as part of the carnival freak show. Often, they or their wives were an exhibit in the show, while they tattooed attendees (Mifflin 2013). Second, tattooists were adept at responding to changing economic conditions that would affect their income. According to Rubin (1988), they sensed when military installments were growing, shrinking, or shutting down; when various military crackdowns would limit their number of clients (Parry 1933); or when legal prohibitions loomed (Maguire 2013; Steward 1990).

8 The most comprehensive accounts of the sailors and tattooing appear in Lodder (2015b), Schonberger (2005), and *Skin and Bones: Tattoos in the Life of the American Sailor*, an exhibit at the Independence Seaport Museum (2009) in Philadelphia. Closely related to tattooing is the folkcraft of scrimshaw. Sailors in the United States practiced it by engraving images on ivory teeth or whalebones. Then they rubbed soot or ground gunpowder over the engraving to produce a vivid image. Scrimshaw often depicted patriotic and battle scenes, memories of loved ones, or religious and nautical imagery—the kinds of images found in much of traditional American-style tattooing.

9 Independence Seaport Museum (2009); Lodder (2015b).

10 Lodder (2015b: 202).

11 Myles (2015).

12 McCabe (1994).

13 Morgan (1912); Parry (1933).

14 Maguire (2013).

15 Reiter (2011).

16 Pops, quoted in Maguire (2013: 9).

17 Mifflin (2013: 30).

18 Eldridge (1982).

19 Sanders (1989a: 16–17); St. Clair and Govenar (1981) and Morgan (1912).

20 Sanders (1989b).

21 Morgan (1912); Schonberger (2005).

22 Many were quite resourceful and did not limit themselves to water and alcohol. For example, those on ships occasionally used urine, and it is known that some would mix the dried pigments with their own saliva or various oils to produce an ink (Parry 1933).

23 Schonberger (2005: 75).

24 This was not the first type of prestige hierarchy among tattooists. Burchett (1958: 47) and Parry (1933) describe Japanese tattoo masters such as Hori Chyo, who others regarded as one of the finest in the world. In the 1800s, an American millionaire even offered Chyo a $12,000 a year salary to relocate to New York City. This kind of prestige hierarchy was qualitatively distinct from the emerging hierarchy in the United States.

25 Quoted in Maguire (2013: 9).

26 There are many examples of this. Perhaps one of the most well-known is Norman "Sailor Jerry" Collins. He was the first to develop a purple pigment that would remain visible on the skin for many years. He would share the pigment with trusted associates but did not reveal the recipe for the mixture (Hardy 2013).

27 Lodder (2015a); Independence Seaport Museum (2009).

28 Independence Seaport Museum (2009). See also Schonberger (2005).

29 Schonberger (2005: 80).

30 Sanders (1989b).

31 St. Clair and Govenar (1981).

32 Rubin (1988).

33 DeMello (2000); Hardy ([1982] 2012: 39).

34 Morgan (1912: 72).

35 The influence of Cap Coleman's flash in American-style tattooing is evidence of this process (Maguire 2013).

36 Sanders (1989b).

37 Morgan (1912: 70).

38 Rubin (1988).

39 Hardy (1982: 42).

40 Schonberger (2005: 74).

41 Quoted in Parry (1933: 51–52).

42 Schonberger (2005).

43 According to Parry (1933: 51), during this time period there were only four tattoo-ists who advertised mail-order business in *Popular Mechanics*: "Miller of Norfolk, Sargent Bonzey of Providence, Percy Waters of Detroit, and William Moore of the Chicago Tattoo Supply House." However, other suppliers were in Detroit, including: J. F. Barber, Edwin and Sadie Brown, and a young Owen Jensen (Tattoo Archive 2010). Eventually, Waters's supply company offered three different models of machines (the Standard, the Special, and the Side Wheeler; Schonberger 2005).

44 Tattoo Archive (2010: 7).

45 Weber ([1968] 1978: 24–26).

46 DeMello (2000); Rubin (1988); Tucker (1981).

47 Rubin (1988).

48 See Goffman ([1963] 1986: 41–42) for a discussion of the discredited as a known stigmatized identity.

49 Kitamura and Kitamura (2001).
50 Kitamura and Kitamura (2001).
51 Hardy (2013).
52 Kitamura and Kitamura (2001).
53 Crane (1976).
54 First Fridays occur on the first Friday of the month. They are events where collectives of artists and galleries open to display their works to the public.
55 Shop tattooists often reject clients (a privilege of their position) who are known to possess diseases that can be transmitted through tattooing, those who do not have enough money for their services, and those who are unruly or otherwise difficult to deal with. Shopless tattooists fill the demand for tattoos from clients that tattooists would ordinarily turn down in a shop.
56 Gusfield ([1963] 1986: 16–19) depicts status politics as conflicts over prestige and its assignment to groups. Status politics tends to occur when one status group feels less prestige assigned to it. This moves the focus of the conflict beyond the materialist concerns of class politics to focus on the "values, beliefs, consumption habits, and cultural items" associated with different status groups (18).

Chapter 2 Organizing Space

1 Becker ([1982] 2008).
2 To date, only a few studies have gathered data in tattoo shops. Sanders (1989a), Atkinson (2003b), and Roberts (2016) were all ethnographic studies with the researcher situated in tattoo shops. Thompson (2015) and Barron (2017) collected data in tattoo shops and discussed the tattoo convention. However, all these studies focused on the tattoo collector and their identity.
3 Goffman (1959). See Roberts (2016) for a study connecting dramaturgy to tattoo wearers.
4 Goffman (1959).
5 Hughes ([1958] 2012: 49–53) used the concept of "dirty work" to refer to occupations or tasks that are degrading or disgusting, which requires managing a work identity to avoid stigmatization. Dirty work involves things like handling bodily fluids, the dead, or garbage.
6 DeMello (2000); Tucker (1981).
7 Rubin (1988).
8 Rubin (1988); Sanders (1989a); Tucker (1981).
9 Tucker (1981: 42).
10 DeMello (2000); Rubin (1988); Sanders (1989a).
11 Tucker (1981).
12 Tattooists work in a relatively sterile manner compared to the past due to the increased focus on sterilization. Some tattooists may not even be aware that they are more sterile. For example, it has now become customary for tattooists to use individual ink cups for each customer. Now that needles are mass manufactured, presterilized, intended for single use, and affordable, tattooists are more likely to dispose of them instead of attempting to reuse them. These changes reduce the risk of cross contamination and the spread of blood-borne pathogens, whether the tattooist knows about it or not.
13 Rubin (1988).
14 DeMello (2000); Kosut (2014).

15 When sociologists discuss culture as a social process, they are generally referring to the ways people perceive the world and how culture shapes those perceptions to engage in socially meaningful action. Swidler (1986) depicts the ways in which culture is a resource or "tool kit" that is used during interactions. Similarly, Collins (1981, 2005) discusses how these interactions not only make up social institutions but also shape existing cultural patterns.

16 See Pavalko ([1971] 1988: 19–29) for a depiction of the characteristics that separate professions from other forms of work. Pavalko summarizes that professions tend to be defined by eight characteristics: theory or an intellectual body of knowledge; a definition of their works that states its value to society; lengthy training that includes the development of specialized knowledge, an emphasis on concepts, theories, or ideas and socialization into an occupational subculture; an understanding that their work provides a service for a client; autonomy and control over their labor; a sense of commitment to their work, which is often long term or lifelong; membership in an occupational community; and a written or unwritten code of ethics.

17 Goffman (1959).

18 Hughes ([1958] 2012: 49–53).

19 Preston (1976).

20 DeMello (2000).

21 Goffman ([1963] 1966: 18) described *gatherings* as special environments where two or more individuals are in the presence of one another for the intention of interacting with other(s) present.

22 There is one exception to this. There are a few tattooists who have climbed the hierarchy and are able to sustain a home tattoo business. However, these tattooists still work in shops and have connections with other established tattooists who condone their work. While they may work from home, they also work in shops, attend tattoo conventions, and travel to be guest tattooists at various shops, and so have earned to right to work in this manner.

Chapter 3 Careers of Tattooists

1 Hughes ([1958] 2012: 127–128). The notion of the career has been used to explain various forms of deviant involvement, including sex work (Forsyth and Deshotels 1998; Oselin 2014), homelessness (Snow and Anderson 1993), substance and drug use (Adler 1993; Becker 1963), mental illness (Goffman [1961] 2007; Gove 2004), youth subcultures (Adler and Adler 2011; Haenfler 2007), and even entry into tattooing (Sanders 1989a). The paths through deviant careers lack the rigid structure found in respectable careers and have higher degrees of uncertainty, shorter durations, and multiple forms of mobility (Adler 1993; Luckinbill and Best 1981); they are also more susceptible to change.

2 Hughes ([1958] 2012: 127–128); Stebbins (1970).

3 Luckinbill and Best (1981).

4 Many sociologists have extensively documented deviant careers and their characteristics. Collectively, Becker (1963), Brown (1991), Goffman (1963), and Sykes and Matza (1957) summarize this line of scholarship.

5 See Brown (1991) for an explanation of the *ex-* and how a present identity reflects a past identity. Luckinbill and Best (1981) explain how people learn new forms of deviance as part of their career, and Adler (1993: 133–140) explains how maintaining contacts with deviants can lead toward oscillating in and out of a deviant scene over time.

6 All tattooists interviewed did not enter the occupation at the same time. Some respondents were still attempting to enter the occupation; others had worked in tattooing for many years or even multiple decades.

7 Steward (1990).

8 Shaw ([1991] 2012).

9 Kitamura and Kitamura (2001).

10 The use of *family* here is a departure from the English version of the word. In this context, it refers to a house of people learning under a master. These people do not have to be related by blood. Their relationship as a family comes from their training under the master. If deemed credible of carrying on the traditions and teachings of their master, they will honorifically take on the title of the master as part of their name to continue their artisanal legacy.

11 Kitamura and Kitamura (2001: 118–119).

12 The phrase *tattoo school* does not mean an actual school. While it is a form of a school, many in the occupation, especially established tattooists, do not approve of the practice. Instead, they claim it is a for-profit type of learning that is a scam.

13 Luckinbill and Best (1981).

14 Historically tattooists have had to contend with various legal or market forces that preempted their lateral shifts. As Rubin (1988: 234) notes, laws often were the impetus that pushed them to find work elsewhere. For others (Hardy 2013), the desire to learn from established tattooists often preceded the decision for mobility. Perhaps there were some who stayed in one place for a decade or more, but these tattooists were often exceptions rather than the rule.

15 Mars, Ondocsin, and Ciccarone (2018) discuss the history of findings indicating that intravenous drug use is disproportionately high in Baltimore compared to the nation as a whole and other cities.

16 An example is Sander's (1989a) research, which primarily focuses on entry into tattooing as a deviant career. However, like most studies on deviant careers, his research does not explore the middle or later stages.

17 What is meant is that people attempt to conceive of their identity as formerly belonging to a group. They do not fully exit their careers because their current identity reflects their status as an *ex-*: ex-alcoholic, ex-prostitute, ex-doctor (Brown 1991).

18 Hardy (2013: 217–275).

Chapter 4 Legal Consciousness among Workers

1 See Griswold (1981); Peterson (1982); Peterson and Anand (2004).

2 Peterson (1982: 145).

3 As Griswold (1981; see also Peterson and Anand 2004: 315) explains, copyright laws before 1891 shaped the kinds of content found in novels produced by American publishers. Copyright law prior to this time did not cover foreign writers, so American publishers produced American versions of English novels. This was less expensive than having to pay the American writers. As a result, the content of the American novel changed. American writers often explored subjects not written about in English novels, such as adventure, enabling them to secure contracts with American publishers. The legal framework consolidated power in the hands of American publishing companies, whose interest was in producing novels for the most competitive market price.

4 Merry (1990: 5).

5 Just like all legal consciousness research, participants were not asked about their experiences with the law (Silbey 2005; see also Abrego 2008; Fritsvold 2009). Instead, these were emergent conversations.

6 Ewick and Silbey (1998).

7 Ewick and Silbey (1998: 46; emphasis in original).

8 Darwin ([1874] 1902: 739).

9 Jones (2000: 7).

10 Taylor (1998).

11 Schrader (2000).

12 O'Kane (1961: 45).

13 *New York Times* (1959).

14 Ewick and Silbey (1998: 108–164).

15 Clark (1963).

16 Lodder (2010: 220–221); see also People v. O'Sullivan (1986).

17 Lodder (2010: 225).

18 Tattooists in New York City unsuccessfully argued that tattooing was an art form protected under the First Amendment. In 1966, the New York Court of Appeals, the highest state court, upheld the ban, stating that tattooing posed too much of a health risk to the population.

19 DeMello (2000: 129–131).

20 Yurkew v. Sinclair (1980).

21 Yurkew v. Sinclair (1980).

22 On one occasion, Edgar, an interviewee, told me about tattooists in New York City and shop decoration. Among them, it became important to take a photograph of themselves tattooing a uniformed police officer or firefighter. They would then place the picture on the wall of the tattoo shop. These pictures symbolized the tattooists' relationship with these respected employees of the city.

23 Orlean (2001) explains the context of tattoo bans in Massachusetts, and Talley (2006) describes the issues of tattoo bans as contributing to the spread of infectious disease in Oklahoma.

24 Meredith (1997); Orlean (2001).

25 New York City Administrative Code (2006: § 17-360).

26 Talley (2006).

27 Lanphear v. Commonwealth of Massachusetts (2000).

28 Frederick (2003).

29 Frederick (2003).

30 South Carolina Code of Laws (2004: §44-34).

31 Manufacturing zones are industrial areas, B3 zones are for businesses of a highway-commercial nature, and B5 zones are densely populated offices and work zones.

32 Everstine (1966: 393).

33 Many tattooists have undergone extensive training to reduce the potential for the spread of disease, including receiving certifications and developing a working knowledge of medicine and the body.

34 Tattoo Archive (2017: 9).

35 Ewick and Silbey (1998: 165–222); also see Fritsvold (2009).

36 Many tattooists left when the 1953 Baltimore City Code required registration with the Department of Health (Tattoo Archive 2017: 10).

37 USFDA (2010).

38 USFDA (2010).

39 Despite the lack of evidence that tattoo ink is potentially dangerous, there is some evidence that tattooing can pose a health risk in the form of disease outbreaks. The two most notable are the hepatitis outbreak in New York City, which led to the banning of tattooing as a health concern. The other is the nontuberculosis myco-bacterial outbreak that occurred in late 2011 through early 2012. There were a total 22 confirmed cases, 4 probable cases, and 26 possible cases reported nationally. All cases occurred in New York, Washington, Iowa, and Colorado, with the majority in New York (14 confirmed, 4 probable, and 1 possible) and Washington (5 confirmed, 26 possible; Nguyen and Kinzer 2012).

40 Nguyen and Kinzer (2012: 653).

41 See OSHA (n.d.)

42 At the time of this study, there was no statewide law that prohibited tattooing minors. In the absence of this, many tattooists still attempted to regulate the ages of persons who can be tattooed. Since conducting this research, a statewide bill passed that prohibited the tattooing of minors without a parent or guardian's written consent. This new law took effect on October 1, 2012, six months after I stopped gathering data.

43 Silbey (2005).

Chapter 5 Ties to Conventional Institutions and Ideas

1 See Bowler's (1994: 249–253) critique of artistic autonomy. See Bourdieu (1993) on the field and autonomy.

2 Weber (1946: 342).

3 Bowler (1994: 249–253).

4 Bourdieu (1993).

5 Bowler (1994: 251).

6 DeMello (2000); Irwin (2003); Kosut (2014); Rubin (1988); Sanders (1989a); Tucker (1981).

7 "Stoney" St. Clair attended Johns Hopkins for two years beginning around 1918. He credits Johns Hopkins with teaching him how to draw (St. Clair and Govenar 1981: 24).

8 Reiter (2010: 15).

9 "Stoney" St. Clair (1981: 93) described him like this: "Dietzel was one of the greatest tattooers that ever lived. He was in the Coleman bracket." For Steward (1990: 159), "His line-work was thin and superb; his shading and coloring surpassed even his line. The colors stayed brilliant for years."

10 Shaw (1991: 17).

11 Lodder (2015a: 110).

12 See Morgan ([1912] 2015: 36). Parry (1933) referred to Morgan as one of the great masters of tattooing.

13 The British tattooist Sutherland Macdonald tried to make a similar distinction. He referred to his activities as art and not any kind of craft (Bolton 1902).

14 Bolton (1902: 175).

15 Morgan (1912: 17–18).

16 Parry (1933).

17 DeMello (2000); Kosut (2014); Rubin (1988).

18 With no numerical counts of artists in tattooing over time, it is impossible to track this change. Studies (DeMello 2000; Rubin 1988; Tucker 1981) imply a change

has occurred, but this comes from analyzing different data sources. They focus on tattooing and tattoo aesthetics increasingly appearing in places like museums, or on anecdotal accounts of people describing this transformation in tattooing. Neither measure is sufficient to claim tattooing did not already share a relationship with art worlds over the past century in the United States.

19 For news articles, see George (2001) and O'Conner (1996). For academic research, see DeMello (1995) and Irwin (2001, 2003).

20 Irwin (2001, 2003).

21 This is similar to the way styles adopted by youth subcultures served as visual markers that reproduced the social order in British society (Hebdige 1979; Hall and Jefferson 1975).

22 DeNora (2000).

23 Parry (1933: 90–110).

24 Burchett (1958); Ebensten (1953); Parry (1933).

25 Bolton (1902); Burchett (1958); Parry (1933).

26 Ebensten (1953).

27 Burchett (1958: 50–51).

28 Bolton (1902).

29 Lombroso (1896).

30 Lombroso (1896: 793).

31 Morgan (1912).

32 McCabe (1994: 15–23).

33 Mifflin (2013: 20–21).

34 Parry (1933: 88–19).

35 Farber and Bailey (2010: 57).

36 Rubin (1988: 252–254).

37 See Atkinson (2002).

38 Brank (n.d.).

39 Bourdieu (1984).

40 DeMello (2000: 97–135).

41 Irwin (2001).

42 Halnon and Cohen (2006).

43 Morse (1977); Rubin (1988); Tucker (1981).

44 Only Govenar (1988) and Santos (2009) explicitly discuss the racial dimensions of tattooing.

45 This process is similar to the ways Omi and Winant ([1986] 1994: 57–70) described racial projects and racial formation.

46 Govenar (1988).

47 Omi and Winant ([1986] 1994).

48 These are typically referred to as "smile now, cry later" tattoos. The tattoo features two theater masks, with one crying and one smiling. It is a staple tattoo of the urban aesthetic.

49 See Vail (2000) for an explanation of tattooists selecting clients to appropriately represent the craft.

50 See West and Zimmerman (1987) for a depiction of gender as social performance. See Santos (2009) for a depiction of Chicana tattoos as gender performance.

51 Miller (2016) provides an elaborate summary of the lack of research on gender in art. Mifflin (2013) provides an exceptional history and discussion of tattooed females in the United States. Thompson (2015) is the only other recent work to

seriously consider the role of gender in the world of tattooing. Using a framework based largely on embodiment and politics of the body, Thompson had similar findings. While her work primarily focused on what it means to be tattooed, she did find that female tattooists reported facing additional constraints in the workplace. Atkinson (2002), Mifflin (2013), and Santos (2009) explained tattooing as a practice of gender resistance.

52 For an explanation of gender as an interactional performance, see West and Zimmerman (1987).

53 Thompson (2015: 136–140) describes similar stories of sexism and harassment occurring from men toward female tattooists.

54 This stigma is rooted in the historical associations of tattoos with criminality or the lower classes. While largely a generalization, it is not completely unfounded. At least historically, there have been many time periods when tattoos were exclusively used to mark criminals, slaves, and other social undesirables (Taylor 1998: 77–83). Vail (2000) also reports that tattooists specifically attempt to select clientele who will represent tattooing appropriately. This involves shunning "bad clients" who want highly visible tattoos on the hands, face, and neck.

Chapter 6 Sources of Contention

1 Steward (1990).

2 Becker (1982: 28–34).

3 Weber ([1968] 1978: 25–26).

4 Hardy (2013: 83).

5 Hardy (2013: 83).

6 See Tattoo Archive (2014).

7 Maguire (2013: 6).

8 Collective memory refers to the social process, or continual activity, of developing definitions of the past, especially in terms of its symbolic meaning (see Wagner-Pacifici and Schwartz 1991; Olick and Robbins 1998).

9 Quoted in Maguire (2013: 5–6).

10 Cohen ([1972] 2002).

11 Some of the bans discussed in chapter 4 were the result of a public panic over the potential for tattooing to spread diseases.

12 Durkheim (1982, [1984] 2014) notes that this kind of activity is normal to clarify moral boundaries. Erikson (1966) provides an analysis of this process among Puritans.

13 Scully and Marolla (1984) analyze this process among convicted rapists.

14 Sykes and Matza (1957: 667).

15 Scott and Lyman (1968: 52).

16 Grattet, Jenness, and Curry (1998); Nooteboom (1994).

17 Abrahamson, Whitham, and Price (1989).

18 See Lodder (2010); Schonberger (2012).

19 This is not the case with all companies producing rotary machines. A few of them are tattooist owned (most notably Bishop Rotary), and some tattooists have always fabricated their own rotary machines. But the Cheyenne Hawk is a popular rotary machine, and tattooists do not produce it.

Chapter 7 External Threats and the Maintenance of Boundaries

1 See Hardy's (2013) depiction of his experience with Christian Audigier for a detailed account of the "Ed Hardy" brand licensing and exploitation.

2 See Horkheimer and Adorno ([1969] 1993) for an in-depth discussion of the relationship between authenticity and the production of culture.

3 Traditionally, these relationships were reliant upon personal contacts and social networks (Atkinson 2003b; Sanders 1989a).

4 DeMello (2000).

5 Bourdieu (1984).

6 Ciferri ([2003] 2011a: 51).

7 Ciferri ([2003] 2011b: 132–133).

8 Rubin (1988); Tucker (1981).

9 Rubin (1988: 252) compiled a more comprehensive list of those associated with the Tattoo Renaissance in the United States. His work is an excellent depiction of the aesthetic changes ushered in by these tattooists and their significance in altering tattooing.

10 DeMello (2000: 129–131) documented this conflict. The National Tattoo Association primarily consisted of old-school folk tattooists who were attempting to assert their control over the field by dominating the production and distribution of tattoo equipment. In contrast, Yurkew's organization aligned more with those tattooists who had some degree of fine arts training and sought to professionalize the occupation. The two organizations were competing to assert their control over the direction of the occupation.

11 Phil Sparrow (a.k.a. Phil Andros, Samuel Steward) had several exchanges with Milton Zeis while attempting to learn from his tattoo correspondence course. According to Sparrow, Zeis never actually tattooed people. He was "only a merchant, not a tattooist, and his course was made up of everything that con-men tattooists had told him" (Steward 1990: 12).

12 DeMello (2000: 129).

13 DeMello (2000: 198).

14 For a discussion of the conflict between the National Tattoo Club and the National Tattoo Association, see DeMello (2000: 129–131).

15 Rubin (1988).

16 Preston (1976: 25).

17 NTA (2019).

18 Tattoo Archive (2010); Steward (1990).

19 See Ed Hardy's (2013: 83) story about Sailor Jerry's development of purple ink for an example of closely guarded secrets only shared with trusted associates.

20 Authenticity can also reflect commitment and status within social groups, music forms (Grazian 2003; Peterson 1997), and youth subcultures (Haenfler 2007; Muggleton [2000] 2004). In contemporary cultural sociology, authenticity is a social construction people consider real or believable and original (see Peterson 1997: 205–210).

21 Grazian (2003: 10–11).

22 Peterson (1997).

23 Grazian (2003: 17).

24 Bascom (1965); Ben-Amos (1971).

25 Snow et al. (1986) define *frames* as rhetorical social constructions that align a person's interpretations of the world with a motivation for participation in action.

Conclusion Continuity and Change

1 See Lane (2014) for a critique; see also Lane (2017); Lodder (2010, 2015a); Sanders (1989a); Schonberger (2005).
2 Blumer (1969); Mead (1934).
3 Berger and Luckmann ([1966] 1967).
4 Fine (1983); Becker ([1982] 2008).
5 Alexander (2003); Griswold (1987).
6 Mead (1934).
7 Berger and Luckmann ([1966] 1967).
8 Faulkner and Becker (2009); Grazian (2003); Haenfler (2007); Ramirez (2018).
9 Hochschild (1985); Hughes ([1958] 2012); Kanter ([1977] 1993); Perrow (1986). Bourgois (2003); Desmond (2016); Hays (2003); Snow and Anderson (1993); Venkatesh (2006).
10 See Krause (1971) and Weber ([1968] 1978) on economy and society.
11 Weber ([1968] 1978)
12 Ritzer (2007).
13 Ritzer (2004).
14 There are far too many critiques of organization in capitalism, and this is a general summary of overarching perspectives. Early scholars were concerned with declining shared values or beliefs that would lead people to feel detached from society (Durkheim 1951) or conflicts between groups over scarce resources (Marx 1978). Later scholars would concern themselves with the effects advanced capitalism would have on social mobility and class conflict (Bourdieu 1984; Dahrendorf [1957] 1959), consumption (Linder 1970), and colonization of the life-world (Habermas 1987).
15 Weber ([1968] 1978: 25–26).
16 Lane (2014, 2017).
17 See Hughes ([1958] 2012) for a classic example.

Appendix A Methodology

1 See Maxwell (2005); Silverman (2000).
2 Silverman (2000).
3 Corbin and Strauss ([1990] 2008).
4 Sanders (1989a).
5 See Bourdieu (1986) for a discussion about the types of capital.
6 Maxwell (2005); Silverman (2000).
7 Punch (1986).
8 Denzin (1996).
9 See Irwin (2003); Strohecker (2011); Sanders (1989a).
10 Neuman (2000).

References

Abrahamson, Warren G., Tomas G. Whitham, and Peter W. Price. 1989. "Fads in Ecology." *BioScience* 39:321–325.

Abrego, Leisy. 2008. "Legitimacy, Social Identity, and the Mobilization of the Law: The Effects of Assembly Bill 540 on Undocumented Students in California." *Law & Social Inquiry* 33:709–734.

Adler, Patricia A. 1993. *Wheeling and Dealing: An Ethnography of an Upper-Level Drug Dealing and Smuggling Community*. 2nd ed. New York: Columbia University Press.

Adler, Patricia A., and Peter Adler. 2011. *The Tender Cut: Inside the Hidden World of Self-injury*. New York: New York University Press.

Aguirre, Benigno. 1988. "The Collective Behavior of Fads: The Characteristics, Effects, and Career of Streaking." *American Sociological Review* 53:569–584.

Alexander, Victoria D. 2003. *Sociology of the Arts: Exploring Fine and Popular Forms*. Hoboken, NJ: Wiley-Blackwell.

Armstrong, Myrna L. 1991. "Career-Oriented Women with Tattoos." *Journal of Nursing Scholarship* 23:215–220.

Atkinson, Michael. 2002. "Pretty in Ink: Conformity, Resistance, and Negotiation in Women's Tattooing." *Sex Roles* 47:219–235.

———. 2003a. "The Civilizing of Resistance: Straight Edge Tattooing." *Deviant Behavior* 24:197–220.

———. 2003b. *Tattooed: The Sociogenesis of Body Art*. Toronto: University of Toronto Press.

Barron, Lee. 2017. *Tattoo Culture: Theory and Contemporary Contexts*. New York: Rowman & Littlefield.

Bascom, William. 1965. "The Forms of Folklore: Prose Narratives." *Journal of American Folklore* 78:3–20.

Becker, Howard S. 1963. *Outsiders: Studies in the Sociology of Deviance*. New York: Free Press.

———. [1982] 2008. *Art Worlds*. Berkeley: University of California Press.

Bell, Shannon. 1999. "Tattooed: A Participant Observer's Exploration of Meaning." *Journal of American Culture* 22:53–58.

Ben-Amos, Dan. 1971. "Toward a Definition of Folklore in Context." *Journal of American Folklore* 84:3–15.

215

Berger, Peter L. [1967] 1990. *The Sacred Canopy: Elements of a Sociological Theory of Religion.* New York: Anchor Books.

Berger, Peter L., and Thomas Luckmann. [1966] 1967. *The Social Construction of Reality: A Treatise in the Sociology of Knowledge.* New York: Anchor Books.

Best, Joel. 2006. *Flavor of the Month: Why Smart People Fall for Fads.* Berkeley: University of California Press.

Blumer, Herbert. 1969. *Symbolic Interactionism: Perspective and Method.* Berkeley: University of California Press.

Bolton, Gambier. 1902. "A Tattoo Artist." *Pearson's Magazine*, August, pp. 174–179.

Bourdieu, Pierre. 1984. *Distinction: A Social Critique of the Judgment of Taste.* Translated by R. Nice. Cambridge, MA: Harvard University Press.

———. 1986. "The Forms of Capital." Pp. 241–258 in *The Handbook of Theory and Research for the Sociology of Education.* Edited by J. Richardson. New York: Greenwood Press.

———. 1993. *The Field of Cultural Production.* Edited by R. Johnson. New York: Columbia University Press.

Bourgois, Philippe. 2003. *In Search of Respect: Selling Crack in El Barrio.* 2nd ed. New York: Cambridge University Press.

Bowler, Anne. 1994. "Methodological Dilemmas in the Sociology of Art." Pp. 247–266 in *The Sociology of Culture.* Edited by D. Crane. Cambridge, MA: Blackwell.

Brank, Chuck. n.d. "Lyle Tuttle: Forefather of Modern Tattooing." *Prick Magazine.* Retrieved October 10, 2012, from http://www.prickmag.net/lyletuttleinterview.html.

Brown, David J. 1991. "The Professional Ex-: An Alternative for Exiting the Deviant Career." *Sociological Quarterly* 32:219–230.

Burchett, George. 1958. *Memoirs of a Tattooist: From the Notes, Diaries and Letters of the Late "King of Tattooists."* Edited by P. Leighton. London: Oldbourne.

Carswell, John. 1958. *Coptic Tattoo Designs.* Beirut: American University of Beirut.

Ciferri, Seth. [2003] 2011a. "Machine Theory 101." In *Tattoo Artists Magazine: Volume One,* hardcover collection of issues 1–5, 51. N.p.: Tattoo Artists Magazine.

———. [2003] 2011b. "Machine Theory 101." In *Tattoo Artists Magazine: Volume One,* hardcover collection of issues 1–5, 132–133. N.p.: Tattoo Artists Magazine.

Clark, Alfred E. 1963. "City Tattoo Ban Ruled Illegal; Health Code Called Sufficient." *New York Times,* July 2, p. 31.

Coe, Kathryn, Mary P. Harmon, Blair Verner, and Andrew Tonn. 1993. "Tattoos and Male Alliances." *Human Nature* 4:199–204.

Cohen, Stanley. [1972] 2002. *Folk Devils and Moral Panics.* 3rd ed. New York: Routledge.

Collins, Randall. 1981. "On the Microfoundations of Macrosociology." *American Journal of Sociology* 86:984–1014.

———. 2005. *Interaction Ritual Chains.* Princeton, NJ: Princeton University Press.

Corbin, Juliet, and Anselm Strauss. [1990] 2008. *Basics of Qualitative Research.* 3rd ed. Thousand Oaks, CA: Sage.

Crane, D. 1976. "Reward Systems in Art, Science, and Religion." *American Behavioral Scientist* 19:719–734.

Crossley, Nick. 2005. "Mapping Reflexive Body Techniques: On Body Modification and Maintenance." *Body & Society* 11:1–35.

Dahrendorf, Ralf. [1957] 1959. *Class and Class Conflict in Industrial Society.* Stanford, CA: Stanford University Press.

Darwin, Charles. [1874] 1902. *The Descent of Man and Selection in Relation to Sex.* New York: P. F. Collier.

Davis, Kingsley, and Wilbert E. Moore. 1945. "Some Principles of Stratification." *American Sociological Review* 10:242–249.

DeMello, Margo. 1993. "The Convict Body: Tattooing among Male American Prisoners." *Anthropology Today* 9:10–13.

———. 1995. "'Not Just for Bikers Anymore': Popular Representations of American Tattooing." *Journal of Popular Culture* 29:37–52.

———. 2000. *Bodies of Inscription: A Cultural History of the Modern Tattoo Community*. Durham, NC: Duke University Press.

DeNora, Tia. 2000. *Music in Everyday Life*. Cambridge: Cambridge University Press.

Denzin, Norman K. 1996. *Interpretive Ethnography: Ethnographic Practices for the 21st Century*. Thousand Oaks, CA: Sage.

Desmond, Matthew. 2016. *Evicted: Poverty and Profit in the American City*. New York: Crown.

Dunnier, Mitchell. 1999. *Sidewalk*. New York: Farrar, Straus and Giroux.

Durkheim, Emile. 1951. *Suicide: A Study in Sociology*. Edited by G. Simpson. Translated by J. A. Spaulding. New York: Free Press.

———. 1982. *The Rules of the Sociological Method and Selected Texts on Sociology and Its Method*. Edited by S. Lukes. Translated by W. D. Halls. New York: Free Press.

———. [1984] 2014. *The Division of Labor in Society*. Edited by S. Lukes. Translated by W. D. Halls. New York: Free Press.

Ebensten, Hanns. 1953. *Pierced Hearts and True Love: An Illustrated History of the Origin and Development of European Tattooing and a Survey of Its Present State*. London: Derek Verschoyle.

Eldridge, C. W. 1982. *The History of the Tattoo Machine*. Winston-Salem, NC: Tattoo Archive.

Erikson, Kai. 1966. *Wayward Puritans: A Study in the Sociology of Deviance*. Boston: Allyn and Bacon.

Everstine, Carl N., ed. 1966. *The Baltimore City Code Containing the General Ordinances of the Mayor and City Council of Baltimore, Maryland, in Force on April 1, 1966*. Baltimore.

Ewick, Patricia, and Susan S. Silbey. 1998. *The Common Place of Law: Stories from Everyday Life*. Chicago: Chicago University Press.

Farber, David, and Beth Bailey. 2010. "Hotel Street." Pp. 50–78 in *Homeward Bound: The Life and Times of Hori Smoku Sailor Jerry: A Collection of Photographs, Ephemera and Essays from the Film, Hori Smoku Sailor Jerry*. N.p.: Sailor Jerry.

Faulkner, Robert R., and Howard S. Becker. 2009. *Do You Know? Jazz Repertoire in Action*. Chicago: Chicago University Press.

Fine, Gary Alan. 1983. *Shared Fantasy: Role-Playing Games and Social Worlds*. Chicago: Chicago University Press.

———. [1996] 2009. *Kitchens: The Culture of Restaurant Work*. Berkeley: University of California Press.

Forsyth, Craig J., and Tina H. Deshotels. 1998. "A Deviant Process: The Sojourn of the Stripper." *Sociological Spectrum* 18:77–92.

Frederick, Bobby G. 2003. "Tattoos and the First Amendment-Art Should Be Protected as Art: The South Carolina Supreme Court Upholds the State's Ban on Tattooing." *South Carolina Law Review* 55:231.

Fritsvold, Erik D. 2009. "Under the Law: Legal Consciousness and Radical Environmental Activism." *Law & Social Inquiry* 34:799–824.

George, James. 2001. "From Back Alleys to Beauty Queens: Suddenly, Tattoos Are Mainstream and All Over. Yes, All Over." *New York Times*, July 27, pp. NJ1, NJ7.

Goffman, Erving. 1959. *The Presentation of Self in Everyday Life*. New York: Anchor Books.

———. [1961] 2007. *Asylums: Essays on the Social Situation of Mental Patients and Other Inmates*. New Brunswick, NJ: Transaction Press.

———. [1963] 1966. *Behavior in Public Places: Notes on the Social Organization of Gatherings*. New York: Free Press.

———. [1963] 1986. *Stigma: Notes on the Management of Spoiled Identity*. New York: Simon & Schuster.

Gouldner, Alvin W. 1954. *Patterns of Industrial Bureaucracy: A Case Study of Modern Factory Administration*. New York: Free Press.

Gove, Walter R. 2004. "The Career of the Mentally Ill: An Integration of Psychiatric, Labeling/Social Construction, and Lay Perspectives." *Journal of Health and Social Behavior* 45:357–375.

Govenar, Alan. 1988. "The Variable Context of Chicano Tattooing." Pp. 209–217 in *Marks of Civilization: Artistic Transformations of the Human Body*. Edited by A. Rubin. Los Angeles: Museum of Cultural History, University of California.

———. 2000. "The Changing Image of Tattooing in American Culture, 1846–1966." Pp. 212–233 in *Written on the Body: The Tattoo in European and American History*. Edited by J. Caplan. Princeton, NJ: Princeton University Press.

Grattet, Ryken, Valerie Jenness, and Theodore R. Curry. 1998. "The Homogenization and Differentiation of Hate Crime Law in the United States, 1978 to 1995: Innovation and Diffusion in the Criminalization of Bigotry." *American Sociological Review* 63:286–307.

Grazian, David. 2003. *Blue Chicago: The Search for Authenticity in Urban Blues Chicago*. Chicago: Chicago University Press.

Griswold, Wendy. 1981. "American Character and the American Novel: An Expansion of Reflection Theory in the Sociology of Literature." *American Journal of Sociology* 86:740–765.

———. 1987. "A Methodological Framework for the Sociology of Culture." *Sociological Methodology* 17:1–35.

———. 2013. *Cultures and Societies in a Changing World*. 4th ed. Thousand Oaks, CA: Sage.

Grumet, Gerald W. 1983. "Psychodynamic Implications of Tattoos." *American Journal of Orthopsychiatry* 53:482–492.

Gusfield, Joseph R. [1963] 1986. *Symbolic Crusades: Status Politics and the American Temperance Movement*. 2nd ed. Urbana: University of Illinois Press.

Gustafson, Mark. 2000. "The Tattoo in the Later Roman Empire and Beyond." Pp. 17–45 in *Written on the Body: The Tattoo in European and American History*. Edited by J. Caplan. Princeton, NJ: Princeton University Press.

Habermas, Jürgen. 1987. *The Theory of Communicative Action, Volume 2: Lifeworld and System: A Critique of Functionalist Reason*. Translated by T. McCarthy. Boston: Beacon.

Haenfler, Ross. 2007. *Straight Edge: Clean-Living Youth, Hardcore Punk, and Social Change*. New Brunswick, NJ: Rutgers University Press.

Hall, Stuart, and Tony Jefferson. 1975. *Resistance through Ritual: Youth Subcultures in Postwar Britain*. New York: Routledge.

Halnon, Karen Bettez, and Saundra Cohen. 2006. "Muscles, Motorcycles and Tattoos: Gentrification in a New Frontier." *Journal of Consumer Culture* 6:33–56.

Hardy, Ed. [1982] 2012. "Interview: Paul Rogers." Pp. 37–45 in *TattooTime: New Tribalism*. Vol. 1. Edited by D. E. Hardy. Honolulu: Hardy Marks.

———. 2013. *Wear Your Dreams: My Life in Tattoos*. New York: St Martin's Press.

Hays, Sharon. 2003. *Flat Broke with Children: Women in the Age of Welfare Reform*. New York: Oxford University Press.

Hebdige, Dick. 1979. *Subculture: The Meaning of Style*. New York: Routledge.

Hochschild, Arlie Russell. 1985. *The Managed Heart: Commercialization of Human Feeling*. Berkeley: University of California Press.

Horkheimer, Max, and Theodor Adorno. [1969] 1993. *The Dialectic of Enlightenment*. Translated by J. Cumming. New York: Continuum.

Hughes, Everett C. [1958] 2012. *Men and Their Work*. London: Forgotten Books.

Independence Seaport Museum. 2009. *Skin and Bones: Tattoos in the Life of the American Sailor*. Exhibit. Philadelphia: Independence Seaport Museum.

Irwin, Katherine. 2000. "Negotiating the Tattoo." Pp. 469–479 in *Constructions of Deviance: Social Power, Context, and Interaction*. Edited by P. A. Adler and P. Adler. Belmont, CA: Wadsworth.

———. 2001. "Legitimating the First Tattoo: Moral Passage through Informal Interaction." *Symbolic Interaction* 24:49–73.

———. 2003. "Saints and Sinners: Elite Tattoo Collectors and Tattooists as Positive and Negative Deviance." *Sociological Spectrum* 23:27–57.

Jacobs, Jerry A., and Kathleen Gerson. 2004. *The Time Divide: Work, Family, and Gender Inequality*. Cambridge, MA: Harvard University Press.

Jennings, Wesley G., Bryanna Hahn Fox, and David P. Farrington. 2014. "Inked into Crime? An Examination of the Causal Relationship between Tattoos and Life-Course Offending among Males from the Cambridge Study in Delinquent Development." *Journal of Criminal Justice* 42:77–84.

Jones, C. P. 2000. "Stigma and Tattoo." Pp. 1–16 in *Written on the Body: The Tattoo in European and American History*. Edited by J. Caplan. Princeton, NJ: Princeton University Press.

Kanter, Rosabeth Moss. [1977] 1993. *Men and Women of the Corporation*. New York: Basic Books.

Kitamura, Takihiro, and Katie M. Kitamura. 2001. *Bushido: Legacies of the Japanese Tattoo*. Atglen, PA: Schiffer.

Kosut, Mary. 2000. "Tattoo Narratives: The Intersection of the Body, Self-identity, and Society." *Visual Sociology* 15:79–100.

———. 2006a. "An Ironic Fad: The Commodification and Consumption of Tattoos." *Journal of Popular Culture* 39:1035–1048.

———. 2006b. "Mad Artists and Tattooed Perverts: Deviant Discourse and the Social Construction of Cultural Categories." *Deviant Behavior* 27:73–95.

———. 2014. "The Artification of Tattoo: Transformations within a Cultural Field." *Cultural Sociology* 8:142–158.

Krause, Elliot A. 1971. *The Sociology of Occupations*. Boston: Little, Brown.

Lanphear v. Commonwealth of Massachusetts. 2000. CA No. 99-1896B.

Lane, David. C. 2014. "Tat's All Folks: An Analysis of Tattoo Literature." *Sociology Compass* 8:398–410.

———. 2017. "Understanding Body Modification: A Process-Based Framework." *Sociology Compass* 11: https://doi.org/10.1111/soc4.12495.

Lemma, Alessandra. 2010. *Under the Skin: A Psychoanalytic Study of Body Modification*. New York: Routledge.

Linder, Staffan B. 1970. *The Harried Leisure Class*. New York: Columbia University Press.

Lodder, Matt. 2010. "Body Art: Modification as Artistic Practice." PhD dissertation, Department of History of Art, University of Reading, Reading, U.K.

———. 2015a. "The New Old Style: Tradition, Archetype and Rhetoric in Contemporary Western Tattooing." Pp. 103–119 in *Revival: Memories, Identities, Utopias*. Edited by A. Lepine, M. Lodder, and R. McKever. London: Courtauld Books Online.

———. 2015b. "'Things of the Sea': Iconographic Continuities between Tattooing and Handicrafts in Georgian-Era Maritime Culture." *Sculpture Journal* 24:195–210.

Lombroso, Cesare. [1876] 2006. *The Criminal Man*. Translated by Mary Gibson and Nicole Hahn Rafter. Durham, NC: Duke University Press.

———. 1896. "The Savage Origin of Tattooing." *Appleton's Popular Science Monthly* 48 (April): 793–803.

Luckinbill, David F., and Joel Best. 1981. "Careers in Deviance and Respectability: The Analogy's Limitations." *Social Problems* 29:197–206.

Maguire, Kathy. 2013. *The Collection*. Chicago: Modern Tattoo.

Mars, Sarah G., Jeff Ondocsin, and Daniel H. Ciccarone. 2018. "Sold as Heroin: Perceptions and Use of an Evolving Drug in Baltimore, MD." *Journal of Psychoactive Drugs* 50:167–176.

Martin, Cayla R., and Sharon L. Cairns. 2015. "Why Would You Get THAT Done?! Stigma Experiences of Women with Piercings and Tattoos Attending Postsecondary Schools." *Canadian Journal of Counseling and Psychotherapy* 49:139–162.

Marx, Karl. 1978. *The Marx-Engels Reader*. 2nd ed. Edited by Robert C. Tucker. New York: W. W. Norton.

Maxwell, Joseph A. 2005. *Qualitative Research Design: An Interactive Approach*. Applied Social Research Series, vol. 41. Thousand Oaks, CA: Sage.

McCabe, Michael. 1994. *New York City Tattoo: The Oral History of an Urban Art*. Honolulu: Hardy Marks.

Mead, George H. 1934. *Mind, Self, and Society: From the Standpoint of a Social Behaviorist*. Edited by C. W. Morris. Chicago: Chicago University Press.

Meredith, Robyn. 1997. "Tattoo Art Gains Color and Appeal, despite Risk: Unlicensed Tattoo Parlors Have Some Doctors Worried." *New York Times*, February 17, pp. 52.

Merry, Sally. 1990. *Getting Justice and Getting Even: Legal Consciousness among Working-Class Americans*. Chicago: Chicago University Press.

Mifflin, Margot. 2013. *Bodies of Subversion: A Secret History of Women and Tattoo*. 3rd ed. New York: powerHouse Books.

Miller, Diana L. 2016. "Gender and the Artist Archetype: Understanding Gender Inequality in Artistic Careers." *Sociology Compass* 10:119–131.

Mills, C. W. [1951] 2002. *White Collar: The American Middle Classes*. New York: Oxford University Press.

Morgan, Louis. [1912] 2015. *The Modern Tattooist*. Originally published by Courier in Berkeley, CA. Reprinted Winston Salem, NC: Tattoo Archive.

Morse, Albert L. 1977. *The Tattooists*. San Francisco: Albert L. Morse.

Muggleton, David. [2000] 2004. *Inside Subculture: The Postmodern Meaning of Style*. New York: Berg.

Myles, Michelle. 2015. "Martin Hildebrandt's Tattoo Legacy." Needles and Sins Tattoo Blog, January 16. Retrieved January 3, 2019, from http://www.needlesandsins.com/2015/01/martin-hildebrandt.html.

National Tattoo Association (NTA). 2019. "History." Retrieved January 2, 2019, from http://www.nationaltattooassociation.com/history.html.

Neuman, W. Lawrence. 2000. *Social Research Methods: Qualitative and Quantitative Approaches*. 4th ed. Boston: Allyn and Bacon.

New York City Administrative Code. 2006. Tattoo Regulation Act. 17-355–363.

New York Times. 1959. "Tattoo Men Summoned: City Calls Operators to Talk on Sanitary Conditions." October 2, p. 19. Retrieved August 10, 2012, from https://search-proquest-com.libproxy.lib.ilstu.edu/docview/114778975.

Nguyen, Duc B., and Michael H. Kinzer. 2012. "Tattoo-Associated Nontuberculous Myco-bacterial Skin Infections—Multiple States, 2011–2012." *Morbidity and Mortality Weekly Report* 61:653–656.

Nikora, Linda Waimarie, Mohi Rua, and Ngahuia Te Awekotuku. 2007. "Renewal and Resistance: Moko in Contemporary New Zealand." *Journal of Community & Applied Social Psychology* 17:477–489.

Nooteboom, Bart. 1994. "Innovation and Diffusion in Small Firms: Theory and Evidence." *Small Business Economics* 6:327–347.

Occupational Safety and Health Administration (OSHA). n.d. 29 CFR 1910.1030(f)(2)(i). Retrieved August 10, 2012, from http://www.osha.gov.

O'Conner, James V. 1996. "Tattooing: More Female Clients Enter a Formerly Male Realm: Tattoo Shops Attracting More Female Clients." *New York Times*, October 6, pp. WC1, WC5.

O'Kane, Lawrence. 1961. "City Bans Tattoos as Hepatitis Peril: Board of Health Orders 8 Parlors Shut Down by Nov. 1—Spread of Disease Cited." *New York Times*, October 10, pp. 45, 84.

Olick, Jeffrey K., and Joyce Robbins. 1998. "Social Memory Studies: From 'Collective Memory' to the Historical Sociology of Mnemonic Practices." *Annual Review of Sociology* 24:105–140.

Omi, Michael, and Howard Winant. [1986] 1994. *Racial Formation in the United States: From the 1960s to the 1980s.* New York: Routledge.

Orend, Angela, and Patricia Gagne. 2009. "Corporate Logo Tattoos and the Commodification of the Body." *Journal of Contemporary Ethnography* 38:493–517.

Orlean, Susan. 2001. "How the Fight to Legalize Tattooing in Massachusetts Was Won." *New Yorker*, July 2. Retrieved August 10, 2012, from http://www.theemploymentlawyers.com/Articles/New%20Yorker.htm.

Oselin, Sharon S. 2014. *Leaving Prostitution: Getting Out and Staying Out of Sex Work.* New York: New York University Press.

Parry, Albert. [1933] 2006. *Tattoo: Secrets of a Strange Art.* Mineola, NY: Dover.

Pavalko, Ronald M. [1971] 1988. *Sociology of Occupations and Professions.* 2nd ed. Itasca, IL: F. E. Peacock.

People v. O'Sullivan. 1986. 121 A.D.2d 658 N.Y. App. Div.

Perrow, Charles. 1986. *Complex Organizations: A Critical Essay.* 3rd ed. New York: McGraw-Hill.

Peterson, Richard A. 1976. "The Production of Culture: A Prolegomenon." *American Behavioral Scientist* 19:669–684.

———. 1982. "Five Constraints of the Production of Culture: Law, Technology, Market, Organizational Structure, and Occupational Careers." *Journal of American Popular Culture* 16:143–153.

———. 1997. *Creating Country Music: Fabricating Authenticity.* Chicago: Chicago University Press.

Peterson, Richard A., and N. Anand. 2004. "The Production of Culture Perspective." *Annual Review of Sociology* 30:3011–3334.

Peterson, Trond, and Laurie A. Morgan. 1995. "Separate and Unequal: Occupation-Establishment Sex Segregation and the Gender Wage Gap." *American Journal of Sociology* 101:329–365.

Pew Research Center. 2010. "Millennials: A Portrait of Generation Next." Retrieved January 2, 2019, from http://www.pewresearch.org/wp-content/uploads/sites/3/2010/10/millennials-confident-connected-open-to-change.pdf.

Phelan, Michael P., and Scott A. Hunt. 1998. "'Prison Gang Members' Tattoos as Identity Work: The Visual Communication of Moral Careers." *Symbolic Interaction* 21:277–298.

Pitts, Victoria. 2003. *In the Flesh: The Cultural Politics of Body Modification*. New York: Palgrave Macmillan.

Polhemus, Ted, and Lynn Proctor. 1978. *Fashion and Anti-fashion: Anthropology of Clothing and Adornment*. London: Thames and Hudson.

Preston, Marilynn. 1976. "Tattoo Artists' Convention: Celebrating Decorations of Independence." *Chicago Tribune*, January 27, Section 3: Tempo, pp. 25–26.

Punch, Maurice. 1986. *The Politics and Ethics of Fieldwork*. Beverly Hills, CA: Sage.

Ramirez, Michael. 2018. *Destined for Greatness: Passions, Dreams, and Aspirations in a College Music Town*. New Brunswick, NJ: Rutgers University Press.

Reiter, Jon. 2010. *These Old Blue Arms: The Life and Work of Amund Dietzel*. Vol. 1. Milwaukee, WI: Solid State.

———. 2011. *These Old Blue Arms: The Life and Work of Amund Dietzel*. Vol. 2. Milwaukee, WI: Solid State.

Richie, Donald, and Ian Buruma. 1980. *The Japanese Tattoo*. New York: Weatherhill.

Ritzer, George. 2004. *Enchanting a Disenchanting World: Revolutionizing the Means of Consumption*. 2nd ed. Thousand Oaks, CA: Sage.

———. 2007. *The McDonaldization of Society 5*. 2nd ed. Thousand Oaks, CA: Sage.

Rivardo, Mark G., and Colleen M. Keelan. 2010. "Body Modifications, Sexual Activity, and Religious Practices." *Psychological Reports* 106:467–474.

Roberts, Derek. 2016. "Using Dramaturgy to Better Understand Contemporary Western Tattoos." *Sociology Compass* 10:795–804.

Rosenblatt, Daniel. 1997. "The Antisocial Skin: Structure, Resistance, and the 'Modern Primitive' Adornment in the United States." *Cultural Anthropology* 12:287–334.

Rubin, Arnold. 1988. "Tattoo Renaissance." Pp. 233–261 in *Marks of Civilization: Artistic Transformations of the Human Body*. Edited by Arnold Rubin. Los Angeles: Museum of Cultural History, University of California.

Ruffle, Bradley J., and Anne Wilson. 2017. "Tat Will Tell: Tattoos and Time Preferences." LCERPA Working Paper No. 0106, Laurier Centre for Economic Research and Policy Analysis. Waterloo, Ontario.

Sanders, Clinton R. 1988. "Marks of Mischief: Becoming and Being Tattooed." *Journal of Contemporary Ethnography* 16:395–432.

———. 1989a. *Customizing the Body: The Art and Culture of Tattooing*. Philadelphia: Temple University Press.

———. 1989b. "Organizational Constraints on Tattoo Images: A Sociological Analysis of Artistic Style." Pp. 232–241 in *The Meanings of Things: Material Culture and Symbolic Expression*. Edited by I. Hodder. Boston: Unwin Hyman.

Santos, Xuan. 2009. "The Chicana Canvas: Doing Gender, Race, and Sexuality through Tattooing in East Los Angeles." *NWSA Journal* 21:91–120.

Schonberger, Nick. 2005. "Inking Identity: Tattoo Design and the Emergence of an American Industry, 1875–1930." MA thesis, Department of Early American Culture, University of Delaware, Newark.

———. 2012. *Forever: The New Tattoo*. Edited by R. Klanten and F. E. Schulze. Berlin: Gestalten.

Schrader, Abby M. 2000. "Branding the Other/Tattooing the Self: Bodily Inscription among Convicts in Russia and the Soviet Union." Pp. 174–192 in *Written on the Body: The Tattoo in European and American History*. Edited by J. Caplan. Princeton, NJ: Princeton University Press.

Scott, Marvin B., and Stanford M. Lyman. 1968. "Accounts." *American Sociological Review* 33:46–62.

Scully, Diana, and Joseph Marolla. 1984. "Convicted Rapists' Vocabulary of Motive: Excuses and Justifications." *Social Problems* 31:530–544.

Shaw, Bob. [1991] 2012. "The Tattoo World of Bob Shaw." Pp. 8–25 in *TattooTime: Art from the Heart*. Vol. 5. Edited by D. E. Hardy. Honolulu: Hardy Marks.

Silbey, Susan. 2005. "After Legal Consciousness." *Annual Review of Law and Social Science* 1:323–368.

Silverman, David. 2000. *Doing Qualitative Research: A Practical Handbook*. Thousand Oaks, CA: Sage.

Sinclair, A. T. 1909. "Tattooing of the North American Indians." *American Anthropologist* 11:362–400.

Snow, David A., and Leon Anderson. 1993. *Down on Their Luck: A Study of Homeless Street People*. Berkeley: University of California Press.

Snow, David A., E. Burke Rochford Jr., Steven K. Worden, and Robert D. Benford. 1986. "Frame Alignment Processes, Micromobilization, and Movement Participation." *American Sociological Review* 51:464–481.

South Carolina Code of Laws. 2004. Section 44-34-10–44-34-110.

St. Clair, Leonard S., and Alan Govenar. 1981. *Stoney Knows How: Life as a Tattoo Artist*. Lexington: University of Kentucky Press.

Stebbins, Robert A. 1970. "Career: The Subjective Approach." *Sociological Quarterly* 11:32–49.

Steward, Samuel M. 1990. *Bad Boys and Tough Tattoos: A Social History of the Tattoo with Gangs, Sailors and Street Corner Punks 1950–1965*. Binghamton, NY: Harrington Park Press.

Stirn, Aglaja, and Andreas Hinz. 2008. "Tattoos, Body Piercing, and Self-injury: Is There a Connection? Investigations on a Core Group of Participants Practicing Body Modification." *Psychotherapy Research* 18:326–333.

Strohecker, David Paul. 2011. "The Popularization of Tattooing: Subcultural Resistance and Commodification." MA thesis, Department of Sociology, University of Maryland, College Park, MD.

Sweetman, P. 1999. "Anchoring the (Postmodern) Self? Body Modification, Fashion and Identity." *Body & Society* 5:51–76.

Swidler, Ann. 1986. "Culture in Action: Symbols and Strategies." *American Sociological Review* 51:273–286.

Sykes, Gresham M., and David Matza. 1957. "Techniques of Neutralization: A Theory of Delinquency." *American Sociological Review* 22:664–670.

Talley, Tim. 2006. "Tattoos Are Getting Oklahoma's OK." *Seattle Times*. May 9. Retrieved August 26, 2012, from http://seattletimes.com/html/nationworld/2002981410_tattoo09 .html.

Tattoo Archive. 2010. *The Life and Times: Percy Waters*. Winston Salem, NC: Tattoo Archive.

———. 2014. *Tattoo Museums in North America*. Winston Salem, NC: Tattoo Archive.

———. 2017. *The Life & Times of "Tattoo Charlie" Geizer*. Winston Salem, NC: Tattoo Archive.

Taylor, Mark C. 1998. "Dermagraphics." Pp. 74–146 in *Hiding*. Chicago: Chicago University Press.

Thompson, Beverly Yuen. 2015. *Covered in Ink: Tattoos, Women, and the Politics of the Body*. New York: New York University Press.

Tucker, Marcia. 1981. "Tattoo: The State of the Art." *Artforum* 19:42–47.

U.S. Food and Drug Administration (USFDA). 2010. "Tattoos & Permanent Makeup: Fact Sheet." Retrieved January 2, 2019, from https://www.fda.gov/Cosmetics/ProductsIngredients/Products/ucm108530.htm.

Vail, Angus. 1999. "Tattoos Are like Potato Chips . . . You Can't Have Just One: The Process of Becoming and Being a Collector." *Deviant Behavior* 20:253–237.

———. 2000. "The Tattoos We Deserve: Producing Culture and Constructing Elitism." PhD dissertation, Department of Sociology, University of Connecticut, Storrs, CT.

Vale, V., and Andrea Juno. 1989. *Re/Search #12: Modern Primitives, and Investigation of Contemporary Adornment and Ritual.* San Francisco: Re/Search.

Venkatesh, Sudhir Alladi. 2006. *Off the Books: The Underground Economy of the Urban Poor.* Cambridge, MA: Harvard University Press.

Wagner-Pacifici, Robin, and Barry Schwartz. 1991. "The Vietnam Veterans Memorial: Commemorating a Difficult Past." *American Journal of Sociology* 97:376–420.

Weber, Max. 1946. *From Max Weber: Essays in Sociology.* Edited and translated by H. H. Gerth and C. W. Mills. New York: Oxford University Press.

———. [1968] 1978. *Economy and Society: An Outline of Interpretive Sociology.* Berkeley: University of California Press.

West, Candace, and Don H. Zimmerman. 1987. "Doing Gender." *Gender and Society* 1:125–151.

Yurkew v. Sinclair. 1980. 495 F. Supp. 1248 (D. Minn).

Index

Page numbers followed by *f* and *t* refer to figures and tables, respectively.

acquired immune deficiency syndrome (AIDS). *See* human immunodeficiency virus (HIV)
Aitchison, Guy, 161
Alberts, Lewis "Lew the Jew," 14
Alliance of Professional Tattooists (APT), 167–168
American Civil Liberties Union (ACLU), 105
art: in capitalism, 122, 123; as commodity, 122; within social spheres, 122, 123
artistic autonomy, 121–123
Audigier, Christian, 96, 212n1

Bakaty, Mike, 121
Baltimore City Health Department, 111
Barber, J. F., 204n43
Best Intentions Tattoo Magazine, 161
blood-borne pathogens (BBPs), 105, 116, 117, 118, 153, 168, 179, 180, 205n12
Bonzey, Sargent, 204n43
Bowler, Anne, 122
Brown, Edwin, 204n43
Brown, Sadie, 204n43
Burchett, George, 140, 141

Cain, Aaron, 26, 33, 176
career: blocked path in tattooing, 69–72; deviant, 67, 206n1, 206nn4–5, 207n16; sociological perspective of, 66–67

Cefarri, Seth, 33, 144, 161, 175, 176–177
Centers for Disease Control and Prevention (CDC), 115, 116
Chicago Tattoo Supply House, 204n43
Chicago Tribune, 166
Chyo, Hori, 125, 204n24
Coleman, August "Cap," 14, 18, 20, 148, 204n35, 209n9
Collins, Norman "Sailor Jerry," 22, 148, 175, 181–182, 204n26, 212n19
culture: production of, 10; sociological perspective, 206n15; tattoo, 158–159; traditions of, 158

Davies, Ash, 161
DeNora, Tia, 124
DeVita, Thom, 98, 99
Dietzel, Amund, 122–123, 124, 141

Eldridge, Chuck, 149

Federal Food, Drug, and Cosmetic Act, 115
First World Tattoo Convention of Tattoo Artists and Fans, 47, 165–166
Flash, 159
flash. *See* tattoo(s): flash
Food and Drug Administration (FDA), 101, 115–116
Fox, Dave, 178

Funk, "Crazy Philadelphia" Eddie, 88, 96, 97, 178–179

Getchell, "Electric" Elmer, 14
Goffman, Erving, 39–40, 206n21
Grime, 161
Grimshaw, Bill, 14

Hardy, Don "Ed," 18, 96, 123, 126, 143, 159, 181, 183, 212n1, 212n19
Hardy Marks Publications, 96
hepatitis, 116–117, 179; B virus (HBV), 116, 117; C virus (HCV), 116, 117; outbreak in New York City, 101–102, 209n39; outbreak in Oklahoma, 105
Hildebrandt, Martin, 13–14
Hollywood Tattoo Convention, 91
Horihito families, 77, 207n10
Horiyoshi, Shodai, 12, 22
Horiyoshi families, 77, 207n10
Horiyoshi III, 12–13, 20, 22, 158
human immunodeficiency virus (HIV), 104, 116–117, 167

Inked (TV show), 25
Inked: Culture, Style, Art, 160
International Tattoo Art, 159, 160

Jensen, Owen, 204n43

Kosut, Mary, 6

Lanphear, Stephan, 105
law: copyright, 207n3; and cultural production, 119–120; and First and Fourteenth Amendments (see tattooing: as free speech); historical role in tattooing, 100–101; and production of culture, 10; as social control, 98; and social organization, 98; and tattoo work, 98–99, 100–101, 112, 207n16
Lee, John, 26, 32–33, 52, 54, 70–71, 84, 90, 106–107, 116, 130, 146, 169, 172
legal consciousness: defined, 99; research, 208n5; resistant, 115, 117, 118, 119; of tattooists, 99, 102, 103, 104, 105, 106–110, 113, 119–120
Leu, Filip, 74
Lodder, Matt, 14, 123
Lombroso, Cesare, 125

MacDonald, Sutherland, 123–124, 125
Maguire, Kathy, 148
Malone, Mike "Rollo Banks," 66, 161, 175, 181–182
Massachusetts Declaration of Rights, 105
Mescher, Bill, 106
Miami Ink (TV show), 164
Miller, E. J., 14, 204n43
Moore, William, 204n43
Morgan, Louis, 14, 16–17, 123

National Tattoo Association (NTA), 47, 74, 165, 166, 212n10, 212n14. See also National Tattoo Club of the World
National Tattoo Club of the World, 165, 166, 212n14. See also National Tattoo Association (NTA)
National Tattoo Supply, 165
Next Tat Star (TV show), 25
North American Tattoo Club, 104, 165

Occupational Safety and Health Administration (OSHA), 115, 116
O'Reilly, Samuel, 14, 15
O'Sullivan, Joseph. See Webb, Spider
Owen, Zeke, 143, 181

Parkinson, John, 105
People v. O'Sullivan, 104
Peterson, Richard, 98
Platt, Lenora, 14
Popular Mechanics, 165, 204n43
Prevention of Disease Transmission in Tattooing (PPTT), 167
profession, 43, 206n16

Raven, Cliff, 20, 123, 126, 166
Rebel Ink, 160
Reinventing the Tattoo (Aitchison), 161
relationships, cooperative, 9, 203n51
Rogers, Paul, 18
Rubin, Arnold, 20

Sanford, Mark, 106
scrimshaw, 14, 203n8
Shaw, Bob, 39, 74
Shaw, Bobby, 74
Shaw, Larry, 74
Skin and Ink, 159–160
Skin Art, 159

Skiver, Mike, 148–149
social worlds perspective, 8–9, 19, 184
sociology, role of work in one's life, 8, 202n42
South Carolina Code of Laws, 106
Sparrow, Phil, 123, 140, 141, 212n11
Spaulding, "Huck," 18
Spaulding and Rogers Supply Company, 18
Sperry, Kris, 167
State of Grace Convention, 52
Steward, Samuel. *See* Sparrow, Phil
stratification, 40–41
Sturtz, Andy, 14
Summers, Jamie, 126

Tattoo, 159
tattoo(s): acetate pressing of, 79; aesthetics, 159; and age groups, 1; as art form, 7; bans, 101, 102t, 103–106, 117, 119, 150, 208n23, 209n39, 211n11; barrio, 128; booth, 1; and color realism, 154; as consumer commodity, 6–7; consumer price shopping, 56; designs of, 1, 16–17, 40; flash, 16–17, 22, 37, 40, 45, 50, 130, 148, 159, 170, 174–175, 181, 204n35; folklore, 159; hard-line, 30–31, 143; highly visible, 135–138; as ideological symbol, 128; ink, 2, 35, 77, 92, 115–116, 144, 152, 155, 170, 204n22, 205n12; Japanese style, 129; license (*see* tattooing: license); and "looky-loos," 44; machine builders, 25, 79, 82, 92, 144–145, 175–177; meaning assigned to, 5–6, 137–138; as membership symbol, 6; needles, 2, 46, 77, 81, 82, 145, 152, 157, 170, 172, 174, 205n12; new aesthetics in, 31; pachuco, 128; parties, 37; pigment(s), 26–27, 40, 143–144, 145, 169, 173; portrait, 142, 143; production of, 11; referrals to, 3; as resistance symbol, 6, 127; and risks, 103–105, 111–113, 208n18, 209n39; and sanitation, 61, 180, 205n12; as social position identification, 6; as social process, 5, 10; and stigmatization, 100, 123, 135–138, 211n54; suppliers, 17–19; supply companies, 18, 19, 88, 97, 159, 165, 168, 169–170, 174, 175, 176f, 204n43; uses by dominant group, 6; watercolor, 20–31; wearer, 5. *See also* tattooing: folklore; tattoo machine(s)

Tattoo Advocate, 159
Tattoo Artist Magazine (*TAM*), 160–161
tattoo conventions, 47–57, 65, 159, 180; benefits of, 48–51; and capitalism, 51–52; commodification of, 47; and contests, 48–49; drawbacks to, 51–57; knowledge diffusion through, 173–174; and networking, 54–55; as occupational socialization, 51; open to public, 47–48; and skill development, 50–51; and space organization at, 40, 41, 50, 53–57; and supplies, 49; tattooist-run, 52
Tattoo Energy, 160
tattooing: accessibility to, 126–127; and aesthetic innovations, 152–157; as alternative to formal capitalism, 186–187; and apprenticeships, 123; apprenticing in, 33; and art world, 8, 32, 122–124, 209n18; as art world, 108, 121, 145; body alteration of, 68; career shifts in, 91–92; as cash-based work, 92; casual apprenticeship in, 76, 80–82; and circuses/carnivals, 126; class divisions in, 159–161; as criminal act, 100; and criminals, 125; as deviant career, 207n16; "dirty work" in, 40, 43, 167, 205n5; division of labor in, 9; in early maritime, 14, 126, 127, 203n8; earned right to, 15, 18, 46–47, 75, 79, 84, 85; and elites / upper class, 125, 126; ethical issues in, 150; and famous people, 126, 127; as folkcraft, 14, 122; and folklore, 137, 179–182; formal apprenticeship in, 76, 77–79; as free speech, 103–104, 105–106, 208n18; gendered nature of, 74, 131–135, 138, 210n51, 211n53; genre boundaries of, 24; hierarchy in, 8, 11, 15, 16, 17, 18, 19, 21, 22, 26, 27, 28, 33, 34, 38, 41, 52, 55, 63, 67, 74–75, 76, 81, 89, 112, 152, 180–181, 188, 204n26, 206n22; and Horihito families, 77–78; and Horiyoshi families, 77–78; Japanese traditions in, 77–78; and lack of systematic regulation in the United States, 114–117; and legal code myths, 113–114; legalization of, 105; license, 108, 110–111, 112, 150; and lower class, 127; mainstream, 130; and material innovations, 153–157; and mechanistic production, 172–173; medical, 93, 95; as membership symbol, 202n24

tattooing (*continued*)
 and middle class, 124, 126–127; minimal
 health risk in, 114–118; and minors,
 118–119, 209n42; networks, 97, 168,
 175–179; as occupation, 4; and occupa-
 tional hazards in, 94; as occupational
 organization, 4, 8–9; and organization
 of labor, 40; passion for, 95, 188; past
 research on, 5–6, 131; as pathology, 5,
 201n6, 201n11; process, 1–4; as profession,
 163; profitability of, 69, 70; and public
 morality, 107; racialized dimensions
 of, 128–131, 138, 210nn44–45; as sacred
 craft, 182; self-taught, 76–77; shift to
 for-profit occupation, 14; and skill with
 machine, 18; and "skin tinting," 125, 126;
 social organization of, 15, 38, 124–127, 138,
 155, 185, 186; as social process, 10; social
 world of, 3, 8, 12, 13, 20, 21f; as state record
 keeping, 100; systems of stratification
 in, 19–22, 21f, 40–41, 124, 125, 138; and
 tattoo schools, 76, 84–85, 207n12; and
 tool distribution, 168–171; traditions of,
 22, 23, 24, 27, 50–51, 78–79, 155, 158, 173,
 180; training methods in, 76–86; and
 urban aesthetic, 130–131, 210n48. *See also*
 tattoo(s): folklore; tattooing: hierarchy
 in; tattooing: systems of stratification
 in; tattooist(s): apprentices; tattooist(s):
 social world of
tattooist(s): apprentices, 23, 41–42, 44,
 45, 46–47, 57, 69–72, 73–82, 171, 188;
 and apprentice selection, 73, 83–84;
 and artificial legal code, 113–118; and art
 interest, 68, 69, 70, 71; as artists, 21, 21f,
 28–34, 40–41, 141–145, 159, 166; and art
 training (formal), 29–30, 33, 71–72, 85,
 103, 124, 165; and authenticity, 174–179;
 black, 128–129, 130; career exits of,
 96–97; careers of, 66–97; Chicano/a,
 128, 130; and class-based model, 20; and
 clean working environment, 117–118;
 and clientele, 59–60, 63–65, 129, 131–138,
 139, 162–164; and client rapport, 2–4;
 and competition, 110; conflicts between,
 92; contemporary, 20, 38; as craftsmen,
 21, 21f, 23–27, 28, 141–145, 174, 184; cul-
 tural code of, 8, 10, 13, 15–16, 17, 19, 38,
 49, 67, 84, 88, 90, 95, 113, 118, 147, 157,

169, 183, 187; decisions of, 1–2, 8, 10, 64;
 descendants of, 74; division of labor of,
 17, 18; early, 13–17, 203n7; early exposure
 to the tattooed, 68–69, 72; earned right
 of, 23; and egotism, 180, 181; ex-, 96–97,
 207n17; experience as female, 132–135;
 experimentation of, 72, 75–76, 85–86; as
 "folk devil" (*see* tattooist[s]: as "scratch-
 ers"); frequent travel of, 91; as gatekeep-
 ers, 19, 74, 83, 84, 114, 145; ideal types
 of, 20; increased media attention on,
 159–166; independence of, 140–141, 168,
 185; as independent contractors, 42–43;
 interdependence of, 140–141, 144, 145,
 184; as journeymen, 27–28; as knowledge-
 able elder, 146–147; lack of research on,
 7, 205n2; as legends/masters, 21, 21f, 22,
 26, 33–34, 48, 51, 52, 96, 122; as machine
 builders (*see* tattoo[s]: machine builders);
 as mentors, 73, 76, 77, 78, 79, 83; mobile,
 59–61; mobility of, 67, 97; and network-
 ing, 82, 87; and new aesthetics, 142; occu-
 pational entry, 67–76; old-school ethic of,
 145–147, 148, 149, 150, 157, 159, 163, 164,
 168, 170, 171, 173, 174, 175, 182, 186, 187;
 and organization of labor, 41–47; as per-
 formance team, 39–40, 41–47; prestige
 among, 15; and professional associations,
 165–168; and professional legitimacy,
 123–124, 166; referrals to, 3; and rejection
 of clients, 205n55; reputation of, 41, 42,
 54–55, 56–57, 65; and respect, 133; and
 risk, 179; and rules of the game, 9, 13, 119,
 141, 142, 145, 146, 152, 153, 154, 184; safety
 burden on, 115; as "scratchers," 21, 21f,
 34–35, 37–38, 96, 112, 113, 128, 149–152,
 157, 185, 186; self-pride of, 123, 208n22;
 and self-regulation, 100, 102, 111–112,
 115, 116, 117, 119, 167, 208n33; self-taught,
 85–86; shopless, 34–37, 40–41, 57–64, 65,
 85, 96, 104, 105, 112, 118–119, 159, 205n55;
 as shop owners, 41–43, 44–46, 89–91,
 108–109, 146; socialization process of,
 19–22; social organization of, 16, 39–41,
 64, 97, 141; social pride of, 117–118; social
 world of, 3, 4, 8, 20, 67, 184; and societal
 independence, 9–10; sources of conten-
 tion, 141–145; space organization of, 39,
 40, 41, 53–55, 58–59, 64–65, 183; street

(*see* tattooist(s): shopless); and substance abuse, 94–95; technique, 36; and temporary transitions, 93–95; tool acquisition of, 67, 86–88; and trading, 176–178; traditions, 147, 148, 149, 150, 152, 157, 171, 175, 184, 187; training (*see* tattooing: training methods in); and tricks of the trade, 15–16, 51, 173; and upward mobility, 88–91; victimization of, 63–64; and waivers, 58–59, 99; white, 128, 130–131. *See also* tattooing: apprenticing in; tattooing: social world of

tattoo kit, 35, 75, 86–87, 170–171, 176*f*

Tattoo Life, 160

tattoo machine(s), 15–16, 17–19, 35, 40, 49, 87–88, 126, 144, 145, 152, 187; authenticity of, 176*f*, 176–177; Bishop Rotary, 211n19; Cheyenne Hawk, 156, 211n19; coil, 154, 156, 157; as collectible, 22, 148; mass-produced, 175, 204n43; owned by legends/masters, 174–175; pneumatic, 154, 156; rotary, 156–157, 211n19. *See also* tattoo(s): machine builders

Tattoo Magazine, 160

tattoo magazines, 49, 127, 159–161; knowledge diffusion through, 173–174; published by tattooists, 161, 164; for tattooists, 160–161

tattoo parties, 61–63

Tattoo Renaissance, 7, 20, 40, 41, 103, 122, 123, 124, 126, 127, 143, 165, 166, 212n9

Tattoo Revue, 159

Tattoos for Men, 159

Tattoos for Women, 159

tattoo shop(s), 41–47, 54, 78, 118; and civil laws, 106–107, 110; and counter help, 43–46, 73–74; and dummy rail, 43, 58, 201n2; early, 13, 14; and local zoning laws, 106–110, 119, 208n31; and managers, 44–45; museums in, 148–149; number in the United States, 3, 4; owner's cut, 39, 43; and reality television shows, 161–164; types of, 20

TattooTime, 159, 160, 161

Tin Tin, 52

Tuttle, Lyle, 127, 149

Two Year Autopsy (Grime), 161

Urban Ink, 159, 160

Wagner, Charlie, 14, 18, 124

Walker, Johnny, 148

Waters, Percy, 18, 19, 204n43

Webb, Spider, 103–104, 105–106, 126, 166

Weber, Max, 122, 123

White, Ron P., 105–106

Whitlock, Jimmy, 175

World Convention of Tattoo Artists, 104

Wright, Norm, 177–178

Yoshihito, Nakano. *See* Horiyoshi III

Yoshitsugu, Muramatsu. *See* Horiyoshi, Shodai

Yurkew, Dave, 47, 104, 165–166, 212n10

Yurkew v. Sinclair, 104

Zeis, Milton, 165, 212n11

About the Author

DAVID C. LANE is an assistant professor in the Department of Criminal Justice Sciences at Illinois State University. He holds a doctorate in sociology from the University of Delaware.